The Illustrated History of Natural Disasters

Jan Kozák · Vladimír Čermák

The Illustrated History
of Natural Disasters

 Springer

Jan Kozák
Geophysical Institute
Czech Academy of Sciences
Prague
Czech Republic
kozak@ig.cas.cz

Vladimír Čermák
Geophysical Institute
Czech Academy of Sciences
Prague
Czech Republic
cermak@ig.cas.cz

ISBN 978-90-481-3324-6 e-ISBN 978-90-481-3325-3
DOI 10.1007/978-90-481-3325-3
Springer Dordrecht Heidelberg London New York

Library of Congress Control Number: 2010920318

Printed on acid-free paper

Springer is part of Springer Science+Business Media (www.springer.com)

Foreword

This book tells the story of the Earth itself, explaining the interplay of its gradual geologicalevolution, presented as a generally slow and safe process, with the sudden manifestations of natural hazards, which involve disasters that affect the environment and lead to huge material damage and human losses. The natural forces at play, whether they are violent explosions ofvolcanic eruptions or almost imperceptible deformations of subsurface rock strata, finallyresulting in devastating earthquakes, all control the existence and destiny of a certain part of the global population. The development of man's existence down through history has depended upon his understanding of the world in which he lives, and upon his ability to turn to his own best use the materials that were there for the taking. However, he has had not only to furnish himself with food, water, building materials, and energy to protect himself against occasional natural adversities. Protecting himself from them meant comprehending their causes, and the essential core of his understanding was in recording and depicting them.

This book is written for anyone interested in the Earth in general, and in natural disasters in particular, presenting a unique collection of historical illustrations of volcanic eruptions and earthquake events and their repercussions. The book represents a golden mean between scientific and popular works. Its general arrangement makes it understandable and attractive for a wide range of mid-level as well as high-level educated readers interested in the earth sciences, ranging from college students to specialists. The impressive variety of historic illustrations depicting catastrophic natural disasters and their impact on human life and civilization throughout the centuries may, in addition to its educational value, also please anyone interested in art and history.

The content and arrangement of the book are essentially based on a carefully selected set of large-scale images – reproductions from originals of rare engravings, belonging to the private collection of one of the authors. The individual smaller and full-page reproductions (both color and black-and-white) present manifold (historical) views on various natural disasters, generally arranged in chronological order, e.g. Basel 1356, Azores 1592, Tokyo 1650, Etna 1669, Val di Noto 1693, Constantinople 1762, Lisbon 1755, Calabria 1783, Naples 1805, Charleston 1886, San Francisco 1868 and 1906, and many more. The illustrations are accompanied by descriptive texts that outline the geophysical and historical background, briefly explaining where, when, and why such disasters occur. Additional texts then inform the reader about the origin of the individual engravings and describe concrete stories behind some of the events.

The pictorial part of the book is introduced by a brief explanatory text informing the reader about the historical development of modern views on the dynamic manifestations of the Earth, its structure, and the description of the internal forces that spark catastrophic events. We have not simplified the arguments or the scientific observations, but have tried to present them in an easy to understand manner without unnecessary technical jargon. In the historical review, we have only mentioned the names of those whom we consider to have made the most significant contributions to the development of earth sciences.

For the authors of this book, who had worked actively in fundamental geophysical research for many years, several good reasons recently emerged, which stimulated them to compose this pictorial book on historical natural disasters. On most social, educational and professional levels, the modern populace is increasingly mentally occupied with the fast-moving process of civilization, and with their own day-to-day efforts to cope with the rapid advancement of new electronic technologies, computers, etc. Such an engagement quite naturally drives modern people toward a certain life in the *"present moment."* It necessarily follows that most of us thus lose our awareness of our historical continuity and consequences of the life that came before us.

The last millennium with its advancement of civilization was based on free rational considerations and, later on, scientific thinking. We believe that – in this context – the earth sciences, which together with astronomy and mathematics are among the oldest disciplines of science, offer convincing examples of this process.

More than that, it seems to us that a *pictorial* historical excursion through the last few centuries focused on dynamic manifestations of the Earth, commonly known as *natural disasters* – if properly understood and correctly interpreted – may even help to answer some acute questions of the present times, namely those related to the sustainability of ecological equilibrium in the modern world. Needless to say, any proper prognoses or extrapolations necessitate a detailed knowledge of the past.

The image reproduction techniques have made remarkable progress. At present, in the age of the practically unlimited possibilities offered by digital photography, which has been a welcome innovation in the last several years, many people, especially the younger generations, are already no longer cognizant that in the past any reproduction of words or images was entirely dependent on printing – from original matrices on paper sheets – using mechanical printing machines. This was true for book printing, for woodcut "stamp" printing, for making engravings, and for lithographic prints, to name the most important techniques. Today only few people remember that the images from the printing machine ruled the European world from the turn of the Middle Ages up to ca. 1900, i.e., some four centuries. The illustrations presented in this book bear witness to this fact, and should not be forgotten.

Lastly, the attractiveness of old prints, their beauty, authenticity, and – in some cases – also their sweet naivety definitely soothe the eye. The old pictorial prints thus exemplify and may revive the long-forgotten atmosphere of far-off events, which occurred and were portrayed at those times.

Jan Kozák
Vladimír Čermák

Contents

List of Tables

List of Figures

Introduction

Through the last 300,000 years, at least, men of various ethnics and from different parts of the globe have explored their world for living space, food, shelter, and later also for various materials to accommodate their increasing living needs. The environment was – with temporary exceptions – generally favorable, and nature generally provided mankind with all that people needed and wanted. Human society was gradually developing and its living conditions were steadily improving.

However, from time to time, nature showed its less friendly face, and from the very beginning, the human society was confronted with adversities of various kinds, among them are natural disasters, such as earthquakes and volcanic eruptions. Just remember that a "mega-colossal" super-volcano eruption at Lake Toba in Indonesia some 74,000 years ago allegedly wiped out almost all of the global human population, reducing it from at most 60 million to less than 50,000–60,000. Primitive people did not understand these natural manifestations, just as they did not understand many other mysteries of the surrounding world. They passively accepted all the catastrophic events as certain inflictions and imputed them to the will of their deities. This universal perception did not change much in the course of the millennia which followed; it was only very recently that the modern science disclosed the fundamental principles of natural hazards. The individual catastrophes, which presented important events for mankind, were often assigned as certain milestones in the human history and as such remembered, retained in traditions, and later recorded in verbal form and sometimes also depicted.

We live on a planet in which continents and oceanic basins are in a state of constant change and movement. The strongest volcanic eruptions may alter the face of extensive areas and annihilate whole populations. Large earthquakes can additionally move whole blocks of the Earth's crust, damage towns and large settlements, and cause wide-scale havoc. These two phenomena have been common in some areas, often close to places densely populated, as the volcanic soil soon becomes fertile and productive. The European Mediterranean region, Japan, China, Central America, and others, where early civilizations came into existence, advanced and flourished, and also represent the principal natural scenes, where earthquakes and volcanic events have regularly occurred.

To meet the central topic of the book, namely, the presentation of depictions of outstanding earthquakes and volcanic events, we had to return to the recent past, to the time when people began to be interested in the principles of the surrounding nature and tried to describe it. The accounts on great disasters, which have struck mankind, were recorded in the oldest existing written documents. It was especially the European civilization, which – in the course of the last 2,000 years – named and came step-by-step to a correct description of the basic problems of the Earth, the planet which has been its host. Finally, in the second half of the eighteenth century such an effort found the reliable way of advancement, which can be characterized as "*data collecting – their coding and classification – understanding of mutual relationships – interpretation*." This procedure, in addition, also requires the attainment and evaluation of the universal empiric knowledge of a given subject.

Within approximately the last 200 years the European naturalists, savants, and scholars, who – in principle – accepted this scheme successfully moved the knowledge in Earth sciences ahead. We may thus claim, together with the French philosopher Denis Diderot (1713–1774): "*Vive la philosophie des lumières!*"(Long live the Enlightenment). It was at that time that the development of the West European civilization advanced. This remarkable boom of rational thinking obviously had several reasons; above all, it was no doubt closely related to the institution of the Catholic Church and the later Protestant Christianity, which regardless of certain Church hierarchy excesses in the Middle Ages substantially contributed to the search of a unique comprehensive and rational way of the human thinking evolution. Opening parish schools and Episcopal schools for broader social classes and easier access to literacy and common education were important inputs from the Church; the ecclesiastic education system was transformed and, during the eighteenth century, finally conduced to the installation of a general obligatory education school system. An important character of the newly established educational process in Europe was the adoption of the findings of Greek philosophy, formal logic, mathematics, and geometry, and on the higher educational levels also accepting principles of Judaic speculative abstraction. Also, the application of the so-called Arabic numerical system appeared and proved to be very positive.

J. Kozák and V. Čermák, *The Illustrated History of Natural Disasters*,
© Springer Science+Business Media B.V. 2010

The first civilizations, which mastered the language as not only a tool of basic communication but also as a tool of exact and refined locution, sometimes had difficulties with recording spoken words or with quantitative formulation of the sense-observed data. They could rely only on the simplest sequence of numbers (positive, integer) and on the most primitive numerical calculations. In such a situation, the range of solvable problems aimed to understand the Earth's manifestations was essentially reduced. Paradoxically enough, the celestial orbit movements of the Sun and the Moon were for the first observers much nearer than the Earth itself, even though it concerns the surface on which they walked. The changes on the sky had to be carefully observed and systematically recorded to set up an annual cycle to establish a calendar – the major requirement and achievement of the men dependent on primitive agriculture.

The first comprehensive concepts on the structure and composition of the Earth and the first observations of volcanic eruptions or earthquakes in Europe were evidenced in the last millennium BC, by the philosophers of ancient Greece. Among them, first of all, the thinkers living in the Greek colony on Sicily should be named, who addressed the dynamical manifestations of the Earth, namely, Aeschylus, Pindar, and Empedocles (490–430 BC). The latter systematically studied and recorded the eruption activity of Etna; he is also said to be the author of a well-known theory about four primary elements (earth, water, air, and fire), of which the whole universe was composed; this concept was later reworked by Aristotle (384–320 BC). Also Plato (428–348 BC) studied volcanism; allegedly he speculated that it had been just the huge explosion of Thira volcano (Santorin) in the Aegean Sea in 1600 BC, which possibly buried the mythic Atlantis in sea waves.

At the advent of our era, Greek geographer Strabo (64/63 BC–AD 24) described the volcanic activities of Vesuvius, and later focused his attention on the Aeolian (Lipari) Islands, especially on Santorin. Among the Roman men of letters and polymaths who were concerned with volcanoes and earthquakes, Vergilius (Virgil) (70 BC–AD 19), Ovidius (Ovid) (43 BC–AD 17), and above all Pliny the Elder (AD 23–79) became famous; the last named died when observing the historical eruption of Vesuvius in AD 79.

The attention of the Middle East savants in the sixth century AD was attracted by a volcanic catastrophe near Sumatra, where – most probably – a giant submarine volcano exploded and initiated a huge tsunami wave. This event negatively affected the life on a global scale for several following years (Keys 1999). In summary, it is necessary to stress that all ancient and early medieval reports had a strictly descriptive character, mostly based on subjective speculations. Nevertheless, one has to appreciate these attempts, at least for the fact that for their explanation the interpreters had to look below the Earth's surface no matter how much their accessibility was limited.

Christianity, represented by its highest authority, the pope in Rome, in the Middle Ages managed to unite most of the European population under the common denominator of the Christian faith, morality, and the Christian law based on the Ten Commandments. In addition, the Roman Church, loyal to the legacy of Thomas Aquinas (1225–1274), opened a more rational way of thinking. As mentioned above, the efficiency of this important position of the Church was further amplified by establishing and supporting the Christian teaching and education in the church schools and monasteries. Contrary to these positive approaches, and paradoxically enough, against the proper interests of the Church to enforce its role, rational thinking took up certain roots within the lower and middle circles of the church hierarchy and also in the secular public. They became aware of a certain rigid dogmatism of the official Church orthodoxy and eventually opposed it. The following contradictions resulting in the facedown during the fifteenth to sixteenth centuries finally ended in the schism of the Catholic Church and eventually contributed to the establishment of the independent Protestant Church. The separation was confirmed on the Trident Council in 1547–1556; the Roman Church completely closed up and reacted as a close militant formation, in which only little space for an open academic discussion was left. Logical exchange of ideas was replaced by a tough discipline together with full obedience toward the official orthodoxy of the highest Church representatives.

Under these conditions potential questions related to the origin, structure, and behavior of the Earth were put aside. And, if discussed at all, the answers were strictly searched for within the conformity of the religious dogma, preferentially in harmony with the biblical texts; anyhow, as we shall see in the following lines some exceptions still emerged from the inner church circles. It is noteworthy that the religious interpretation of the natural events was espoused also by many Protestant scholars with no difference, even though in formal liturgy and ceremonial acts they opposed Rome firmly.

Only later, in the course of the eighteenth century, "jinnee" of rational thinking, formal logic, and scientific interpretation of the observed facts escaped from the bottle. And this "jinnee" – or better a new spirit – within the last three centuries had freed the natural sciences of religious or religion-based interpretations and opened the way for modern scientific thinking.

Natural Disasters in Historical Pictures

The sequence of various pictures and illustrations is presented in this book with the aim to demonstrate how the major natural catastrophes, such as earthquakes, tsunamis, and volcanic eruptions, were depicted and commented. The first group of these images presents the oldest examples, sometimes omitting

details. Probably the early artists tried to depict the scenes which they had witnessed and which had affected their life experience. Hand paintings, which illustrated old chronicles or various religious documents, mural frescos in churches or palaces, reflected concepts based on the artist's vision. Again, unwillingly, the painter or illustrator sometimes portrayed certain event, which had impressed him heretofore.

Figure 1 presents a mural painting, which was accomplished by the German painter Nicolas Würmser from Strasburg in 1360 on the request of the Emperor Charles IV. Allegedly, Würmser was an eye-witness of the earthquake that devastated Villach and the surrounding parts of the Lower and Upper-Carinthia on January 25, 1348. The medieval picture of the destruction of the Arnoldstein castle, built on two hills, presents one of the oldest existing depictions of an earthquake, namely, a reference on an authentic earthquake or on a locality affected by an earthquake. The painting can be found in the Castle Karlštejn (near Prague), in St. Mary's Chapel. The 1348 earthquake, besides the large seismic damage to buildings, also caused a huge landslide on the southern slopes of the Dobrač Mountain (2,166 m), which buried over 5,000 people in 17 villages and completely locked the nearby valley of the Gail River. By far, this was not the first landslide in the region; similar catastrophic mountain slides had occurred in the Dobrač chalky massifs in prehistoric times. Another strong earthquake occurred in this region later, namely, in 1690 (I_o = IX, MSK-64) and in 1855.

The late medieval illustrations portraying earthquakes can be also found in Italian manuscripts of the thirteenth to sixteenth centuries. As in other countries where earthquakes were frequent, Italian views showing destroyed towns or damaged houses and people in horror were also based on long life experiences. Most of these illustrations were allegories with a little or no distinguishable relation to actual events. Figure 2, entitled "People keeping out of earthquake in caverns", is a good example; here, an angel standing at the left gives his care to the survivors looking for a shelter in protection against the natural disaster. This picture is a book illumination on parchment and was taken over from an undefined Italian manuscript of the fourteenth century. Only later, in the fifteenth century the first pictures appeared which addressed a concrete disaster. It was quite natural that most

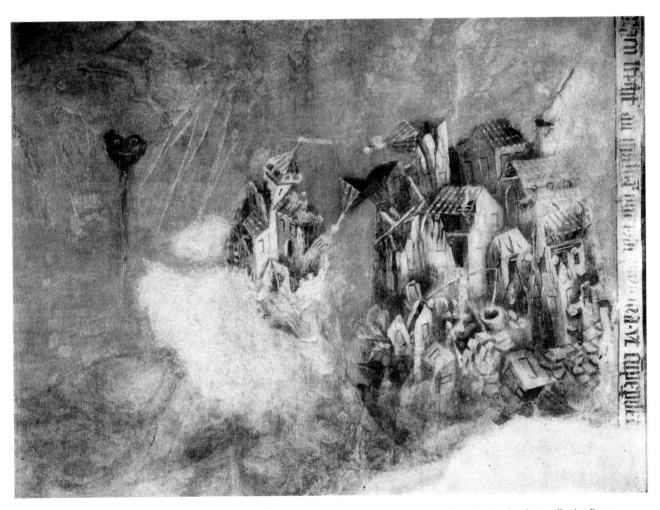

Fig. 1 The 1348 earthquake at Villach in Carinthia, Austria. Contemporary fresco, tempera wall-painting. Reproduction in private collection Prague

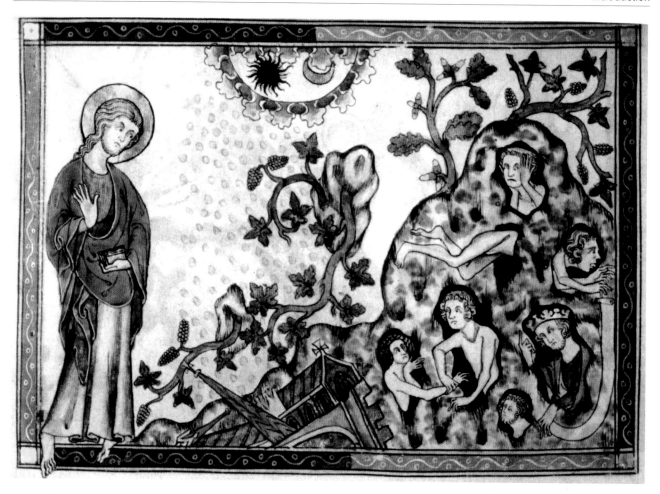

Fig. 2 Allegorical portrayal of an earthquake, given in a religious version. Reproduction kindly granted by C. Margottini, Rome. Private collection, Prague

of these illustrations had certain religious background, which sometimes dominated the composition.

Figure 3 may serve as another example. The illustration relates to the Siena earthquake of August 22, 1467; it is the work of Francesco Giorgio di Martini, a painter who decorated the anonymous manuscript entitled "*La Vergile protegge Siena dal terremoti*"(St. Mary protecting Siena against the earthquake). The original of the manuscript is preserved in the State archive of Siena. The Siena quake was relatively weak; its intensity did not exceed degree VII of the MCS scale. Anyhow, the ground tremor had frightened the citizens of Siena to such an extent that they fled from the endangered town and spent a couple of days under tents outside the town ramparts. Their concern was even multiplied 12 days later, on September 3, when a similar earthquake thrilled the town again. In agreement with the reported minimum damage, G. Martini also did not express any obvious harm to the town (such as cracks in the walls or fallen chimneys) in his picture.

Earthquake depictions which decorated various Bible editions and other religious manuscripts or prints may be con-

sidered as the next specific series of illustrations. This type of images, which became popular since the end of the fifteenth century, may be introduced by an impressive woodcut (Fig. 4) presenting allegorical "*Fall of Babel*" (Revelation of St. John, 14:8). The image was taken from *Weltchronik* (Chronicle of the World) by H. Schedel, published in Nürnberg (Schedel 1493). The event, which allegedly destroyed (?) the biblical town of Babel (Babylon) was sometimes in the modern literature interpreted as a consequence of the strong Near East earthquake. The reliable historical facts, which could explain the doom of a great ancient metropolis, however, are not available.

On one hand Babylon was located in the seismically active region at the contact of the Arabian plate colliding here with the Eurasian plate in the north. Even the effects of more distant earthquakes could have been intensified here due to the thick layer of unconsolidated sediments. The deadly effects could have been caused by earthquakes with epicenters in the Eastern Mediterranean, in the Red Sea region, along the Anatolian fault in Turkey, or in the seismically active zones in Iran. An ancient earthquake felt in Babylon was actually reported to occur as

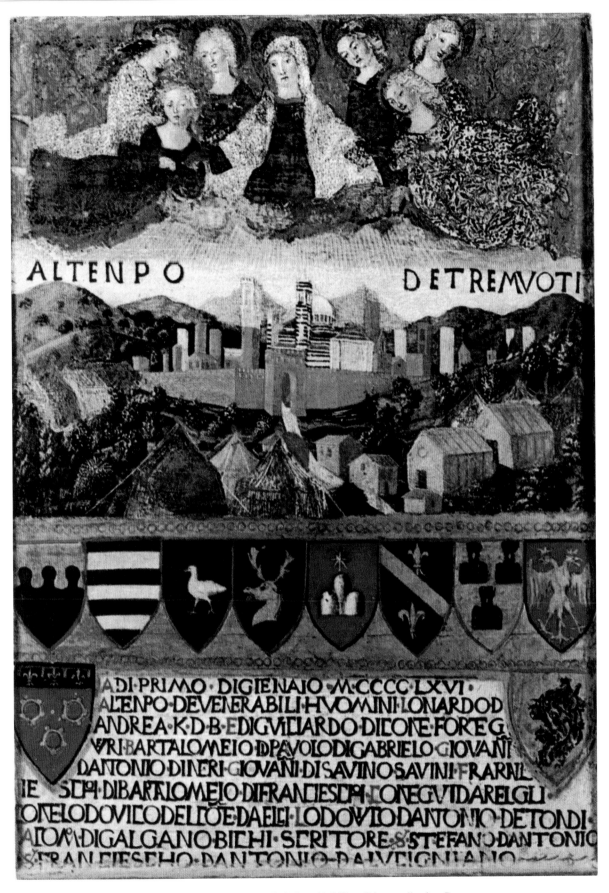

Fig. 3 The 1467 Siena earthquake in Tuscany, Italy. Courtesy of M. Stucchi, Milan, Private collection, Prague

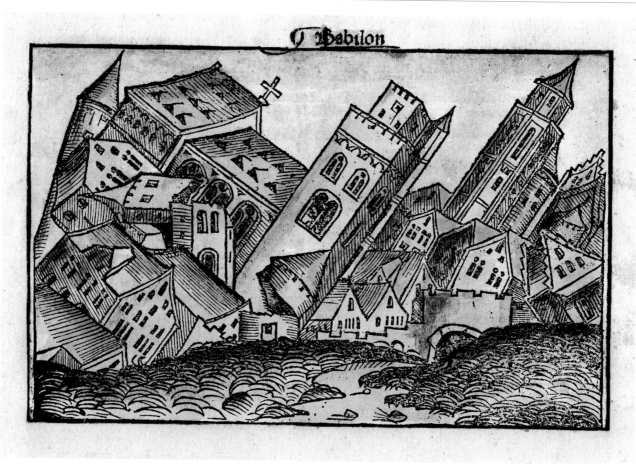

Fig. 4 "*Fall of Babylon*". Hand colored woodcut from a German incunabula of 1493. Private collection, Prague

long ago as in the year 1260 BC, and the region nearby Baghdad was struck by an earthquake on December 22, AD 856. Another catastrophic earthquake in Baghdad in the year 1007 took heavy toll of almost 10,000 victims. A long list of strong Near East earthquakes has continued till present.

On the other hand, no historical records confirm the destruction (fall) of Babylon. When the Persian ruler Kyros captured Babylon in 539 BC, he did not harm the town, and the town inhabitants welcomed him as a liberator. The peaceful decline of the town began during the rule of the Greek King Seleukos I (358–280 BC.), who ruled the (today's) Near East countries; he ordered to raise a new town called after him as Seleukia near Babylon (~45 km south of present Baghdad) and the abandoned Babylon had been slowly buried under sand. It follows that the biblical "*Fall of Babel*" is a fiction which, most probably, had never happened, neither through God's anger, nor through an earthquake.

Figure 4 does not deny its German origin; all buildings in the ruined ancient metropolis of Babylon are given in the style of the late middle age Bavarian architecture. A closer look clearly confirms that the artist had obviously neither seen any Near East masonry town, nor the war damages produced by a

furious military attack; the artist was hardly able to present realistically the damage caused by a strong earthquake.

Pictorial Reproduction Techniques

The characteristic of many European illustrations – since the beginning of the sixteenth century – changed considerably; this period of oversea voyages and discoveries and rapid development of book printing and reproduction techniques strongly influenced European life. Common needs to display newly discovered territories and make inventories of them resulted in the rapid advancement of cartography. The expanding environment, new observations, and widely spreading knowledge found reflection as a new way of thinking. This effort was characterized by a certain return to antic ideals, which also led to secular thinking and encouraged the revolt of the Cisalpine Europe against the dogmatic and autocratic position of the Roman Church. Printed materials became easily available to public, people were more interested about the world around them, a large number of new books were published, encyclopedia-type volumes appeared; and all these called for illustrations

in any form. The "hunger for information" was something quite new, but it was quickly understood by savants, travelers, cartographers, editors, and printers; a large volume of new information was written, printed, and distributed throughout the whole continent. Not only expensive bulky volumes, but also single, one-page leaflets, sheets, maps, and other simple printed documents were often richly illustrated. As a substantial part of the consumers of this printed output was still illiterate, plain and easy-to-understand pictures (e.g., woodcut illustrations) were ideal to meet the increasing demand. The attractiveness of these illustrations certainly played an important role and various images depicting remote earthquakes or volcanic eruptions met such assignments well; these illustrations were presented – with no limitation – as suitably exaggerating the reality in a sensational implementation.

In the late Middle Ages various illustration techniques were actually available, such as oil painting, tempera, aquarelle, hand drawing (by pencil, pen, chalk, or charcoal), wood carving, relief embossment, etc., but all these techniques were rather expensive, laborious, and able to create only a single original copy. On the other hand, the reproduction printing techniques, which were imported to Europe from the Orient through Italy in the fourteenth and fifteenth centuries, made it possible to produce a number of copies easily. The only drawback was the problem to create a side-reversed (left–right reversed) model depiction in printing matrices (including the script if any text was a part of the print). Two new basic printing techniques of this kind used in the sixteenth century appeared, namely, woodcut (letterpress) and, at the turn of the century, copper engraving (intaglio printing).

Woodcut is a relief printing technique in which an image is carved into the surface of a block of wood. The areas to show "white" were cut away with a knife or gouge leaving the characters or image lines to show in 'black' at the original surface level (the technique resembles today's stamps and stamping). The printing matrices were cut along the grain of the wood (in contrast to wood engraving where the matrices were cut in the end-grain). Beech wood (hard and homogeneous enough) was the most used material. The surface bas-relief was covered with ink by rolling over the surface with a roller, leaving ink upon the flat surface but not in the non-printing concave areas. In Japan the woodcut techniques were improved by preparing several identical wooden matrices for each composition; then covering the cut-in pages of the individual matrixes by different color, a multicolor final image can be obtained by successive co-printing of individual matrixes on one paper. The final image is usually called a *wood-block-print*.

The woodcut matrices may also contain "cut-in" texts. Also additional mechanical nailing of metal letters/digits into wooden matrix was used for text printing inside the woodcut pictorial compositions. Woodcut technique was the most common in the fifteenth and sixteenth centuries, as it was relatively cheap, wood was generally available, and each wooden block enabled to produce a large number of copies; on the other hand, the coarse structure of the image, not suitable for an expression of details, was a certain handicap.

Engraving is based on mechanical incising of a design onto a hard flat surface of a printing plate, usually made of copper or another metal (zinc, brass) by cutting grooves into it. After removing the metal shavings, the incised lines were filled with printing ink, the plate with a sheet of paper was passed under pressure through the printing press machine, the ink from the grooves was pulled out by pressure, and the engraved pattern was imprinted from the matrix (e.g., a copper plate) on paper, creating a copper engraving. This technique represented a significant progress; engraving became a historically important method of producing images on paper, both in artistic printmaking, for illustrations in books, and later also in newspapers and magazines. The printed images were much finer than those of woodcut technique and enabled to distinguish many details by shading. However, the engraving technique was costly, the plate preparation laborious, and the number of quality reprints was generally limited to approximately 200 prints before the engraved pattern began to deform. Among master engravers of the time were, e.g., Albrecht Dürer, Jacques Callot, Václav Hollar, and Rembrandt van Rijn who could be named. Engraving techniques offered a broad spectrum for creating magnificent artistic works. Thereafter, engraving tended to lose ground to etching, which was an easier variant of printing matrix fabrication. The difference to previous engraving techniques was in covering the metal plate by a thin layer of separating material, such as asphalt or wax or Burgundy resin, and painting the image by a needle or burin through the isolation layer creating "scratched-in" (drawn) lines. By means of dipping the metal plate, prepared in such a way, into the "aqua forte" (lye) bath the picture lines were etched in by the chemical way and the printing matrix was ready for print. As an example of the engraving technique, Fig. 5 presents an allegory image entitled "The Earth", one of the picture series illustrating four Aristotle elements.

Before the onset of photography, prints were widely used to reproduce other forms of art, for example, rare and valuable paintings. Engravings continued to be common in periodicals and books up to the turn of the nineteenth century.

Many readers may question as to why the photographs already known since 1840s were not used as illustrations in printed materials in the second half of the nineteenth century. The reason was simple: proper technology of good-quality reproduction of a photograph in printed books and journals was not known for a long time; it was intensively searched for during the decades. The first satisfactory results were obtained in 1890s. Therefore, in the "transitional" period of ~1840–1900 the desired photo illustrations were fabricated indirectly only: photographs were redrawn (later optically transferred) on a hard-wood plate, and engraved in it. Further printing process was identical to the case of the

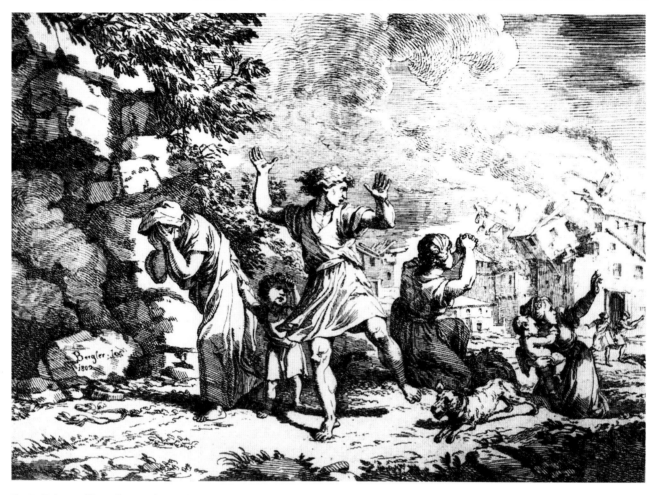

Fig. 5 *"The Earth"*, an allegory of an earthquake scene. Copper etching created by J. Bergler, Prague 1802. Private collection, Prague

copper plate matrix. This way of reproduction "from photograph" was denoted as wood engraving or xylography; xylographic images were the most popular illustrations in periodicals and book illustrations in the second half of the nineteenth century.

As an interesting point, the degree of correctness of the illustration may be mentioned, namely, the conformity between the portrayed locality and its depiction. A certain imperfection must be admitted; many authors of the geographic views, which appeared in old chronicles of the sixteenth century, often simplified their work. The interest in new images was great; however, correct presentation of distant localities was questionable, especially if the pertinent model image was not at the drawer's disposal. Thus, in some cases, the printer randomly published any other town-vedute, which he just had at hand. This sixteenth to seventeenth century habit is sometimes called "stamp method". As an example, two smaller woodcut prints published in Sebastian Münster's *Cosmographia* (Münster 1544) are shown in Fig. 6 Both woodcuts illustrated the town of Basel ruined by the 1356 earthquake. Note a slight

distortion between the upper (first edition) and the lower (later edition) versions.

After the first edition of *Cosmographia*, which appeared in Basel in 1541, a series of 44 richly illustrated re-editions followed up till 1628. Some of the wooden matrices – woodcut blocks – presenting the illustrations of strong world earthquakes, which were used in later editions, had been originally fabricated for the book by Lycosthenes (1557). Lycosthenes (by own name Wolffardt) actually sold his wooden matrices to Münster after 1557 (both savants lived in Basel and knew each other well for a long time; they had been using the services of H. Petri, the Basel printer). Later, Münster was using six or seven of Lycosthenes' wood blocks quite routinely, as a certain "logo", when illustrating several tens of earthquakes from all over the world in his *Cosmographia*. All these woodcut blocks, today we would more likely call them "woodcut stamps", presented simple pictures of South German-type towns, showing all typical signs of earthquake damage, such as inclined towers, destroyed houses, havoc of local inhabitants, or a crowd of terrified people.

Fig. 6 The 1356 Basel earthquake. The upper figure is from the 1544 edition (Münster, 1544), the bottom figure comes from a later edition. Private collection, Prague

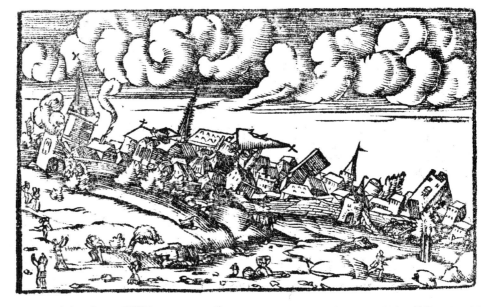

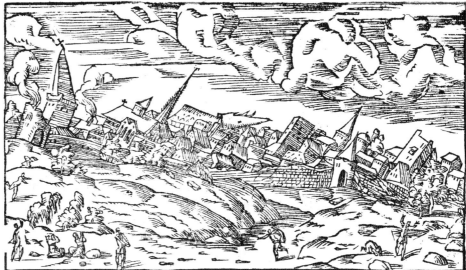

In the seventeenth century, printed illustrations already corresponded, more or less, to the portrayed reality, with an exception of cheap printed letter sheets distributed on markets, fairs, or pilgrimages. A certain role in the improvement of topographic images may be attributed to the Thirty Years' War (1618–1648), during which it was confirmed and verified how useful the reliable topographic plans might be for military operations. And, once the principle to produce a correct printing material was generally accepted, the previous fallible "logo-like" prints became obsolete and insolvable.

This tendency for a permanent improvement of illustration quality continued during the whole of the eighteenth century. It was especially the Great Lisbon earthquake in 1755, the greatest European seismic disaster ever, which upset all European population in such a way that pictures with the catastrophic themes were in great demand. While, on one side artworks on high technical standard existed, on the other side a number of various lower-quality copies flooded the market, often fantasies, which had nothing in common with the reality (Kozák et al. 2005). On the contrary, the second most tragic seismic disaster of the eighteenth century, namely, the disastrous Calabrian earthquake in February/March 1783, was iconographically documented quite correctly. The iconography of both these disasters is discussed in detail in a copious series of examples and the Lisbon and Calabria events belong to the highlights of the historical earthquakes' portrayals. The response on these tragedies continued for many decades till the mid of the nineteenth century; as a nice example,

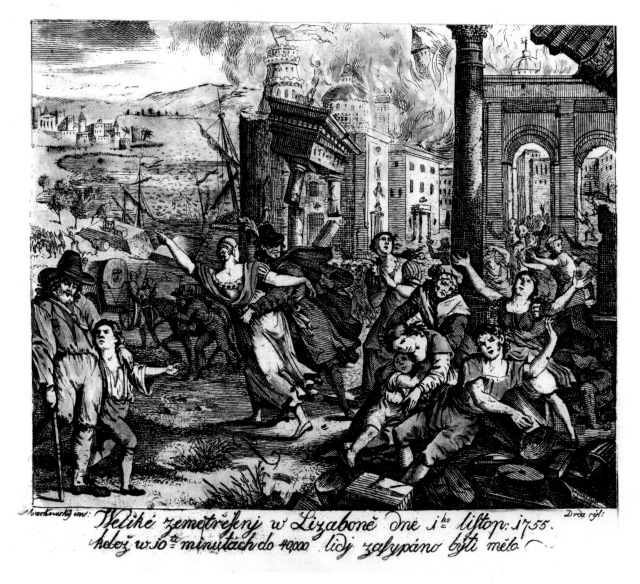

Fig. 7 The 1755 Great Lisbon earthquake. Czech leaflet, hand colored copper engraving from about 1820-1830. Signed by Markowsky and Drda. Private collection, Prague

see a fantasy presentation of the Lisbon earthquake, in which the painter focused on the panic of local inhabitants (Fig. 7).

Similarly, as the sixteenth century was certainly a turning period in the infancy of illustrating the dynamical manifestations of the Earth, the nineteenth century presented a turning period of the end of the prephotographical iconographical epoch. Since the discovery of the chemical photography in 1840s and the utilization of this process as a new documentary technique, photography started to compete with all older or new printing techniques. Photography brought the highest degree of exactness to reflect the reality and from the very beginning it was predestinated to win this competition.

Regardless of the fact that the verity and objectivity of a photographic image is beyond any question, the proper choice of a view angle or the selection of a snapshot of the whole object or only of its part may impeach the composition. As an example of such sensation-aimed manipulation see the documentary material of the 1887 Nice earthquake (Fig. 8). In fact, during the earthquake only a single building collapsed, namely the maiden school, most probably due to its incorrect static foundation. French journalists took photographs of the unhappy building from all sides and thus evoked the general readers' opinion of a serious town destruction.

The end of the 1860s signified the understanding of the nature and causes of the giant sea waves, today known as

Fig. 8 The 1887 Nice earthquake in French Riviera. Xylographic illustration prepared from the photograph by E.A. Tilly, published in *L'Illustration*, Paris. Private collection, Prague

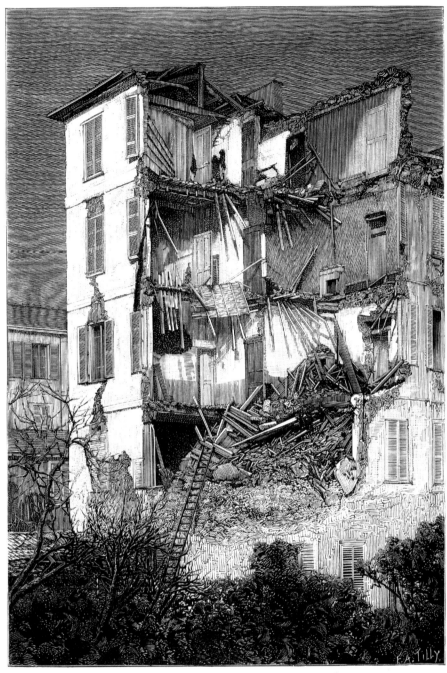

NICE : LA MAISON DE L'ÉCOLE MATERNELLE, QUARTIER SAINT-ÉTIENNE
D'après la photographie de M. Courret, à Nice.

tsunamis, which occur in seismic zones due to the sudden vertical movements of large portions of the oceanic bottom. Before 1868, the obvious connection between tsunami waves and strong suboceanic earthquakes was not fully understood and the huge sea waves were sometimes related to regular tidal waves. It was only the strong seaquake of August 13, 1868, located near Arica (Peru) on the western Pacific coast, which paved the way for a general understanding of tsunami (see Fig. 27).

At the turn of the nineteenth century, when necessary procedures were invented to convert photo image directly into print as a newspaper or book illustration, the xylographic presentation "from photograph" was definitely abolished and the former period of the domination of graphic representations was more-or-less definitely concluded. Simultaneously, the last 2 decades of the nineteenth century merged with the time when the first applicable instruments appeared for quantitative measurements of earthquake parameters, today

known as seismometers. In this way, seismometers and seismograms initiated the birth of a new discipline of seismology, namely, seismometry.

The first simple seismometers were developed in Italy in the 1870s, and soon afterwards also in Japan and elsewhere. However, it took another 20 years before the first damped seismometer came into existence, which could record an interpretable seismic wave pattern, a seismogram. Seismograms obtained by modern seismometers, which allow the determination of the absolute size of seismic displacements together with a number of other important seismic characteristics, in a combination with objective photo-documentation, gradually shaded the older macroseismic pre-instrumental studies.

At this point, we may raise a question whether the old historical, pre-photography illustrations of seismic events are still of any use. We believe that they are. When studying historical earthquakes, sometimes a careful assessment of the macroseismic data together with the inspection of the contemporary picture can help, namely, to support or modify proper value of the studied earthquake intensity given in a pertinent national catalog, i.e., in the list of all earthquakes which had occurred in a certain territory. However, such a procedure is not easy and is conditioned by a severe test of the authenticity and credibility of the treated depiction. What remains for ever is the beauty and the undeniable personality of most of the old engravings, which in the course of centuries have accompanied and enriched the human way of cognition of nature.

The following chapter will briefly explain the basic terminology of the deadliest natural disasters, their reasons, consequences, and occurrences, namely, volcanic eruptions, earthquakes, and tsunamis in relation to the structure of the Earth and its tectonic evolution. We shall see how people in their history comprehended these threats, how they tried not only to understand and describe them but especially how people pictured natural catastrophes. The past generations left us a wonderful legacy, which no doubt is worth of our interest. The following sequence of carefully selected pictorial documents covers a number of historical disasters with a description of each corresponding event. Most of the old pictures, engravings, and prints presented in this book are the results of a lifetime effort of a collection obsession of one of the authors (Jan Kozák). Unless otherwise mentioned, all illustrations are part of the private collection, which contains over 2,000 pre-photographical images portraying 193 strong earthquakes, tsunamis, and volcanic eruptions covering the long period of 1348–1908. An additional series of more than 100 allegorical compositions of natural catastrophes complements the main collection.

Volcanoes, Earthquakes, and Tsunamis

From Ancient Myths, Through Medieval Perceptions, to Present Understanding

Grecian myths tell of Atlantis, a fabled island with its advanced civilization, which sank into the sea. It is now believed that Atlantis was identical to the island of Santorin (Thira) in the Aegean Sea destroyed by a series of giant volcanic explosions around 1620 BC. The explosion of ancient Thira allegedly generated colossal tidal waves (tsunami), estimated at 30 m height, which raced across the Aegean Sea, and attacked the northern coast of Crete.

The Greek word used to describe volcanoes was *etna*, or *hiera*, after Heracles, the son of Zeus. The Roman poet Virgil, in interpreting the Greek mythos, held that the hero Enceladus was buried beneath Etna by the goddess Athena as a punishment for disobeying the gods; the mountain's rumblings were understood as his tormented cries, the flames his breath, and the tremors as his railing against the bars of his prison. Enceladus' brother Mimas was buried beneath Vesuvius by Hephaestus, and the blood of other defeated giants welled up in the Phlegraean Fields surrounding Vesuvius. Any harm caused by natural disasters was thus understood as either a way of how the gods "solved" their mutual problems or their punishment for people's wrongdoings.

In those times, the first attempts appeared to give a more realistic explanation of volcanoes. Greek philosopher Empedocles saw the world divided into four elemental forces, namely, earth, air, fire, and water; volcanoes were the manifestation of this elemental fire. Plato contended that channels of hot and cold waters flow in inexhaustible quantities through subterranean rivers. He believed that in the depths of the earth a vast river of fire exists, which feeds all the world's volcanoes. Aristotle considered underground fire as a result of "*the friction of the wind when it plunges into narrow passages.*"

Later, Roman philosopher Lucretius claimed that the Etna volcano was completely hollow and that the fires of the underground were driven by a fierce wind circulating near sea level. Ovid believed that the flame was fed from "fatty foods" and eruptions stopped when the food ran out. Vitruvius contended that sulfur, alum, and bitumen fed the deep fires.

Observations by Pliny the Elder noted the presence of earthquakes preceding an eruption; he died in the eruption of Vesuvius in AD 79. His nephew, Pliny the Younger, gave a detailed description of the eruption, attributing the death of his uncle to the effects of toxic gases.

The early Christianity partly adopted the early concepts of the governing highest divine authority. However, against the Lord, who personified God, stood Satan, who represented Evil. The volcanic manifestations were thought to be his work or the expressions of the wrath of God. Volcanic eruption with red-hot lava ejected from the depth thus nicely presented the hell-fires destined to punish the deadly sins. People can avoid the eternal condemnation only by pious and prayerful life, and be redeemed. No rational explanation of volcanic activity was given and actually no such explanation appeared during the following centuries. For more serious ideas, it was necessary to wait till the early Modern Times.

The text accompanying Fig. 9 says: "*Troubles are sent on mankind as God's punishment for their sin-full life. Troubles come from the sky in the form of natural disasters or originate from the inter-human hostility.*" Anyhow, historical advancement of the European society of the Middle Ages resulted in radical changes in its approach toward the observed natural effects, which found its reflection in the first attempts to offer the public a more realistic physical interpretation of natural phenomena. Dominican priest and famous German scholar of the thirteenth century Albertus Magnus (1193–1280) deserves special appreciation in this context, not only for his comprehensive knowledge but also for his advocacy for a peaceful coexistence of science and religion. Among many others, he also proposed a simple physical model of a volcano. His model consisted of a bronze vessel filled with water and heated from below; the vessel was equipped with a number of specially distributed valves. After the critical temperature was reached, steam from the boiling water started to leak and the system was supposed to resemble an exploding volcano. Modeling natural events in such a way was surely primitive and still only sporadic, but, however, signified the advent of certain rational thinking.

At the outset of Modern Times, some scholars directly referred to volcanism. As an example we can mention

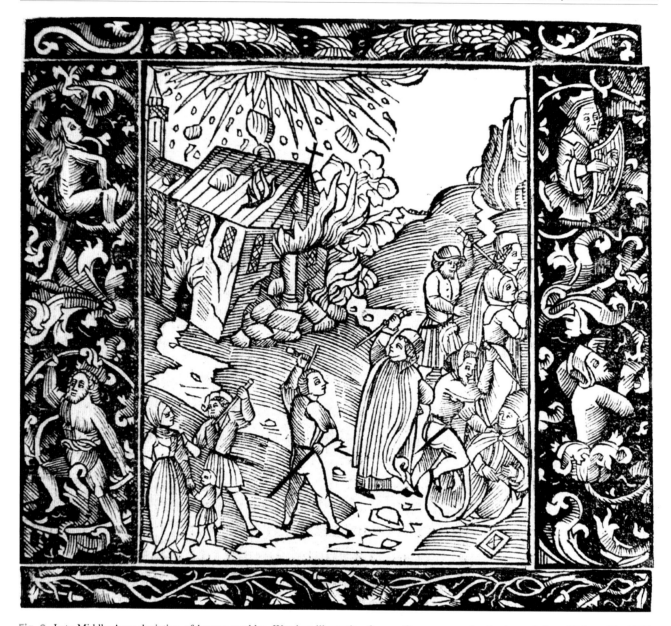

Fig. 9 Late Middle Ages depiction of human troubles. Woodcut illustration from a German second-order incunabulum (Grünpeckh, 1509). Courtesy of the Royal Kanonia of Premonstratensian Order, Prague-Strahov. Copy in private collection, Prague

Georgius Agricola, by proper name Georg Bauer (1494–1555), a German scholar and naturalist, one of the father-founders of mineralogy, who thought that vapor under pressure caused eruptions of "mountain oil" and basalt. Swiss naturalist Konrad Gessner (1516–1565) speculated about the crystallization of minerals from water, the theory which was reactivated two centuries later by Plutonists.

· Among the first scholars of the sixteenth century, who were either directly interested in volcanoes and their activities or at least admitted the fact that earthquakes and volcanic catastrophes presented natural events, Johannes Kepler (1571–1630), German mathematician and astronomer, should be named. He considered volcanoes as conduits for the tears and excrements of the earth, omitting bitumen, tar

(asphalt), and sulfur. Another outstanding naturalist René Descartes (1596–1650), French philosopher, mathematician and scientist, considered that God had created the Earth in an instant and declared that he had done so in three layers; the fiery depths, a layer of water, and the air. Volcanoes, he said, were formed where the rays of the Sun pierced the Earth.

However, it was Athanasius Kircher (1602–1680), an outstanding German Jesuit, polyhistorian of the seventeenth century, who – though he himself was an ardent Catholic cleric – formulated a self-contained theory on the earth's internal structure and described physical reasons for volcanic eruptions and earthquakes on a natural basis (Fig. 10). On a visit to southern Italy in 1638, the ever-curious Kircher was lowered into the crater of Vesuvius, then on the verge of

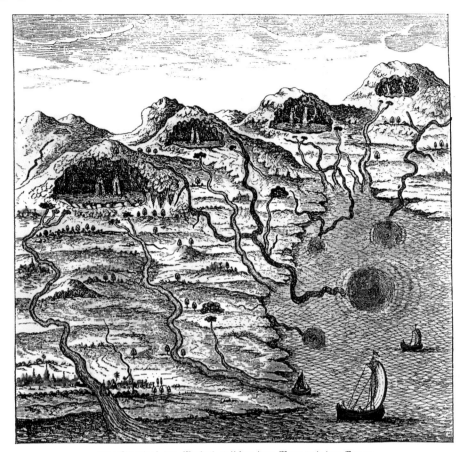

Der Kreislauf des Wassers zwischen dem Meer und den Bergen
Nach Athanasius Kircher (1665)
Die blauen Flußläufe führen das Quellwasser von den Bergen herab zum Meere, die schwarzen (unterirdischen) Kanäle
leiten das Wasser vom Meere wieder zu den Bergen zurück

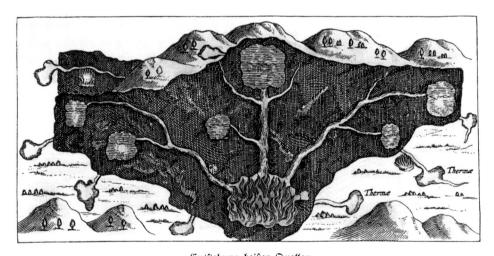

Entstehung heißer Quellen
Nach Athanasius Kircher (1665)
A = Unterirdischer Feuerherd B = Unterirdisches Wasserbecken

Fig. 10 Seventeenth century speculative idea explaining volcanic and seismic activities by underground interaction of water and fire. This idea originally presented by A. Kircher (1678) was reproduced by H. Krammer (1902-1904). Private collection, Prague

eruption, in order to examine the volcano's interior. He was also intrigued by the subterranean noise which he heard at the Strait of Messina. Kircher deserves a prodigious merit for being the first to adopt a clear secular posture that the natural events had nothing to do with religion. Such a stand was really revolutionary, especially in the whole of seventeenth and part of the eighteenth centuries when such viewpoints were strictly rejected and condemned by the Catholic Church.

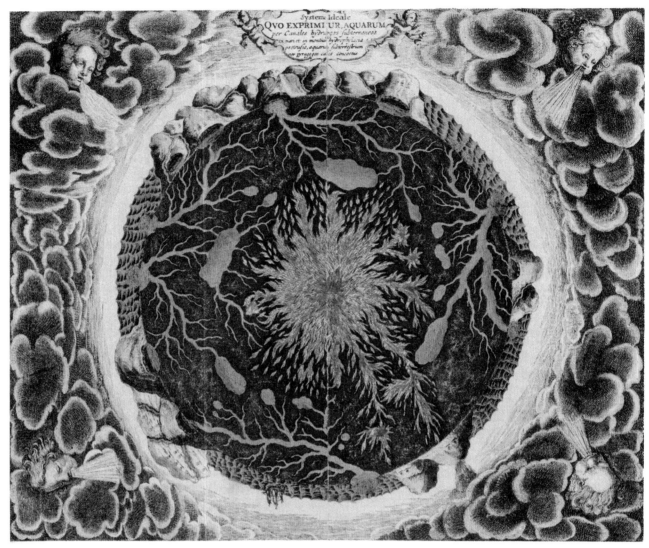

Fig. 11 The image illustrating Athanasius Kircher's concept of the internal structure of the Earth (Kircher, 1678). Red color denotes fire, blue color denotes water. Copy of the original hand colored copper engraving. Private collection, Prague

Remember the situation which occurred after the Great Lisbon earthquake in 1755, when (other) Jesuits, led by bigot Father Malagrida, fanatically fulminated against such "forwardness" and threatened the city inhabitants of an earthquake as God's wrath for their sinful life.

A copper engraving in Fig. 11 presents an ideal view of the internal earth's structure by A. Kircher; the image was reproduced from his work *"Mundus Subterraneus"* (Kircher 1678). Kircher formulated a speculative theory, according to which the earth's interior was penetrated by a complex net of broad channels of three different types. The internal connecting lines included (i) "water" tubes interconnecting all world oceans, seas, and lakes as giant vessels, (ii) air-holes or ventilation pipes, and finally (iii) corridors burned through the earth by fire. When the corridors come in contact with inflam-

mable substances, such as sulfur, coal, or asphalt, they blaze up and trigger a volcanic eruption or an earthquake. As such it might have been a childish theory, but we have to keep in mind that the author in the seventeenth century had no real chance to check his ideas and was entirely dependent on his imaginations. Anyhow, Kircher's work gained a great credit among other scholars of the time and the obvious respect to his achievements caused the survival of his image of the Earth and its interior for more than 100 years, till the mid of eighteenth century.

Regardless of the fact that Kircher's theory was later questioned step-by-step, and finally completely abandoned, his idea that earthquakes and volcanic eruptions are interrelated, and his strong confidence that both events have some kind of mutual *"subsurface engine"* eventually appeared as

viable. This is confirmed by a number of scientific communications of that time, published under the standard title "*Volcanoes and Earthquakes*". It took another century after Kircher's death in 1680 till the first instrumental data began to be collected and the earlier speculative theories abandoned. Still later on, in the course of the nineteenth century, the advancement of new scientific disciplines, such as seismology, geomagnetism, gravimetry, and geochemistry, initiated the principal turn for a revised understanding of the earth sciences.

In the eighteenth century new ideas on volcanism came out from rather speculative ideas of the general genesis of the volcanic rocks, basalt formations, or description of different lava types, supplemented by an improved and more detailed classification. The discussions on the origin and sources of earth materials went through, including, e.g., disputations on "oxidation" – i.e., origin of rocks by terrestrial heat, not from volcanic sources, but by subterranean burning of coal or sulfur. Emotional discussions on this topic split up the early geologists into two irreconcilable groups, Neptunists and Plutonists. The former believed that all rocks had their origin in the world of oceans where rocks sedimented and were later thermally metamorphosed by oxidation. Plutonists and the great majority of volcanologists who were ardent Plutonists believed in the volcanic origin of the earth's rocks.

These rapturous discussions continued simultaneously with other important historical changes in Europe. The Age of Enlightenment was approaching; principles of human rights, citizen freedom, and social claims were declared and manifested through the Great French Revolution. Diderot's great Encyclopedia was published, and Buffon's voluminous works on nature were published, his scientific methods and procedures being defined. New scientific disciplines were born, such as geology and volcanology, mineralogy, and crystallography, and they developed rapidly. Previous sharp discussions between Plutonists and Neptunist appeared to be productive and useful since they catalyzed the geological sciences advancement.

Progress was also remarkable in understanding the physics of volcanic processes. French explorers and naturalists Pierre Bouguer (1698–1758) and Charles-Marie de la Condamine (1701–1774), Scottish diplomat, archeologist, and volcanologist William Hamilton (1730–1803), German geologist Abraham Gottlob Werner (1749–1817), and many others had engaged in thorough studies of rock properties; their work brought new data and new relations which enabled the formulation of a new hypothesis. Figures 12 and 13 present typical types of illustrations popular at that time, such as maps combined with illustrated listings of important mountains, rivers, and other geographical objects, as well as pop-up picture books summarizing individual stages of geological processes, which could be used for educational purposes.

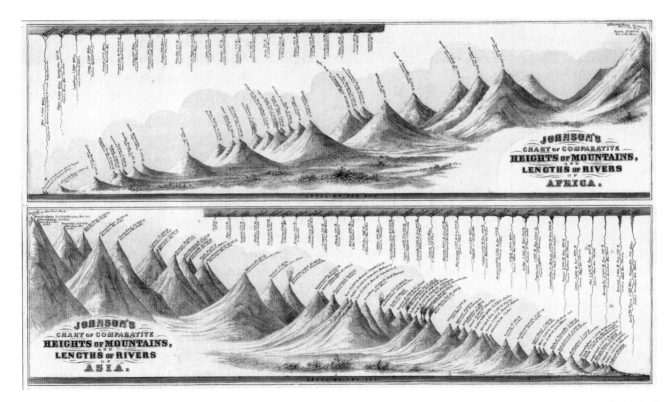

Fig. 12 Johnston's chart of comparative mountains heights (including volcanoes) and rivers lengths for Africa and Asia, from "Physical Atlas" (Johnston and Ward, 1864). Private collection, Prague

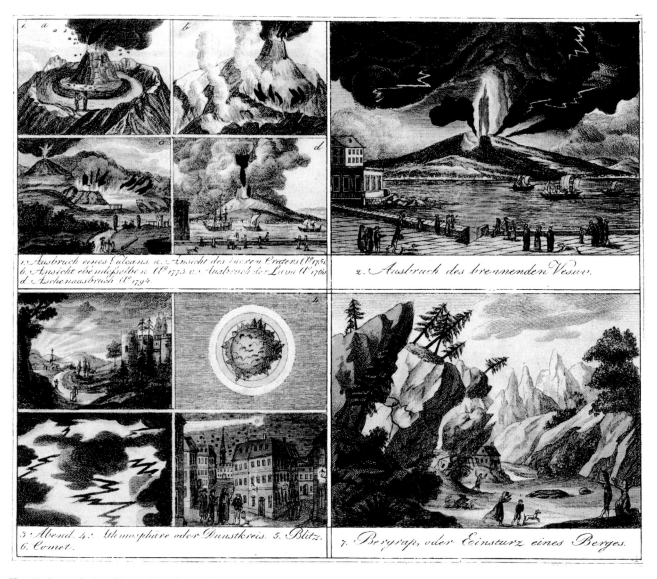

Fig. 13 Dynamical earth's manifestations collected and displayed for education of the youth. Hand colored copper engravings from "*Schauplatz der Schöpfung*" (Theatre of [Natural] Manifestations), Vienna (Riedl, 1816). Private collection, Prague

Four principal centers for earth sciences emerged in Europe, all of them more or less focused on solving the volcanic problems, namely, in France, Central Europe, Italy, and England. Their occurrence and location was definitely not accidental; this fact could be confirmed by means of the that-time geological map of Europe: in addition to the region of active volcanoes in Italy, there were two complex – on a geological map clearly identifiable – regions north of the Alps, rich in rocks of different age and origin and boasting about deposits of precious metals. All these three (Subalpine and Cisalpine) zones represented certain natural volcanological and geological "laboratories." The fourth center, England, had been actually a well-established center of European natural sciences since the seventeenth century.

An important location for geological studies was Massif Central and its Tertiary Chaîne des Puys in France. If we consider the activity of the renowned French Academy and the many famous works of the Encyclopedists, there are no doubts that France presented one of the most important nuclei of the early European geological and volcanological school. The very first geological map – map of France – was worked on by the French naturalist and mineralogist Jean-Étienne Guettard (1715–1786) in the 1740s; the whole project, unfortunately, could not be completed.

We cannot forget George-Louis Leclerc, Comte de Buffon (1707–1788), whose views and ideas influenced the next two generations of naturalists, including Jean-Baptiste Lamarck and Charles Darwin. Buffon is best remembered for his great work "*Histoire naturelle, générale*

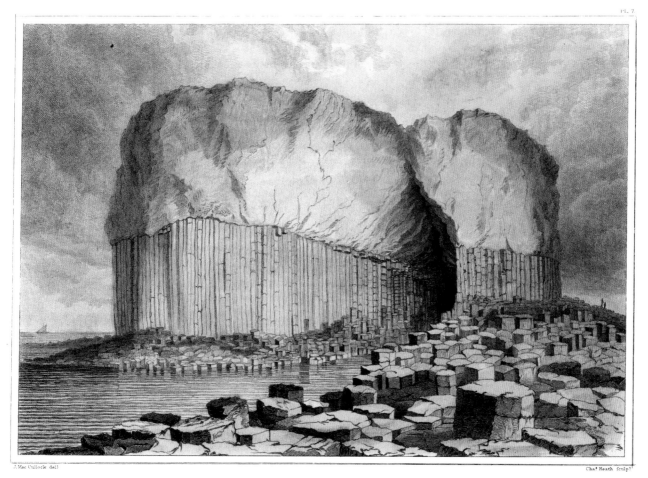

PL. 7

J. Mac Culloch del? Cha? Heath sculp?

ENTRANCE OF FINGAL'S CAVE, STAFFA.

Published June 1.1819. by Constable & C? Edinburgh.

Fig. 14 Entrance of Fingal's cave, Staffa. Published in June 1829 by Constable R.C. Edinburgh. Private collection, Prague

et particulière" (Buffon, 1749–1804), a colossal work in 44 volumes. Geologist Nicolas Desmarest (1725–1815) contributed to the Diderot's "*Encyclopedia*" by detailed analyses of the lava fields in the region Chaîne de Puys in central France and cast doubts upon the Neptunist concept of rock origin. In 1763, Desmarest made observations in Auvergne recognizing that the prismatic basalts there were old lava streams. He compared them with the columns of the Giant's Causeway in Ireland, and referred to them as extinct volcanoes. Barthélemy Faujas de Saint-Fond (1741–1819), geologist, in his most important work "*Recherches sur les volcans Eteints du Vivarais et du Velay*" documented his astute observations allowing him to develop a theory about the origin of volcanoes. Faujas was also the first to recognize the volcanic nature of the basaltic columns in Fingal's Cave, on the Staffa Island, North Scotland (Fig. 14).

Jean-Baptiste Élie de Beaumont (1798–1874) was an outstanding geologist and close coworker of Leopold von Buch. They both visited Italian volcanoes and further elaborated on

the uplift theory of volcanoes. Constant Prévost (1787–1856), cofounder of the French Geological Society, was delegated to investigate the newly emerging island (in the Graham shoal) near Sicily coast, where the volcano Ferdinandea had risen up on the sea surface in July 1831. Having studied the volcanoes of Italy and Auvergne, he opposed the views of Christian Leopold von Buch regarding craters of elevation, maintaining that the cones were due to the material successively erupted. Like Lyell, Prévost advocated a study of the slow and incessant forces in action at present, in order to illustrate the past, he defended the principle, which discounted catastrophic events, called in geology as uniformitarianism.

Deodat de Pratet de Dolomieu (1750–1801), professor on *École de Mines de Paris* (Parisian Mining academy), managed in his short scientific career valuable analytical volcanological studies in central and southern Italy and became convinced that water played a major role in shaping the surface of the earth through a series of prehistoric, catastrophic events. French artist and engraver Jean-Claude

Richard de Saint-Non, who visited several important volcanic regions of Europe, became famous for his encyclopedic work on volcanoes in Italy and Sicily, which he decorated by large copper-engraving compositions of great artistic and factual value.

Jean Baptista de Bory (1778–1846) should also be remembered; he realized one of the very first volcanological expeditions outside Europe, namely, to the Indian Ocean, where he spent 2 years investigating volcanoes in the Reunion Island (Bory de Saint Vincent 1804). Pioneering measurements of the eruptive gases were carried out by the French mineralogist Charles Sainte-Claire Deville (1814–1876), who in 1842 visited a number of volcanoes in the Central Atlantic Ocean and in the Antilles Islands and conducted a series of analytical tests of gaseous emanations and their qualitative changes during volcanic explosions. At last but not the least, French geochemist Ferdinand André Fouqué (1828–1904), student and successor of the above-mentioned Ch. Deville, visited island Thira (Santorin) in the Aegean Sea during a series of eruptions in 1866–1867 and executed analyses of individual gas-emanation types.

The second outstanding zone of the European geological diversity and mineralogical richness represented the region of Bohemian Massif and especially its Krušné Hory Mountains (Ore Mountains), with its coal basins, Tertiary volcanoes, Joachimstal silver mines, Zinwald zinc locations, and numerous hot springs. Not by chance, at Freiberg in the adjacent Upper Saxony, the *Bergakademie* (Mining academy) was founded in 1765, which shortly became an important center of the Central European geological studies. Unfortunately, later – due to the rather narrow-minded Neptunist conviction of Gottlob Werner, the chief person of the Academy – this center fell behind as a stronghold of scientific hypothesis that had become obsolete. However, from this center new specialists grew up, e.g., Jean de Voissins or Alexander von Humboldt (1769–1859), an outstanding German naturalist, geo-savant, and explorer. Between 1799 and 1804, Humboldt traveled to Latin America, exploring and describing it from a scientific point of view for the first time. The scientific achievements of his 5-year expedition had been written down and consequently published in an enormous set of volumes in the next decades. Humboldt was one of the first researchers who proposed that the lands bordering the Atlantic were once joined (South America and Africa in particular). Later, his five-volume work *Kosmos* (Humboldt 1845) attempted to unify various branches of scientific knowledge. Humboldt coworked with other scientists, e.g., Johann Wolfgang Goethe, Heinrich Berghaus, and Aimé Bonpland.

From the scholars of the Saxony-Lusatia region, Leopold von Buch (1774–1853) should be named, an outstanding geologist and paleontologist, author of several books in which he summarized his knowledge gained by the studies of the Italian and French volcanoes and where he explained and promoted his theory of uplifted craters. His idea was that the volcanoes swell up prior to the explosion and then after they erupt voluminous flow of lava, they collapse down creating a characteristic caldera.

Traditionally, the other center of volcanological studies was in Italy, the country where the quaternary-uplifted Alps offered a wide spectrum of geological formations for a pioneer study and where – in addition to that – three active volcano regions can be found, Vesuvius with the Phleghraean fields, the Lipari islands, and Etna.

It is characteristic for the "Italian volcanological laboratory" that not only Italians, such as Giuseppe M. Mecatti, Giuseppe Recupero, and Francesco Ferrera, worked there but also scientists from other countries, namely, from France and Germany, were involved.

And what about England? The most important research institution was the Royal Society of London founded as a learned society for science already in 1660. Among many outstanding scholars who had worked there, Robert Boyle (1627–1691) and Isaac Newton (1643–1727) are to be remembered. In the second half of the eighteenth century, it was James Hutton (1726–1797), a Scottish chemist with a deep interest in geology and a leading Plutonist in the British Isles. In his book *Theory of the Earth* (Hutton 1795), he defended the Plutonistic concept of the origin of rocks and correctly explained the principles of volcanic activities. Sir William Hamilton (1730–1803), Hutton's contemporary, the Ambassador of the UK for the Kingdom of Naples and the President of the Royal Society of London, monitored, commented, and analyzed a long series of activity of Italian volcanoes in the second half of the eighteenth century. Hamilton, by his comprehensive work, markedly strengthened the Plutonist standpoints.

Among the geologists and volcanologists of the UK, George Julius Poulett Scrope (1797–1876) became famous. During the winter of 1816/17 he was at Naples, and was so keenly interested in Vesuvius and its volcanic manifestations that he renewed his studies on volcanoes; in the following year he visited Etna and the Lipari Islands. Later, he visited the Eifel district (France) and began to study the volcanic regions of central France. In 1825, Scrope published his work *"Considerations on Volcanoes"*, which led to the establishment of a new theory of the Earth. In his works on volcanic formations in the French Massif Central he cast doubts on von Buch's theory of the dome craters. Scottish physician Sir Charles Lyell (1797–1875), one of the foremost geologists of the period, was a protagonist of uniformitarianism and the author of a famous work *"Principles of Geology"* (Lyell, 1830–1833), which is considered to be the first coherent monograph on geology.

At the end of the nineteenth and in early twentieth century volcanology went through a very dramatic evolution. First of

all, new more sophisticated instruments and research methods were utilized. Additionally, new geological subdisciplines were born, such as geochemical analyses of gas emanations, and the mineralogical analyses of the volcanic rocks by standard rock laboratory tests, as well as by means of microscopic thin rock sample investigation. Portable seismometers appeared and became generally used for monitoring volcanic eruptions in situ, in quiescence stages as well as during the eruption; composition and transport of the volcanic ashes and dust were studied. Numerous volcanological observatories were built all over the world, on the Hawaiian Islands, in Japan, New Zealand, and Iceland. A new generation of young scientists joined their older colleagues, geologists, as well as geophysicists.

Since the beginning of the twentieth century systematic volcanological studies have been performed in many research centers of the world, generally in the regions of active volcanic activity. In principle, the research has not yet finished and successfully goes on: to the classical studies and interpretation modern methods of aerometry, precise geodetic measurements, and global positioning system (GPS) were added. New commented catalogs of the world's volcanoes and volcanic eruptions were published, see, e.g., Simkin et al. (1981) and Aprodov (1982). What concerns the illustration and documentary material, the previous paintings, drawings, and prints were completely substituted by photography (including aerometry and satellite photography), movies, and in the most recent time by various digital recording media.

Volcanoes

Volcanoes have accompanied mankind through all its existence, sometimes terrifying and killing thousands of people, and sometimes being practically unnoticed. Since one of the most famous historical volcanic event, the Vesuvius explosion in AD 79, which destroyed the towns of Pompeii and Herculaneum and annihilated their population, many more violent eruptions have brought widespread disasters. The eruption of Laki in 1783 transformed one tenth of the surface of Iceland into a desolation of lava. Indonesian volcano Mount Tambora in 1815 killed more than 70,000 people. The formidable explosion of Krakatoa in the Sunda Strait in 1883 caused a tsunami which drowned thousands of people. In 1902, Mount Pelée ruined the town St. Pierre in Martinique and killed almost all its inhabitants. One could continue listing all these deadly events (Table 1).

A volcano is a vertical opening, rupture, or crack, serving as a conduit, on the earth's surface deep enough to allow hot, molten rock, ashes, and gases to escape from below the

TABLE 1. List of the deadliest volcanic eruptions, adapted from <http://en.wikipedia.org/wiki/list_of_natural_disasters_by_death_toll>

Date/Year	Volcano	Location	Death Toll
1815	Mount Tambora	Indonesia	71000
August 26-27, 1883	Krakatoa	Indonesia	36000
May 7, 1902	Mount Pelée	Martinique	29000
November 13, 1985	Nevado del Ruiz	Colombia	23000
1631	Mount Vesuvius	Italy	18000
1792	Mount Unzen	Japan	15000
1586	Mount Kelut	Indonesia	10000
June 8, 1783	Laki	Iceland	9350
1902	Santa Maria	Guatemala	6000
May 19, 1919	Mount Kelut	Indonesia	5115
1822	Mount Galunggung	Indonesia	4000
August 24, 79	Mount Vesuvius	Roman Empire	3600
March 29 and April 3-4, 1982	El Chichón	Mexico	3500
January 18, 1951	Mount Lamington	Papua New Guinea	2942
1770 - 1775	Tseax Cone	Canada	2000
May 7, 1902	Soufrière	St. Vincent	1680
1963-1964	Mount Agung	Indonesia	1584
1930	Mount Merapi	Indonesia	1369
June 23, 1897	Mount Mayon	Philippines	1335
1911	Mount Taal	Philippines	1335
1783	Mount Asama	Japan	1151
1877	Cotopaxi	Ecuador	1000

1) Eruption of Toba volcano is not listed because it occurred before the recorded history.

2) Thera eruption in the Aegean Sea between 1550 and 1650 B.C. may have caused a large number of deaths throughout the region from Crete to Egypt. This item is not listed.

surface. Volcanic activities involving the extrusion of rock tend to form mountains or features like mountains over a period of time. Structurally, a volcano is to be considered in two separate parts – the outer part (the part which is visible) and the internal part (a complex system of magma chamber(s), conduits, and volcano's vents). A volcanic eruption begins when the pressure on a magma chamber forces magma up to the surface. In the eruption process, immense forces are involved, the earth vibrates and trembles, and the eruption is often accompanied (sometimes preceded) by its "own" (volcanic) earthquakes. During a strong eruption, the entire mountain body may split from top to bottom, heavy smoke and flames are poured out from the crater and molten rocks are hurled into the air. For illustration, Fig. 15 presents a nineteenth century concept of a volcano structure.

Lava is the name given to the molten material, which reaches the surface, forced out of the volcano's cone during the eruption; lava is also the name of the rock formations that are formed when the molten mass cools and solidifies on the outer volcano slopes. The term magma applies to the molten-rock material while it still remains at a depth below the surface. Lava and magma differ in position and degree of solidity. In addition to the molten rocks of a broad variety, the magma contains large amounts of water, gas, and other volatile

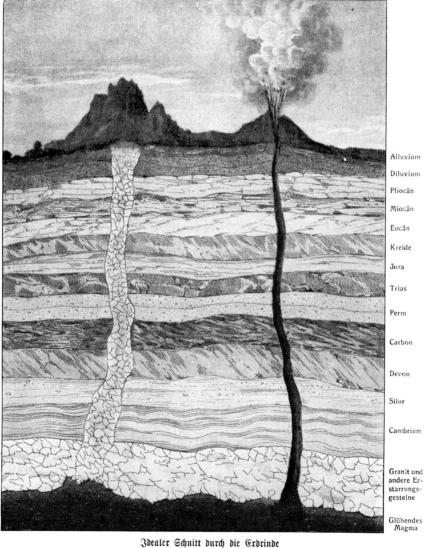

Alluvium

Diluvium

Pliocän

Miocän

Eocän

Kreide

Jura

Trias

Perm

Carbon

Devon

Silur

Cambrium

Granit und andere Erstarrungsgesteine

Glühendes Magma

Idealer Schnitt durch die Erdrinde

mit Verbindungskanälen zwischen dem glühenden Erdinnern und der Oberfläche. Links ein durch emporgequollenes und erstarrtes Gestein gebildeter Berg, rechts ein tätiger Vulkan. Die Namen am rechten Rande bezeichnen die — im nächsten Abschnitt (Versteinerungen und Erdgeschichte, S. 149 ff.) ausführlich behandelten — wichtigsten Schichten bezw. Bildungsperioden der Erdrinde

Nach Emile With „L'Écorce terrestre", Paris 1874

Fig. 15 A cross-section of an extinct and active volcano. This illustration appeared in the first volume of the natural sciences encyclopedia "*Weltall und Menschheit*", edited by H. Krammer (1902-1904). Private collection, Prague

substances dissolved in magma. Most of these volatiles are later lost when a volcano erupts, or even before, but their relative volumes play an important role in the eruption scenario.

The type of eruption depends – first of all – on the composition of the ejected material, namely, on the relative amounts of water, gases, and silica. The amount of silica determines how sticky (viscous) the magma is. Volatiles, mostly water amount present in lava, provide the explosive potential of the steam. When silica content is high, lava becomes more viscous; it flows slowly and forms a thick cover on the earth's surface. When lava of this type does not contain much water, the eruption is relatively "quiet" and the outpouring lava tends to build domes. The eruption, however, may be extremely violent in the case when the lava contains high volume of dissolved water; then the suddenly released pressure has an explosive character. Lava with low silica content is less viscous; after reaching the surface, "runny" lava easily flows away, effuses quickly, and cremates all alive for miles away. Presence of high water content adds a certain "fountain" effect and thin molten lava may be splashed far away.

Also mechanical obstacles in the volcano's vertical chimney may influence the type of eruption. When the volcano pipe is blocked by a stopple, by accumulation of pumice or remains of older solidified lava, the increasing pressure finally results in a huge explosion. Lava, when reaches the surface, may pour out in gentle streams called lava flows or erupt violently into the air. Rocks ripped loose from the inside of the volcano or torn apart by the gas may be shot into the air with the lava. These rocks blown out of a volcano are called pyroclastic rocks and they may present a substantial part of the total volume of the erupted material. The rock fragments fall back to the earth in many different shapes and sizes. We may distinguish volcanic dust, consisting of very tiny particle fraction less than a millimeter in diameter. Dust particles may be carried to great distances by wind and after powerful eruptions in the past dust traveled around the earth several times. Volcanic ashes present fragments of millimeter to centimeter size in diameter. Most of the volcanic ashes fall to the surface, are cemented together by water, and create rock formations called volcanic tuff. Lager fragments of solidified magma are called volcanic bombs (rounded pieces of hardened lava, which adopt different shapes while flying through the air), volcanic blocks (pieces of lava that have sharp corners), cinder (bubby rock formed by liquid lava cooling in the air), and pumice (cinder so bubby that it even floats on water).

Volcanic activity is classified according to the frequency of eruptions. A volcano may be active, intermittent, dormant, or extinct. Active volcanoes erupt permanently. Intermittent volcanoes erupt fairly regularly with only short intermissions. When a volcano ceased to erupt it is called dormant and when the volcanic activity is thought to have subsided completely and further eruptions considered unlikely, the volcano is denoted as extinct. Dormant volcanoes are inactive, but it is almost impossible to distinguish between an extinct volcano and a dormant one; volcanoes may lie dormant for centuries without giving any signs of activity and then suddenly explode with a gruesome and all destructing force. At present, there are more than 600 active volcanoes and about 10,000 extinct or nearly extinct volcanoes of several sizes and forms. Over 1,200,000 km² of the earth's surface is covered by volcanic products, which represents thousands and thousands of cubic kilometers in volume. Figure 16 presents a rare historical (nineteenth century) concept of volcanic manifestations illustrated through an example of a New Zealand volcano. Due to the relative short modern history of the country only limited amount of such pictorial material prior to 1900 exists.

Most volcanoes are grouped within the belts coinciding with deep crustal fracture zones tracing the active tectonic plate boundaries; they are generally found where tectonic plates are pulled apart or compressed together. In mid-oceanic ridges, for example, in the Mid-Atlantic Ridge, there are volcanoes caused by a divergence of tectonic plates; in the so-called Pacific Ring of Fire (Fig. 17) numerous volcanoes can be found, which are generated by convergent tectonic plates. This Pacific Ring of Fire is the most spectacular volcanic belt, which girdles the Pacific Ocean, starts at Alaska and continues to the south through western Canada, USA, Mexico, and Central America, along the Pacific coast of South America to Antarctica, turning to the west to New Zealand and Polynesia, then runs to northwest and north including Indonesia and Philippines and continues to Japan and Kuril Islands and finally through Kamchatka returns back to Aleutian islands. Prominent volcanoes can also be found in a belt running from Iran across Asia Minor to the Mediterranean Sea, and also in Azores and Canary Islands. Other, smaller belt areas, where volcanoes are concentrated include, e.g., West Indies, Eastern Africa, and several areas in the Atlantic Ocean. Few volcanoes occur independently, in the so-called hot spot locations on the earth's surface above hot upwelling mantle plumes. At present, the most active hot spot locations are Hawaii, Reunion, Iceland, Galapagos, and Yellowstone.

Some volcanoes exist for a long geological time and their origin is difficult to determine, however, many new volcanoes have been born recently and people have witnessed their birth in every detail. In May 1538, *Monte Nuovo* ("new mountain") rose out of the plain near Pozzuoli in Italy, and within several days had reached a height of more than 100 m. Another, very recent example is the birth of a new volcano Paricutín in Mexico. In February 1943, a farmer was plowing when he was surprised by smoke coming from a small furrow in his field. Soon the ground began to tremble and crack. Alarmed, the farmer panicked, escaped to his village, when a much stronger quake destroyed part of the village. The horrified villagers observed stones, cinders, blocks of rocks, and molten lava being showered from a hole in the ground. In the

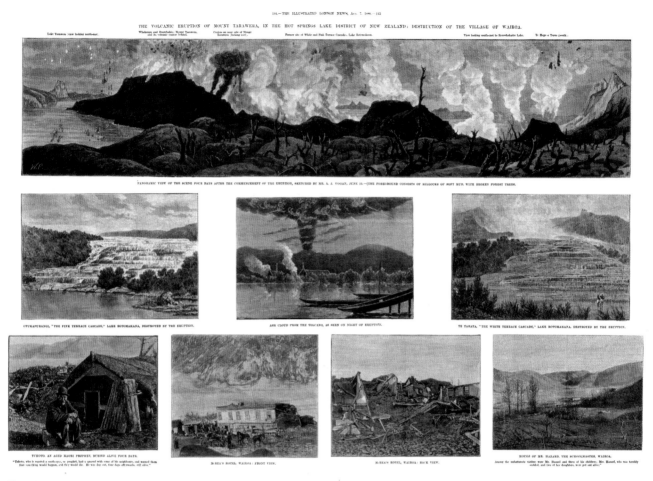

Fig. 16 A set of illustrations presenting various dynamical manifestations accompanying the eruption of Mount Tarawera and the destruction of the village of Wairoa, New Zealand. Hand colored xylographic illustration published in "*The Illustrated London News*" of August 7, 1886. Private collection, Prague

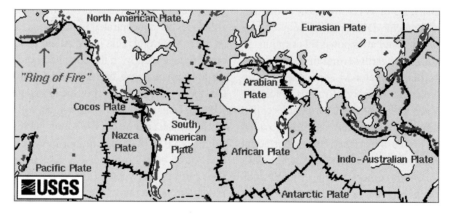

Fig. 17 Tectonic plates and the Ring of Fire, red dots indicate active volcanoes. Adapted from <http://en.wikipedia.org/wiki/File:Volcano_Map.png>

next days a mountain was growing around the hole; the new cone was about 10 m high next morning, 150 m high in a week, and finally it towered 300 m above the plain 2 years later when the volcanic activity terminated. Similar events are not rare, the birth of Jorullo volcano in Mexico in 1759, the emergence and the subsequent submersion of the volcanic island Ferdinandea south of Sicily in 1831, or the creation of Surtsey, a small island off the southern coast of Iceland in 1963 are all good examples testifying some unexpected products of the present volcanic activities.

The greatest lava flows, generally, make their way up to the surface of the earth, not through the volcanoes themselves, but along the fissures on volcano slopes. Vast outpourings, called fissure flows, have emerged from them, and not from the volcanic cones. Sometimes these flows cover hundreds of square kilometers and are hundreds of meters thick. Although fissure flows may contain other types of lava, those of basalt are most extensive. Because basalt lavas are extremely fluid, they move fast, and consequently they get farther before hardening. Basalt flows of Hawaii have been known to move at a velocity of 10–20 km/h. Such plateau basalts also exist in Iceland, Africa, and South America.

As stated above, magmas rich in silica component are very viscous and tend to resist movement until blown out of the vents under accumulated gas pressure. Volcanoes erupting magma of this type are generally violent, and their steep-sided cones are composed mainly of fragmented materials. At the other extreme, basaltic magmas, which are low in silica, usually flow freely, and produce gentle-sloped shield volcanoes and a quiet-type activity characterized by extensive lava flow. If highly charged with gases, however, basaltic magmas can become highly explosive and build up cinder cones.

Most of the known volcanoes eject magmas which lie between these two extremes and contain only average amount of silica; they build composite volcanic cones. Magma of this type flows freely at high temperatures but hardens rapidly when cooling. Temperature and gas content determine whether an explosion or lava flow accompanies this type of eruption. It is common to call certain volcanic characteristics by the names of the volcanoes known to possess such properties; so we have Hawaiian, Strombolian, Vulcanian, Vesuvian, and Pelean types of volcanic eruption (listed in order of increasing violence of activity).

Hawaiian volcanoes are typical shield volcanoes, with broad domes or plateaus and gently convex upward profiles. They are typical extremely fluid lavas and have numerous flows from vents on the lower slopes. Their lavas solidify in long, rope-like length, perforated with little cavities formed by expanding gases and steam. Some of volcanoes on the Hawaii Islands are in almost permanent activity, fountains of lava gush up in the lakes, sometimes shooting 100 m high. Extremely fluid lava offers little resistance to the release of gases and steams, violent explosions are therefore rare, and there are no bombs, blocks, or ashes. Volcanoes similar in form and activity to the Hawaiian shield volcanoes are found in Iceland and in Samoa Island.

Strombolian volcanoes have seething, incandescent, semi-fluid lava, not as fluid as the Hawaiian lava-type, but can still produce large lava flows, which follow the land contour up to the sea. Steam and gas are not easily released; small eruptions are therefore almost continuous. The cone is mostly formed of debris. Typical of this type are volcanoes on the Lipari Islands, and some volcanoes in Indonesia.

Vulcanian volcanoes are quite similar to the preceding type, with their lava slightly more viscous in nature; small lava flows are quickly cooled down on the surface, and the rapidly formed solidified crust in the crater presents an obstacle to the escape of the gases and creates an inevitable outcome for frequent explosions.

Vesuvius, Etna, and also Krakatoa are the volcanoes which are very famous for their disastrous eruptions in history. The immense central craters very rarely pour out fluid lava, whereas most of it is issued from a number of subsidiary cones that are scattered on their slopes. Types of their eruptions varied in time; sometimes it was Strombolian, Vulcanian, or Pelean according to the temperature and degree of fluidity of the lava. However, their explosions were usually catastrophic, with enormous quantities of pumices, dust, and ashes thrown up. The steep-sided higher portions of the volcano cone are built up by various fragments, while the lower and softer slopes are usually composed entirely of solidified lava. The upper part of such a volcano can be from time to time blown up in an explosion; the former cone remained as a large irregular ridge (caldera) with a new crater located inside.

Pelean volcanoes belong to the most extreme types of volcanic activity, typified by Mount Pelée's eruption in 1902. This type may be dormant for a long time with no or little sign of the increasing danger of the forthcoming eruption (fumaroles, hot springs, some seismic tremors, etc.). Then, in a minute, with a roar of thunder, immense cloud of black smoke gushes out of a gigantic rupture opened in the side of the mountain, and the whole mountain explodes. Such a behavior is completely different compared with that of the Hawaiian type and denotes a particularly viscous lava. Under the block chimney, gas and steam accumulate and finally burst through the surrounding walls as a "fiery cloud". The plug of the partly solidified lava together with part of the mountain is usually blown up. The volcanic behavior similar to Mount Pelée volcano (Guadeloupe, West Indies) was described also for some Alaskan volcanoes (Mount Katmai); several peaks of the Cascades range (at present classified as dormant) probably experienced similar history in the geological past.

Submarine volcanoes which developed on the seafloor, in principle, also fall into the categories mentioned above. Indeed, Vulcano, Stromboli, and the Hawaiian volcanoes were originally large submarine volcanoes which have ultimately risen above sea level. The birth of a new volcanic island, actually a submarine volcano appearing above the water level, was observed in many parts of the world. As the unconsolidated pyroclastic material is immediately attacked by the surrounding sea, the newly born piece of land is usually quickly disintegrated and sunken again.

An attractive, even when not correct, image of earthquake is presented in (Fig. 18).

Volcanic Explosivity Index, VEI, (Table 2) is widely used as an important parameter in modern volcanological

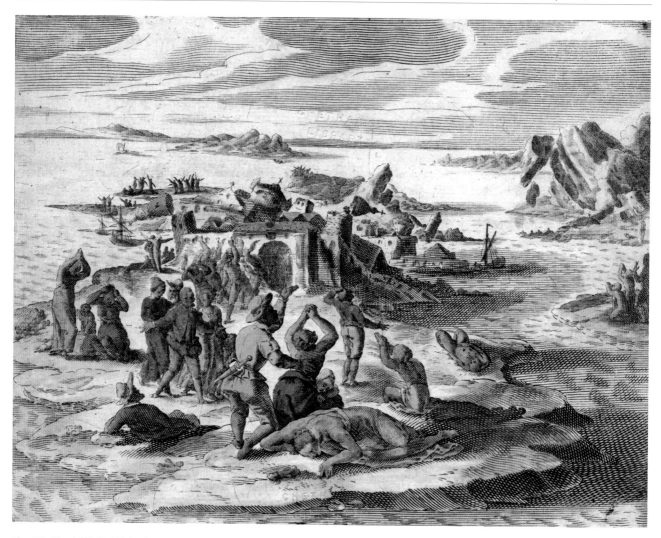

Fig. 18 The 1591 St. Michael (Azores) earthquake. Hand colored copper engraving. The illustration from an unidentified book by Theodor de Bry (end of the 16th century). The image presents a quite unrealistic representation of the scene, in which neither the dimensions of the individual picture elements nor their mutual relations were respected. The artist's main focus was on conveying the panic of the stricken inhabitants. Private collection, Prague

TABLE 2. Volcanic Explosivity Index (http://en.wikipedia.org/wiki/Volcanic_Explosivity_Index).

VEI	Description	Plume	Ejecta volume	Frequency	Example
0	non-explosive	< 100 m	< 10,000 m³	daily	Mauna Loa
1	gentle	100-1000 m	> 10,000 m³	daily	Stromboli
2	explosive	1-5 km	> 1,000,000 m³	weekly	Galeras (1993)
3	severe	3-15 km	> 10,000,000 m³	yearly	Koryaksky
4	cataclysmic	10-25 km	> 0.1 km³	≥ 10 yrs	Soufrière Hills (1995)
5	paroxysmal	> 25 km	> 1 km³	≥ 50 yrs	St. Helens (1980)
6	colossal	> 25 km	> 10 km³	≥ 100 yrs	Mount Pinatubo (1991)
7	super-colossal	> 25 km	> 100 km³	≥ 1000 yrs	Tambora (1815)
8	mega-colossal	> 25 km	> 1,000 km³	≥ 10,000 yrs	Toba (73,000 BC)

Note: For comparison, as concerns the recent famous eruptions, Mount St. Helens (1980) was classified at the lower end of VEI=5, and as for both Mount Pinatubo (1991) and Krakatoa (1883) at the values of VEI=6.

No eruption of VEI=8 have occurred within the last 10,000 years. Lake Taupo's (New Zealand) eruption was probably the most recent giant eruption of this explosivity level; it occurred ca 26,500 years ago.

considerations. It is a simple relative measure to assess the explosiveness of a volcanic eruption (Newhall and Steve 1982); the index begins with VEI = 0 given to "gentle" non-explosive eruption (less than $10^4 m^3$ tephra ejected), and VEI = 8 corresponds to "mega-colossal" eruption with $1,000 km^3$ of tephra and cloud column height of over 25 km. Each interval on the scale represents a tenfold increase in the observed eruption criteria. Unfortunately, VEI does not take into account the power output magnitude, which would be difficult to detect for the prehistoric or unobserved eruptions.

Earthquakes

Earthquakes together with volcanic eruptions are common natural catastrophes; they have a manifold range of various consequences and in many cases they may initiate several subsequent disasters, such as, e.g., landslides and floods. Earthquakes are practically inevitable, and they belong to real natural manifestations of our planet. People have been meeting with the earthquakes since the early days of their existence. Later, when they tried to understand them, they had to think on how to record their distribution, how to evaluate their destructive power, and how to mitigate their impact. The deadliest earthquakes are listed in Table 3; the estimated death toll is to be taken with certain caution, the indicated number of victims may sometimes differ from source to source.

Strong earthquakes occur in large-scale patterns associated with the earth's global-size structures such as tectonic plates, mountains, rift valleys, mid-oceanic ridges, and ocean trenches. All these structures are subjected to the inner earth's forces, such as tectonic stresses, thermodynamic processes occurring due to volcanic activities, and forces of gravity.

TABLE 3. List of deadliest earthquakes in the history, adapted from <http://en.wikipedia.org/wiki/earthquake>

Year	Event	Location	Death Toll
1556	Shaanxi earthquake	China	830000
1976	Tangshan earthquake	China	255000
1920	Haiyuan earthquake	China	240000
1138	Aleppo earthquake	Syria	230000
856	Damghan earthquake	Iran	200000
893	Ardabil earthquake	Iran	150000
1730	Hokkaidō earthquake	Japan	137000
1948	Ashgabat earthquake	Turkmenistan	110000
1923	Great Kanto earthquake	Japan	105000
1908	Messina earthquake	Italy	100000
1755	Lisbon earthquake	Portugal	100000
1290	Chihli earthquake	China	100000
2005	Kashmir earthquake	Pakistan	87000
1854	Great Ansei Nankai quakes	Japan	85000
1667	Shamakhi earthquake	Azerbaijan	80000
1727	Tabriz earthquake	Iran	77000
1932	Changma, Gansu earthquake	China	70000
2008	Sichuan earthquake	China	69136
1970	Ancash earthquake	Peru	66000
1693	Sicily earthquake	Italy	60000
1935	Quetta earthquake	British India	60000
1783	Calabria earthquake	Italy	50000
1927	Gulang, Gansu earthquake	China	40000
1498	Meio Nankai	Japan	40000
1703	Genroku earthquake	Japan	37000
1990	Manjil Rudbar earthquake	Iran	35000
1939	Erzincan earthquake	Turkey	32962
1707	Great Hoei earthquake	Japan	30000
2003	Bam earthquake	Iran	30000
1988	Spitak earthquake	Armenia	25000
1978	Tabas earthquake	Iran	25000
1293	Kamakura earthquake	Japan	23700
1976	Guatemala earthquake	Guatemala	23000
2001	Gujarat earthquake	India	20000
1812	Caracas earthquake	Venezuela	20000
1939	Chillán earthquake	Chile	20000

In general, earthquakes can be classified by their mode of generation.

By far the most common, strongest, and most frequent are tectonic earthquakes, which occur when large rock massifs break suddenly in response to stress accumulation due to various geological processes. Tectonic earthquakes are scientifically important as they provide data, which facilitate the study of the structure of the earth's interior. On the other hand, they pose the greatest seismic hazard and are of tremendous social significance. Actually, most earthquakes discussed in this book are of this type.

The second well-known type of earthquake accompanies volcanic eruptions. In fact, the old concept that earthquakes are linked primarily with volcanic activities goes back to the Greek philosophers, who were impressed by the common occurrence of earthquakes and volcanic eruptions in many parts of the Mediterranean. Today volcanic earthquakes are generally understood as the shocks that occur in conjunction with volcanic activity. They usually precede the proper volcanic eruption or lava extrusion and their hypocenter is located at, or near, the lava vent or a subsurface rupture serving as the supply of ascending magma (Fig. 19).

Collapse earthquakes are weak quakes occurring in regions of both natural and man-made underground caverns, cavities, and mine openings. The immediate cause of ground shaking is the implosion or collapse of the roof and/or the walls of the mine corridor or cave. An often-observed variation of this phenomenon is the so-called rock burst or mine burst. This happens when the induced stress around the underground mine corridor causes an implosive destruction of large mass of rock that generates seismic waves. It follows that the collapse earthquakes are often of anthropogenic (man-caused) origin; mine seismicity is sometimes called induced seismicity.

To complete the list of earthquake types, one has to mention the shocks initiated by massive land sliding or meteoritic

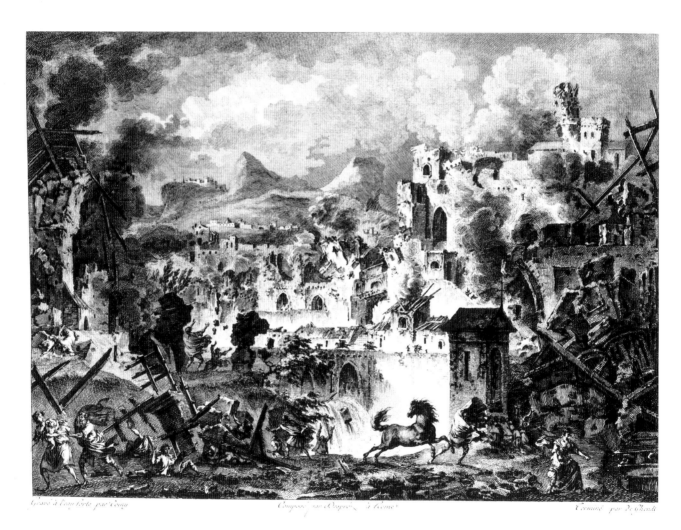

Fig. 19 Destruction of Catania by the 1693 catastrophic earthquake with the epicenter at Monti Iblei (I_o=XI, MCS). Copper etching, made by original drawing of Louise Jeane Désprése. The illustration appeared in the comprehensive five-volume work "*Voyage pittoresque Sicile*", written by Saint-Non (1781-86). Private collection, Prague

impacts also. Vice versa, massive landslides are often triggered by earthquakes. For anthropogenic, artificial generation of seismic waves also chemical and nuclear explosions can be used; for instance the so-called deep seismic sounding is nowadays a useful geophysical method to study the earth's crust by a series of explosions located along 100 km-long profiles across geological structures under study.

Location of an earthquake's origin in the earth's interior (also called earthquake focus) is usually denoted as hypocenter; its vertical projection to the earth's surface is called earthquake epicenter, and the distance between hypocenter and epicenter is the earthquake's depth.

Earthquakes occur within a layer extending from the earth's surface to the depths of about 700–800 km. The terms classifying earthquakes according to focal depth are *shallow, intermediate,* and *deep,* characterized by focal depths ranging 0–70 km, 70–300 km, and deeper than 300 km, respectively. Most shocks occur within the depth down to ~60 km; deeper earthquakes occur less frequently and they, in general, do not bring about extremely disastrous effects on the earth's surface as strong shallow seismic events. One of the deepest shocks which have been ever recorded is the one which occurred in the Flores Sea, East Indies, on June 29, 1934; its focus was determined at the depth of 720 km.

Shallow earthquakes are apt to occur frequently in the so-called seismogenic zones of the world. So do also seismic shocks of deeper foci though their occurrences are much lower than those of shallow ones. Often, intermediate earthquakes tend to occur in volcanic chains around the Pacific coasts while deep focus earthquakes are found to be prevalent in areas characterized by deep ocean trenches, such as Kermadec and Tonga Islands, Java and Japan, the Aleutian Islands and South Alaska and also under the main mountain ridges of South America (Fig. 20).

Strong earthquakes are sometimes followed by a number of weaker shocks, which occur in the vicinity of the principal event's location (hypocenter). These smaller earthquakes are called aftershocks of the strong one which is referred to as the main earthquake. Aftershocks are believed to occur in connection with the process of mechanical adjustment in the earth's crust or mantle, after the energy stored up is released in the form of the main shock. This process is sometimes called "stress-redistribution" initiated by the change of the earth's stress field after the main shock occurrence. The frequency of the aftershock occurrences is usually higher immediately after the main shock, and decreases gradually with time, sometimes in a course of several years.

Some large earthquakes are preceded by shocks of smaller magnitudes, and these are denoted as foreshocks; any small earthquake can correctly be called as a foreshock only when the main shock occurs in the region soon after. Sequences of standard foreshocks preceding the main event follow certain regularities. In some cases, the frequency of foreshock occurrence and also their strength increases in time toward the main shock occurrence; however, this is not a common rule.

Occasionally, in specific regions of the earth, many small earthquakes – without any main shock – occur successively in a limited area, usually in a longer time period. Such earthquake series are called earthquake swarms. Sometimes, we can count several hundreds or thousands of small earthquakes in a prominent swarm series, which may continue for weeks and even months.

Seismologists speak about the focus of an earthquake, as if the energy originated at a point. Clearly, this is only the

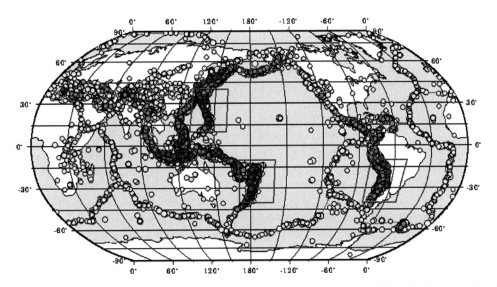

Fig. 20 Earthquake locations (M>4.5) and their depth distribution; based on 5 years of observations 1991-1996. Color identification: yellow 0-70 km, orange 70-300 km, red >300 km. Blue-line boxes limit zones of frequent deep earthquake occurrence. Adapted from <http://seismo.berkeley.edu/seismo/istat/ex_depth_plot>

first approximation, but from the viewpoint of kinematic analysis of seismic wave propagation, it is a useful simplification. In reality, seismic focus, i.e., seismogenic fault may have a length of several kilometers; for the strongest earthquakes, seismogenic fault may extend over the length of 50 km or more.

A quasi-modern explanation of the earthquake occurrence is the strain-rebound theory (Lawson et al. 1908–1910; Reid 1911).) based on the study of the visible effects of the 1906 San Francisco earthquake. A fault is assumed to be a planar fracture in rock along which the rock blocks on both sides move each other. The faults (or more complex fault zones) separate individual blocks of rocks or individual tectonic plates. Large faults within the earth's crust are the result of differential or shear motion and active fault zones are the causal locations of most earthquakes. Earthquakes are caused by energy release during rapid slippage along a fault.

Every earthquake is characterized by three fundamental parameters: where and when it occurred and how strong it was, which means to determine the seismic focus location, fix the time of the earthquake occurrence, and assess the quake's strength as related to the level of the effects observed on the earth's surface (earthquake intensity I or earthquake magnitude M or both). As for the earthquake's strength determination, we have to consider the determination of this quantity in two historical periods:

(1) The pre-instrumental era (before approximately 1900–1930) when the earthquake's macroseismic intensity I was assessed exclusively by means of subjective human observation and classification of earthquake surface effects.

(2) The instrumental era (after 1900–1930), when the strength of the earthquake was determined objectively, by means of actual displacement of the ground recorded by seismographs. Since 1935 the earthquake strength has been classified by computational determination of magnitude M of the earthquake, based on recorded ground displacement absolute values.

It is reasonable to mention the substantial difference in description of volcanic and seismic events in previous centuries (Fig. 21). Volcanologists had always some visible effects of volcanic activity at their disposal, such as location of volcanic eruption and its origin time. Also, other parameters and quantities of the event's size (such as time duration, amount of lava ejected, etc.) were usually available. Thus, the classification of the event was not linked with principal difficulties. For an earthquake's description and classification, however, this was not true. Disastrous shaking of the earth often came unexpected, and within a few seconds a whole settlement was ruined and people killed. In addition to it, the giant forces vexing

large territories came from the unknown and cryptic depths of the earth's interior and nobody was able to submit their rational explanation. This was a reason why seismology – in the pre-instrumental era – developed so slowly in comparison with volcanic studies.

The first modern "*Erdbeben Messer*" (earthquake meter, in German) was constructed by Ewing, Milne, and others only at the end of the 1880s (Davison 1927). After the year 1900, more effective types were offered, e.g., by Milne, Rebeur–Paschwitz, Mainka, Wiechert, Vicentini, Omori, and others. New instruments were installed in newly arranged seismic observatories located in various localities all over the world (Plešinger and Kozák 2003). Seismology entered into its instrumental era; seismic displacements began to be measured objectively, by suitable scientific instruments, seismometers. Before 1900 – and we should not forget that most of depictions displayed and discussed in this book come from that period – seismic observations had to be done exclusively on the basis of human senses (pre-instrumental or *macroseismic* observations).

In the course of the nineteenth century numerous efforts had been made to classify macroseismic effects on the earth's surface in degrees of damage (macroseismic intensity) caused by an earthquake to constructions, level of ground deformation, effects felt by humans, animals, and changes on objects of nature. Pioneering work in this field was done by the German mineralogist Otto Volger, who studied the 1855 Visp (Wallis) earthquake in southern Switzerland (Volger 1856). His outstanding macroseismic intensity map of this event (Fig. 22), together with similar maps by Jeitteles (1859) and Mallet (1862), served as a certain guide for later maps of seismicity. Volger collected and evaluated large series of local reports on damage to buildings and other constructions from territories of Switzerland and adjacent parts of Italy, France, and Germany and proposed his 7-degree macroseismic intensity scale (0, 1, …, 6), in which he assessed the reported damages according to this scale, the strongest degree was assigned to "0", and the weakest effect to "6". After plotting intensity values into a map, he constructed isolines, which afterwards were called isoseismal lines. Regardless of the fact that Volger's intensity scale was later reversed ("0" degree allocated to the weakest intensities) and prolonged, first to 10 and later up to 12 degrees, his idea of macroseismic intensity scale met the requirements of the incoming generations of seismologists.

A 10-degree macroseismic intensity scale was proposed soon after by Rossi and Forel (1881), which quantified the amount of resulting physical damage reported, and sorted it on a scale of I–X, with I denoting a weakest earthquake and X one that causes almost complete destruction. This scale was revised by Italian volcanologist Giuseppe Mercalli in 1883 and 1902 and later again by Italian physicist Adolfo Cancani, who expanded it to 12 degrees, as the earlier

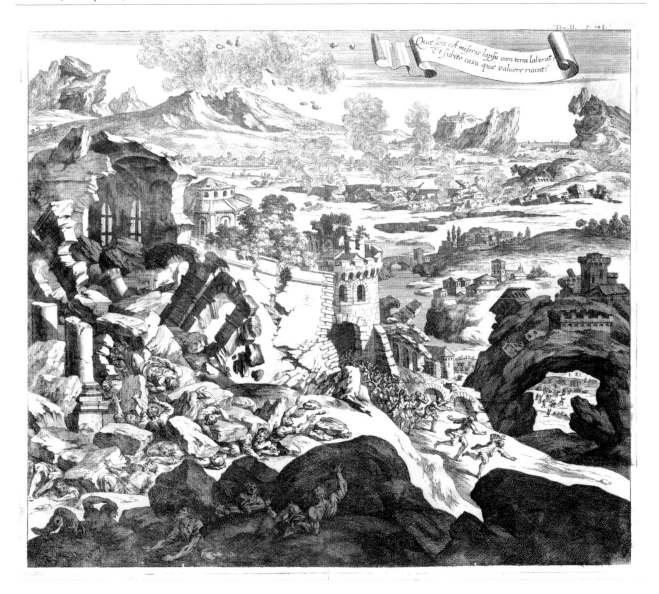

Fig. 21 The 1693 Val di Noto (Monti Iblei), Sicily earthquake. The picture appeared in a work by Zahn (1696). It represents an exceptionally good example of depicting an earthquake disaster. All the main earthquake effects are presented, such as the collapse of the church towers and other edifices, ground surface deformation, sinking settlements, towns in flames, following volcanic activities, the terror of the inhabitants, etc. The picture was frequently used in the first half of the 18th century to be reproduced (and often simplified) in other tracts. Private collection, Prague

10-degree scale did not give enough space for the strongest earthquake's effects. When the scale was completely rewritten by German geophysicist August Heinrich Sieberg, it became known as the Mercalli-Cancani-Sieberg (MCS) scale. The MCS scale was modified again in 1931 by Harry O. Wood and Frank Neumann as the Mercalli-Wood-Neuman (MWN) scale and when revised by Charles Richter, the scale became known as the Modified Mercalli Scale (Table 4) and abbreviated as MM. Lower degrees of the MM scale generally deal with the manner in which the earthquake is felt by people; higher numbers of the scale are based on observed structural damage. In 1960s the scale was revised again and

replaced by the Medvedev-Sponheuer-Karnik (MSK-64) scale, generally accepted as an international scale in the last third of the twentieth century. The updated, most detailed and corrected macroseismic intensity scale was introduced by Grünthal (1998) under the name European Macroseismic Scale (EMS-98).

Earthquake intensities (I_o) are estimated on the basis of direct observations; they are collected and evaluated at seismological institutions. The intensities are presented in the form of isoseismal maps. The intensity is largest in the epicenter area (the area around epicenter, usually the region of the highest seismic damage) and decreases outwards in all

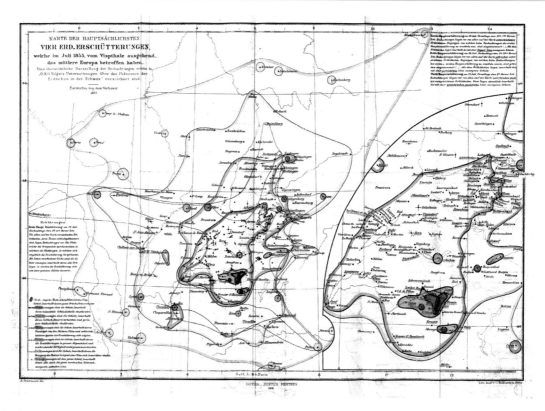

Fig. 22 The first macroseismic intensity map constructed for the 1855 Visp earthquake by O. Volger (1857-8). Private collection, Prague

TABLE 4. Modified Mercalli macroseismic (MM) intensity scale

I	Instrumental	Detected by seismographs, but not felt by most people unless in favorable conditions.
II	Feeble	Felt only by sensitive persons at best; delicately suspended objects may sway.
III	Slight	Felt quite noticeably by many individuals, generally indoors, especially on the upper floors of buildings; many do not recognize it as an earthquake; standing motor cars may rock slightly; vibration similar to the passing of a truck; strong enough for duration and direction to be estimated.
IV	Moderate	Felt indoors by many and outdoors by a few; at night, some sleepers awakened; moveable objects, dishes, windows, doors disturbed; floors and walls make cracking sound; standing motor cars rocked noticeably; dishes and windows rattle alarmingly.
V	Rather strong	Generally felt by everybody, excerpt heavy sleepers; shifting of furniture, including beds; ringing on bells; unstable objects overturned.
VI	Strong	Felt by all; many frightened and run outdoors, walk unsteadily; windows, dishes, glassware broken; books fall off shelves; clocks stop; some heavy furniture moved or overturned; a few instances of fallen plaster; damage slight.
VII	Very strong	Difficult to stand; furniture broken; walls crack and plaster falls; damage negligible in building of good design and construction; slight to moderate in well-built ordinary structures; considerable damage in poorly built or badly designed structures; some chimneys broken; noticed by people driving motor cars.
VIII	Destructive	Walls fissured; damage slight in specially designed structures; considerable in ordinary substantial buildings with partial collapse; damage great in poorly built structures; fall of chimneys, factory stacks, columns, monuments, walls; heavy furniture moved; sand and mud ejected from the ground in small quantities.
IX	Ruinous	General panic; buildings shifted out of foundations; damage considerable in specially designed structures, well designed frame structures thrown out of plumb; damage great in substantial buildings, with partial collapse; noticeable cracks in ground; underground pipes broken.
X	Disastrous	Some well built wooden structures destroyed; most masonry and frame structures destroyed with foundation; ground badly cracked; railway rails bent; landslides considerable in river banks and on step slopes; sand and mud shifted; some flooding from lakes and rivers.
XI	Very disastrous	Few, if any masonry structures (**Fig. 23**) remain standing; bridges and embankments destroyed; rails bent greatly; earth slumps; landslips and flooding.
XII	Catastrophic	Total damage and almost everything destroyed; objects thrown into the air; waves seen on ground surfaces; lines of sight and level distorted; large amounts of rock may move position.

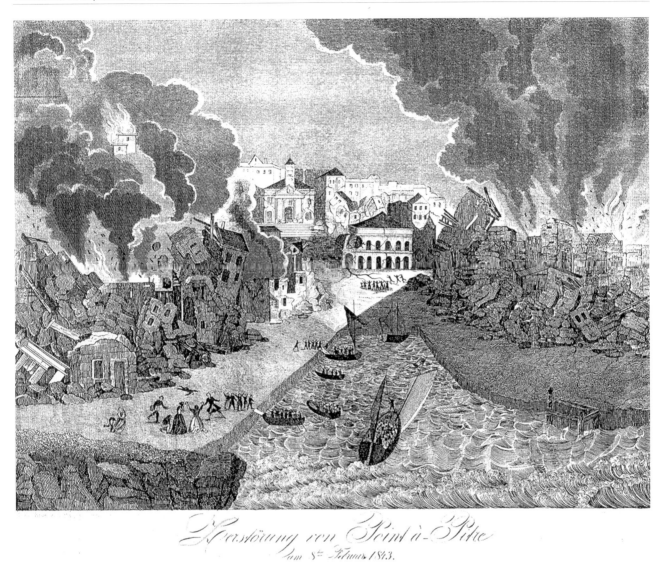

Zerstörung von Point à-Pître
am 8^t^ Februar 1843.

Fig. 23 The 1843 Point-a-Pître earthquake in Guadeloupe (Reinhold, 1844). The engraving was apparently created with the help of documentation obtained in situ. The damage to the edifices in the central part of the settlement, built on the solid bed-rock, are minor in comparison with the parts of the town on alluvial sediments (left and right sides of the image) which were totally destroyed. Private collection, Prague

directions, usually not quite regularly, but according to the given ground properties and source parameters. Macroseismic studies are still carried on in spite of modern instrumental developments, because they suitably furnish valuable complements to the seismograph records. Maps of seismic risk summarizing seismicity of a given region in a long-time horizon are mainly based on local isoseismal maps.

The seismicity or the seismic activity of the studied region can be mapped qualitatively, just showing the epicenters of the earthquakes. However, in many cases it is useful to have a quantitative measure of seismicity. Earlier maps either showed epicenters with no regard to the earthquake strength or used arbitrary definitions of seismicity, which often gave erroneous ideas on the distribution of released seismic energy.

For modern, instrumental earthquake strength determination, the magnitude scale was proposed, which assigns a single number to quantify the amount of seismic energy released by an earthquake. The scale was developed in 1935 by Charles Richter and Beno Gutenberg. The scale is a base-10 logarithmic scale derived from absolute displacement values recorded on special types of seismographs.

A difference in magnitude of 1.0 is equivalent to a factor of 31.6 in the energy released; a difference of two magnitude units is equivalent to a factor of 1,000. It means by words that, e.g., the earthquake classified by magnitude $M = 3.0$ released 1,000-times less energy than the earthquake classified by $M = 5.0$ (http://earthquake.usgs.gov/learning/topics/richter.php). Earthquake magnitude M is a practical quantity

TABLE 5. Magnitude and corresponding earthquake effects, adapted from <http://en.wikipedia.org/wiki/Richter_magnitude_scale>

Magnitudes	Description	Earthquake Effects	Frequency of Occurrence
Less than 2.0	Micro	Microearthquakes, not felt.	About 8,000 per day
2.0-2.9	Minor	Generally not felt, but recorded.	About 1,000 per day
3.0-3.9		Often felt, but rarely causes damage.	49,000 per year (est.)
4.0-4.9	Light	Noticeable shaking of indoor items, rattling noises. Significant damage unlikely.	6,200 per year (est.)
5.0-5.9	Moderate	Can cause major damage to poorly constructed buildings over small regions. At most slight damage to well-designed buildings.	800 per year
6.0-6.9	Strong	Can be destructive in areas up to about 160 kilometres across in populated areas.	120 per year
7.0-7.9	Major	Can cause serious damage over larger areas.	18 per year
8.0-8.9	Great	Can cause serious damage in areas several hundred miles across.	1 per year
9.0-9.9		Devastating in areas several thousand miles across.	1 per 20 years
10.0+	Epic	Never recorded; see below for equivalent seismic energy yield.	Extremely rare (Unknown)

Strong world earthquakes occur once a year, in average. The largest recorded earthquake was the Great Chilean Earthquake of May 22, 1960, which had a magnitude M=9.5.

determined from ground displacement on a seismograph record and relates to the total seismic wave energy released in an earthquake.

Generally the magnitude M is defined by the following relation: $M = \log (a/T) + f(\Delta, h) + C_s + C_r$, where a is the ground displacement value (μ), T is the corresponding wave period (s), Δ is epicentral distance (degrees), h is the focal depth (km), C_s is the station correction for local ground conditions, and C_r is the regional correction, which is different for different earthquake regions, and depending on the earthquake mechanism and the seismic rays' path properties. As magnitude is a scalar quantity – one number – characteristic for each shock, its determination from different stations at any distance should be theoretically identical, practically it agrees within certain error limits, usually within about ±0.2–0.3 units of M. The relation between magnitude M and total seismic energy released by an earthquake E (erg) can be expressed by relation $\log E = 11.8 + 1.5 M$.

In case of historical earthquakes, for which no seismograms existed, the estimated macroseismic intensities can be approximately recounted into corresponding magnitude values. However, such recounting may sometimes appear questionable, and especially for either very weak or very strong earthquakes it cannot be done at all. For an estimative judgment only, valid for the mid-parts of both scales, magnitude and intensity ones, we may accept the relation $I_o \approx M + 2$ (where I_o is earthquake intensity and M is magnitude).

For illustration, typical effects of earthquakes of various magnitudes are given in Table 5. This table should be taken with certain caution, since intensity and thus ground effects depend not only on the magnitude, but also on the distance to the epicenter, the depth of the earthquake, and the geological conditions (certain terrains may amplify seismic signals).

Strong world earthquakes occur once a year, in average. The largest ever recorded earthquake was the Great Chilean Earthquake of May 22, 1960, which had a magnitude $M = 9.5$ Disastrous combination of volcanic and seismic effects are demonstrated on example of the Asama-Yama event in Japan in 1783 (Fig. 24).

Tsunamis

Tsunamis are defined as a series of gigantic waves which are created when a large volume of water, such as in the ocean, is rapidly displaced vertically. This displacement occurs due to mass movement below water. Coastal earthquakes, similar to submarine volcanic eruptions, may generate these huge water waves, which are usually accompanied by coastal flooding; pertinent damage caused by these waves is sometimes higher than the damage caused by the preceding earthquake: anything along the coast is swept away by the approaching wall of water, ships are carried far inland, and thousands of people inland are drowned into the sea (Fig. 25).

Strong tsunamis have been generated by some specific crustal earthquakes, during which fast vertical movements of tectonic plates along their incident boundaries occur. The uplifted plate below water causes the water to push up and the overlying water creates a huge wave. It follows that they are, namely, the subduction earthquakes, which are particularly effective in generating tsunamis.

The Indian Ocean Tsunami of December 26, 2004 (called also Boxing Day tsunami), with the epicenter near the northern coast of Sumatra, was one of the most destructive natural catastrophes in recent history. It killed as many as 225,000 people, thousands of bodies either being lost to the sea or unidentified, many more were injured. The death toll of over

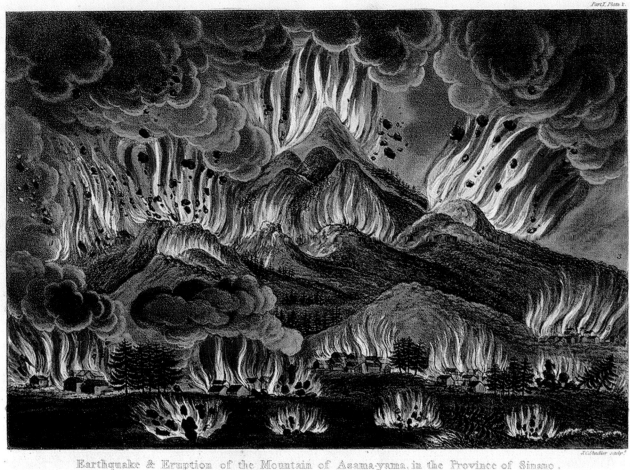

Part I. Plate V.

Earthquake & Eruption of the Mountain of Asama-yama, in the Province of Sinano.

1. *Mountain of Asama-Yama.* 3. *Pole which marks the boundaries of the Provinces of Sinano & Kozouké.* 5. *Village of Oppake, where there are warm springs.*

2. *Kosouts-Yama (origin of the Fire.)* 4. *Village at the foot of the Mountain, but more than ten miles from its summit.* 6. *Mountain twenty miles from Kosouts-Yama.*

London, Published 1822, by R. Ackermann, 101 Strand.

Fig. 24 *"Earthquake and volcanic eruption of the Mountain Asama Yama in the Province of Sinano, Japan"*. Color lithograph from the book by Titsing (1822). Evidently, the effects of fire are exaggerated. Private collection, Prague

40,000–60,000 was the result of the tsunami which followed the 1755 Great Lisbon earthquake (more died due to the earthquake itself and subsequent fire). More than 70,000 people died due to tsunami in the 1908 Messina earthquake. The tsunami, which followed the Krakatoa volcano eruption in 1883, killed about 36,000 people. Fatal destruction of the Egyptian city of Alexandria in AD 365 is now presumed to have been caused by a tsunami. Historically speaking, tsunamis are not rare, at least 25 tsunamis occurred in the last century. Of these, many were recorded in the Asia-Pacific region – particularly along the Japanese coasts; tsunami, however, represent a global phenomenon, which may occur wherever large bodies of water are found, including inland lakes, where tsunamis can be caused by landslides (see Table 6 for the list of the historic tsunamis).

Tsunami has a relatively small wave height at deep sea, about 0.5–1 m, and a long wavelength approaching to 100 km. That is why tsunami generally passes unnoticed at deep sea, forming only a low, imperceptible hump in the ocean. Tsunamis have been historically referred to as tidal waves because as they approached land, they resembled a violent onrushing tide rather than a series of cresting waves formed by wind. Since earthquakes are often a cause of tsunami, an earthquake felt near a body of water may be considered an indication that a tsunami may shortly follow. Before tsunami arrival the sea first withdraws from the coastline (sometimes for several kilometers) and soon it returns as an immense high wave (of several meters or tens of meters high) extending hundreds of kilometers along its wave-front. This approaching crest of water struck on the shore, sweeping

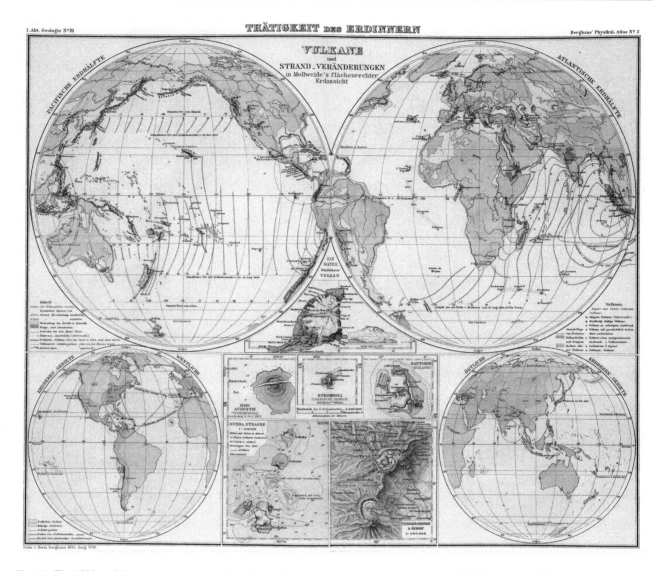

Fig. 25 The 1888 world map presents propagation of tsunamis generated by two strong earthquakes (1854 Japan and 1868 Peru) and by the 1883 Krakatoa volcanic eruption. Positions of the tsunami wave front were plotted in one-hour step intervals. The map is reproduced from the "*Physical Atlas*" (Berghaus Hermann, 1888). Private collection, Prague

along at unbelievable speed, which may reach some hundreds kilometers per hour.

Depiction in Fig. 26 comes from the collection "*Thirty six views on Mount Fuji*". It offers a dramatic, but still a romantic look on a gigantic overhanging wave near the Japanese coast. Below the wave two smaller ships are running their way and the mountain Fuji dominates the scene in the background.

Japan is located in an extremely tectonically complex region; its location on the Pacific Ring of Fire, at the juncture of three large tectonic plates, gives Japan frequent earthquakes and occasional volcanic activity. Destructive earthquakes, often generating tsunamis, occur several times each century. At the northeast, where the Pacific

plate is subducted below the Eurasian plate along the Japanese trench a devastating tsunami triggered by a recent earthquake of $M = 7.8$ swept a small island Okushiri near Hokkaido on July 12, 1993, and killed over 200 local inhabitants.

On June 15, 1896, the Japanese island Honshu was struck by a huge Meiji Sanriku tsunami wave; the fishermen who were just 30 km offshore did not observe any water elevation, but a coastal area of 275 km was devastated and some 22,000 people were killed. Tsunami occurs also in the Nankai region on the southwest of Japan, where the Philippine tectonic plate collides with the Eurasian plate. As an example, the destructive Ansei Nankei tsunami in 1854 may be mentioned. Since the year AD 684, when the

TABLE 6. List of the deadliest tsunamis in history, adapted from <http://en.wikipedia.org/wiki/list_of_natural_disasters_by_death_toll#tsunamis>.

Year	Event	Afflicted Area/Country	Death Toll
2004	Aceh or Indian Ocean tsunami	Indian Ocean	~ 225000
1755	Lisbon earthquake and tsunami	Portugal and Morocco	40000-100000
1908	Messina earthquake and tsunami	Italy	100000 (?)
1883	Krakatoa volcano explosion	Indonesia	36000
1707	Tokaido-Nankaido	Japan	30000
1826		Japan	27000
1868	Arica earthquake	Chile	25674
1896	Sanriku	Japan	22070
1792	Caused by Mount Unzen, Southwest Kyūshū	Japan	15030
1771		Ryukyu Trench	13486
1703	Tokaido-Kashima	Japan	5233
1605	Nankaido	Japan	5000
1976	Moro Gulf	Philippines	5000
1952	Borneo	Indonesia	4000
1998		Papua New Guinea	3000
1933	Sanriku	Japan	3008
1952	Kuril, Kamchatka	Russia	2300
1960	Great Chilean earthquake	Chile, United States (Hawaii), Philippines and Japan	2000
1607	Bristol Channel	United Kingdom	2000
1946	1946 Nankai earthquake and tsunami	Japan	1330
1944	Tonankai	Japan	1223

Note: for death toll estimates sources sometimes vary

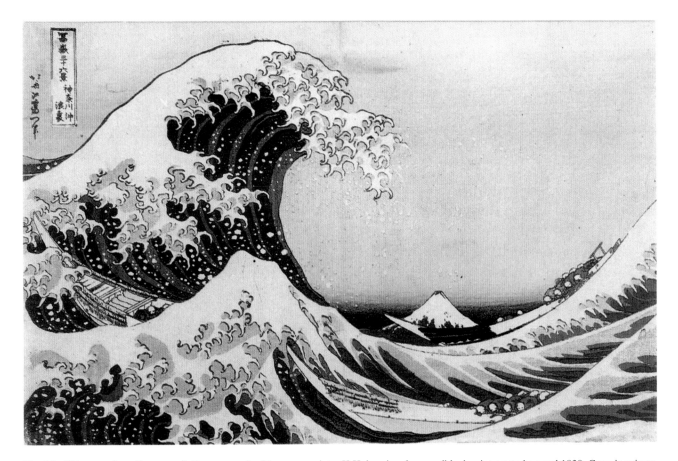

Fig. 26 "*Big wave from Kanagawa*". Famous work of Japanese painter K.Hokusai, color woodblock print created around 1830. Copy in private collection, Prague

damage caused by tsunami was for the first time mentioned, over 200 tsunamis were recorded. The statistics proved that the death toll of tsunami was usually more unrelenting than that of earthquakes.

The Peruvian and Chilean coast in the southeastern part of the Pacific Ocean is the zone where the oceanic tectonic plate Nazca subducts beneath the South American continent, forming the Peru–Chile trench here. The subduction process proceeds fast in time and the released strain has been always a source of mighty earthquakes in this region often accompanied by tsunamis. One of them, in 1868, destroyed the coastal town Arica (Fig. 27).

The composition in Fig. 28 is reproduced from the "*Meteorologia Philosophico-politica*", a treatise of Jesuit scholar Francisco Reinzer (1712). This composition has only an illustration value; it does not depict any concrete situation

and presents the reminiscence of a strong earthquake in southern Sicily (near Val di Noto) during the disasterous earthquake of 1693. The earthquake catastrophe (I_o = XI on the MCS scale), which affected a substantial part of the eastern Sicily, was accompanied by a sea quake, stormy waves, and whirlpools, and the author did not hesitate to remind this event in his work published later, in 1712. The figure illustrates the damaged town of Messina (?), together with wave turbulences on the sea surface, sunk down ships, as well as fish and sea shells washed ashore. The content of the composition is not quite clear, but it carries evidence on tsunamis that ravaged the Italian coast at the time of high seismic and volcanic activities in 1680s and 1690s.

Indonesia's location on the edges of the Pacific, Eurasian, and Australian tectonic plates makes it the site of numerous volcanoes and frequent earthquakes. Indonesia has at least

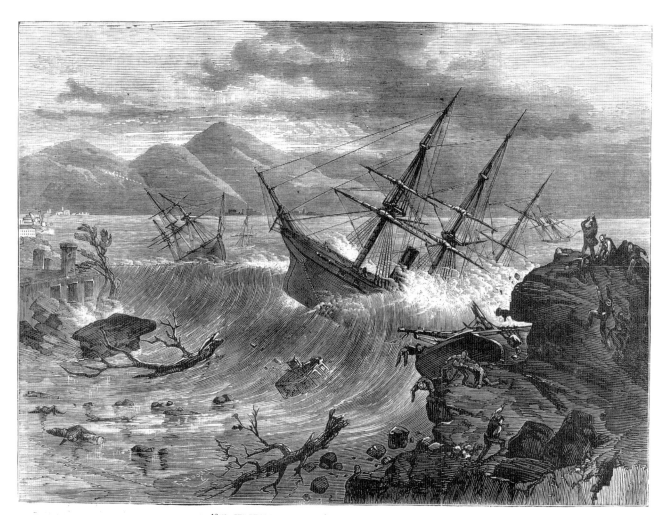

THE TERRIBLE EARTHQUAKE IN SOUTH AMERICA, AUG. 13TH—THE TIDAL WAVE SWEEPING THE U. S. STEAMER WATEREE ON SHORE, AT ARICA, PERU, AND DESTROYING THE VESSELS IN THE HARBOR.—SEE PAGE 37

Fig. 27 "*Earthquake in Peru - flooding of Arica*". Xylograph illustration from *Harper's Weekly Journal* (of Nov. 21, 1868). The stormy coastal waters of the Pacific Ocean rage in front of an Arica town. Several ships capsize among the rushing waves, which wash wooden debris from the destroyed buildings to the sea surface. The town itself was ultimately swept away. Private collection, Prague

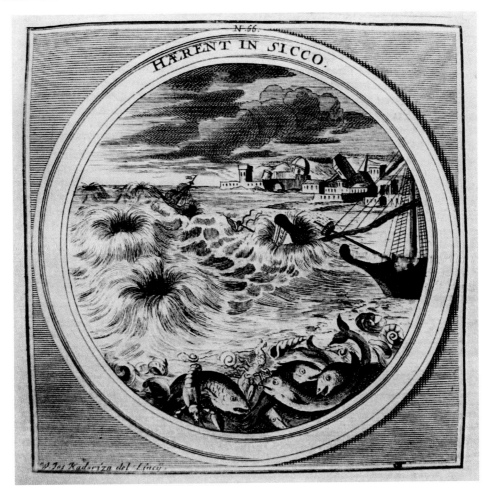

Fig. 28 Copper engraving, an allegory illustrating tsunami effects in the Messina Strait. Reproduced from Reinzer (1712). Private collection, Prague

150 active volcanoes, including Krakatoa and Tambora, both famous for their devastating eruptions in the nineteenth century.

Figure 29 demonstrates a scene near Sumatra when tsunami waves approaching the coast splashed violently on the coast; especially where the water was shallow, the incoming tsunami wave was the highest. Not much information about this earthquake is available; however, during recent history, several similar disastrous seismic events occurred in this region, for example, the 1935 earthquake had a magnitude $M = 8.1$, and the later earthquake in the region of Andaman and Nicobar Islands in 1941 was even stronger, classified by $M = 8.7$.

At present the danger of tsunami effects has got another dimension. In the early times, only the locals living in the regions endangered by tsunami generally suffered, namely, those settled at the Pacific and Indian Ocean coasts. Those, who lived inland, hardly knew what the "tsunamis" are. However, during the last 2 or 3 decades, encouraged by the modern and cheap transport techniques, the rapidly growing number of Europeans, North-Americans, and many others used to spend their holiday in the paradise of coral atolls in the tropic seas, in areas exposed to the danger of tsunamis. What this danger really is, some of them realized in the 2004 Aceh (or Indian Ocean) tsunami.

Plate Tectonic Theory

The Earth, the world in which we live, is one of the four terrestrial (inner) planets of our Solar System. The Earth is actually the largest of them in diameter, mass, and density and also it is the only one with active plate tectonics. The Earth's body consists of three principal layers, namely, the Earth's crust, mantle, and core. This division is the result of indirect geophysical observations and is based mainly on the knowledge acquired from monitoring and consequently analyzing the seismic waves generated by earthquakes. The velocity of seismic waves is depth (and pressure and temperature)-dependent and reflects the rheological (and

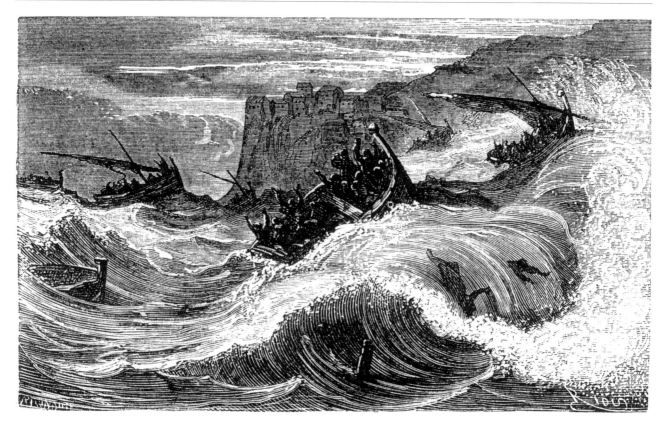

Fig. 55.—INCIDENT DURING THE EARTHQUAKE AT SUMATRA (1861).

Fig. 29 Tsunami wave accompanying the 1861 Sumatra earthquake. Xylographic illustration, signed by Gauchard and Riou, reproduced from the book by Zürcher and Margolle (1869). Private collection, Prague

also mechanical, chemical) properties of the earth's interior. The velocity of the seismic waves generally increases with depth, and reflects basic structural characteristics of the earth's internal structure.

The earth's crust is separated from the mantle by the so-called Mohorovičić discontinuity, which corresponds to a pronounced (step-like) increase of the seismic wave velocity. The thickness of the crust varies from 6 to 10 km under the oceans and from 30 to 50 km (or more) under the continents. The solid silicate crust of the earth is composed of a great variety of igneous, metamorphic, and sedimentary rocks. The crust is underlain by a highly viscous mantle, the upper part of which is composed mostly of rocks of higher density than rocks common in the overlying crust. Below the mantle, at the depth of approximately 2,900 km and deeper is a liquid layer, the earth's outer core, composed of iron; sulfur and oxygen could also be present there. Still deeper, at the depth under 5,150 km is the inner core, which is solid due to the increasing pressure rather than due to the different chemical composition.

According to another subdivision, the outer part of the earth's interior is built up of two layers: the upper layer, usually named lithosphere, which comprises of the crust and the rigid uppermost part of the mantle, and the asthenosphere located underneath. Although solid, the asthenosphere has relatively low viscosity and shear strength, and when seen in geological time scales it can flow like a liquid. The deeper mantle below the asthenosphere is more rigid again. This is, however, not due to lower temperature but due to high pressure.

The lithosphere displays a different structure and composition below the oceans and below the continents. In other words, we may distinguish oceanic lithosphere and continental lithosphere. While the oceanic lithosphere encompasses a crust composed of sediments and thin layers of basalt and gabbros, considerably thicker continental lithosphere is composed of 15–20 km thick granitic layer, underlain with equally thick or even thicker mafic lower crust, totaling up to 50 km (or even 60–70 km in extreme cases under the highest mountain ranges).

The temperature of the crust increases with depth, reaching values in the range from about 200°C up to 600°C at the boundary with the underlying mantle. Because of convection in the underlying plastic (although non-molten) mantle and

asthenosphere, the lithosphere, broken into a number of large continental-size "blocks", called tectonic plates, may slowly move along the horizontal plane. The temperature under the continents increases by as much as 20–30°C for every kilometer in depth locally in the upper part of the crust, but the geothermal gradient is smaller in the deeper crust and further decreases with depth in the mantle to only a few degrees per kilometer.

Present geographical distribution of the continents is not (and never was) firmly fixed; in the geological history individual continents and oceans moved substantially over distances of thousands of kilometers. Actually, already at the end of the sixteenth century, Dutch cartographer Abraham Ortelius in his work "*Thesaurus Geographicus*" (Ortelius 1596) suggested that the Americas were "*torn away from Europe and Africa ... by earthquakes and floods*" and went on to say that "*the vestiges of the rupture reveal themselves, if someone brings forward a map of the world and considers carefully the coasts of the three continents.*" This idea was revived later when Antonio Snider-Pelegrini published two maps of the world in 1858, illustrating the global continental pattern before and after the separation of America from Africa and Europe.

The hypothesis that the continents were initially joined in a single huge landmass and later broke up and drifted to their present locations was first formulated in 1912 by the German meteorologist and geologist Alfred Wegener (1880–1930). He hypothesized that the continents were slowly drifting and supported his idea by evidential geological arguments (Wegener 1915). He demonstrated that similar plant and animal fossils were found around different continental shores of Africa and South America, suggesting that both continents were once joined. Widespread distribution of Paleozoic glacial sediments in a number of locations all over the world, or the presence of large coal deposits under the present ice cover of Antarctica, have been understood as an evidence for the continental drift. These facts supported the idea that the individual continents had previously been in different locations, as well as contiguous with each other.

However, Wegener was unable to demonstrate convincingly the mechanism of continental drift and thus, during his lifetime, his theory of continental drift was severely attacked by many leading geologists. The lack of a known driving force of such a drift and also the absence of other convincing evidence beyond the coastline shapes and the records of fossils were the major arguments against it.

Due to the technical progress in the late 1950s and the early 1960s resulting in new discoveries on the earth's lithosphere, the possibility of continental drift gradually became accepted. Systematic geological and geophysical research conducted by, e.g., Robert S. Dietz, Bruce Heezen, and Harry Hess, along with a revision of the theory including a drift mechanism by J. Tuzo Wilson, led to a general agreement

with the continental mobility and movements. Among the most important new discoveries of the early 1960s, which helped to find the acceptable solution, belonged a worldwide detailed mapping of the ocean's bottom and a thoroughgoing documentation of the distribution of zones of strong earthquakes and locations of active volcanoes. The very first evidence that crustal plates did move around came in the 1950s with the paleomagnetic achievements, namely, by the detection of the variable magnetic field orientation in rocks of different ages. Following the recognition of magnetic anomalies defined by symmetric, parallel stripes of similar magnetization on the seafloor on either side of a mid-ocean ridge, plate tectonic concept quickly became broadly accepted. Simultaneous advances in the early imaging techniques in and around the deep active seismic areas in a subduction zone (called Wadati-Benioff zones) together with numerous other geologic observations soon indorsed plate tectonics as a theory with extraordinary explanatory and predictive power.

Seen from another angle, plate tectonic theory encompassed and superseded the older theory of continental drift and the concept of seafloor spreading developed in the 1960s. As a modern update of the old ideas of Wegener about "plowing" continents, plate tectonic theory accommodates continental motions through a modern mechanism. New rocks are created by volcanism at mid-ocean ridges, where the new lithosphere is born, transported away and returned by subduction back to the earth's mantle at ocean trenches, where they are probably dissolved in the surrounding asthenosphere.

As stated above, the lithosphere essentially "floats" on the asthenosphere. The surface of the earth consists of 15 principal plates, together with 41 minor ones, 11 ancient plates, and 3 plates within orogenes, making a total of 70 plates (Fig. 30). The largest plates include the African (61.3 × 10^3 km^2), Antarctic (60.9), Australian (47.2), Eurasian (67.8), North American (75.9), South American (43.6), and Pacific Plates (103.3). Other notable plates include the Indian, Arabian, Caribbean, Cocos, Juan de Fuca, Nazca, Philippine, and Scotia Plates. The Australian Plate actually fused with the Indian Plate between 50 and 55 million years ago. The fastest-moving plates are the oceanic plates, with the Cocos Plate advancing at an average rate of 75 mm/year and the Pacific Plate moving 52–69 mm/year. At the other extreme, the slowest-moving plate is the Eurasian Plate, progressing at a typical rate of about 21 mm/year.

The individual tectonic plates of different size and shape behave as rigid segments that move in relation to one another at one of the three types of plate boundaries: convergent, divergent, and transform. The last occurs where two plates move laterally relative to each other, creating a strike-slip fault. Earthquakes, volcanic activity, mountain-building, and oceanic trench formation can occur along these plate boundaries. The thickness of the plates varies from ~60 km to about 150 km. The distinction between continental crust

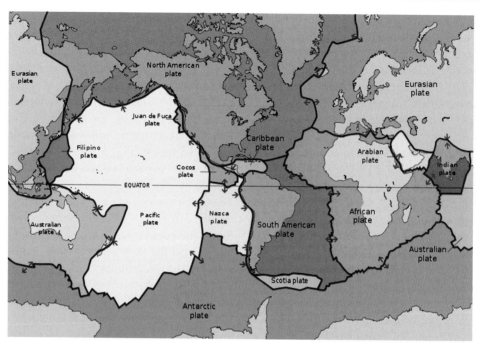

Fig. 30 World plate tectonics, adapted from <http://en.wikipedia.org/wiki/File:Plates_tec2_en.svg>

and oceanic crust is based on the density of the constituent materials; oceanic crust is denser because it has less silicate rocks and more heavier rocks (such as basalt and gabbros) than continental crust, which is formed mostly by granites and intermediate rocks. As a result, oceanic crust generally lies below sea level while the continental crust projects above sea level.

One plate meets another along a plate boundary, and plate boundaries are commonly associated with both dynamical geological events such as earthquakes and slow-running geological processes such as the creation of topographic features like mountains, volcanoes, and oceanic trenches. The majority of the world's active volcanoes occur along plate boundaries, with the Pacific Plate, being the most active and commonly well known.

Divergent boundaries (also called constructive boundaries) occur where two plates slide apart from each other. Mid-ocean ridges (e.g., Mid-Atlantic Ridge) and active zones of rifting (such as Africa's Great Rift Valley) are both typical examples of divergent boundaries. At divergent boundaries, the space that increases by the apart-moving plates is filled with new material sourced by molten magma from below. Here, large convective cells bring huge quantities of hot asthenospheric material near the surface and the process is strong enough to break apart the lithosphere. A so-called hot spot, which may have initiated the Mid-Atlantic Ridge system, currently underlies Iceland which is widening at a rate of a few centimeters per year. Divergent boundaries are typical in the oceanic lithosphere by the rifts of the oce-

anic ridge system, including the Mid-Atlantic Ridge and the East Pacific Rise, and in the continental lithosphere by rift valleys such as the East African Great Rift Valley. Spreading rate is generally not uniform and massive transform faults can occur, which is a major source of submarine earthquakes. The seafloor map shows a rather strange pattern of blocky structures that are separated by linear secondary faults perpendicular to the main ridge axis.

Convergent boundaries (also active or destructive margins) occur, where two plates slide toward each other forming either a subduction zone (if one plate moves underneath the other) or a continental collision (if both colliding plates contain continental crust). Deep marine trenches are typically associated with subduction zones. Because of the friction and the heating of the subducting slab, volcanism is almost always closely linked. A good example of plate interaction of this kind is typically the Andes range in South America and the Japanese island arc. The nature of the convergent boundaries depends on the type of lithosphere in the colliding plates. Where a dense oceanic plate collides with a less-dense continental plate, the oceanic plate is typically thrust underneath because of a greater buoyancy of the continental lithosphere, forming a subduction zone. At the surface, the topographic expression is commonly an oceanic trench on the ocean side and a mountain range on the continental side, see, e.g., the area along the western coast of South America where the oceanic Nazca Plate is being subducted beneath the continental South American Plate.

During the subduction process, rock temperature increases, and the volatiles (mostly water) encased in the porous oceanic crust are driven off. As water rises into the overriding plate, it lowers the melting temperature, produces melts (magma) with large amounts of dissolved gases. These melts then rise to the surface and become often the source of the most explosive volcanism on earth because of their high volumes of extremely pressurized gases (consider, e.g., Mount St. Helens). On the surface, the magma cools down and forms long chains of volcanoes inland from the continental shelf and parallel to the coast line. The continental spine of the western South America is rich with this type of volcanic mountain building; the Cascade mountain range in North America is another example of this type. Such volcanoes are characterized by alternating periods of quiet and episodic eruptions that start with an explosive gas expulsion with volcanic ashes and spongy cinders, followed by hot magma.

As shown above, where two continental plates collide, the plates either buckle and compress or one plate gets under or overrides the other. Both kinds of interaction result in the creation of extensive mountain ranges. A dramatic effect of such a process can be seen in the Indian subcontinent where the northern margin of the Indian Plate is being thrust under a portion of the Eurasian plate, lifting it and creating the Himalayan Mountains and the Tibetan Plateau beyond. When two oceanic plates converge they typically create an island arc; the arc is formed from volcanoes which erupt through the overriding plate as the descending plate melts below it. The arc shape occurs because of the spherical surface of the earth. A deep undersea trench is located in front of such arcs where the descending slab dips downward. Good examples of this type of plate convergence would be Japan, the Aleutian Islands, and Alaska. Plates may sometimes collide at an oblique angle rather than head-on (e.g., one plate moving north, the other moving southeast), and this may cause strike-slip faulting along the collision zone, in addition to subduction.

Because of the enormous friction, when the plates collide, plates cannot simply glide past each other. Rather, stress builds up in both plates, and when it reaches a level that exceeds the shear strain threshold of rocks, the accumulated potential energy is released in a form of the mutual plates' fast displacement. Strain is both accumulative and/or instantaneous depending on the rheology of the rock. The ductile lower crust and mantle accumulates deformation gradually via shearing, whereas the brittle upper crust reacts by fracture, or instantaneous stress release to cause motion along the fault. The ductile surface of the fault can also release instantaneously when the strain rate is too great. The energy released by instantaneous strain release is the cause of earthquakes, a common phenomenon along transform boundaries.

A good example of this type of plate boundary is the San Andreas Fault which is found in the western coast of North America and is one part of a highly complex system of faults. At this location, the Pacific and North American plates move relative to each other in such a way that the Pacific plate is moving northwest with respect to North America. Other examples of transform faults include the Alpine Fault in New Zealand and the North Anatolian Fault in Turkey. Transform faults were also found offsetting the crests of mid-ocean ridges, such as the Mendocino Fracture Zone offshore northern California.

The intensive volcanic and earthquake activities must not be related exclusively to the continental margins or be connected with the mutual plate movement; these phenomena may also occur within a plate. A very good example represents the Hawaiian Archipelago, which is of volcanic origin, situated in the Pacific Ocean more than 3,000 km from the nearest Pacific plate boundary. In order to insure volcanic activity in a single place for a long time of tens of millions of years, a permanent mighty heat source is necessary. One can assume that such heat can be generated deep in the earth's mantle, probably as deep as somewhere near the mantle-core boundary. From such deep heat sources the molten mantle rocks may rise upwards under slowly moving lithosphere on the surface. A huge magma hearth on the top of such mantle plume seems to provide enough magma; in such configuration, repeated volcanic eruptions create a narrow belt of volcanic island and submarine volcanoes. In geology, this phenomenon is called hot spot and the whole volcanic chains like the Hawaiian Islands probably resulted from the slow movement of a plate across a "fixed" hot spot situated deep beneath the surface of the planet. The total length of the Hawaiian volcanic belt exceeds 6,000 km and the belt spreads out to the northwest as far as the Aleutian through. In addition to the Hawaiian Islands another 50 active hot spots are known, among them, e.g., the Canary Islands or Yellowstone caldera. Hot spot volcanoes should not be confused with island arc volcanoes. While each will appear as a string of volcanic islands, island arcs are formed by the subduction of the converging lithospheric plates.

Subduction is an evident product of plate motion, and the whole process is the result of mighty thermodynamical forces acting deep under the earth's surface. It seems that it is, namely, the earth's inner heat field and its spatial and time development that rule the movement of the individual tectonic plates. Two- and three-dimensional imaging of the earth's interior shows that there is a laterally heterogeneous (varying with depth and with geographic coordinates) density distribution throughout the mantle. Such density variations can be caused by material diversity (rock chemistry), or can be of mineral character (according to variations in mineral structures), or caused by thermal variations (through thermal expansion and contraction from heat

energy). The above lateral density heterogeneity is manifested by mantle convection from buoyancy forces. The way in which the mantle convection contributes (directly and indirectly) to the motion of the plates is a matter of ongoing study and discussion in geodynamics. Somehow, this energy must be transferred to the lithosphere in order for the plates to move. Essentially, there are two types of forces that are considered as influencing plate motion: friction and gravity.

We noted at the beginning of this chapter that seismic waves from earthquakes and their analysis have submitted valuable information on the structure of the inner parts of the earth and enabled us to reconstruct the physical portrayal of the earth's interior. In this context, we may compare seismic waves in geosciences to Roentgen rays in medic.

Now, being armed with certain basic knowledge of the nature of the earth's dynamic manifestations – namely, volcanic eruptions, earthquakes, and tsunamis – we can better understand their causes. We can imagine how these disasters afflicted the human life and help to formulate their thinking. Let us enjoy a small excursion back to history and admire how natural disasters have been depicted and illustrated through the past centuries. What is the cultural heritage that the older generations handed down? In the pages which follow, we will see a number of unique images which document, probably uneasy and arduous, but definitely in an impressive and elaborate way, from simple and primitive pictures to complex and splendid artworks (Fig. 31).

The first section of pictures with appropriate comments is devoted to the various volcanic phenomena, such as eruptions, explosions, lava flows, and volcanic rock formation together with portrayals of several famous volcanoes. The second part will present seismic manifestations and their consequences; destroyed structures and whole devastated towns, horror and panicked inhabitants. Such a division, however, is not a rule; in some cases, both disasters struck jointly and the subsequent fire completed the fatal work. Both volcanic and seismic sequences are arranged chronologically to enable the reader to detect the successive advancement of the earth sciences, reflected in the gradual advancement of the pictorial documentation in both technical improvement and in the growing reliability of the content.

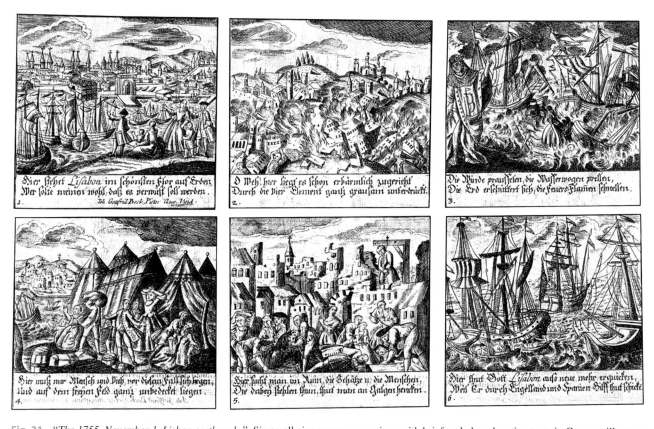

Fig. 31 *"The 1755, November 1, Lisbon earthquake"*. Six small-size copper engravings with brief verbal explanation texts in German, illustrate the destruction of the city of Lisbon and a heavy damage to the Morocco town Mekness. Printed and published by J.A. Steisslinger in Augsburg after 1755. Original print is kept in the Municipal Museum of Lisbon; the print copy kindly granted by the Lisbon municipal representatives. Private collection, Prague

Vesuvius–Somma Volcano, Bay of Naples, Italy

Vesuvius Mt. is a relatively young stratovolcano, which originated from an older volcanic complex of Somma. This complex rose up from the alluvial plateau of the Bay of Naples some 12,000 years ago and reached the height of about 1,000 m. At present, the Vesuvius–Somma complex covers an area of 480 km². A number of parasite craters have been evidenced, scattered on the outer slopes of the Somma Mt., in the last three millennia, ejecting tephrite and trachyte lava streams. After a strong eruption in AD 79, a new crater – Vesuvius (49°49′N, 14°26′E) – sprang up in the Somma's largest caldera. Mount Vesuvius was regarded by the Romans as being devoted to the hero and demigod Hercules and the town of Herculaneum, built at its base, was named after him.

Vesuvius is located on the coast of the Bay of Naples, about 9 km east of Napoli (= Naples), in a short distance from the shore. Its cone is conspicuous in the beautiful surrounding landscape, when seen from the sea with Naples in the foreground. Mount Vesuvius is the only volcano in the European mainland that has erupted within the last 100 years. The two other active volcanoes in Italy (Etna and Stromboli) are located on islands. Vesuvius is best known for its eruption that caused destruction of the Roman cities of Pompeii and Herculaneum. It has erupted many times since then; however, today's Vesuvius activities are reduced to little more than steam emanations from vents at the bottom of the crater. Nevertheless, because of the population of about three million people living close to Vesuvius and its hardly predictable tendency toward explosive eruptions, the volcano must be regarded as one of the most dangerous in Europe.

Vesuvius has a distinctive structure, namely a summit caldera surrounding a newer cone. The height of the main cone constantly varied due to numerous eruptions; at present it amounts to 1,281 m. Monte Somma is 1,149 m high, separated from the Vesuvius cone by the valley of Atrio di Cavallo, which is about 5 km long.

Vesuvius is a stratovolcano at the convergent tectonic boundary, where the African Plate is being subducted beneath the Eurasian Plate. Its lava is composed of viscous andesite. The strata of lava, scoria, volcanic ashes, and pumices have built up the mountain. The volcano is one of those forming the Campanian volcanic arc. Others include Campi Flegrei (Phlegraean Fields), a large caldera few kilometers to the North West, Mount Epomeo, 20 km to the west on the island of Ischia, and several undersea volcanoes to the south. The arc forms the southern end of a larger chain of volcanoes initiated by the subduction process, which extends northwest along the length of Italy, as far as to Monte Amiata in Southern Tuscany.

Since the times of ancient Roman civilization, Vesuvius has been the best known, described, analyzed, and portrayed volcano of the world. There are two main reasons for it. First, long-term continuous activities of the Somma–Vesuvius complex including its deadly explosion in AD 79, followed by series of strong eruptions in the last four centuries. Second, the location of Vesuvius in Central Italy, that is, in the former center of the Roman Empire and later the cradle of the nascent Christian Europe, enthroned the volcano as the principle object of natural and permanent interest of European geo-savants and naturalists, especially due to its spectacular eruptive and seismic manifestations.

As a result of this long-term massive interest, hundreds of specialized comments, papers, monographs, books, maps, sketches, images, schemes, etc., have been written, drawn, and published. It follows that the authors in their effort to reserve some necessary space for the presentation of other volcanic and seismic events had to make a careful selection of the pictorial material available on Vesuvius. A pertinent choice of historical events and their depiction was carried out with the aim of covering the best of important and significant manifestations of the volcano and simultaneously to present the most attractive and commonly not-known images.

On August 24, AD 79, the area around Mount Somma was trembling with numerous quakes. Afterward, the mountain's top split open and a monstrous cloud raced upward. The inhabitants of Pompeii were showered with ashes, stones, and pumices. A convincing approximation toward the total havoc and panic of Pompeii inhabitants can be attained by observing a large nineteenth-century illustration. Figure 32 is a famous pictorial composition entitled *The last day of Pompeii*, a work of K.P. Brüllow (1799–1852). The composition was created during his visit to Italy in 1830–1833 and was generally based on the verbal account of the disaster recorded by Pliny the Younger.

J. Kozák and V. Čermák, *The Illustrated History of Natural Disasters*,
© Springer Science+Business Media B.V. 2010

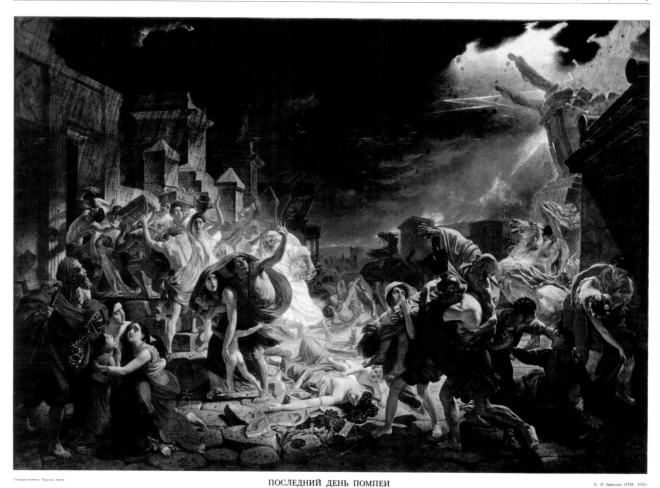

ПОСЛЕДНИЙ ДЕНЬ ПОМПЕИ

Fig. 32 *"The last day of Pompeii"*. Oil painting by K.P. Brüllow, original is at the Hermitage Gallery, St. Petersburg, Russia. Copy in private collection, Prague

A thick blanket of ashes and river of mud buried the city of Herculaneum. During several hours the volcano released about 4 km³ of ashes and molted rocks over a wide area to the south and southeast of the new crater; Pompeii town itself was covered by a 3-m-thick stratum of tephra falling. The height of the smoke and dust eruption column was estimated as 32 km. The cloud of superheated gasses, ashes, and rocks that erupted from volcano rushed down the flanks of the mountain and covered everything around it. The temperature of the ashes approached to 850 °C when emerging from the mouth of Vesuvius and had cooled down below 350 °C by the time it reached the city. Strong ground tremors accompanied the eruption. Sun was shadowed out by the eruptive clouds and the daylight hours were left in darkness. Also, the sea was sucked away and successively forced back by a tsunami. The estimates of the pre-eruption population of Pompeii ranged from 10,000 to 25,000 plus about 5,000 of Herculaneum. It is not known how many people actually perished, however, any assessment based on the number of excavated remains of bodies that have been later recovered in and around Pompeii (several thousands of bodies) must represent an underestimation of the total number of deaths over the whole region affected by the eruption. Most casualties were caused by poisoned gasses, which killed people and larger mammals, dogs, and horses, without any physical suffering. Most excavated cadavers were found in more or less "natural" positions.

Later generations have expressed deep sympathy with the inhabitants of Pompeii, Herculaneum, and all surrounding settlements annihilated in the Vesuvius eruption. Modern archeologists already for more than three centuries have excavated once flourishing Roman towns with many ancient artifacts, including intact residential atria, temples, theatres, etc. Without all the findings found in Pompeii our knowledge of Romans and their civic life, social relations, arts, pastimes, crafts, and privacy would be much more modest and incomplete. The earliest accounts of the Pompeii excavations from the 1750s up to 1770s were presented by W. Hamilton (1772).

After Pompeii was buried and seemingly lost for history, the volcano continued to erupt approximately every 100

years until about AD 1037, when Vesuvius entered a 600-year period of a relative quiescence. The situation, however, changed abruptly in 1631, when the volcano explosion killed about 4,000 unsuspecting people. This event actually constituted the moment, when during the restoration works the workers discovered the ruins of Pompeii, buried and forgotten for nearly 1,600 years. Since then, Vesuvius volcanic activities became almost continuous, with more-or-less severe eruptions occurring in every 30–40 years. The quiescent stages have varied from 18 months to maximum 7 years. While at the moment Vesuvius is not thought likely to erupt in the nearest future, danger of a possible eruption is evident.

A closer look over the history of Vesuvius activities confirms that after longer time of volcano "sleep" between AD 685 and 1622 (with the exception of the 1137 burst) the volcano entered a new phases of extreme activity in the seventeenth to nineteenth centuries, starting by a weak eruption in 1622 and continued by the gigantic outburst in 1631. Statistics of that-time eruptions of Vesuvius displays that, as concerns their frequency and intensity, the series of eruptions reached a high level particularly in 4 decades, 1754–1794.

Before admiring the eighteenth century illustrations of Vesuvius and its conjuring fire tricks, we have to stop shortly at the so-called pre-Hamiltonian period of Vesuvius portraying. The renewed eruption of Vesuvius was noticed by the Parisian encyclopaedists who engaged Nicolas Desmarest (1725–1815) to prepare illustrated commentary of the Vesuvius eruptions for their *Encyclopaedia* (Diderot and D'Alembert 1751–1772).

The increasing attempts to portray Vesuvius (Fig. 33) well documented a growing interest in volcanic studies and the progressing level of scientific research in the second half of the eighteenth century, that is, in the period of the Enlightenment, when the natural sciences got emancipated from previous religious standpoints. Two disastrous earthquakes (Lisbon 1755 and Calabria 1783) "shocked" all intellectual elite of Europe and noticeably pushed all geosciences forward. These events greatly contributed to the secularization of the scientific understanding of volcanic and seismic phenomena.

N. Desmarest, as the inspector general, visited also the French region of Massif Central near Clermont and studied the extinct Tertiary volcanoes located there. As a confident Plutonist, he always defeated the priority of igneous rocks as the principle factor ruling the creation of individual rocks. Desmarest completed his ideas in his *Mémoire sur l'Origine et la Nature du Basalte Grandes Colonnes* (Desmarest, 1771).

Sir William Hamilton (1730–1804), British diplomat, statesman, naturalist, and collector came to Naples in 1764 to work here. Sir William, a member of a patrician Scottish family, was appointed as British Ambassador to the Kingdom of Naples and Sicily in Naples, where he stayed until 1800. During this period, besides his professional affairs and private interests in collecting ancient artifacts, he was permanently engaged in studying volcanoes of the region, namely Vesuvius, which was in the stage of intensified activity. Hamilton used to visit regularly the bursting and erupting volcano and kept a systematic record of his observations. His interest in Vesuvius and other Italian volcanoes substantially moved volcanology forward. He gathered his findings in several books (Hamilton 1772, 1776). To illustrate his publications he engaged famous painter and book illustrator Peter Fabris. Sir William Hamilton is often cited as one of the father-founders of modern volcanology.

The dramatic illustration given in Fig. 34 represents 1 of more than 50 plates created by Peter Fabris, which were used to illustrate Hamilton's (1778) book *Campi Phlegrei*. A night scene presents the King of Naples with his court during the impressive spectacular view on a red-glowing lava stream pouring out of a side Vesuvius crater toward the Resina settlement. The mighty summit of the volcano cloaked in the dense smoke towers above at the background. In this case, the artist probably expressed his own experience (the drawer is displayed in the bottom left corner).

The reproduced composition by Peter Fabris presents an interesting testimony that Hamilton's predominant scientific concern on volcanic events had also a social and even political dimension. Servants with sedans and torches, rented draftsman, groom and horses, bodyguards accompanying nobility, which in addition to the court eminent personalities, including the King, and also a group of noble women in evening robes, they all must convince the reader that the adventurous night excursion to visit the furious volcano led by a diplomat scholar was a supreme social and prestige-evoking event. In any case, nothing of such comment detracts both Hamilton's volcanology merits and the artistic level of Fabris' compositions.

Special attention should be paid to the eruption of January 15, 1794, which completed the series of local destructions at the turn of the eighteenth century, a disastrous mass eruption from the secondary craters on the volcano southern slopes. During this event, the majority of the coastal town Torre del Greco was devastated with a number of casualties.

Figure 35 gives a look on the raging volcano, a view which in the night darkness resulted in an especially horrible impression. The image painter selected a safe standpoint over the Bay of Naples, in a distance, near to Castel d'Ovo. The lightning in the sky was not added by drawer's fantasy. According to A. v. Humboldt (quot.) "*hot water vapors escaping from the volcanic vents dissipated in the air, and when cooled down they created a dense cloud around the flamy ashy column, several kilometers high....*" Such a sudden vapor condensation and the rise of the cloud itself initiated electric voltage. Alexander Humboldt stated that "*the lightings were randomly blazing from the dusty column and one can discriminate thunder rumble from the terrible roar*

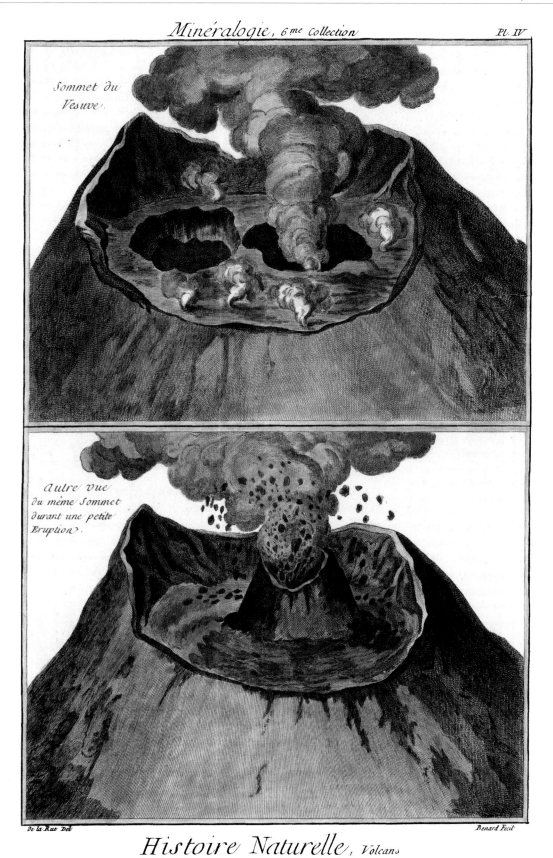

Minéralogie, 6me Collection

Pl. IV

Histoire Naturelle, Volcans

de la Rue Del

Benard Fecit

Fig. 33 Crater of Vesuvius portrayed in a quiescence period (upper image), and in the period of a smaller eruption in 1775 (bottom image). Hand colored copper engraving by N. Desmarest. Private collection, Prague

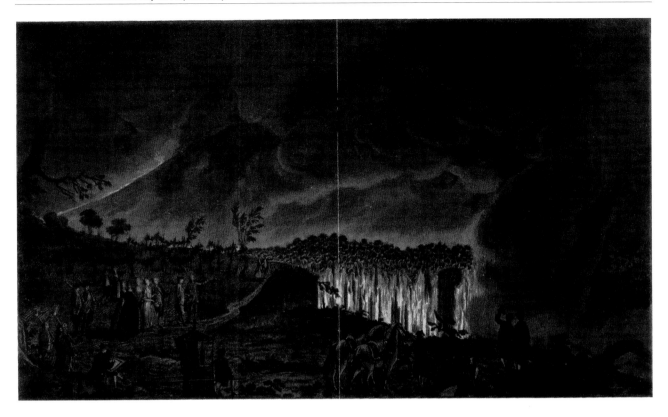

Ein Lavaſtrom des Veſuv

Nach Sir William Hamiltons „Campi Phlegraei" vom Jahre 1776

Fig. 34 *"A night view of a current of lava that run from mountain Vesuvius on May 1, 1771"*. Plate XXXVIII by Fabris in Hamilton (1776). Private collection, Prague

inside the volcano … at no other volcanic explosion the show of the electric discharges was so spectacular" (Humboldt 1906).

Topographically, the situation is shown in the map of Vesuvius; see the top image in Fig. 36, in which the lava flows adjoined to the 1794 eruption are denoted by dark color. The bottom map shows Torre del Greco town partly flooded by molten lava. Both figures were taken from the "Bilderbuch" edited by F.J. Bertuch (1791).

In the nineteenth century, Vesuvius, no doubt, was the most often described, painted, analyzed, and commonly discussed volcano of the world (Fig. 37). The bibliographic list summarizing the illustrated reports of the volcano published by Furchheim (1897) consists of 1,800 items (!). Large number of pertinent illustrations, mostly steel engravings, lithographs, and xylographs (=wood engravings) and, of course, also photographs, cannot be introduced here. For all of them let us present a xylographic illustration, typical for the Vesuvius pictorial production of the nineteenth century. Xylographic image (Fig. 38) displays the scenery inside the main Vesuvius crater during a period of a certain volcanic quiescence. This illustration is reproduced from an unidentified pictorial German jour-

nal published in the mid-nineteenth century. The image confirms that at certain, rather infrequent periods, it was possible to visit the bottom of the main crater and even dare to walk within a couple of steps there. Today readers, who have climbed the summit of Vesuvius recently and remember how arduous descent it was to manage those several hundred meters down to the circular abyss of the central crater, may be surprised by the flatness of the irregular crater shape presented in Fig. 38. Really, the volcano often changed its appearance, not only the crater shape and form, but also its depth. Alexander v. Humboldt claimed that some sketches could be easily dated according to the crater shape recorded.

The first volcanological observatory on Vesuvius was built in 1841, according to the suggestion of Ferdinand II, the King of two Sicilies. The first director Macedonio Melloni (1798–1854) studied, above all, magnetism of the volcanic rocks. His successor, famous volcanologist and seismologist Luigi Palmieri (1807–1896), constructed a simple seismograph, which he used when recording and analyzing the 1872 eruption accompanied by seismic tremors. Other directors were Raffaele Matteuci, who investigated namely the 1906 eruption, and Guiseppe Mercalli (1850–1914), the author of the

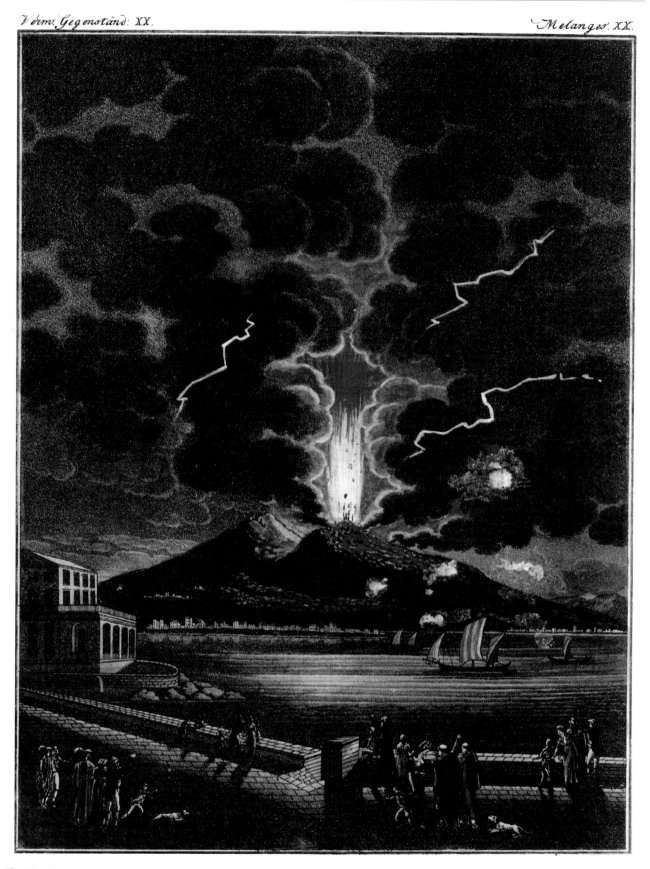

Fig. 35 Night view of the eruption of Vesuvius on January 15, 1794. Hand colored copper engraving (Bertuch, 1794). Private collection, Prague

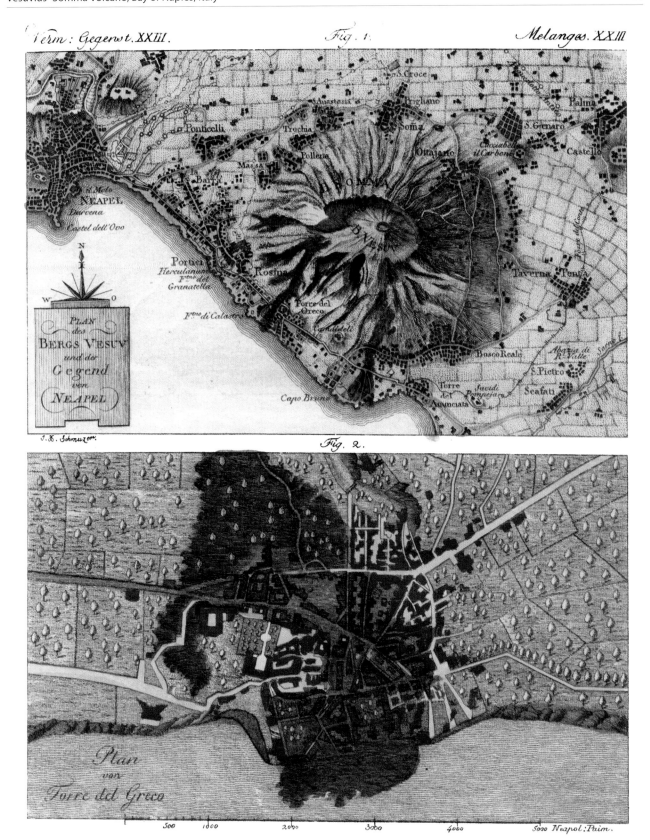

Fig. 36 The map of Vesuvius and Torre del Greco during the 1794 massive eruption. Hand colored copper engraving reproduced from Bertuch (1794). Private collection, Prague

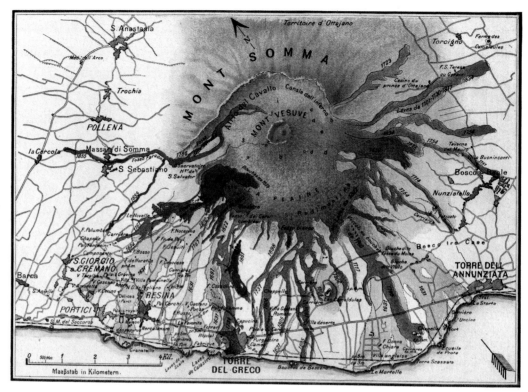

Fig. 37 Individual lava flows plotted on Vesuvius' slopes (Hon, 1865). Private collection, Prague

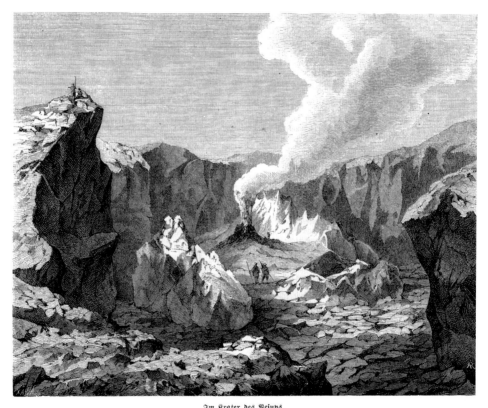

Fig. 38 Inner part of Vesuvius main crater. Xylography print from an unidentified German periodical of mid-19th century. Private collection, Prague

macroseismic intensity scale. At the beginning of the twentieth century, for a short time, two more observatories were erected to investigate Vesuvius volcanic manifestations. One of them was founded by a well-known pioneer of German volcanology Immanuel Friedländer (1871–1948); the construction of the other one was initiated by pope and administered by priest Giovanni Battista Alfano (1875–1955).

The original observatory of 1841, later named Palmieri Observatory, was reconstructed in the last decades and serves today as a historical landmark remembering the early stages of the volcanological research in Italy. There is a small museum with an archive; the building is also used as an attractive place to organize scientific symposia and seminars.

Italy has always belonged one among the most attractive European countries for the visitors from abroad; Vesuvius, together with Rome, Naples, and Venice, ranks to the most favored destinations in Italy. If in the sixteenth to eighteenth centuries Italy was visited predominantly by naturalists and artists, later, in the second half of the nineteenth century, Italy with its attractions became a destination of massive wave of tourists, prosperous people from all Europe and America. Needless to say that in strictly differentiated and separated society, rather strong conventions always ruled the behavior and clothing of affluent visitors. The tourist adventures of the nineteenth century when climbing Vesuvius may be ridiculous to a present-day observer. At the end of this section, devoted to the most famous European volcano, two smile-provoking historical compositions are presented.

Figure 39 focuses on a scene of a family climbing the Vesuvius summit in 1872. The visitors, armed for this occasion with pikestaff-looking sticks, the lady, being clothed in a long evening robe, examine numerous seepages of sulfur gas. What a tranquil atmosphere (!). Figure 40 presents an illustration reproduced from *Le Monde Illustrée weekly* (1871). The picture has a subtitle: "*Visitors and travelers in the region surprised by the eruption in the evening of 25 April. At last at the observatory!*" However, a sudden shower of pumices and sulfur gasses unexpectedly changes the moment of travelers' satisfaction into horror. "...*Where is my umbrella? Elisabeth, darling! Your wide-brimmed Parisian hat smolders!*"

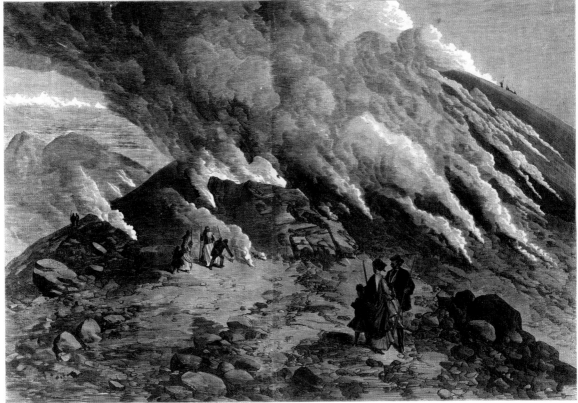

Soptění Vesuvu: Pohled z blízka, nedaleko jícnu.

Fig. 39 Tourist family visiting the rim of the Vesuvius crater. Hand colored xylographic newspaper illustration from the *Světozor, Czech illustrated weekly*, Prague 1872. Private collection, Prague

LE MONDE ILLUSTRÉ

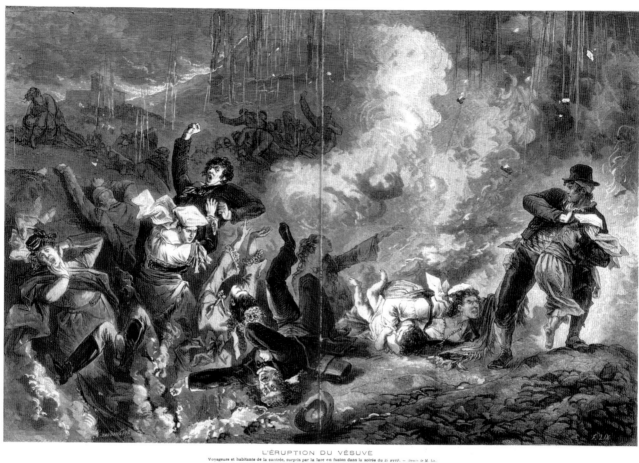

L'ÉRUPTION DU VÉSUVE

Voyageurs et habitants de la contrée, surpris par la lave en fusion dans la soirée du 25 avril. — Dessin de M. Lix.

Fig. 40 Travelers and visitors surprised by a sudden Vesuvius eruption. Double-page newspaper xylographic illustration from *Le Monde Illustré*, 1871, pp. 288-89. Private collection, Prague

Etna Volcano, Sicily

Mount Etna (37°45.3′N, 14°59.7′E), also known as Mongibello in Italian, a combination of Latin "mons" and Arabic "gibel," both meaning "a mountain," is an active stratovolcano on the eastern coast of Sicily, close to towns Messina and Catania. Etna is the largest active volcano in Europe with a base amounting over 2,000 km², currently standing 3,329 m high. However, it should be noted that its exact height may vary with each summit eruption; the mountain in 2009 is 21 m lower than it was in 1981. Etna is not generally regarded as being particularly dangerous; thousands of people live on its slopes.

The pre-Etna mountain, the predecessor of the present volcano, had originally emerged as a submarine volcano at about 300,000 years ago. The volcano alternatively emitted volcanic gases, ashes, powder, and lava, and step-by-step created a number of side craters. The Etna has shaped its present form only during the last 5,000 years, and by its size and elevation became the dominant and the most beautiful volcano in Europe. Figure 41 shows the ground plan of Etna as prepared in the nineteenth century with the distribution of its historical lava flows labeled by the years of eruption; three principle zones can be distinguished: the inhabited zone, the zone predominantly forested, and a waste deserted "nobody's" zone.

Volcanic activities in the region date back about half a million years, with occasional eruptions occurring beneath the sea off the coastline of Sicily. Volcanism gradually moved to the southwest of the present-day volcano summit, and centered at Etna's present position. Eruptions built up the first major volcanic edifice, forming a stratovolcano characterized by alternating explosive and effusive eruptions. The growth of the mountain was occasionally interrupted by major eruptions leading to the collapse of the summit and newly re-formed caldera. During one of them, thousands of years ago, the eastern flank of the mountain experienced a catastrophic collapse, generating an enormous landslide, which caused a huge tsunami evidenced in many places of the Mediterranean. A huge eruption, which can be geologically dated approximately around the year 1600 BC, was one of the five strongest and most destructive volcanic explosions in Europe in the last 10,000 years. Most volcanic activities in the historical time have been well archived; almost 200 major events have been documented. The individual eruptions have been usually preceded by warning volcanic tremors, lava flows were generally viscous and slow, and the casualties were thus not as fatal as one could expect due to the densely populated fertile Etna slopes.

Geological mapping of the urban area of Catania revealed that the area now occupied by the city was considerably covered by lava flows on six occasions during the past 5,000 years: (about) 4500 BC, in 693 BC, in 425 BC, in AD 252 (or 253), in 1381, and finally in 1669. The most voluminous of these flows was that of 4,500 BC, which covered much of the central portion of the present city area, while both the fourteenth century and the 1669 flows essentially stopped not far behind the rim of the city.

The last of these great events, namely the 1669 eruption, which lasted from March 11 to July 15, however, was quite dramatic. The 1669 eruption was actually the climax of Etna activities of the seventeenth century (1614–1624, 1634–1638, 1651–1653), when the volcano ejected up to 1–2 m³ of lava in a second, much more than any time later. After 1669, the Etna activity quickly decreased, only weaker eruptions were reported later, e.g., in 1689 (when four people died under a block of lava when observing the lava advance), in 1693, 1702, 1755, and in 1792. In 1805, a new crater opened in Valle del Leone by a strong explosion and the renewed activity was accompanied by another explosion and ashes eruption. In November 1832, several people perished when the lava flows crossed the snow field on the Etna slope and the steam suddenly exploded. This incident repeated later in November 1843 when a steam explosion killed 59 people observing the lava flow near small town of Bronte. The eruption in 1865 belonged to the most violent after the year 1669; more than 10,000 m³ of lava and pyroclastic material were thrown out (Fig. 42).

Several weeks after the 1865 eruption, an earthquake of magnitude of 4.7 occurred, during which over 70 tourists on the eastern slope of Etna lost their lives near village Macchia. This earthquake, which can be related to the fault crossing of the Malta scarp and of the Messina–Giardini fault in Eastern Sicily, was, by far, not the only one which accompanied Etna eruptions.

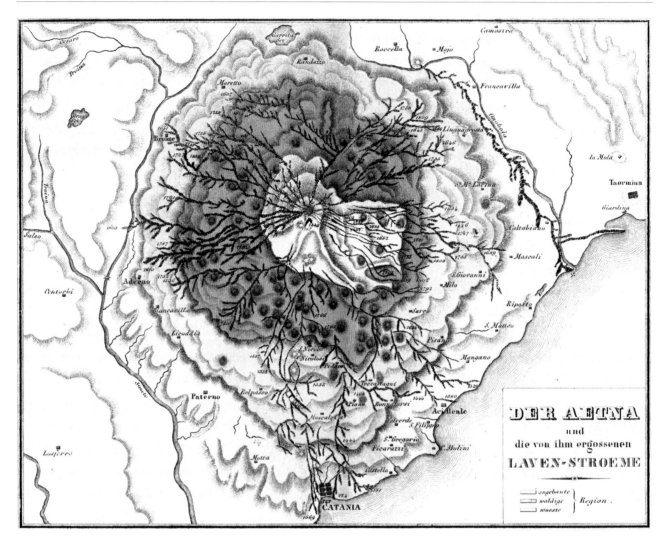

Fig. 41 Ground plan of Etna. Hand colored copper engraving (Leonhard, 1844). Private collection, Prague

The most destructive Etna eruption of the twentieth century ruined the town of Mascali in 1928. This time a 15-m high lava flow moved quickly with a speed of several tens of meters per second. Thanks to an early warning, no victims were reported and people had enough time to save most of their property. Periods of increased volcanic activity followed in years 1949–1951 and 1955–1960 when the eruptions concentrated into the NW crater; in 1966–1971 a new Bocca Nuovo crater was formed. In 1971, lava buried the Etna Observatory, destroyed the first generation of Etna cable-car, and seriously threatened several small villages on Etna's east flank. On September 12, 1979, nine tourists were killed and many more were injured when a sudden burst occurred in Bocca Nuovo. Etna has not been resting even in the first years of the third millennium; several explosive eruptions in 2000–2003 and in 2005 presented convincing evidence. The series of eruptions continued, throwing up a huge column of ashes that could easily be seen from space satellites; ashes fell as far away as on the North African coast, some 600 km south across the Mediterranean Sea. The last event occurred on 4 September, 2007, when Etna violently erupted, ejecting lava up to 400 m into the air.

The position of Catania, a large Italian town at the foot of Mount Etna, always constituted certain threat, when violent outbursts of the volcano desolated large regions in its vicinity from time to time. Let us return to the spectacular 1669 Etna eruption and try to assess to what degree this disaster may have affected the history of the town. In this context an unexpected question emerges: Do historical pictorial documents always present a correct and reliable source of veritable facts?

In the last 1,000 years Catania was heavily destroyed twice; on February 4, 1169, when 15,000 people perished (Baratta 1901) and in 1693 (see below). More often the town was damaged moderately. Heavy damage was mainly related to earthquakes occurring in the coastal segment of the Hyblean foreland, while slighter or moderate harm effects

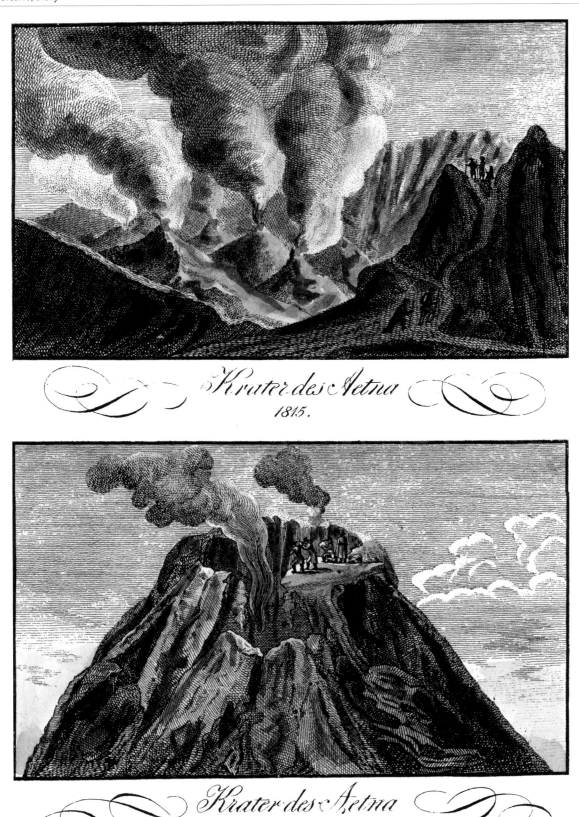

Krater des Aetna
1815.

Krater des Aetna
1788.

Fig. 42 Two views on the main crater of Etna, in 1788 and in 1815. Hand colored engraving published in the mid-19th century. Note the substantial difference between the volcano structures in both illustrations. Private collection, Prague

were usually due to earthquakes taking place in shallow seismogenic zones within the Messina Strait and in the inner Hyblean region.

The 1669 Etna eruption occurred in a crater near the town Nicolosi and generated a voluminous lava flow, which after destroying 15 smaller villages approached the city walls of Catania, about a month after the beginning of the eruption. Initially, the city walls deflected the flow around the southern part of the city into the Ionian Sea, but the failure of one segment of the rampart eventually permitted lava to invade the city. Fortunately, the lava lobes that entered the city were small and poorly fed so that only relatively smaller parts of the town suffered. Furthermore, it was possible to prevent the advance of lava stream by constructing barriers across the main access roads to Catania.

Figure 43 is the illustration created by Athanasius Kircher, which appeared in his book *Mundus Subterraneus* published in 1678, 9 years after the Etna eruption. It gives a general look over the scene; evidently, the illustration is a highly stylized composition, in which the size factor and the principles of correct topographic relations were not respected. Another illustration of the 1669 event is shown in Fig. 44, a color copper engraving taken from an unspecified English scientific book published in London in the mid-eighteenth century. The picture clearly shows a newly created crater, which occurred on the southeastern slope (close to the settlement of Nicolosi). The original figure caption explains: *Redhot volcanic bombs are emitted from the crater and a broad molten lava stream is flowing down the slope.* The lava stream destroyed several villages at the foot of the hill, at the

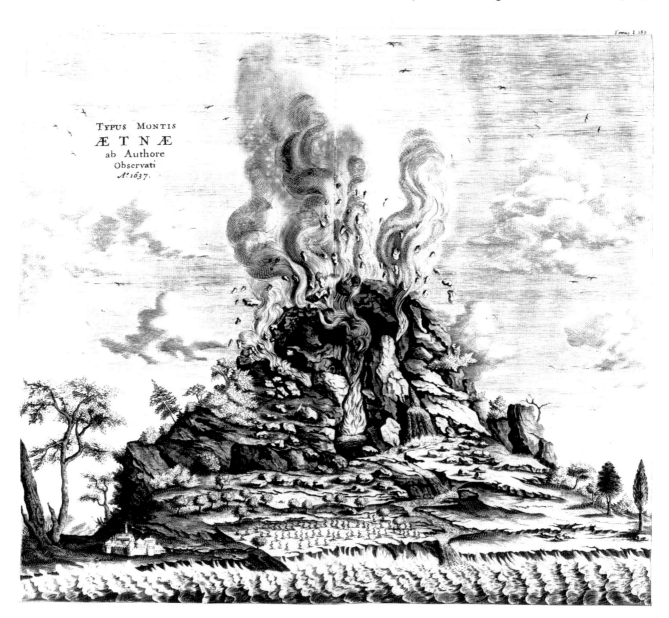

Fig. 43 Eruption of Etna in 1669. Black and white copper engraving illustration reproduced from Kircher (1678). Private collection, Prague

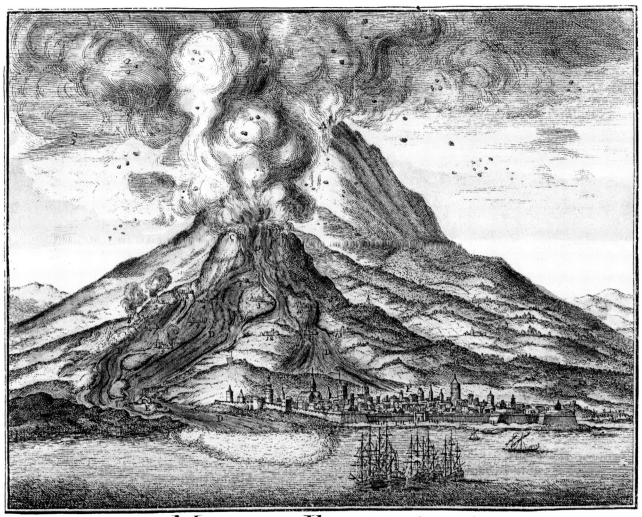

A Profpect of MOUNT ÆTNA, with its Irruption in 1669.

A Top of Ætna. B Irruption. C Two Hills made by the Irruption. D Fiery Currents. E The Arch of Marcellus. F City of Catania.
1 Montpileri. 2 La Guardia. 3 La Annunciata. 4 La Potielli. 5 Malpasso. 6 Campo Rotundo. 7 St Pietro. 8 St Antonino. 9 Mostorbianco.
10 Falicchi. 11 Placchi. These Towns were quite Consumed, no Footsteps of them remaining. 12 St Giovanni de Galermo. 13 Mascalucia
partly ruin'd by the Fiery Inundation._ a. Nicolosi, wholly ruin'd by the Earthquake. b. Padara. c. Tre Castagne, ruin'd in part.

Fig. 44 A remarkable English depiction of the Etna eruption in 1669. Hand colored copper engraving printed in London in mid-18th century. Private collection, Prague

place where the side crater gave birth to two smaller knolls. Lava flow divulged into two parts: one of which reached the sea shore south of Catania, the other one flooded a small part of the unhappy town and set it in fire. The illustration itself was drawn up about 80 years after the event itself, based on older drawings. While the outward form and quality of the illustration well represented a progress, which had been done both in volcanology and in drawing and printing techniques in the second half of the seventeenth and the early eighteenth centuries, the illustration authenticity was obviously lost. The volcano is erroneously located too close to the sea shore

and its elevation was exaggerated. It was also wrongly estimated that thousands of the inhabitants lost their lives.

The misinterpretation of the true number of victims somehow became a repute and the 1669 Etna eruption had been often described in older books as having caused a total destruction of Catania with as many as 20,000 of its inhabitants perished. Such information is totally false. The main lava flow generated by the 1669 eruption did cause certain damages to Catania, but the damage was limited to the western and southern marginal parts of the city; more than three quarters of the town were hardly touched and suffered no harm.

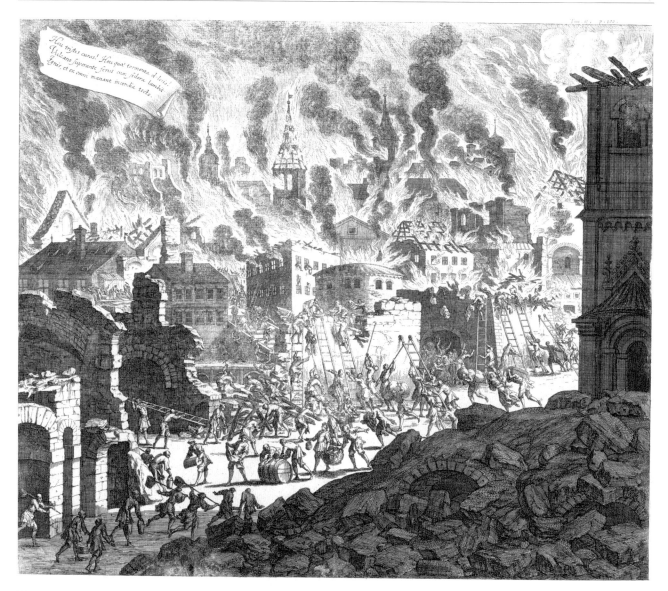

Fig. 45 *"Destruction of Catania in 1669"*. Copper engraving illustrating the encyclopedic book by Zahn (1696). Private collection, Prague

None of the contemporaneous reports of the 1669 event mentioned any fatalities, which would have been certainly mentioned if some people were killed by the eruption.

The total destruction of Catania (and many other towns in southeastern Sicily) together with the death of about 16,000 people, an equivalent of two thirds of Catania's population at that time, however, tallied with an almost coincident devastating earthquake. A strong earthquake of intensity $I_o = $ IX struck the region in 1693; this event is known as Monti Iblei (or Val di Noto) earthquake. This earthquake was of tectonic origin and occurred 24 years after the 1669 Etna eruptive activity. Most probably, in some later German depictions of the seventeenth to eighteenth century, both the seismic and volcanic disasters were mixed together; see, for example, the prospect created by J. Zahn (Fig. 45). This composition illus-

trates drastic scenes of a collapsing town seized by fires; the city inhabitants, who survived the first series of seismic shocks were desperately running away to save their lives in a half-ruined town flooded by molten lava. The back part of the town with imposing churches and magnificent palaces was drawn as completely set on by fire; the front part of the picture showed the debris of the building destroyed by an earthquake. In the centre we can see the feverish pace of local inhabitants to save their lives and the most valuable property. The upper part of the town, close to the northern ramparts over which, allegedly, an avalanche of molten lava broke in, was engulfed by flames; those who imprudently searched their safety in the upper floors were condemned to die. It is of interest to mention that there were some rescuing activities. The rescuers made use of the ladders enabling

access to the inner parts of the endangered edifices from out-side, from the streets; they tried to save the inhabitants imprisoned in buildings. We may anticipate that according to painter's assessments these houses were already statically impaired so that the rescuers did not undergo the risk to enter the houses from the inner house staircases.

Unfortunately, the impressive, large composition adorning Zahn's (1696) encyclopedia seems to be confused by combin-ing the effects of the 1669 Catania volcanic disaster and the 1693 Monti Iblei earthquake in one illustration. On the other hand, Zahn's illustrations have been always highly appreci-ated by both, naturalists as well as old-print collectors, not only for their high artistic expression, but also for their seem-ing authenticity derived from the presumable exactness of the scene presentation. No doubt, the above-mentioned Zahn's drawing was really a professional master piece and its impres-sion on a transalpine reader, who never got in contact with a real volcanic or seismic nature catastrophe, had to be fasci-nated. Zahn's involuntary allegation that during the 1669 disaster allegedly tens of thousands of people perished due to earthquake and fire led to the misunderstanding and overesti-mation of the toll of Etna eruption. The discussed composi-tion was often copied in later works in the eighteenth century, in which the authors discussed seismicity and volcanic activi-ties in the Mediterranean.

Today we know that the degree of volcanic damage to Catania in 1669 was rather negligible in both, the lava vol-ume and its advancement to the town. Lava flows were slow enough and people could easily escape. Other way round, the reported earthquake toll in Catania, namely 16,000 victims and another thousands of wounded or homeless evidently related not to Etna 1669 eruption, but to the 1693 Monti Iblei (Val di Noto), Eastern Sicily earth-quake (Baratta 1901).

Sicilian earthquakes of tectonic origin have their source in the collision zone between the Eurasian and African tectonic plates (which move each other), in the critically stressed seg-ment where this collision zone turns of W–E direction toward the north. A volcanic earthquake, which possibly accompa-nied the Etna 1669 eruption, was certainly a weak seismic event, which affected only the nearest vicinity of the active side-crater of Etna.

Stromboli (38°47'N, 15°13'E, 926 m high) is a permanently active stratovolcano located on a small island of the same name in the Lipari Archipelago, which belongs to the Aeolian volcanic arc. The name Stromboli is a corruption of the ancient Greek name *strombos* (=cone) given to it because of its round swelling form. The topographic configuration of the Lipari Islands can be introduced by a more than 160-year-old map (Fig. 46) reproduced from "*Vulkan Atlas*" (Leonhard 1844), the publication of which summarized fundamental elements of islands' geology.

Stromboli volcano stands up nearly 1,000 m above the sea level, but actually rises more than 2,000 m above the sea floor.

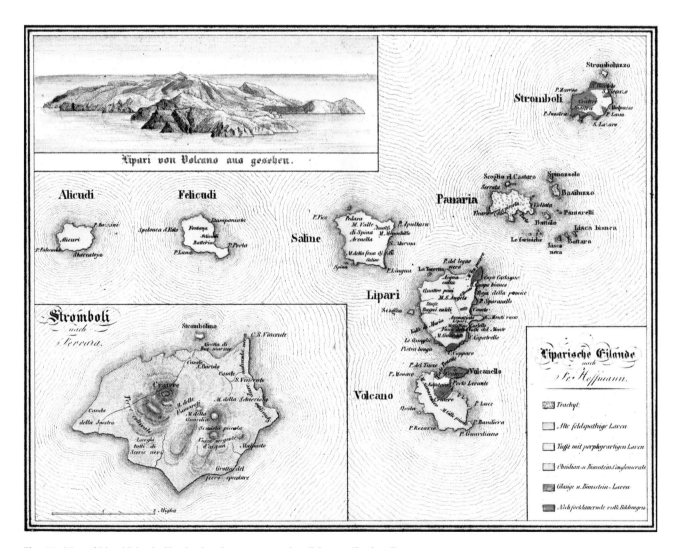

Fig. 46 Map of Lipari Islands. Hand colored copper engraving. Private collection, Prague

There are three craters at the volcano peak. A significant geological feature of the volcano is the Sciara del Fuoco ("Stream of fire"), a big, horse shoe-shaped depression generated in the course of the last 13,000 years by several collapses on the northwestern side of the cone.

The volcano is characterized by its specific course of eruptive activities; for the last 2,000 years of written-record evidence, the same eruption pattern has been always observed. It consists of volcanic explosions, which occur at the summit craters with mild to moderate eruptions, emitting ashes, incandescent volcanic bombs, and lava up to a height of few hundred meters at the time intervals ranging from minutes to hours. Regardless of the fact that Sromboli's activity is almost exclusively explosive, lava flows occur occasionally. In front of the mountain, solidified lava has formed down stretching tongues reaching up to the seawater level. This characteristic course of eruptions was observed at some other volcanoes worldwide; volcanic activity of this type is often referred to as a strombolian eruption.

Mild explosive eruptions of Stromboli are occasionally punctuated by stronger eruptions. In 1919, for example, four people were killed and 12 houses were destroyed by falling stony blocks, some of which weighted 60t. The largest eruption of the last 100 years occurred in 1930 and caused death of several local inhabitants and destruction of number of houses by pumices. In 1986, a biologist was killed by stony blocks catapulted from the volcano crater during his observations. These large eruptions occur at intervals of years to decades;

the most recent large eruption began in 2002, which enforced the local administration to close the island to nonresidents for several months. The eruption started with a lava flow along the Sciara del Fuoco flank, which rapidly reached the sea. A huge volume of rocks collapsed from the Sciara, generating at least two landslides and tsunami waves; the highest wave reached 10 m and caused serious damage to Stromboli village. The rocks ejected from the summit crater, reached Ginostra village, and damaged some houses there on April 5, 2003. On February 7, 2007, two new craters opened on the island with lava flowing into the sea. A gripping narrative was published by Tazieff (1951), who described his adventures when examining slopes and craters of erupting Stromboli.

Figure 47 is a reproduction taken from the famous book by Hamilton (1776). It is 1 of 50 beautiful image compositions of the book, which were illustrated by Peter Fabris, the painter especially engaged to do this job, in the years 1773–1776. The reproduced depiction may present either one of the own Fabris' drawings or a copy of an earlier composition referring to previous Stromboli eruptions. Regardless who was the author of the first model depiction, the image represents a very likeable and sweet-tempered illustration. Viewed over a quiet sea level, only gently caressed by a breeze, the apparently "blameless" volcano in the background was ready to play its volcanic wonders. A romantic atmosphere of the scene was emphasized by several ships sailing about. On the right, we can localize two side craters (on the other drawings of this scene, several buildings destroyed by fire were depicted

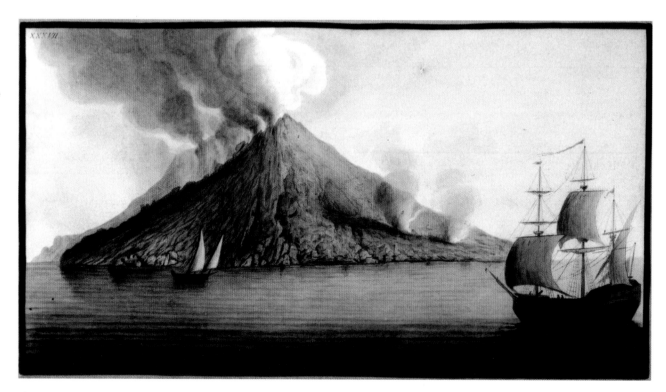

Fig. 47 The Stromboli volcano during its mild eruption. Private collection, Prague

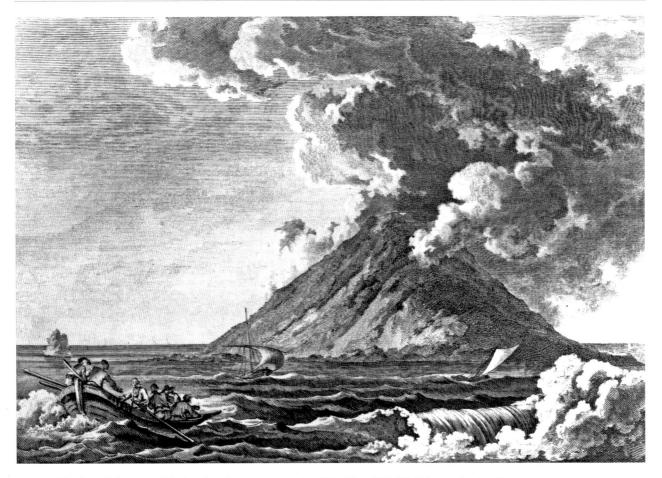

Fig. 48 The Stromboli volcano. Black-and-white copper engraving (Saint-Non, 1781-86). Private collection, Prague

just near this location). On the left, great part of volcano cone was covered by down-flowing lava, and huge flames engulfed the summit. In front of the mountain, the livid solidified lava formed down stretching tongues reaching the sea level.

Increased volcanic and tectonic activities in the Central Mediterranean Sea, which occurred in the second half of the eighteenth century, inspired a number of European naturalists to study these extreme natural manifestations. Except the above-mentioned volcanic events in the south Tyrrhenian Sea and eruptions of Vesuvius and Etna, also seismic activities in the region, such as a long series of disastrous Calabrian earthquakes (30,000–35,000 casualties) in 1783–1794 excited European naturalists and stimulated them to detailed volcanic and seismic studies.

Finally, let us look at the second portrayal of the Stromboli Island presented in Fig. 48, which is a sizeable copper engraving taken from the book *Voyage Pittoresque à Naples et en Sicile* by French painter and engraver Jean Claude Richard de Saint-Non (1781–1786). During his several-year-long visit to south Italy, the author drew a number of model depictions for the copper-engraving illustrations of his book. The final work presented fully informative and true views on

the volcanoes of the Lipari Islands, Sicily and central Italy; these illustrations belong to the works of extraordinary high artist impression. Chatelet is mentioned as the author of the reproduced image, and engraving was executed by Laenar.

The above image presents the side view on the volcano, in a "quiet" atmosphere, with heavy smoke rising from the crater, but without any explosions or lava eruptions. The undoubted concept affinity with the previous illustration calls out an impression that the artist was inspired by the Fabris' work. This impression is further confirmed by the presence of the vessels on the sea as well as by the scenery of sea waves contributing to a general romantic presentation.

In general, the volcanic activities of the Lipari (Aeolian) Islands, Etna, and Vesuvius are closely related to the plate collision of the African and Eurasian tectonic plates, which occurs from west along the northern coast of Africa to Tunisia and further through the Mediterranean Sea across Sicily, toward Asia Minor. The deep structure of the collision zone north of Sicily, that is, just below the location of the Lipari Islands, is still the subject of scientific discussions. There are several indications that the Peninsula of Apennines, Adriatic Sea, Dalmatia, western coast of Greece and the Peloponnesus

geologically belong to the African tectonic plate. It can be also considered that the named regions create a smaller microplate, which has been moving in between the African and Eurasian plates. Intensive volcanic and seismic activities occurring frequently there can be understood as direct consequences of this motion in a broader region of south Italy and in the Sea of Crete. Also many strong earthquakes in southern Europe and namely those in Italy and Greece have occurred here due to deep tectonic processes in the lithosphere.

Seen from this angle the exposed region of the Central Mediterranean Sea between Sicily, Calabria, and the Lipari Islands seems to play a key role of complex geophysical "polygon" in a zone, where mighty tectonic, volcanic, and seismic forces meet together. Simply, a paradise for geoscientists.

Phleghraean Fields

Phlegraean Fields (in Italian Campi Flegrei) is a large territory, which includes a 13 km wide and 458 m high caldera, located west of Naples, Italy. Today, most of the area lies underwater. The Fields include the town of Pozzuoli and the Solfatara crater, mythological home of Vulcan, Roman god of fire. It is believed that the giant caldera was created by two major events. The first of them allegedly occurred about 40,000 years ago, erupting about 200 km^3 of magma and created the Campanian ignimbrite complex. Approximately, 12,000 years ago, another major eruption occurred, which created a smaller caldera inside the main one, centered near the town of Pozzuoli (Ciancio 2005).

The Phleghraean Fields belong to the most interesting wonders of central Italy. Together with Vesuvius, the newly born volcano Monte Nuovo, which sprung up only in 1538, enormous sea-level variations were observed near the town of Pozzuoli at the Serapio Temple columns, and many other postvolcanic manifestations. Phlegraean Fields always attracted visitors from all over the world. And, tourists of these days are equally enchanted as were admirers centuries ago.

The map (Fig. 49), a black and white copper engraving, is focused especially on the illustration of the relics of volcanic manifestations in the region. There are 13 important events described in the map, which are all related to the local volcanic activities. The three wide calderas within the reported region include the largest Monte Barbaro on the north and the two smaller calderas on the northeast, the smaller La Solfatara and the larger Astruni. A small crater of a new volcano (Monte Nuovo), located at the coast to the southwest from Monte Barbaro caldera, was born in 1538. There are several more or less recognizable signs of extinct volcanoes at places of round-shape lakes. Their origin had a close relation with the later flooding of the bottom of the old craters of inactive volcanoes. Similarly, the entire northwestern shape of the Bay of Pozzuoli clearly indicates the longtime existence of the submarine volcanoes and their eruptions.

A huge natural theatre of Forum Vulcani (Fig. 50), i.e., part of which nowadays occurs above the sea level, is easily accessible from Pozzuoli on foot. It incorporates a large number of fumaroles, still issuing steam, and several thermal pools of boiling mud. Smaller subsidiary cones and tuff craters can be found within the caldera. In the direction of Solfatara, another historical caldera is filled by water and forms the Lago d'Averno (the Averno Lake).

Although, today, this area, in comparison to its abundant historical manifestations, may seem to be less active, the entire region is situated in a tectonically complex zone, which definitely has not been stabilized yet. Several smaller earthquakes have occurred inside and around the major caldera. The nearby Ischia island was affected twice by strong earthquakes, in 1881 and 1883 (see Figs. 106 and 107). There are other volcanic cones not far from here, namely, St. Elmo, Chiaia, and Monte Echia, all witnesses of past volcanic activities.

Agnano is a volcanic crater located around 8 km northwest of Naples, which is also in the Campi Flegrei region. This place was famous among both Greeks and Romans, especially for its hot springs. Lake Agnano was a circular lake, approximately 6.5 km in circumference, which originally occupied the crater, but it was drained in 1870. On its southern bank, we can find Stufe di San Germano, a natural sulfur vapor bath; not far away is the famous Grotta del Cane. From the floor of this cave, warm carbonic acid gas constantly emanates, and due to its higher density, it keeps not more than about 0.5 m at the ground level. This place had been actually mentioned by Pliny the Elder in his "*Naturalis Historia*". There, also the patron of Pozzuoli, Saint Proculus, and the patron of Naples, Saint Januarius, underwent their martyrdom in AD 305.

Monte Nuovo is a cinder cone volcano within the Campi Flegrei region, west of Pozzuoli; on September 28, 1538, an eruption took place there, which built the cone of a "new mountain" in less than a week. The eruption was preceded by a decade-lasting period of a steady uplift. The beginning of this process is not precisely known, but the emergence of a piece of new land from places formerly occupied by sea was first reported in 1502. This activity was later accompanied by seismic tremblements, which intensified especially after 1534 and increased dramatically during September 1538. On September 28, about 20 tremors were felt between daybreak and nightfall.

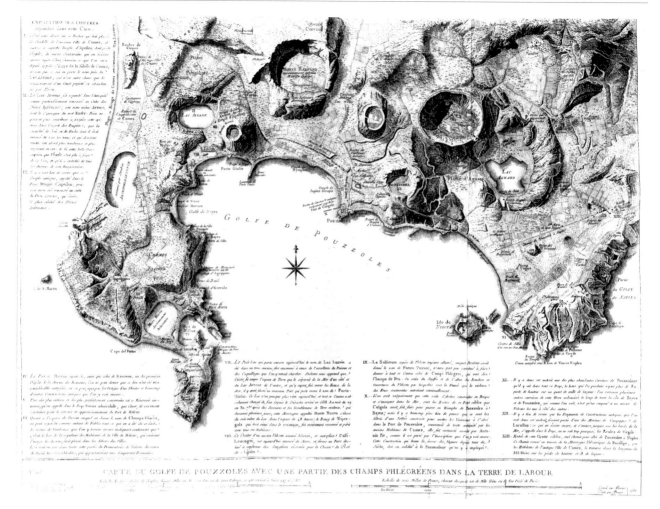

Fig. 49 Map of Pozzuoli Bay showing the principal part of Campi Flegrei. Verbal commentary related to the selected volcanic and other natural phenomena is engraved at the map bottom. The map was created by Droüet and Perrier and was published in the work by Saint-Non (1781-86). Private collection, Prague

Meanwhile, other dramatic events were taking place in the Monte Nuovo vicinity. In the coastal area, a remarkable rapid uplift of the ground was observed upheaving the ground by about 7 m and displacing the sea coast by hundreds of meters. On the evening of September 29, a crack opened in the area of the maximum uplift, near the ancient Roman settlement of Tripergole. According to the contemporary sources, a newly opened vent emitted vast amounts of pumice, fire, and black and white "smoke". Most of the ejecta fell as muddy ashes, indicating that water had played a significant role in the initial stages of the eruption. Eruptive style rapidly alternated, magma–water interactions varied. The magma flows were relatively cool and the surges did not flow beyond a few hundred meters from the vent. When an inlet several hundred meters to the west opened, the surges obviously did not cause large waves; an ancient temple standing on the shore was not affected by any wave damage. A vigorous activity of this kind occurred

during the first day of the eruption, followed by 2 days of decaying activity. The fine ashes ejected during the initial eruption fell over a wide area southward as far as in Apulia and Calabria; larger fragments reached even the Vesuvius region.

The illustration in Fig. 51 gives a contemporary expression of the Monte Nuovo birth. Pietro Giacomo da Toledo (1539) described this event (cit.): "*the earth opened and under an ear-deafening ramble and thunder the fire, smoke and boulders were shot out from the yawn opening, later glowing volcanic bombs as big as ox size.*" The pre-eruption large uplift was remembered on the picture by showing an argosy, originally harboring in Termini del Mare, helplessly left aground on the uplifted slope of a new volcano. After the eruption, the terrain subsided back by about 4 m (Falconi 1539).

That time and even later the scholars from all over Europe paid a special attention to the unusual event of the

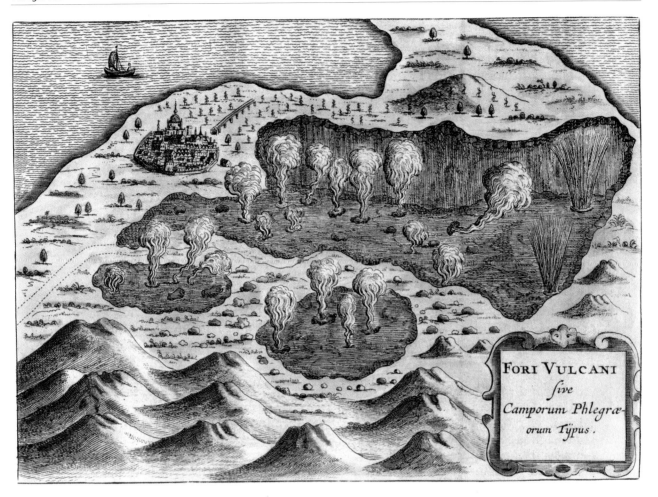

C A P U T V.

De Specu Charonio, *vulgo* la Grotta de Cani, *sito ad* Lacum Agnanum, *non procul* Neapoli, & de Lethæa vi & *proprietate qua introëuntes suffocatos interimat.*

Fig. 50 *"Forum Vulcani"*. Hand colored copper engraving reproduced from Kircher (1678). Private collection, Prague

birth of Monte Nuovo. Many of them argued that all continents, islands, and mountains had their origin in the uplift or eruption of the molten rock material brought from the earth's interior to the surface. Here we can mention, e.g., Anton-Lazzaro Mora (1687–1740), who ascribed this mechanism not only to the origin of mountain belts, but also to the origin of individual geological formations and strata. We can recognize the beginning of the adorning plutonic concept, which at the turn of the eighteenth and nineteenth centuries led into the conflict between Plutonists and Neptunists, who – on the contrary – believed that all rocks had settled out of a large world ocean, the water level of which gradually dropped over time.

Figure 52 is a sizeable copper engraving of Forum Vulcani, an "open space" (forum), in close proximity to the Pozzuoli town, which we could today better describe as a caldera, i.e., the flat bottom of an extinct volcano. This region is characterized by pronounced volcanic and seismic phenomena. The other name of this area "Solfatara" (i.e., Sulpha Terra means sulfur ground) relates to rich deposits of this substance in the crater. Sulfur was collected there from the surface deposits since the fifteenth century.

The composition of the image was reproduced from the ample sixfold atlas of European towns, which was compiled and published in Amsterdam by the famous Dutch cartographer and publisher Johann Jansson (1657). His view must

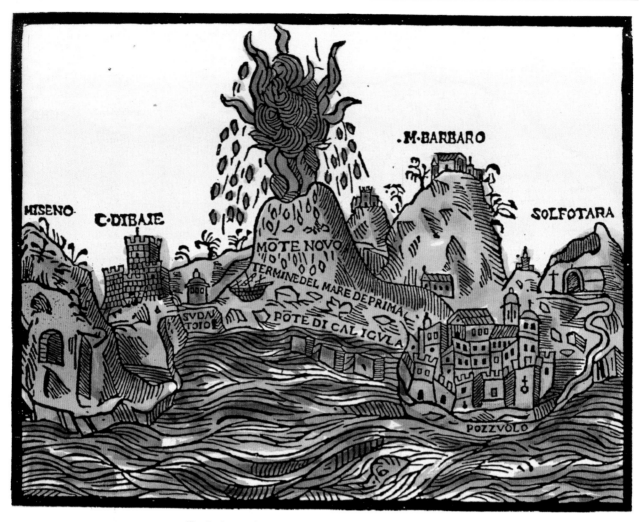

Entstehung des Monte Nuovo im Jahre 1538

Nach „Dell' incendio di Pozzuole, Marco Antonio delli Falconi all' Illustrissima Marchesa della Padulla" vom Jahre 1538

Fig. 51 "*Birth of Monte Nuovo volcano near Pozzuoli in September 1538*". Hand colored woodcut from Toledo (1539). Copy in private collection, Prague

have been inspired by very similar richly Renaissance-decorated earlier artworks by Braun and Hogengerg (1572–1617) published in the third volume of their voluminous work entitled "*Civitates Orbis Terrarum*". Jansson's composition, compared with the older works, was quite "modern"; instead of the older-fashion ornamentation, the artist better concentrated on the depiction of the natural situation with all noteworthy details, such as correctly expressed columns of steam and smoke rising from the bottom and side walls of the caldera.

Small unsigned copper engraving in Fig. 53 introduces the famous cave Grotta del Cane. This older model illustration was later copied by J. C. de Saint-None, who described notable natural events in his book linked with the Lake of Agnano and the Dog cave, a very popular locality of that time, to dem-

onstrate the CO_2 effects on alive animals. Saint-None wrote (quot.): "*poisonous gases accumulate in the grotta up to height of about ten inches and kill all living creatures which found themselves in this layer. I had experienced with my dog, which I brought in the cave and put on all four legs. First, the dog behave as other animals with troublesome respiration, its breathing problems deteriorated, goggled its eye, protruded the tongue ... and finally stiffened. The dog was immediately carried out from the cave on a fresh air, and in minutes it recovered, behaved normally with no signs of problem it had just lived through.*" (Saint-Non, 1781–1786, translation by Krafft, 1993). We can only hope that nobody would test the deadly effect of poisonous gases by a similar experiment today. However, in the past centuries this was a certain curiosity worth not only to report but even to illustrate.

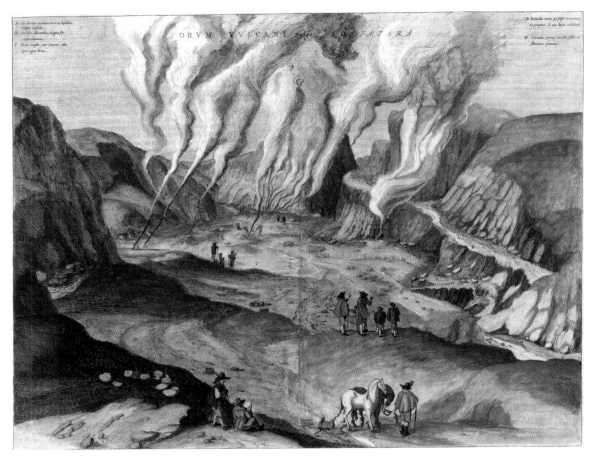

Fig. 52 "*Forum Vulcani or Solfatara by Pozzuoli*". Hand colored folio-sized copper engraving from the fifth volume of the Atlas of the towns of the world by Jansson (1657). Private collection, Prague

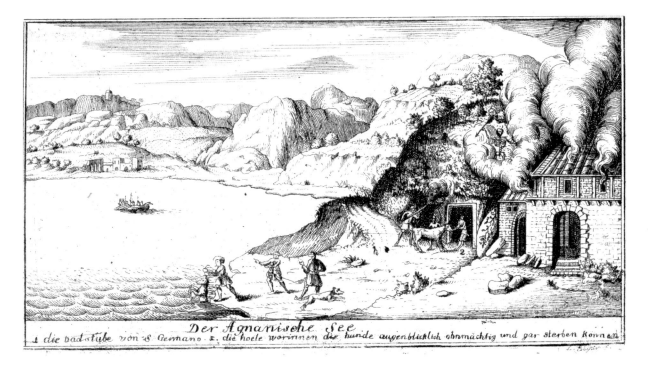

Fig. 53 "*Lake of Agnano and the Dog cave*". Copper engraving of German origin of the late 17th century. Private collection, Prague

Santorin/Thira Volcano, Greece

Santorin (Thira or also Thera in Greek) is a volcanic island (36°24′N, 25°24′E), actually a group of islands, in the Sea of Crete, belonging to the Cyclades Archipelago. The group consists of one large island (Thira) and five smaller islands (Thirassia, Aspronisi, Paleokameni, Neokameni, and Microkameni). Santorin, with the highest point of 566 m above sea level, presents the top of a large undersea volcano. The list of recorded volcanic activities confirms numerous large eruptions in prehistoric times, e.g., a gigantic explosion in 1650 BC and a number of smaller eruptions, e.g., in AD 1707–1710, 1866–1870 (the most famous eruptions), 1940–1941, and 1950.

The Santorin group, located some 130 km north of Crete makes a complex of several overlapping shield volcanoes. Numerous basalt and andesite lava flows are nowadays exposed as rocky cliffs forming the inner caldera wall. There is an evidence of many large explosive eruptions that occurred there in the last 200,000 years. The island's present structure was formed by a huge eruption 21,000 year ago. Today, the islands, together with several rock cliffs scattered in the sea around, form a residual part of the submerged caldera of about 20 km in diameter belonging to a giant submarine volcano (Fig. 54).

Santorin islands create a part of an oval rim of several other volcanic islands framing the northern border of the Sea of Crete. The volcanic arc was created as a consequence of the subduction of the African tectonic plate beneath the Eurasian plate and its partial melting at the depth, where local magma chambers developed. The whole region is a subject of enormous strain, and in addition to the volcanic activity in the Cyclades Island Arc, this strain is manifested by frequent strong earthquakes.

The gigantic eruption of Santorin in 1650 BC ejected about 30 km³ (!) of geological material together with a fiery column, which reached the height of 36 km. The launch of such a large volume of magma caused the volcano to collapse down and to create an enormous caldera. Volcanic ashes fell as far as in the Eastern Mediterranean and Turkey. The eruption further initiated tsunami waves, supposedly 30 m high, which completely smashed down the northern shore of Crete and devastated numerous settlements along the whole East Mediterranean shoreline. The island itself was completely destroyed, its original appearance is thus unknown (Krafft 1993).

This giant eruption drastically hit the Minoan civilization on the island of Crete. There are several myths, which relate this catastrophe to the legend of the fall of the mysterious Atlantis. This story was mentioned by the Greek philosopher Plato in his works. However, other locations of legendary Atlantis, possibly located all over the Mediterranean (and even outside), were mentioned in this context. Akroteri, a Minoan city, has been excavated on the southern coast of Thira (the largest Santorin island). About 2 m of ashes fell on the city, which at that time was populated by some 30,000 inhabitants. The residents were probably successfully evacuated prior to the eruption: no bodies have been found in the ashy sediments, in contrast to Pompeii.

The subsurface unrest continued during the past millennia and from time to time, the volcanic activity stroked Santorin repeatedly. Two Kameni islets were formed inside the caldera in the seventeenth century. In total, 11 eruptions occurred since 197 BC, with the most recent eruption in 1950 on Neo Kameni, the northern inner small island. The eruption was phreatic and lasted almost a month.

A lithographic illustration (Fig. 55) shows the Santorin eruption in 1866; the illustration is taken from the book by Viennese geologist Ferdinand von Hochstätter (1873). The fact that the Santorin eruption appeared among the 16 most famous geological events of that time, discussed in Hochstätter's "Geological Atlas", reflected a general interest in the renewed Santorin eruption. The illustration offers rather a quiet scenery, no doubt corresponding to the later and safer period after the main eruption, when the first observers already ventured to visit the Neo Kameni Island and approached the still active volcano. One can easily recognize volcanic bombs, deposits of volcanic ashes, and volcanic smoke ejected from the volcano crater.

Complex studies on Santorin 1867–1870 eruption performed by J. F.J. Schmidt, A. Fouqué and others are highly valued even at present, since they put volcanology forward as a science, especially that which concerns the chemistry

J. Kozák and V. Čermák, *The Illustrated History of Natural Disasters*,
© Springer Science+Business Media B.V. 2010

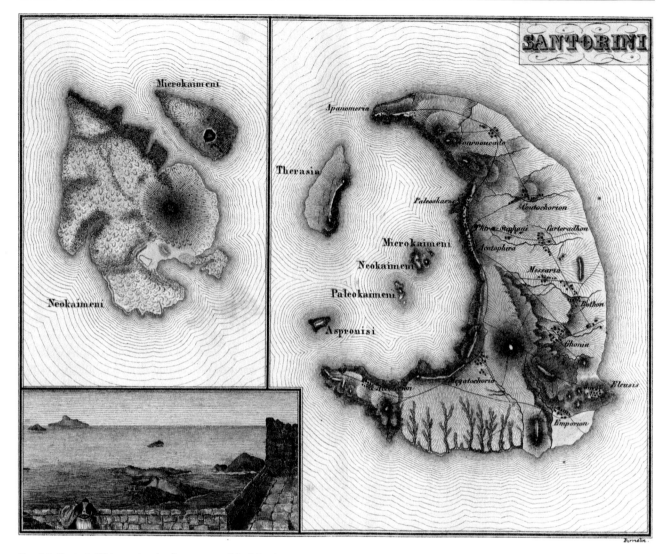

Fig. 54 Santorin/Thira, a sketch of two maps of the island group with a detailed map of Nea Kameni and Micro Kameni erupted islets, complemented by a small side-view picture. Reproduced from "*Atlas*" by Leonhard (1844). Hand colored copper engraving shows the situation 23-years prior to famous eruption activities of 1866–70. Private collection, Prague

of the volcanic processes and the analyses of the chemical composition of the volcanic gases and vapors including the interpretation of the results attained.

Figure 56 is an illustration reproduced from the book by Schmidt (1881). The author depicted the variety of erupted volcanic gases and ashy products. Such illustration may be of interest for volcanologists, as it clearly presents a complex arrangement of the outlet channels of gaseous and solid components, as well as their different appearance. The author actually used five different colors to accent this variety, namely, white, light gray, dark grey, black, and red.

It was French mineralogist André Fouqué (1828–1904), who was delegated to the island immediately after the first volcanic event had appeared to organize direct observations and in situ measurements, and who analyzed the volcanic gases emanated during the whole 1867–1870 Sanorin eruption event. His research on the artificial reproduction of eruptive rocks and his treatise on the optical characters of feldspars deserve special mention (Fouqué 1879).

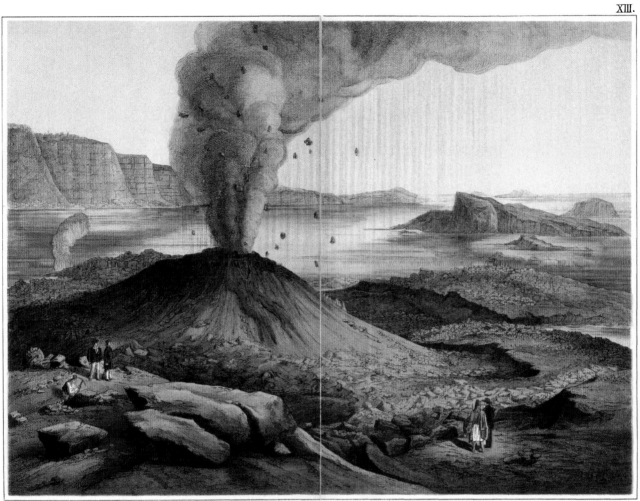

Santorin im griechischen Archipel während des Ausbruches des Georgs-Vulkanes im Jahre 1866.

Fig. 55 Nea Kameni eruption in 1867 as depicted by Hochstaetter (1873). The image shows the situation during one of the final, fading phases of the eruption process, when Volcano George on Nea Kameni Island was already accessible. Private collection, Prague

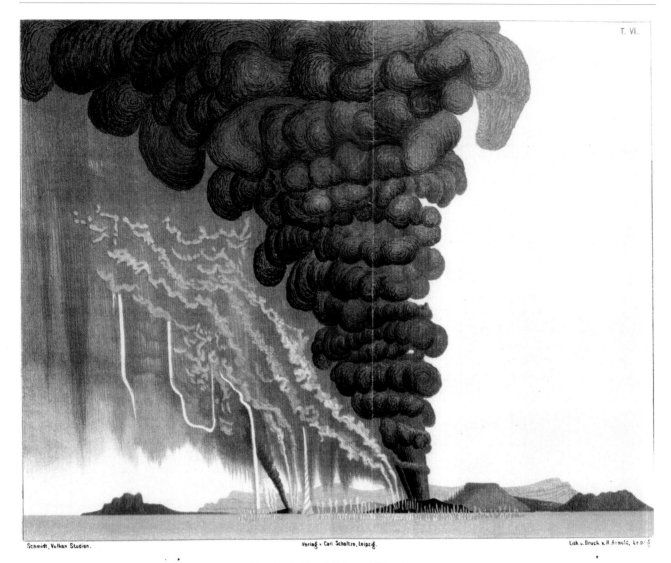

T. VI.

Schmidt, Vulkan Studien. Verlag v. Carl Scholtze, Leipzig. Lith.u.Druck v.H.Arnold, Leipzig.

Eruption des Georg-Vulkanes 1866 Febr. 22.

Fig. 56 The Santorin Island. Emanation of volcanic gases at Neo Kameni during the eruption activities in 1866-67 (Schmidt, 1881). Private collection, Prague

Ferdinandea, a New Submarine Volcano

Ferdinandea is a submerged volcanic island that formed a part of the large underwater volcano named Empedocles (37°10 N, 12°43 E), 30 km southwest of Sicily. In mid-July 1831, a new volcanic island emerged above the sea level in the shelf sea between Sicily and Tunisia. From its crater molted lava, volcanic gases and pumices were ejected. During the next few weeks, new volcano island had grown to its size of about $400 \times 250 \, m^2$ (=0.1 km^2). The maximum volcano height approached to 60 m. The unexpected appearance entailed to an intricate international incident over the sovereignty of this new piece of land. The dispute, however, became unresolved since the island disappeared beneath the ocean waves in December the same year.

Curiously enough, no matter how unusual phenomenon the birth of a new volcano was, European politicians were the first, who – before naturalists – displayed a great interest in the matter. The representatives of the superpowers of that time, namely Great Britain, France, and Italian Kingdom of Naples and Sicily, tried to claim their positions in this strategic part of the Mediterranean Sea. It was expected that the new volcanic activities might possibly result in the creation of a chain of volcanic islands between Sicily and Tunisia (or even a compact-ground isthmus there) what could fundamentally change the geo-political situation in the Mediterranean.

Ferdinand II, king of Naples and Sicily, dispatched promptly his warship Etna to the new island and claimed it as part of Sicily, arguing that it emerged in Sicily territorial waters. In between, the officers of the British Royal Navy landed on the "still-warm" volcano, hoisted the Union Jack on its summit and proclaimed the island "the territory of Her Majesty." Also France acted promptly, French Academy of Sciences delegated father-founder of French Geological Society, Constant Prévost, to visit and explore the island at his earliest convenience and – at this opportunity – to pull up French flag in the island as a symbol of French sovereignty (Prévost 1835).

It follows that as soon as the island cooled down, and enabled access to men, all three flags fluttered on the top of the island named Ferdinandea by Italians, Julia by French, and Graham by British. None of the three pretenders was prepared to make a concession, all three powers prepared their war fleets and a power confrontation seemed to be inevitable. Historical sources do not give us any information whether the English and French Navies really left their home ports in order to meet in a decisive navy confrontation. Luckily, the island sank back into sea and the campaign disappeared as a burst of a soap bubble.

Actually, the island emerged once more in May 1833 for a short period of few days; afterwards, however, it has rested under the sea level up to the present days creating a shelf field named by Italians, Banco Nerita (Black Bank). Its original depth, few meters only, gradually increased in the course of the twentieth century.

The unusual and sensational temporary occurrence of Ferdinandea and especially the following attempts to usurp the ownership over the island were reflected in numerous images presenting the Island, often decorated by one of the rivals' banner (Krafft 1993).

Figure 57 is a hand-colored copper engraving (work of Rieder) taken from the latest editions of popular pictorial atlas for youths edited by F. Bertuch (1791&). Regardless that the illustration does not reflect true topography of the island, it convincingly introduces the volcanic scenery of several small lava streams and smoke and fire coming from the top crater at the last stage of its eruption.

Figure 58 is a raw image, a segment of a large plate summarizing portrayals of the recent wonders of the nature, taken from the Austrian folk calendar for the year 1845. The image entitled *Neuentstandene Vulkan-Inseln bei Sicilien* (newly risen volcanic islands by Sicily) is of a rather illustrative, generally poor quality, and shows, wrongly, three islands except one. Such a composition demonstrated a rapid fall of the report-image quality with the increasing geographical distance from the place of the event; however, it also demonstrated the fact that even in distant places, the population wished to be informed about the world news, on the other hand.

In the light of modern plate tectonic theory, the Ferdinandea occurrence, first described by an eyewitness (Hoffmann

J. Kozák and V. Čermák, *The Illustrated History of Natural Disasters*,
© Springer Science+Business Media B.V. 2010

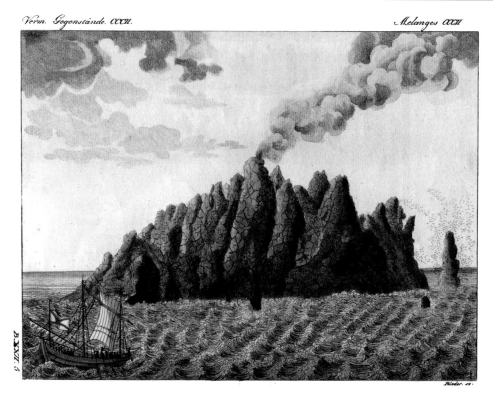

Fig. 57 Ferdinandea. Hand colored copper engraving of Austrian provenience. Private collection, Prague

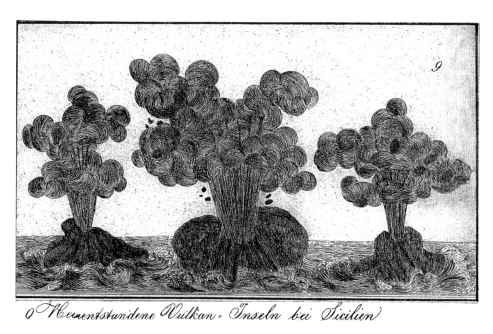

Fig. 58 *"Three islands – newly risen volcanoes by Sicily"*. Copper engraving, Private collection, Prague

1939), may be understood as a short and innocent "play" of two large world tectonic plates, Eurasian and African, during their mutual movements and interactions in the Earth's crust. Small irregularities, which occur along the zone of their collision, may temporarily open the communication channel(s) through which molten lava reach the Earth's surface. As a result, the whole region of Sicily, southern Calabria, and part of the Tyrrhenian Sea are permanently scared by strong seismic and volcanic activities (Bylandt 1836; Parotto and Pratullon 1981).

Volcanism in Iceland

Iceland has a high concentration of active volcanoes due to its unique geological origin. There are about 130 mountains of volcanic origin, 18 of which have erupted since the colonization and the first settlements on the island at the end of the nineth century. Over the past 500 years, Iceland's volcanoes have ejected about one third of the total global lava output. Although the Laki volcano eruption in 1783 was classified as the largest eruption of lava since the island's colonization, the prior Eldgjá volcano eruption in AD 934 and other Holocene eruptions are now considered as much larger.

Among other active volcanoes in Iceland, Hekla volcano (63°59′N; 19°38′W), an active 1,491-m high stratovolcano located in the south of the country always played a dominant role in the island due to its extremely high volcanic activity. Being shaped as a boat turned upside down, it creates a prolonged 6 × 12 km large top plateau, covered by numerous craters; it is assessed that during the last millennium Hekla emitted some 8 km³ of lava and another cubic kilometer of pyroclastic materials. Over 20 eruptions have occurred in and around the volcano since the year 874. During the Middle Ages, Icelanders called Hekla "A gateway to hell" (Fig. 59). Chemically, the lava released from Hekla is a basalt-type low-silica lava associated with effusive volcanism, like the volcanoes in the Hawaii islands. However, in Iceland, there are various kinds of volcanoes, many of which eject more evolved lavas such as rhyolite and andesite lavas.

The most common types of volcanoes are the composite volcanoes, which spread over vast areas of the country and are usually arranged in chains. In the south and southwest segments of the island, we can find Hekla, Mýrdalsjökull with Katla, Eldgjá, and the Laki craters, also Öræfajökull, Snæfellsjökull. In the north of the country and in the interior part, the glacier Vatnajökull with Bárðarbunga, Grímsvötn and Kverkfjöll, Krafla, Askja, and Herpubreip are located. And, off the southern Icelandic coast, there is the Vestmannaeyjar archipelago with the recently active Surtsey, and Eldfell on Heimaey.

Icelandic volcanic eruptions are famous for their enormous volume of erupted ashes and for vast lava outflows. Together with the volcanic ashes, also large quantities of hydrofluoric acid have been released which, with other toxic gasses, contaminated the barren vegetation, the only scarce pasturage for cattle. In this context, a huge eruption of the Laki volcano in southern Iceland in 1783 should be mentioned, when allegedly as much as 14 km³ of lava poured out from the total of 135 newly opened craters. It is estimated that during this eruption, probably the most fatal Icelandic catastrophe ever, some half billion tones of toxic gasses got away into the atmosphere and killed one quarter of total Icelandic population (over 10,000 people) and slaughtered some 60% of cattle in the island (Krafft 1993).

Geologists explain the high concentration of volcanic activity in Iceland by a combination of the island's position on the Mid-Atlantic Ridge and volcanic hot spot underneath the island. Iceland is located astride the boundary between the Eurasian and North American Plates. A great deal of volcanism is concentrated along the plate boundary, which runs across the island from the southwest to the northeast. Some volcanic events occur offshore, too, especially off the southern coast. This kind of volcanism includes submarine volcanoes and newly formed volcanic islands such as the Jólnir Island.

The plate tectonic theory says that the Earth's surface is subdivided into a number of huge continental plates, which move each other. And along the deep faults, by which the individual plates are detached, molten lava can reach the surface. The volcanic activity of Iceland is predetermined by its location and also by history of its origin. The bottom of the Atlantic Ocean along its central ridge has been formed due to never-ceasing magma supply from sub-crustal sources; it is constantly elevated and spread out. The submarine volcanoes supply enormous quantity of new rock material, which finally appears above the sea level. Western part of Iceland belongs to the American plate, and the eastern part belongs to the Eurasian plate, both parts slowly move apart by the velocity of about 2 cm per year.

Since huge Hekla explosion in AD 1104 (lava ejection could have been estimated to approach 2.5 km³), when molten ejecta entirely devastated large territories in the southern part of Iceland, another 157 strong eruptions of this volcano have been recorded. No other European volcano could show off such a record. Being exhausted by such "work," Hekla took a certain long rest of 60 years prior to year 1845 when it suddenly exploded again on September 2: "*With a tremendous crash, two large openings were formed in the sides of*

J. Kozák and V. Čermák, *The Illustrated History of Natural Disasters*,
© Springer Science+Business Media B.V. 2010

79

LIBER SECVNDVS

De fecreta natura quorundam montium.

Fig. 59 A woodcut illustration of Icelandic symbols (mountains and fire), from the book by O. Magnus (1550). Private collection, Prague

the cone, whence there gushed torrents of lava, which flowed down two gorges on the flanks of the mountain. The whole summit was enveloped in clouds of vapor and volcanic dust. The neighboring rivers became so hot to kill fish, and the sheep fled in terror from the adjoining heaths, some being burnt before they could escape...." (An anonymous report of 1872, quoted from <http://en.wikipedia.org/wiki/Hekla>).

Eruptions of Hekla were always preceded by strong ground tremors; the following explosions together with mighty emissions of volcanic ashes took several hours. This scenario was a part of a repeated painful Hekla's effort to get rid of "cork" from the bottle neck; once it did so, a massive outflow of lava followed for many days.

As concerns Hekla volcano itself, its eruptions have varied extremely in time and it was always very difficult to predict the next one. Some eruption spells were short, ranging from a couple of days to several weeks, whereas others could stretch into months and years. However, there was a general correlation: the longer Hekla goes dormant, the larger and more catastrophic was its next blast. For instance, during 1947–1948 lava poured out from Hekla for 13 months and more than 0.8 km^3 of lava and ashes were ejected; lava covered about 65 km^2 and volcanic ashes were blown out by wind up to Scandinavia. The 1991 eruption lasted for 53 days and lava covered 24 km^2. The large recent eruption occurred on February 26, 2000.

The map (Fig. 60) is actually a part of a large graphic sheet illustrating volcanic and seismic events in the Atlantic Ocean summarizing the concepts of the mid-nineteenth century. The part dealing with volcanism in Iceland (Krug,

c.1840) showed that the island is subdivided into three parts: the left and right sectors are marked by green and present large basalt massifs. The *Grosses Längenthal in Trachyt* (Big Trachyte valley) stretches from the southwestern coast across the central part of the island to the northeast. The author marked the position of volcanoes by purple and the areas covered by lava by orange. The reality roughly corresponds to the situation of the year 1840. Two pictures at the bottom present the Big Geyser and volcano Eyafiäl on the southern coast together with a small island in front of the volcano. The exceptional volcanic activity of the region was documented by three tens of active volcanoes shown in the map.

Krug's (c.1840) map was composed a long time before the principles of plate tectonics were formulated; by locating the "big trachyte valley" correctly into the central part of Iceland, the author outran the time by more than 80 years (see also Anonym 1841). Today, we can only admire his right understanding of the relation between his "big trachyte valley" (actually a deep-fault surface projection) and the Iceland's volcanic activity.

Figure 61 is taken from the *Viennese Illustrated Weekly* and introduces the Hekla volcano in one of its frequent eruption periods. The picture, no doubt, looks authentically, but it is a fantasy composition: Hekla volcano is not shaped as a slim, sharp cone and is not located at the sea coast. Evidently, the author of the image did not bother himself with Iceland geography and simply used as a model some portrayal of Etna (?) for his depiction. By other words, Iceland was a too distant and too exotic corner of the world for central-Europeans of Austria in the mid-nineteenth

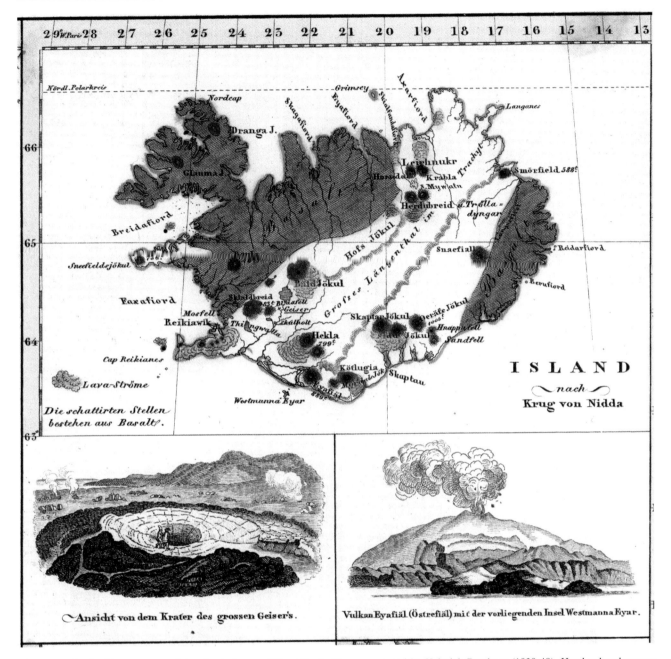

Fig. 60 Iceland with a segment of the physical map of the Atlantic Ocean, prepared by Heinrich Berghaus (1838-48). Hand colored copper engraving. Private collection, Prague

century so that a topographically correct representation – even in a standard periodical – was not a necessity.

Similarly, as in other regions of the world, where hot lithosphere material communicated with the Earth's surface, also in Iceland, hot springs and geysers occur in a large amount. A geyser is a hot spring characterized by intermittent discharge of water ejected turbulently and accomplished by a vapor phase (Fig. 62). The word "geyser" comes from *Geysir*, the name of an erupting spring at Haukadalur, Iceland; that in turn comes from the Icelandic verb equal to English "to gush." The "Great Geyser," which first erupted in the fourteenth century, used to erupt in every 60 min until the early 1900s when it became dormant. Earthquakes in the year 2000 subsequently reawakened the giant geyser, and it now erupts approximately in every 8–10 h and may reach the height up to 61 m.

Fig. 61 Hekla in eruption. Hand colored xylographic illustration from Wiener Illustrierte Zeitung of 1850s. Fantasy composition. Private collection, Prague

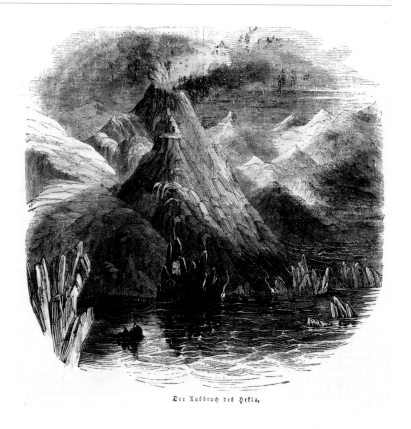

Der Ausbruch des Hekla.

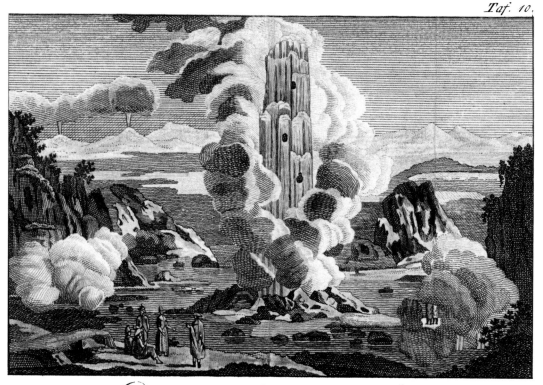

Taf. 10.

Der grosse Geiser, auf Island.

Fig. 62 "*Der grosse Geiser auf Island*". Imaginary composition showing the Great Geyser in Iceland. German hand colored copper engraving of the mid-19th century; unidentified bibliographic source. Private collection, Prague

Pico de Teide, Tenerife Island, Canary Archipelago

Pico de Teide (16°38′W, 28°18′N) is a 3,718 m high volcano in the Tenerife Island, Canary volcanic archipelago, off the northwestern coast of Africa in the Atlantic Ocean. The Tenerife's original huge caldera Las Cañadas was formed during the Late Tertiary and Early Quaternary by empting volcano's large magmatic hearth in combination with the following collapse of the mountain summit. Large caldera of the volcano is of 12–20 km in diameter; it is partly filled by the present cones of Montana Blanca, Pico Viejo, an explosive crater, and the highest point of Pico de Teide. The main volcanic stage culminated about five million years ago. The birth of the Canary islands' volcanoes and of the whole archipelago can be explained by a hot-spot theory, based on the prospect of magmatic reservoirs of melted lava in the Earth's mantle. According to this prospect, one of these hot spots is located deep below the region in question; hot masses melted and weakened the upper-lying rock strata and subsequently enabled the passage of the melt to the surface. The concept of the hot-spot occurrence under Canaries fits well the tectonic structure and the structural disturbances in the northwest part of the African plate.

In addition to Pico de Teide, there are several other active volcanoes in this region. The island Lanzarote (670 m a.s.l.) was formed as a volcano some 20 million years ago, and is typical by its linear lava outflows. Basalt lava during the eruption in 1730–1736 (near Montanas del Fuego) and in 1824 (Nuevo del Fuego) covered about one quarter of the island. Also, volcanic activities in the Palma Island (2,426 m) should be mentioned; in 1585, almost 1,000-m high stromboli-type cone Tahuya was created (composed of papilla, mixture of cinder, and volcanic bombs); 60 years later (in 1645), another cone, San Martin, appeared there.

Three illustrations invite us to the Atlantic coast of Africa, namely the Tenerife island dominated by a beautiful cone of Pico de Teide, climbing high above sea level, however, towering to approximately 7,500 m above the floor of the Atlantic Ocean. Pico de Teide is the highest mountain of Spain and the highest point in the Atlantic Ocean. The island of Tenerife itself is the world's third largest volcanic island by its volume.

Figure 63 (top) confirms the dominant position of the volcano on the island. Since the Spanish colonization in 1402, the volcano has been active several times. Reportedly, Cristobel Colón (Christopher Columbus) was a witness of one of its eruptions. Two centuries later, in 1704, a strong earthquake struck the island and the eruption from Pico's central crater caused havoc in coastal town Garachico, in which numerous victims were reported. The next eruption, this time from the side craters, followed in 1798. The last lava outflow in 1909 at the northwest slope fortunately did not cause any considerable damage. Figure 63 (bottom) provides the possibility to view one of the Pico's craters as it looked in 1835, when the volcanic activity was weak; that time, the crater was only about 30 m deep and 400 m in diameter. The escaping steam and volcanic gases did not prevent the access of the observers. In contrast to the relatively small size of the inner crater, the whole caldera was ~ 55 km in circumference.

Figure 64 enables us to assess the topography of the volcano. We have to keep in mind that in 1835, the volcano had two major craters, namely Pico de Teide and Pico Viejo, which together can be considered as a double stratovolcano. According to the image, there were three localities, where lava tore up the caldera rim and made its way down toward the fertile coastal lands and further to the sea. A number of smaller-size creaters and vents opened and fed their own lava fields.

J. Kozák and V. Čermák, *The Illustrated History of Natural Disasters*,
© Springer Science+Business Media B.V. 2010

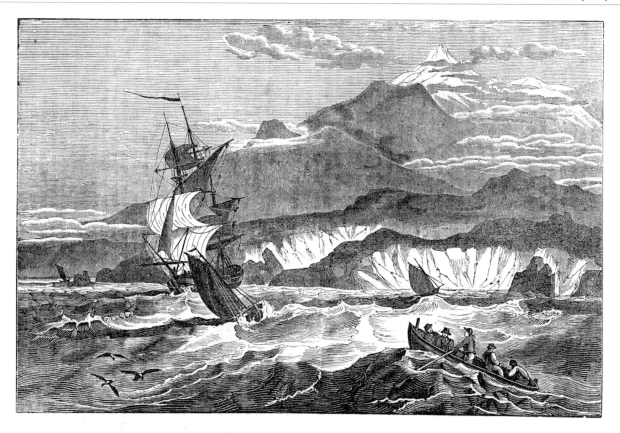

(Der Pick von Teneriffa.)

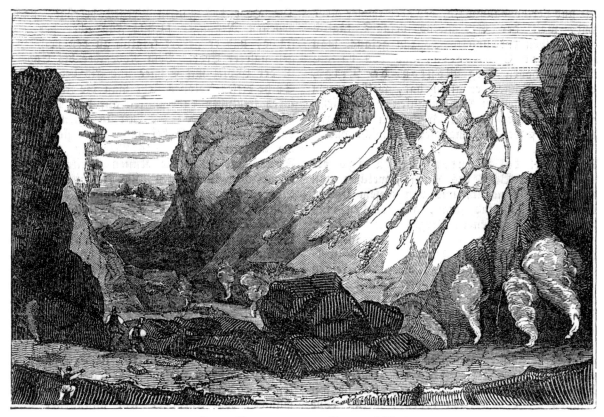

(Der Krater von Teneriffa.)

Fig. 63 *"Der Pick von Teneriffa"* (Pico de Teide). Two xylographic portrayals of the volcano; reproduced from Panorama des Universums (1835). Private collection, Prague

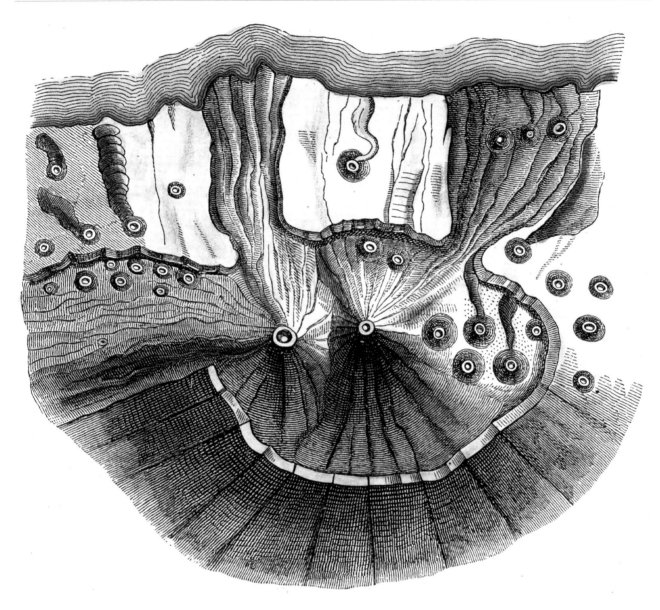

Fig. 64 A bird-eye view of the Pico de Teide volcano. Hand colored reproduction from Geistbeck (1897), Private collection, Prague

Mount Pelée Volcano, Martinique

Mount Pelée (14°48′N, 61°10′W) is a 1,397 m high stratovolcano composed of mostly pyroclastic rocks; it dominates the northern part of the Martinique island, which is a part of the volcanic arc forming the Lesser Antilles (West Indies). The arc itself is a product of the subduction process of the North American tectonic plate plunging under the Caribbean plate. Altogether, 17 volcanoes have been active in the West Indies in the last 10,000 years. Most of them are subaerial and generally represent the mountainous interiors of some of the arc's islands.

Mount Pelée's volcanic cone is composed of volcanic ashes and hardened lava strata. This volcano is mostly famous for its eruption in 1902, which resulted in a high number of victims and extended destruction; this event was the worst volcanic disaster of the twentieth century. On May 8, 1902, on the Ascension-Day, the "eruption" killed around 26,000–36,000 people, including the island's governor, and destroyed the Saint-Pierre town located about 6 km south of the peak, the largest Martinique town at that time.

On that fatal morning, most people on the island were recklessly observing the fireworks the mountain was showing off. The shift-telegraph operator just sent the report describing the volcano's activity to the operator at the Fort-de-France centre, claiming: "*no significant new development*". His last transmission was "*Allez*" [you go], after which he handed over the line to the remote operator. It was 7:52 a.m.; the next second, the telegraph line went dead. A cable repair ship had the city in direct view; the upper mountainside ripped open and a dense black cloud shot out horizontally. A second black cloud rolled upwards, forming a gigantic mushroom cloud and darkening the sky for an 80 km radius. The initial speed of both clouds was later calculated as exceeding 670 km/h. Large horizontal pyroclastic cloud was hugging the ground, speeding down toward the city of Saint Pierre, appearing black and heavy, glowing hot from the inside. In few tens of seconds, it reached the city, instantly igniting everything combustible it came in contact with.

A rush of wind followed, this time toward the mountain. Then, in a half-hour period, the downpour of muddy rain mixed with volcanic ashes occurred. For the next several hours, all communication with the city was interrupted. Nobody knew what was happening or who had an authority over the island, as the governor was not available and his status was unknown. Some survivors were picked from the sea; mostly badly burned sailors, who had been blown into the sea by the volcano's blast and then clung for hours to the floating debris. A warship arrived toward the shore at about 12:30 p.m., but unbearable heat prevented landing until about 3 p.m. The city burned for several more days.

The area devastated by the pyroclastic cloud covered about 20 km^2, with the city of St. Pierre taking its main brunt. The cloud consisted of superheated steam, volcanic gases, and dust of extremely high temperatures reaching allegedly over 1000°C.

Figure 65 is a newspaper xylographic illustration taken from the Czech Journal *Nové Ilustrované Li*sty *1902* (New Illustrated Gazette of 1902), which mediated Mount Pelée eruption to the readers. Technically, the illustrations are of a low quality, but they well illustrated the situation as it appeared both during and shortly after the explosion of Mount Pelée. In the bottom picture, we can see the situation that followed the event, when the furious volcano had calmed down and the burned town of St. Pierre, the pearl of the Lesser Antilles, appeared devastated. The horrified French seamen, members of the rescue squad, stare on dead corpses spread over on the beach.

Saint Pierre was populated by some 30,000 people. During the catastrophe, practically, all inhabitants of the coastal town St. Pierre died. They were mostly intoxicated by the poisonous volcanic gases, as were the inhabitants of Roman Pompeii and Herculaneum, several centuries earlier, during the Vesuvius eruption of AD 67. Many people were also swelled by the minor explosions and mud flows first emitted by the volcano. There were pitifully only a couple of survivors: Léon Compère-Léandre, a man who lived at the edge of the city; one woman, a housemaid, also survived the pyroclastic flow but perished soon after; the only sensation she remembered from the event was a sudden feeling of heat. Included among the victims were the passengers and crews of several ships docked at the Saint Pierre harbor.

As a certain irony of fate, one among the very few who survived was a criminal imprisoned in the municipal penitentiary. The primitive brig had no ventilation; due to no direct contact with the outer space the convicted criminal survived being protected from the all-burning heat and

J. Kozák and V. Čermák, *The Illustrated History of Natural Disasters*,
© Springer Science+Business Media B.V. 2010

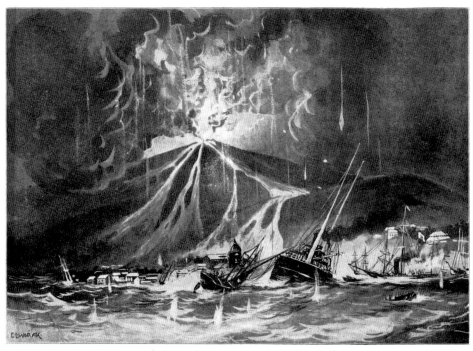

Ku katastrofě na ostrově Martinique: Záhuba města St. Pierru.

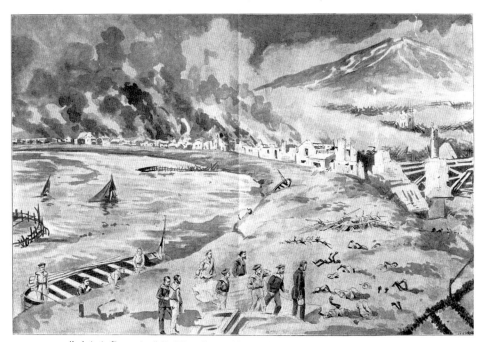

Ku katastrofě na ostrově Martinique: Francouzští námořníci hledají mrtvoly v ssutinách St. Pierru.

Fig. 65 Fall of St. Pierre town (top picture), French sailors searching for cadavers in the ruins of devastated St. Pierre town (bottom). Illustrations from a Czech journal. Private collection, Prague

poisoned air. Later he was freed by the army rescue team and even pardoned.

The top of Mount Pelée is formed by a horseshoe like caldera opened to the south; the present summit crater l'Etang Sec is filled with two lava peaks created during the eruption in 1902 and 1929. Geological survey disclosed the relicts of at least 20 huge explosions within the last 5,000 years. The 1792 and 1851 eruptions were historically confirmed. The eruption of 1902 was a typical example of the "Mount-Pelee-type" volcanic activity, when the active crater is filled with viscous lava, which only partly runs over the caldera brim. During the explosion, predominantly ashes and extreme quantities of gas were ejected. High temperature lava then gravitates down the volcano slopes with a high velocity of several hundred kilometers per hour. The last activity of Mount Pelée was reported in 1932.

Orizaba Volcano, Mexico

Pico de Orizaba (19°02′N, 97°16′W) is a stratovolcano, the highest mountain in Mexico, and the third highest peak in North America. Its height approaches 5,700 m a.s.l. Gigantic cones of the volcano are 30 km in diameter. It is situated in the eastern end of the *Eje Volcánico*, Transversal Mountain Range, on the border between the states of Veracruz and Puebla. The volcano is currently dormant but not extinct; the last eruption occurred in the seventeenth century (1687), which followed several previous events.

Orizaba volcano overlooks the valley and the city of Orizaba, from which it got its modern name; its original Indian name was Citlaltépetl. The mountain is a regionally dominant peak and, in fact, the highest peak between Colombia in South America and Alaska. As a mountain, Pico de Orizaba is ranked seventh in the world in its topographic prominence; among volcanoes, it is the second most prominent volcanic peak in the world after Africa's Mount Kilimanjaro (prominence of the peak is not the height of its summit above sea level, but the height of the peak's summit above the lowest contour line encircling the mountain). Although the volcano is located about 110 km inland, west of the port of Veracruz, its peak is visible to ships approaching the port in the Gulf of Mexico, and at dawn, rays of sunlight strike the Pico while Veracruz still lies in shadow. The Pico is ranked as the 16th in the world for its topographic isolation.

Figure 66 presents a map, plan, and three colored side views of Orizaba. The composition, partly colored lithography, was prepared for the well-known monthly *Petermann's Geographische Mittheilungen* (1857), a series of which had been published since 1855 by Justus Perthes in Gotha under the professional supervision of the famous German cartographer August Petermann. The above illustration presented a typical Petermann's workshop composition combining maps and plans with iconographic elements (side views). This was a way promoted in Potsdam (Germany) by Heinrich Berghaus, Petermann's teacher, to increase the attraction of the cartographic information of the composition by filling decorative pictorial elements in it.

The upper panel gives the basic topographic information about the mountain chain stretching from north to south along the Mexican Bay coast. The chain is dominated by two mountain hills, the volcano Orizaba and the northerly located Cofre de Perote. The plan of the volcano (on left) in the lower panel demonstrates the bird view of Orizaba huge caldera (15 km in diameter), and (on right) we see three different side views of the mountain. From the illustration, it is obvious that this young Quaternary structure underwent a complex geological evolution in three major stages. The present steep cone of Citlaltépetl was formed by viscous andesite and dacite lavas.

J. Kozák and V. Čermák, *The Illustrated History of Natural Disasters*,
© Springer Science+Business Media B.V. 2010

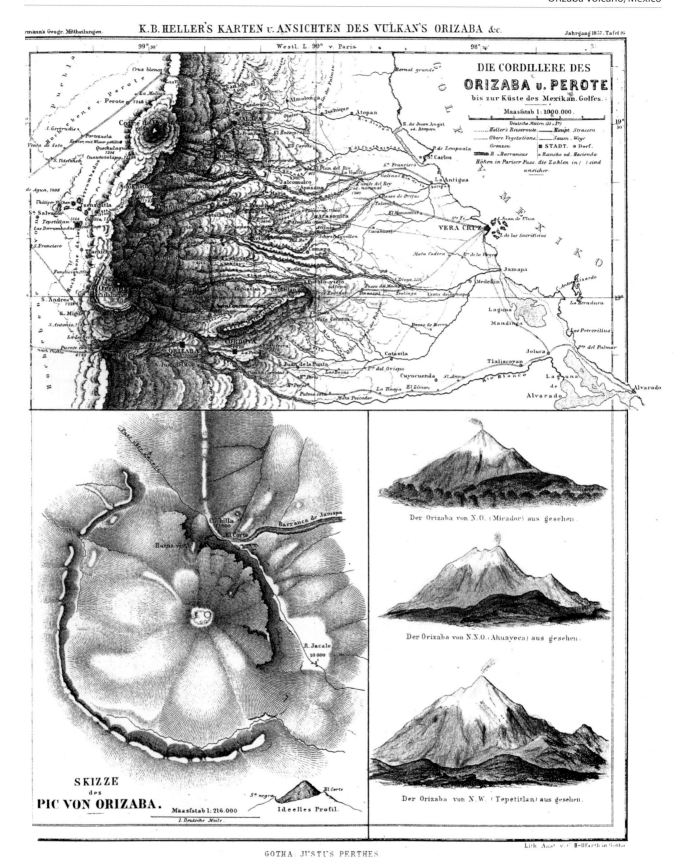

Fig. 66 *"Pic von Orizaba"*. Partly hand colored copper engraving from Petermann (1867). Private collection, Prague

Jorullo Volcano, Mexico

Mount El Jorullo (18°55′N, 101°48′W) is a cinder cone, 1,320 m high volcano, which came into being only recently (1759). It is located in Michoacán state, central Mexico, in an area known as the Michoacán–Guanajuato Volcanic Field. El Jorullo has four smaller cinder cones, which have grown up from the main volcano body. The vents of El Jorullo are aligned in a northeast to southwest direction. The erupted lavas had higher silica contents making lava thicker than the later volcanic products, basalts and basaltic andesites. Present crater of El Jorullo is about 400 by 500 m wide and 150 m deep.

El Jorullo is one of the two volcanoes to have grown up in Mexico in recent history. The volcano located on the main line of the Mexican volcanic belt between Colima and Mexico City was born on September 29, 1759. Several weak earthquakes occurred prior to its first day of existence. Once the volcano began to erupt, its activity continued for the next 15 years, up to 1774. During this period, El Jorullo completely destroyed its closest neighborhood, an area which had originally been a rich agricultural region. El Jorullo grew approximately 250 m from the ground in the first 6 weeks. The primary eruptions were phreatic and the erupted material covered the whole area with sticky mud flows, water flows, and thick layer of ashes. The first, 15-year eruption was the longest one El Jorullo ever had, and it was also the longest ever recorded in case of a cinder cone. The volcano probably erupted again in 1958, nearly 200 years after its initial development, but this later activity was not reliably confirmed; at present, only occasional fumaroles activity has been noticed at the site (Fig. 67).

The second, newly born volcano in the region is the Parícutin Mt., named after a nearby village that it eventually destroyed. Both, Parícutin and El Jorullo rose in an area known for its volcanoes, called the Trans-Mexican Volcanic Belt. This region stretches about 1,120 km from east to west across southern and central Mexico. Geologists say that the eruptive activity deposited a layer of volcanic rock up to 2,000 m thick, which had created a high and fertile plateau; this rich farmland, in turn, has made this belt the most populous region in Mexico. The region may boast with three of the country's four largest cities, namely Mexico City, Puebla, and Guadalajara. Although hundreds of extinct cinder cones can be found here, this zone has experienced only little volcanic activity during the historic times, the only remarkable eruption in human memory was that of El Jorullo in the eighteenth century.

Figure 68 illustrates the situation in 1759 when El Jorullo was born. The truncated arising volcanic cone with a wide throat witnessed the eruption. On the plain in front of the volcano, a number of small cone-shaped 2–5-m high pyramidal formations originated (so-called *hornitos*), with lava pouring from some of them. These hornitos (in local Spanish, hornito means a stove) are temporary formations, which sometimes originate at the contact of the molten lava with water. When the supply of lava terminates, hornitos cool down and after several years their cinder structure disintegrates.

The above illustration is not a fantasy; it was created as a copy of the original Humboldt's (1810) cartoon. It is said that the scientist who visited El Jorullo some 40 years after its birth was still able to see some of hornitos. Also the soil in the area was still warm. Humboldt's documentation together with pictorial material reflected his own experience and linked to the narrative of local eyewitnesses. Today, of course, all relics of former hornitos have completely disappeared. As a detail of interest, the double-stream of lava, pointing to two observers in the foreground, is in other similar pictures of the same scene featured as a water fall.

J. Kozák and V. Čermák, *The Illustrated History of Natural Disasters*,
© Springer Science+Business Media B.V. 2010

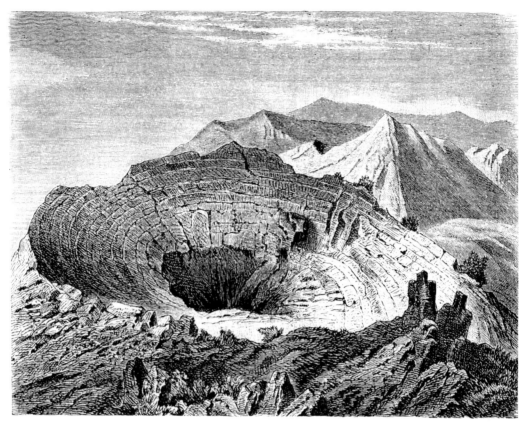

Der Krater des Jorullo. (Nach Pieschel.)

Fig. 67 A side view into the main Jorullo crater. Nineteenth century xylography by Pieschel, published by Geistbeck (1897). Private collection, Prague

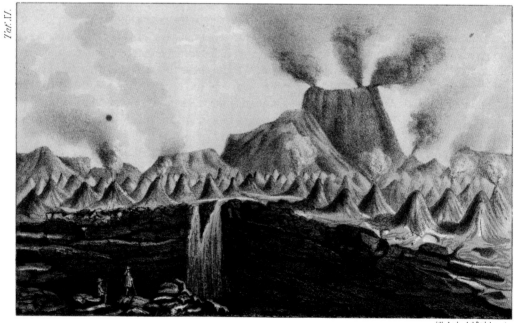

DER JORULLÒ IN MEXIKO.

Fig. 68 Jorullo volcano in Mexico. German color lithography based on original sketch by Humboldt. Printed by J.G. Bach in Leipzig and published around the year 1840. Private collection, Prague

Pacaya Volcano, Guatemala

Pacaya (14°23′N, 90°36′W) is a 2,552 m high volcanic complex, consisting of an older stratovolcano with domes, flows, tephra, and a younger basaltic stratovolcano. Most of the complex has been formed in the last 23,000 years. Little is known about its early historic eruptions; however, since 1565, Pacaya has erupted at least 23 times; the strongest eruption was recorded in 1775.

Pacaya complex creates a part of a chain of volcanoes stretching along the Pacific coast of Guatemala. Tectonically, the whole chain was formed by the subduction of the Cocos Plate underneath the Caribbean Plate. The mountain itself is located at the southern edge of a sizable caldera formed in the Pleistocene age. The caldera has been the source of at least nine large explosions over the last 300,000 years, during which some 70 km³ of magma erupted. Since the last caldera-forming eruption, several smaller vents within and around the caldera displayed eruptive activities. About 1,100 years ago, the volcano's edifice collapsed, which initiated a huge landslide, whose deposits were transferred about 25 km off the volcano down to the Pacific coastal plain. The landslide left a large crater, within which the present active cone has grown. The presence of a magma chamber in the shallow depth beneath Pacaya indicates that the older distortion of the cone, leading to the structural instability, remains and represents a certain hazard to the surrounding area.

After Pacaya remained dormant for a century, a collapse near the summit of the volcano formed a pit crater in 1962. The pit crater has become the focus of recent volcanic activities and gave birth to a new cone gradually growing within the crater. Since 1965, Pacaya has been erupting quasi-continuously. The type of eruption alternated between strombolian and plinian. In some time periods, hundreds of explosions have occurred daily. During the strombolian type of eruptions, incandescent bombs were flung up hundreds of meters into the air. Pacaya lies only about 30 km south of Guatemala City, the country's capital. Its eruptions are visible from a large distance and due to a relatively easy access, either from Antigua Guatemala or Guatemala City, the volcano serves nowadays as a point of popular tourist attraction.

The following two figures were published in the book of J.H. Feldman (1993). Both illustrations reproduce older anonymous sketches created by in situ observer(s). Original paintings are deposited in the Archivo General des Indias, Sevilla, Spain. The archive management kindly granted permission for the image reproduction.

Figure 69 presents a view of the three huge volcanoes, the central of which – Pacaya – is depicted during its strong eruption in the year 1775. A high column of flames was ejected from the deep gullet together with the molten volcanic material. Volcanic ashes, pumices, and red-glowing rocks fell down on the mountain's slopes. Lava flows were pouring out from several openings in the broken caldera rim. Notice the dead trees on the top of a hill on the right; one may presume that the defoliation was the result of the burning effect of a hot air whirlwind. Figure 70 presents an untutored attempt to construct a primitive local map or, better, an oriented plan of volcano Pacaya with two other side volcanoes together with a compass rose. Eleven nearby settlements are marked with their names. Individual volcanoes and their activities are described in the legend given in the map heading.

J. Kozák and V. Čermák, *The Illustrated History of Natural Disasters*,
© Springer Science+Business Media B.V. 2010

Fig. 69 Explosion of Pacaya on July 21, 1757. Original depiction is saved in the *Archivo General des Indias,* Sevilla, Spain. The image copy is kept in a private collection, Prague

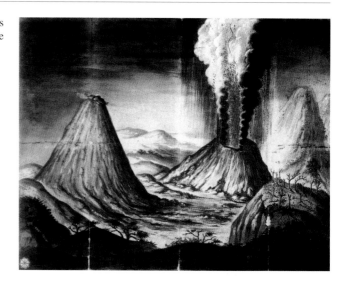

Fig. 70 Sketch map of the topographic situation pertinent to the 1775 Pacaya explosion. The map copy is kept in a private collection, Prague

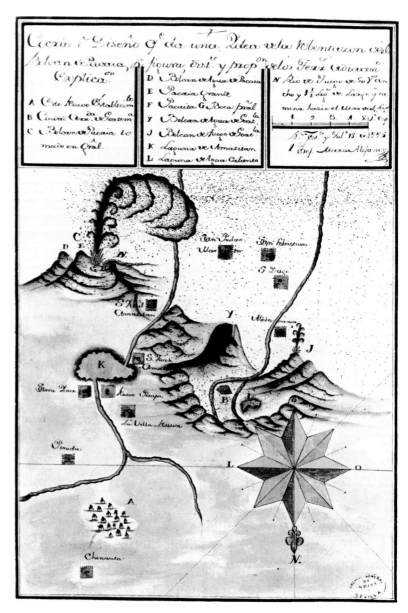

Cotopaxi Volcano, Ecuador

Cotopaxi (0°42′S, 78°24′W) is a stratovolcano with a summit elevation of 5,911 m above sea level. It has erupted 50 times since 1738. The 1877 eruption melted snow and ice on the summit, which produced mudflows that traveled a distance of 100 km far from the volcano top. Recent weak volcanic activities, in 1975–1976, consisted of an increase in steam emissions, melting snow, and small earthquakes occurrence.

The stratovolcano Cotopaxi is one among the famous active volcanoes located in the mountain range of the Ecuador Eastern Cordillera of the Andes. The present steep cone was formed about 5,000 years BC; later, it was completed by a group of side craters. Massive lava flows often reached the mountain roots and caused severe damages. During the periods of relative inactivity, the summit used to be covered by a glacier; the renewed volcanic activity was usually accompanied by lahars, flows of mud composed of pyroclastic material, and water that rushed down from the summit, dredging deep valleys. A horrible catastrophe occurred in 1877, when huge black masses of volcanic debris, water, and muddy ashes rolled down with unbelievable speed and the lahar front reached upto the 100 km-distant Pacific coast on the west and the rim of the Amazonian Basin on the east. The strongest eruptions of Cotopaxi occurred in 1743, 1768, 1853, and 1877. The most recent prominent disaster dates back to 1904, with several minor events in 1939, 1940, and 1942.

Figure 71 presents volcano Cotopaxi at the stage of low activity. The picture is a hand-colored lithography of the beginning of the nineteenth century, signed by Ignazio

Fig. 71 Cotopaxi volcano. Color litography by I. Fumagalli, early 19th century. Private collection, Prague

J. Kozák and V. Čermák, *The Illustrated History of Natural Disasters*,
© Springer Science+Business Media B.V. 2010

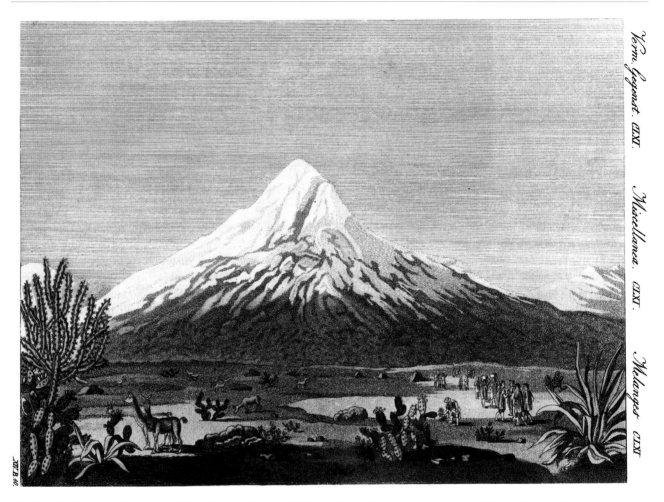

Fig. 73 Chimborazo with examples of flora, fauna and local inhabitants. Hand colored copper engraving. Private collection, Prague

Cotopaxi Volcano, Ecuador

Cotopaxi (0°42′S, 78°24′W) is a stratovolcano with a summit elevation of 5,911 m above sea level. It has erupted 50 times since 1738. The 1877 eruption melted snow and ice on the summit, which produced mudflows that traveled a distance of 100 km far from the volcano top. Recent weak volcanic activities, in 1975–1976, consisted of an increase in steam emissions, melting snow, and small earthquakes occurrence.

The stratovolcano Cotopaxi is one among the famous active volcanoes located in the mountain range of the Ecuador Eastern Cordillera of the Andes. The present steep cone was formed about 5,000 years BC; later, it was completed by a group of side craters. Massive lava flows often reached the mountain roots and caused severe damages. During the periods of relative inactivity, the summit used to be covered by a glacier; the renewed volcanic activity was usually accompanied by lahars, flows of mud composed of pyroclastic material, and water that rushed down from the summit, dredging deep valleys. A horrible catastrophe occurred in 1877, when huge black masses of volcanic debris, water, and muddy ashes rolled down with unbelievable speed and the lahar front reached upto the 100 km-distant Pacific coast on the west and the rim of the Amazonian Basin on the east. The strongest eruptions of Cotopaxi occurred in 1743, 1768, 1853, and 1877. The most recent prominent disaster dates back to 1904, with several minor events in 1939, 1940, and 1942.

Figure 71 presents volcano Cotopaxi at the stage of low activity. The picture is a hand-colored lithography of the beginning of the nineteenth century, signed by Ignazio

Fig. 71 Cotopaxi volcano. Color litography by I. Fumagalli, early 19th century. Private collection, Prague

Fumagalli, who created his composition according to an older model depiction by A. v. Humboldt. The volcano is a perfectly shaped central cone mountain with some remnants of a smaller side cone on right. Humboldt's portrayals of the Central and South American volcanoes became very popular among volcanologists in the nineteenth century and were frequently copied (Humboldt 1810). Another view of the Cotopaxi eruption in 1743 is shown in Fig. 72, entitled *"The Mountain of Cotopaxi as it appeared when it burst in 1743"*. This picture was published in *Relación Histórica del Viáje a la America Meridional*, Madrid 1748 (Condamine and Bouguer 1748).

The Cotopaxi volcano is linked with three outstanding naturalists of the eighteenth and nineteenth centuries. French volcanologists Charles-Marie de la Condamine and his copartner Pierre Bouguer during their research expedition to South America in the 1740s "discovered" Cotopaxi, i.e.,

identified and described this volcano and became the eye-witnesses of its specific eruption in 1743. They also described for the first time in detail the "lahar avalanche", which followed the lava eruption from a permanently snow-covered top cone of the almost-6,000 m-high volcano.

Another scientist, who was one among the father-founders of the American volcanoes, was Alexander von Humboldt. According to Krafft (1993), Humboldt formulated his concept that: *" the groups of volcanoes form long volcanic chains located on deep geological faults, where the earth is unstable … [Humboldt continues] … volcanoes communicate with each other, at least within their own region. Thus, on the high plateau of Quito, [the volcanoes of] Pichincha, Cotopaxi and Tungurahua form a single magmatic source … underground fire erupts sometimes from one of these openings, and sometimes from another."* This concept still has its value today.

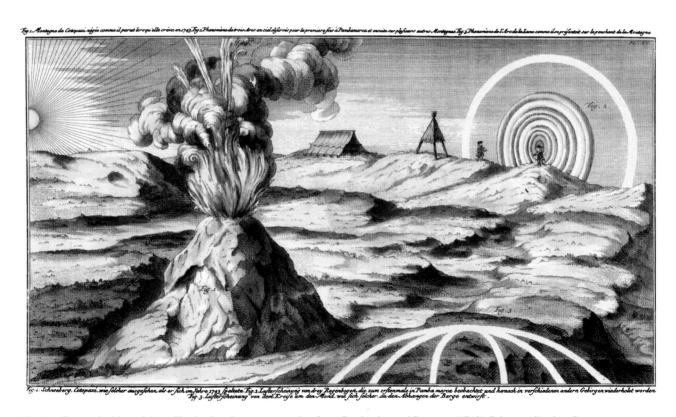

Fig. 72 Cotopaxi with a rainbow. Hand colored copper engraving from Condamine and Bouguer (1748). Private collection, Prague

Chimborazo Mountain, Ecuador

Chimborazo volcano (1°30′S, 78°48′W) is located in the Inter-Andean Rift zone, a north-northeast-oriented structural depression that separates the Western and Eastern Cordilleras of the Andes in Ecuador. It is a Quaternary volcano that has not erupted in the historical times. The elevation of the summit reaches 6,310 m. The summit of Chimborazo constitutes the most remote point from the center of the earth due to its high elevation, the location of the mountain near the equator, and the oblate spheroid shape of the earth.

The highest Ecuador volcano Chimborazo was formed by andesite and dacite lavas of mostly Pliocene-Pleistocene age. The collapse of the original stratovolcano approximately 35,000 years ago dammed up the Rio Chambo River and created a temporary huge lake. The following eruptions subsequently built up a complex of three more craters; the present volcano is located on its most western part. The historical volcanic activity is not known, but the recent pyroclastic sediments are geologically relatively young; they probably originated in the mid-Holocene age.

Figure 73 is a lovely image of a sleeping volcanic giant towering above the peaceful scenery below it. The picture is a copy of the original sketch by A. v. Humboldt of 1799 and was taken from the later edition of "*Bilderbuch für Kinder*" (the Encyclopedia for Youth) (Bertuch 1791&).

Von Humboldt had a personal relation to Chimborazo. According to his own assessments, which he acquired during his visit in Ecuador, he became convinced that the Chimborazo was the highest mountain in the world (no doubt, his ignorance was featured by that time poor knowledge of the Himalayas). In 1799, Humboldt, together with his friend Bonpland, decided to ascend the mountain, and really, they almost managed it regardless of their little skill and poor equipment. Close to the top, totally exhausted and chilled to the bone, both researchers reconsidered their chances and decided to return. Humboldt did not conquer the volcano, but he saved his life and lived another 60 years (he died in 1859). His achievement, however, might be a record, the highest alpinist climbing reached by that time (Humboldt 1810). Actually, the first recorded ascent of the Chimborazo Mountain summit was made later by the famous British alpine climber and explorer Edward Whymper, who climbed Chimborazo twice in 1880.

The above picture, in which Chimborazo plays a dominant role, brings good examples of the local flora (succulents, century plant) and fauna (llamas), which all confirm the drawer's broad cognitive interest. It may be interesting to mention that in the original Humbold's painting, a model depiction of Fig. 73, the author portrayed himself and his friend Bonpland in the picture foreground when making preparations for their ascent of Chimborazo. In the copy reproduced here, figures of both researchers were removed and substituted by depiction of local flora and fauna.

J. Kozák and V. Čermák, *The Illustrated History of Natural Disasters*,
© Springer Science+Business Media B.V. 2010

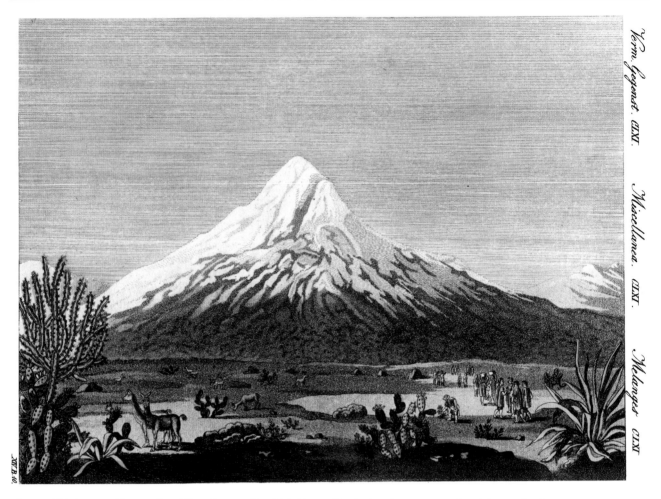

Fig. 73 Chimborazo with examples of flora, fauna and local inhabitants. Hand colored copper engraving. Private collection, Prague

Antuco Volcano, Chile

Antuco (or Antujo in Spanish) volcano (37°24′S, 71°21′W) is a stratovolcano (2,979 m) located in the Bío-Bío region of Chile, near the Sierra Velluda mountains, on the shore of Laguna del Laja. Its last eruption occurred in 1869.

The composition in Fig. 74 is a hand-colored xylographic newspaper illustration of unidentified German periodical of 1870s, entitled *Der Vulkan von Antujo in Chile*. The picture presents the volcano, located at the Chile–Argentine border, during its moderate eruptive activity. A group of wandering researchers studying the volcano runs away, frightened by an unexpected small eruption. The sketch is of a rather humorous character; the picture tries to awaken an impression

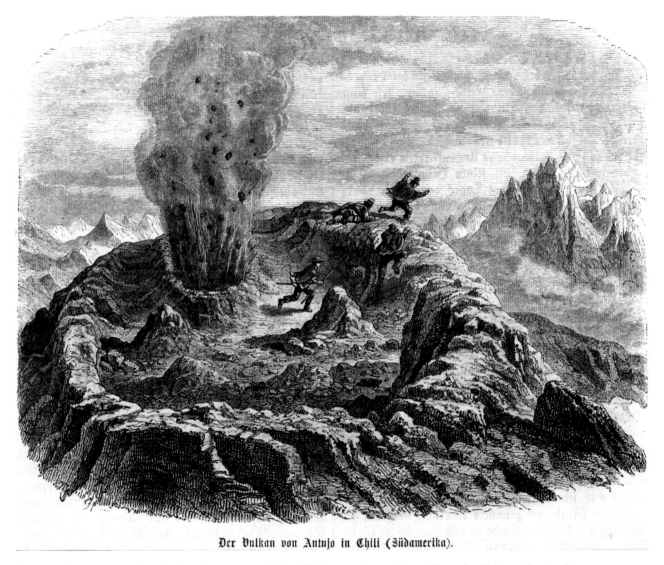

Der Vulkan von Antujo in Chili (Südamerika).

Fig. 74 A fantasy composition showing the top crater of (allegedly) Antuco volcano. Journal illustration. Private collection, Prague

J. Kozák and V. Čermák, *The Illustrated History of Natural Disasters*,
© Springer Science+Business Media B.V. 2010

that investigating minute volcanic explosions may be a great fun.

Volcano Antuco presents the northeastern crater of the Pleistocene stratovolcano Sierra Velluda in Chile. Antuco does not belong to the highest Andean volcanoes; however, it is active, erupting frequently. Humboldt believed that lower volcanoes were more active than those with a high cone, because less power would be needed to force lava from the magma chamber upwards in comparison with the elevated conduits of high mountains.

Antuco history is complex. Its original basalt–andesite cone had been completely blown up in the Early Holocene, and the present cone has grown up later on the northeastern rim of the caldera. The eighteenth- and nineteenth-century eruptions of both major and side craters were of explosive type, during which the lava flows reached the Rio Laja River valley and eventually blocked the river stream to create the Laja Lake (Aprodov 1982).

Antuco is one of about 170 active volcanoes of 1,000 km-long Andean chain stretching north–south along the Chilean–Argentine border. The volcanic activity of this region is closely related to the subduction process of the oceanic Nazca Plate plunging under the South American continental plate. The mutual collision of both plates gave rise to the South American Andes and the Peru–Chile deep oceanic trench. As the direct consequence of this process, numerous devastating earthquakes and volcanic eruptions along the western South American coast have occurred.

Mount Kusatsu-Shirane (36°37′N, 138°32′E) is an active, 2,171m high volcano in Kusatsu, Gunma, Honshu province, some 140km northwest of Tokyo. It is called Kusatsu Shirane to differentiate it from the Mount Nikkō-Shirane on the other side of the Gunma Prefecture. In the historical times, frequent eruptions occurred there, the last event happened in 1989.

The summit of the Kusatsu-Shirane volcano, located north of the Asama volcano, consists of a series of overlapping pyroclastic cones separated by several crater lakes. The largest lake of them is Yu-gama, an acidic turquoise-colored lake with an overlay of yellow sulfur floating on its surface. The Kusatsu-Shirane volcano has an andesite–dacite body; the oldest sediments are of Pleistocene age. Southern and southeastern slopes of the volcano are covered by sintered tuffs and volcanic pumices. The crater was exploited during the intensive sulfur mining in the nineteenth and twentieth centuries. A number of fumaroles and hot springs, usually acidic, confirm the volcano's geologically young origin. Several volcanic eruptions occurred recently, the strongest one in the crater Yu-gama in October 1932.

The whole range of volcanoes, which creates a certain chain encompassing all the Japanese islands, as well as the deepest parts of the Mariana oceanic trench, are related to the contact zone of the Pacific oceanic plate and the Philippine Sea microplate. In the process of subduction, the Pacific Plate plunges under the Eurasian and North American plates. The complex mutual movements resulted in a strong volcanic activity as well as in many devastating earthquakes in the whole region. The main Japanese volcano chain then continues to the north across the Kuril Islands, Kamchatka, and the Aleutian chain; its other arm stretches to the south of Japan, where it meets with the Australian plate.

Figure 75 presents a report illustration published in the seventeenth century by A. Montanus (1669), who visited the Empire of Nippon (= Japan) as an officer of the East Indian Society. In the above composition, the author depicted himself together with a group of copartners as observers watching the erupting volcano from a safe distance. The engraving was created on a high professional level, and by its technique and compositional maturity, it by far exceeded Japanese iconographical compositions of naturalistic motives of that time. Montanus' report also brought authentic portraits of local people, landscape paintings, particular customs, and habits and presented a list of trading and business contacts in this – for most Europeans almost inaccessible – distant country. The author provided much valuable information, including pictorial material about volcanic eruptions and frequent earthquakes in Nippon.

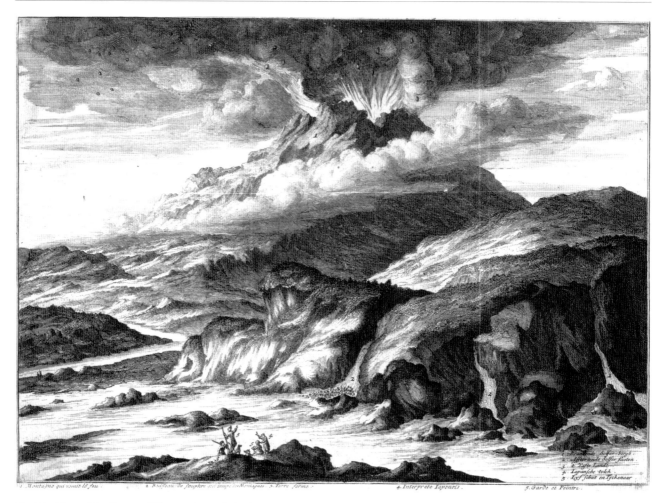

Fig. 75 View of the Kusatsu-Shirane volcano during its eruption in the 1660s. Copper engraving (Montanus, 1669). Private collection, Prague

Volcanoes of Indonesia

Geography of Indonesia is dominated by about 150 volcanoes of all types and dimensions that were formed due to subduction processes occurring along the collision zone separating the Eurasian and the Indo-Australian tectonic plates. Some of the Indonesian volcanoes became especially notable for their eruptions, for instance, volcano of Lake Toba is famous for its super-eruption at *c*. 74,000 BC, which caused a long 6-year volcanic winter. Mount Tambora volcano is known for its most violent eruption in 1815, and the Krakatoa explosion in 1883 became noted for its global effects.

Figure 76 was reproduced from a monthly geographical journal edited by German cartographer H. Zollinger (1858). In the upper part of the panel, cross sections of three volcanic groups were plotted, namely of the southern part of the Indonesian archipelago: Tennger (East Java), Bator volcano (Bali), and Rinjani (Lombok). The profiles were accompanied by a map of the *Indian islands or Malasia* (the territory of present Malaysia and Indonesia), together with a part of New Guinea, Philippines, Formosa (=Taiwan), Hainan, and a substantial part of southeastern Asia.

Indonesian volcanoes create one segment of the Pacific Ring of Fire. They can be subdivided into six geographical regions, four of which belong to volcanoes of the Sunda Arc Trench system, one group includes volcanoes of Halmahera, Sulawesi, and the Sangihe Islands, and another group covers the Philippine volcanoes. At present, the most active volcanoes are Kelut and Merapi on the Java Island, which have brought about thousands of casualties in the region.

An annihilating blow of Krakatoa, located in the Sunda Strait between Java and Sumatra, occurred on 28 August, 1883 (Fig. 77). During the eruption, more than 25 km^3 of rocks, ashes, and pumices were ejected, generating the loudest sound historically reported; two thirds of the island of Krakatoa disappeared during the eruption. The number of casualties in the Sunda Strait and in its vicinity was assessed between 35,000 and 70,000. Giant sea waves reached the height of 40 m and propagated through the whole Indian Ocean as plotted in the map by Hermann Berghaus (1886) (see Fig. 25). Already this map, published 116 years before

the recent damaging tsunami catastrophe following the 2004 Sumatra earthquake, pointed out the deadly potential of the earthquakes occurring in Indonesia for the coastal settlements of the Bay of Bengal and Indian Ocean. Seismic and volcanic consequences of the 1883 Krakatoa explosion were even more devastating than the 2004 tsunami. Gigantean tsunami waves of 1883 smashed down not only the coastal regions of the Indian Ocean and eastern Africa as in 2004, but also ran around the Cape of Good Hope and hit South American Patagonia. The 1883 eruption was accompanied by gigantic emissions of volcanic ashes and gases expelled in a monstrous column of cloud reaching high up to the stratosphere, which then enveloped the whole globe.

That time reports, unfortunately rather fragmentary, informed that the ash clouds had caused twilight for several days and changed days into dark nights in some places, and also the sky had became dark red at sunrise in another localities. The explosion sound could be heard as far as in Australia, Japan, or in Istanbul (!). However, the 1883 Krakatoa event might represent a smaller episode in comparison with the prodigious eruption (equal to a potential collision with a sizeable asteroid), which had allegedly happened in Krakatoa region in AD 535. Although this common disaster causing a 2-year volcanic winter was mentioned and discussed in many early Middle Ages Arabic written sources, a clear unambiguous and verified description of the event has not yet been documented (Keys 1999).

We cannot close our considerations on Indonesian volcanoes without mentioning the work of outstanding German naturalist Franz Wilhelm Junghuhn (1812–1864), who spent many years in Indonesia (from 1835 to his death). He repeatedly made expeditions into that time little-known mountain regions of Java and Sumatra and visited most of the main Indonesian volcanoes. During his journeys, he made detailed sketches of the visited localities in several size levels: from the most detailed portrayals of individual craters, lava streams, and other structural elements, up to general patterns and prospects of long volcanic mountain chains (Junghuhn 1845).

J. Kozák and V. Čermák, *The Illustrated History of Natural Disasters*,
© Springer Science+Business Media B.V. 2010

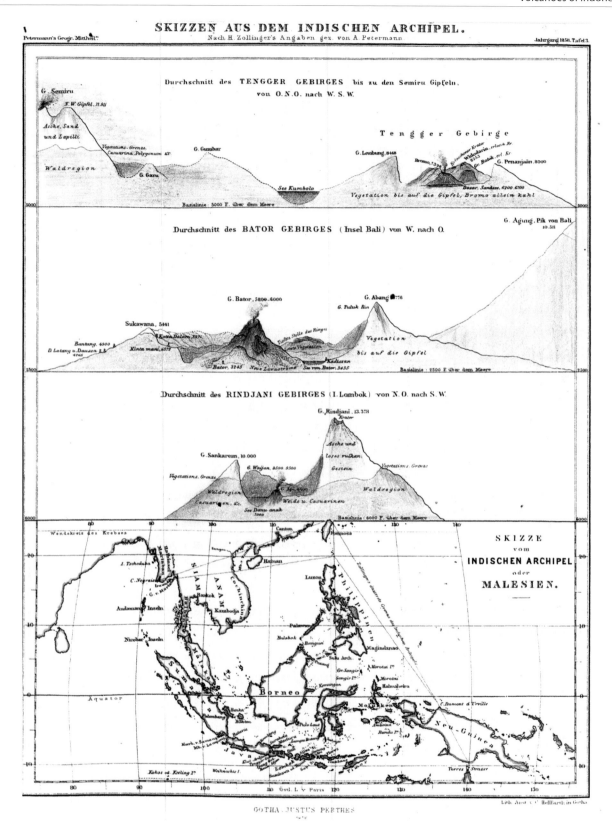

Fig. 76 "*Skizzen aus dem Indischen Archipel*". Three profiles of volcano groups and a map of south-east Asia (Malesia). German hand colored lithographic panel. Private collection, Prague

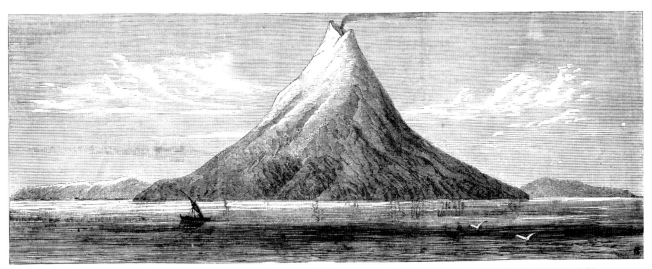

THE ISLAND OF KRAKATOA, FORMERLY IN THE STRAITS OF SUNDA, SUBMERGED DURING THE LATE VOLCANIC ERUPTION IN JAVA.

Fig. 77 Krakatoa Island and volcano before the 1883 eruption. Xylography, late 19th century illustration (Verbeeck, 1884). Private collection, Prague

Gamkonoro Mt., Moluccas Islands

Mount Gamkonoro (1°24′N, 127°32′E), also known as Gammacanorre, is the highest (1,635 m) peak of Halmahera Islands, Indonesia. It is characterized by an elongated series of craters along its north–south stretching rift. Strong eruption of 1673 was accompanied by tsunami waves, which inundated nearby coastal villages. The volcano erupted again on July 10, 2007, when over 8,000 people were reported to have fled their homes located in the endangered region.

Figure 78 is a copper engraving reproduced from the encyclopedic work edited by Kraemer (1902–1904), originally published in the 1780s in the Dutch edition of "*Histoire Générale des Voyages*." The picture probably came into existence in a printing house of a Dutch publisher who utilized a sketch of an anonymous sailor or merchant of the East Indian Trade Company. This company, in the late seventeenth century, had its regional trade domicile on the Moluccas (at present called the Halmahera Islands). The figure illustrated the explosion of the Gamkonoro volcano in 1673. According to Aprodov (1982), Gamkonoro is a large andesite strato-volcano of some 15-km in diameter. It has been split into two parts by a younger rift running in the meridian direction over the volcano summit. Four calderas with a number of fumaroles are located at the rift bottom, at the elevation of some 300 m.

Our pictorial composition, illustrating the seventeenth-century event (but published as late as in the 1780s), presents the volcanic eruption, which may seem to be exaggerated in details, but is a realistic depiction. Similar volcanic explosions were definitely not rare in the region of southeast Asia; remember later violent eruptions of, for example, Tambora in 1815 or Krakatoa in 1680 or 1883. The whole province of the Philippine tectonic plate, especially its collision zone with the southerly Australian plate, is characterized by an increased seismic and volcanic activities, in the region between Australia and New Guinea.

J. Kozák and V. Čermák, *The Illustrated History of Natural Disasters*,
© Springer Science+Business Media B.V. 2010

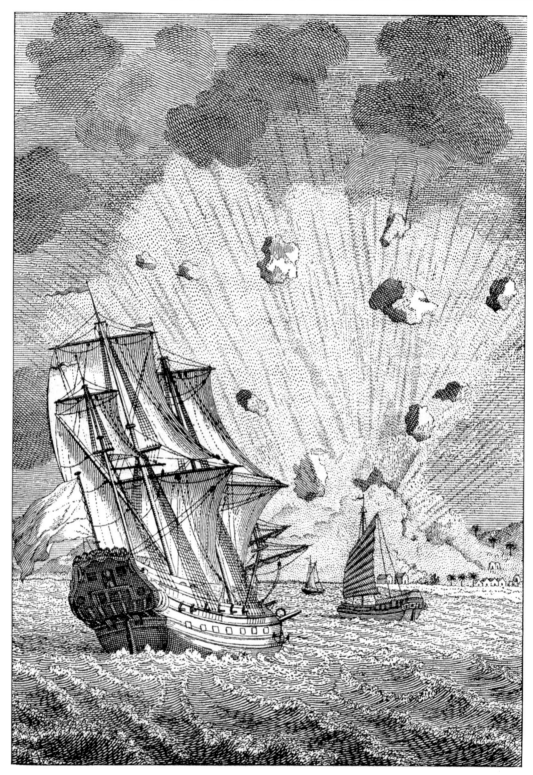

Der Berg bei Gammacanorre (Molukken-Inseln) fliegt 1673 in die Luft
Nach Histoire générale des voyages, Haag 1755

Fig. 78 *"Der Berg des Gammacanorre (Molukken Inseln) fliegt in die Luft"* (The mountain of Gammacanorre, the Islands of Moluccas, flies in the air in 1673). Private collection, Prague

Avacha Volcano, Kamchatka, Far East Russia

Avachinsky volcano, also known as Avacha or Avachinskaya Sopka, (53°15′N, 158°50′E) is an active 2,741 m high strato-volcano situated on the Kamchatka Peninsula in the Far East of Russia. It is located just within the sight of the local capital of Petropavlovsk Kamchatski. Together with the neighboring Koryaksky volcano (3,456 m), it has been designated as a Decade Volcano by the International Association of Volcanology and Chemistry of the Earth's Interior, because it is one of the 16 volcanoes whose history of explosive eruptions in the proximity to populated areas is worth studying. They are named Decade Volcanoes because the project was initiated as a part of the United Nations-sponsored International Decade for Natural Disaster Reduction.

Kamchatka Peninsula makes a segment of the Pacific Ring of Fire, at a region where the Pacific Plate subducts underneath the Eurasian Plate at a rate of about 80 mm/year. The wedge of the Earth's mantle material, sandwiched between the subducting Pacific Plate and the overlying Eurasian Plate, is believed to be the source of dynamic volcanism occurring over the whole Kamchatka Peninsula. Kamchatka with its length of more than 1,500 km stretches from north to south, and along its longitudinal axis, the peninsula is framed by two mountain belts, a Sredinny (Central) and a shorter Vostochny (= Eastern) mountain ridge. The highest volcano of Kamchatka Kluchevskaya sopka (4,750 m) is located in between them, dominating the whole region.

Kamchatka is characterized by a number of active as well as dormant volcanoes; among them, Avacha volcano is situated to the south in the central part of the Eastern mountain belt. This volcano belongs to the most active volcanoes in the area; it began erupting in the middle Pleistocene era. Its horseshoe-shaped caldera was formed 30,000–40,000 years ago during a giant eruption followed by a massive landslide, which covered an area of 500 km² south of the volcano, underlying the present nearby city of Petropavlovsk-Kamchatski.

The Avachinsky volcano has erupted at least 17 times during the recorded history. Eruptions have generally been of an explosive type, and pyroclastic flows and lahars have tended to be directed to the southwest by the breached caldera. The most recent large eruption ($VEI = 4$) occurred in 1945, when about a quarter cubic kilometer of magma was ejected.

Figure 79 illustrates the discussed region of Kamchatka; the drawing is a work of the Viennese graphic designer J. Blaschke. It is a copy of a large-size panorama view from the "*Historie Générale des Voyages, ou Nouvelle Collection de Toutes les Relations de Voyages par Mer et par Terre*" (Hondt 1780). In the image, we can distinguish the Avachinskaya Guba (Bay), a former small stronghold and the settlement Viljuchinsk located along the bay toward the northeast to the region where the town of Petropavlovsk-Kamchatski was built later. The mighty conical "*sopka*" (volcano), in the picture labeled as "*Avatscha*" with its typical smoky flag, dominates the composition. However, it is more probable that the depicted volcano is actually the higher Koryaksky volcano (3,456 m). Both volcanoes are relatively very close to each other, in a distance of about 25–30 km from the bay. In our composition, they may be on purpose portrayed more closely to highlight their grandiosity.

Blaschke's illustration, based on a sketch of the eighteenth century, however, does not trustfully correspond to the reality of the mid-nineteenth century. Even though Petropavlovsk was not a big town that time (it has over 350,000 inhabitants today), it already existed as an important larger settlement.

J. Kozák and V. Čermák, *The Illustrated History of Natural Disasters*,
© Springer Science+Business Media B.V. 2010

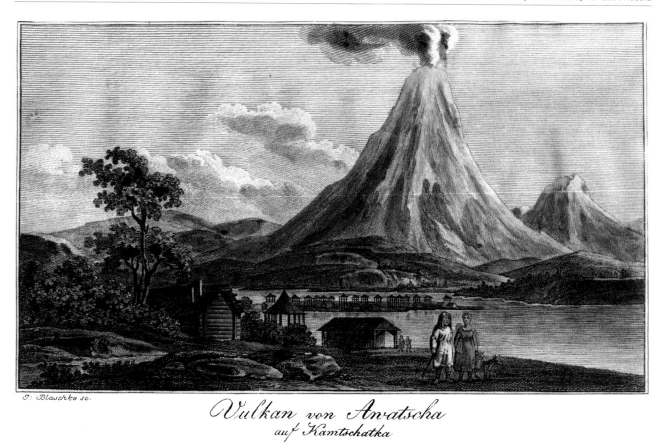

J: Blaschke sc.

Vulkan von Awatscha
auf Kamtschatka

Fig. 79 Avacha and Koryaksky volcanoes in Kamchatka. Solitaire hand colored copper engraving signed by J. Blaschke, first half of the 19th century. Private collection, Prague Figure

Volcanoes of the Hawaiian Archipelago

The Hawaiian Islands form an archipelago of 19 islands and atolls, together with numerous smaller islets and undersea seamounts, extending along the length of some 2,400 km, from northwest to southeast in the North Pacific Ocean, between latitudes 19° and 29°N. The archipelago actually consists of several exposed peaks of a long-stretching undersea mountain range known as the Hawaiian-Emperor seamount chain, which resulted from the volcanic activity above a local hotspot in the Earth's mantle. Hawaiian volcanoes are entirely composed of volcanic rocks of coarse-grained equivalents of gabbros and diabase. Hawaii (Big Island), the largest and youngest island of the archipelago, consists of five different volcanoes. Mauna Loa, the prominent of them, comprising over half of the Big Island, is the largest shield volcano on the Earth.

Kilauea (19°25′N, 155°17′W), a smaller active volcano (1247 m), is currently the most active volcano on the

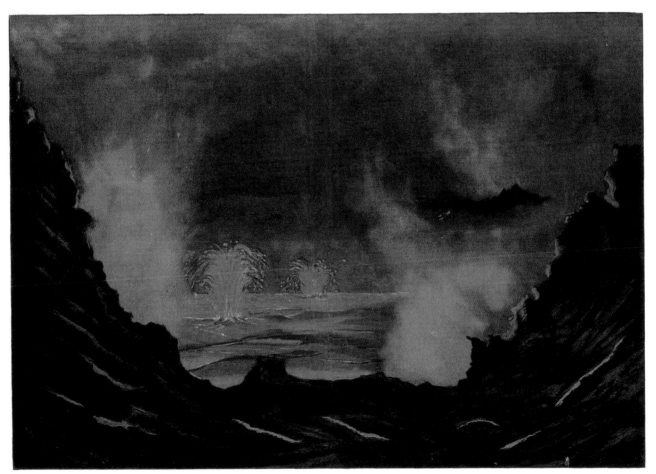

Feuersee im Kilauea-Krater auf Hawaii.
Nach der Natur gezeichnet von Dr. Adolf Marcuse im Jahre 1891.

Beilage zu Hans Kraemer „Weltall und Menschheit".

Deutsches Verlagshaus Bong & Co., Berlin W.

Fig. 80 Permanently melted lava-lake of Kilauea, Hawaii. Color book illustration. Private collection, Prague

J. Kozák and V. Čermák, *The Illustrated History of Natural Disasters*,
© Springer Science+Business Media B.V. 2010

planet. It is located against the southeast flank of the Mauna Loa volcano (4169 m). Kilauea itself is a relatively low, flat shield volcano, different in profile in comparison with high, sharply sloping peaks of other world famous stratovolcanoes such as Mount Fuji or Mount St. Helens. Kilauea is the youngest of the series of volcanoes that have created the Hawaiian Archipelago. In recent decades, eruptions have been almost continuous and characterized by many lava outflows reaching the Pacific Ocean shore. There were 45 major eruptions of Kilauea in the twentieth century.

A. Marcusse illustrated the situation, which occurred in Kilauea in the year 1891 (Fig. 80). This picture appeared in a five-volume encyclopedia work edited by Hans Kraemer (1902–1904). The dramatic illustration showed the lava lake, still glooming, in night when the red glare of molten rocks was especially expressive. We can recognize the lava geysers spraying out of the veins. This lava lake is considered the largest permanently alive volcano crater on the Earth. The Hawaiian Islands are actually a unique locality, where one can observe the volcanic processes "online" and anytime. Here, in contrary to most of the other world volcanoes, liquid lava gets out of veins freely, in the Kilauea case almost continuously. Since molten lava has no time to solidify and block the vein, practically no explosions occur.

Regardless that the history of the Hawaiian Islands is young, and it started only after the archipelago was discovered by James Cook in 1768, present volcanological studies have a high standard there. The American scientist Thomas A. Jaggar together with Ernest Shepherd founded a Volcanological Observatory on the Big Island (Hawaii) already in 1912, which, at present, rates among the best observatories in the world. The date of foundation is fascinating, when we realize that in times, when the native ethnics just tried to organize its first administration, the volcanological research actually advanced.

Figure 81 presents a typical example of the amazing closeness of volcanic manifestations and tropical scenery of the Hawaiian Islands. This picture, a hand-colored copper engraving, signed by J. Archer, was published by H. Fischer & Sons, London, in 1826. As a matter of interest, note an isolated green tree standing in the lava field not far from a burning pipe. Did this tree really grow up there, so close to a fissure when the solidifying lava was only getting colder? Or, was this scene just a fantasy of the artist? Viennese publisher F.J. Bertuch used the older copies of the original Fisher's paintings in his pictorial encyclopedia; however, his colorist expressed the volcanic gases in blue, similar to hot water or steam outputs and stultified a geyser from the volcano. Somewhat free rules on how to illustrate natural events at the beginning of the nineteenth century should be carefully examined before full confidence is assigned.

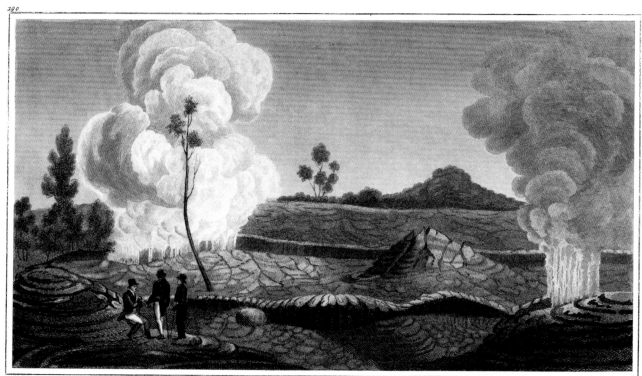

The Burning Chasms at Ponahohoa.

London: Published by H.Fisher, Son,& P.Jackson, March 31,1826.

Fig. 81 *"The burning chasms of Panahohoa"*. Hand colored copper engraving. Private collection, Prague

Kiyev Earthquake, 1230

The Russian handwritten chronicle *Povest vremennikh let* (= Myths of the temporary years) was created in the second half of the sixteenth century on the command of the Russian czar Ivan the Terrible (1530–1584). The chronicle was based on old written records on the history of the country and gathered from older chronicles and other sources. The original is now kept in the Central Library in Moscow (former Lenin State Library); the above image (Fig. 82) was mediated by courtesy of A.A. Nikonov, Moscow.

The portrayed scene was a poor fantasy of the artist, possibly only four inclined columns (knocked down by an earthquake) might have indicated some seismic effects described in the accompanying text. In agreement with the narrative story, groups of people keenly discuss the event. The illustration is, however, related to the true matter of fact. The Russian seismologist A.A. Nikonov suggested that the tremor of the earthquake, which was felt at Kiyev in AD 1230 and was recorded in many documents, had its epicenter in the seismically active Vrancea zone in Romania. The repercussions of the earthquake were felt as far as 1,250 km and its magnitude was later assessed as $M = 7$. In the sixteenth century chronicle, we may find, in total, four illustrations depicting various consequences of seismic events in Ukraine or in the central parts of European Russia, which occurred between AD 1130

(date of the earthquake felt at Rostov-the-Great) and the date when the chronicle appeared completed.

As the territories of Eastern Ukraine and the whole Russian platform are seismically quite inactive, it is very probable that all earthquake images in the *Povesti vremennikh let* were indeed related to seismic events, which occurred at Vrancea. The Vrancea region, located in the abrupt arc of the southeastern Carpathians, is a zone where deep earthquakes ($h \approx 70$–180 km) originate along the sunk slab, part of the submerging Black Sea tectonic microplate. Earthquakes of magnitude $M = 7$ and more may occur here, approximately three times per 100 years. Seismic energy is generally radiated to the northeast, which is in the direction toward Kiyev.

Another earthquake of $M > 7$ occurred in Vrancea in 1802, which caused extensive damage to Bucharest, was felt not only in Istanbul and Ukraine, but also as far as in Sankt–Peterburg. The devastating Vrancea earthquakes may occur even today; two destructive earthquakes can be remembered, namely the 1977 earthquake ($M \approx 7.5$, with over 1,500 victims and 11,000 wounded) and the 1986 event ($M = 7.2$, two dead and over 500 wounded), during which thousands of people in a broad region between Kagul and Kishinev, some 250 km northeast of the epicenter in Vrancea, lost their houses.

J. Kozák and V. Čermák, *The Illustrated History of Natural Disasters*,
© Springer Science+Business Media B.V. 2010

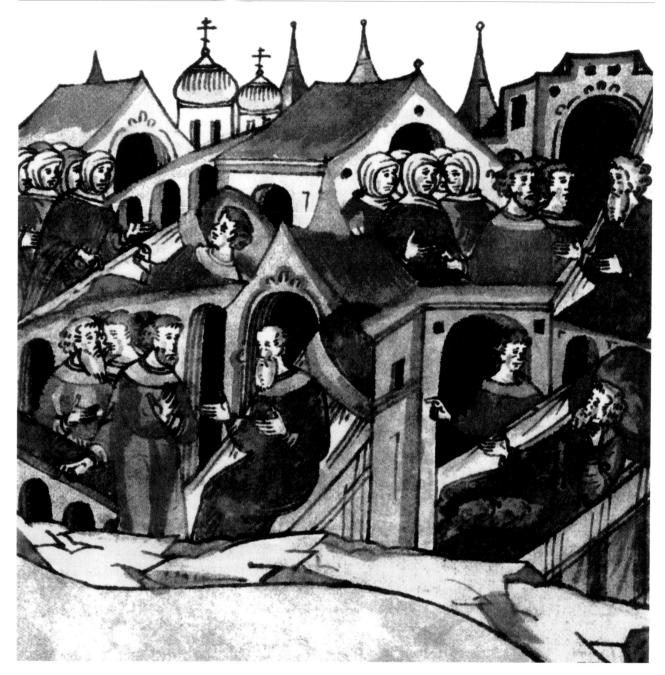

Fig. 82 The 1230 Kiyev earthquake (Ukraine). Watercolor (aquarelle) painting, second half of 16th century. Copy in private collection, Prague

Aix-en-Provence Earthquake, 1708

Figure 83 presents a landscape scene in southeastern France, near the town of Aix-en-Provence, which was affected by an earthquake in 1708. The original copper engraving, probably a German leaflet illustration entitled *Erschröckliches Erdbeben in Provence*, is deposited in the Bibliothèque Nationale in Paris. The image was not signed and its origin was not identified.

The earthquake struck on August 14, 1708 and its intensity was assessed as I_0 = VIII–IX on the MCS scale. The epicenter was located in tectonically unstable region of the Durance River valley near a small settlement Manosque. Several other earthquakes were experienced there later, in 1812 and in 1913, which similar to most of the quakes occurring on the French Mediterranean coast were a response to the deformation processes occurring along the southern rim of the Eurasian tectonic plate. The African plate had collided there with European continent; however, its movement was rather slow with a maximum of 6–7 mm per year, and therefore also seismic activities of the region were moderate and earthquakes were not frequent.

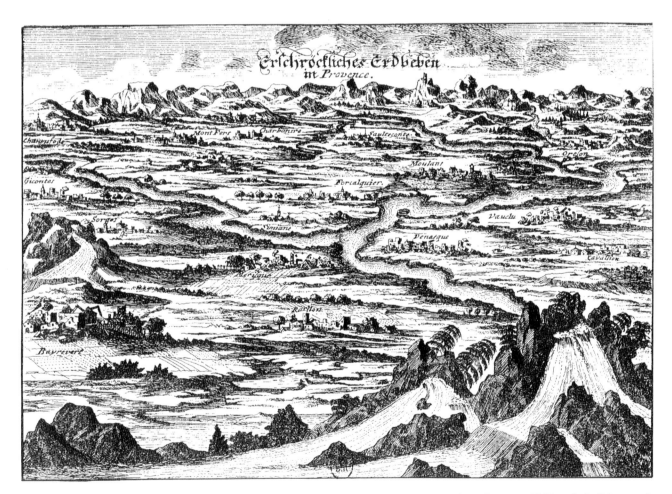

Fig. 83 The 1708 Aix-en-Provence earthquake. Copper engraving, artificially composed country view. Courtesy of J. Vogt, Paris. Print copy in private collection, Prague

J. Kozák and V. Čermák, *The Illustrated History of Natural Disasters*,
© Springer Science+Business Media B.V. 2010

The above composition presents an interesting compromise between a geographic map – still difficult to understand for the general public of that time – and a common side country view. The true view itself could not embrace the whole broad region affected by the catastrophe and the artist thus had to make a certain concession and combine both illustration techniques. Looking at the composition, we cannot but recollect a similar earthquake, which occurred in this Cisalpine corner of France in 1564. We know that this seismic event was, actually for the first time, expressed in a geographic map, but its macroseicmic evaluation did not find admirers and appeared only in few trial copies. Even one-and-half century later (after the 1564 event), the 1708 earthquake effects were still presented in a commonly understandable way, that is, depicted as natural side country view, rather than expressed in geographic map.

Basel Earthquake, 1356

The 1356 Basel earthquake, also known as the Great Basel Earthquake, belongs to the most significant seismological events which occurred in Central Europe in the whole recorded history. The earthquake was felt widely across a greater part of continental Europe, with reports on the event from as far away as Paris in the west and Prague in the east.

The earthquake's epicenter was located in the Swiss Jura Mountains, ~25–30 km southwest of the Basel town, in the depth $h = 10 \pm 5$ km. The maximum range of the earthquake perception was about 800 km in diameter and the pertinent iso-seismal area covered ~500,000 km². The number of casualties was assessed as 1,000–2,000 (Tiedemann 1991; ECOS 2002).

According to the historical accounts, a precursory shock occurred between 7:00 p.m. and 8:00 p.m. local time on October 13, 1356, followed by the main earthquake, which struck later in the evening, around 10:00 p.m. Numerous aftershocks followed during the next day and night. Damages to buildings were recorded not only in the Basel, Blauen, and Hauenstein regions of Switzerland, but also in the Sundgau region of France and in the Baden-Würtemburg region of Germany.

The city of Basel itself was heavily damaged; historical records reported that no church, tower, or house of stone in the town or in the suburb endured, most of them collapsed. The town also suffered from fire, which followed the quake itself, when torches and candles falling to the floor set the wooden houses ablaze. Damage to buildings in the surrounding region was well documented by Swiss chroniclers in the fourteenth to seventeenth centuries, e.g., by Münster (1544), or recently by Mayer-Rosa and Wechsler (1991).

The maximum seismic intensity I_o was assessed between VIII and X on the MSK scale. Notably, a macroseismic map was established on the basis of damage reports collected from the surrounding regions/counties. Making use of these macroseismic data, the earthquake magnitude could have been estimated at around $M \approx 6.2$.

The total number of casualties of the Basel earthquake is uncertain. Contemporary fatality assessments ranged from several hundreds to several thousands. The "*Chronicle of Basel*" suggested that around 300 fatalities occurred within the city of Basel alone. It is possible that the occurrence of a precursor event several hours before the main shock could contribute to relatively few casualties of the event; people had time to get into safety.

Locating the 1356 Basel earthquake epicenter proved a significant challenge. On the basis of the peak intensity observations, the epicenter of the event was most likely located around 10 km or more south of the city. Several authors proposed locations of this earthquake to a zone ranging from a north-northeast to south-southwest trending normal fault along the Basel-Rheinach scarp that bounds the Rhine Graben to the east-west trending thrust fault beneath the Jura Mountains ridge. It is not clear from the historical records whether the effects of this event appeared also as the ground surface ruptures. However, global studies suggested that the events of this magnitude occurring at a shallow depth would cause surface rupture in most cases. A more detailed investigation on the event including pertinent literature search was presented by Wechsler (1987).

The hand-colored woodcut print of anonymous origin (Fig. 84) showing the city of Basel ruined by the 1356 earthquake and by consequent flood of the agitated Rhine River is actually of a much younger origin and was most probably created only in the sixteenth century. It is probably a fantasy of an artist whose illustration possibly leaned on verbal description of the event.

Earthquakes in Switzerland are of a regular occurrence. Recent researches on the earthquake potential of the area argue that a large future earthquake cannot be excluded. Based on archeological excavations, it was confirmed that the earthquake, which destroyed the Roman city Augusta Raurica in AD 250, was located only 10 km east of Basel. Results of recent palaeoseismological studies indicate that the Basel-Rheinach fault was most likely responsible for the 1356 earthquake. Meghraoui et al. (2001) demonstrated that at least three earthquakes occurred in the past 8,500 years along this fault and that the most recent event

J. Kozák and V. Čermák, *The Illustrated History of Natural Disasters*,
© Springer Science+Business Media B.V. 2010

Nur kleine Vorstellung von diesem erschrecklichen Erdbeben.

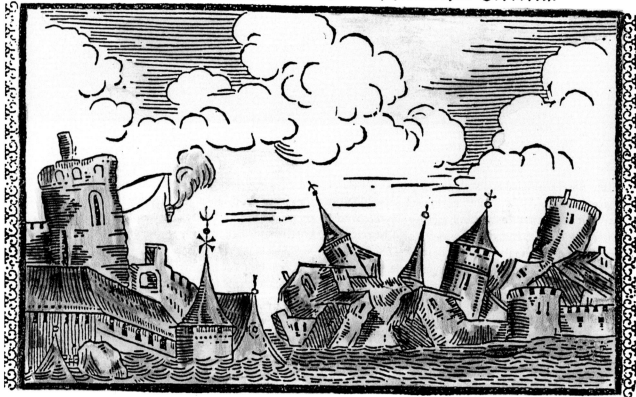

De terræmotibus Basileæ factis

Fig. 84 The 1356 Basel earthquake. Hand colored 16th century woodcut, fantasy composition. Private collection, Prague

(constrained to occur between AD 650 and 1475) might correspond to the 1356 event. The debate continues; in the absence of primary evidence, some uncertainty remains concerning the exact localization of the 1356 event.

However, if the Basel-Rheinach fault was responsible for the discussed Basel earthquake, then the recurrence interval of the 1356 earthquake can be estimated between 1,500 and 2,500 years.

Rhodes Earthquake, 1481

Figure 85 illustrates a written document describing the 1481 Rhodes earthquake prepared by Guillame Cocursin (1496). The hand-colored woodcut portrays the town Rhodes, located on the Greek island of the same name, heavily damaged by an earthquake on May 3, 1481. Actually, a series of earthquakes vexed Rhodes for 10 following months in 1481; the second strongest event occurred on October 3, the same year.

In the middle of the scene, a group of Johannites may be recognized; a sect of Gnostics who proclaimed John the Baptist as the true savior of the world (sent to the World to fulfill the Old Testament prophecy), not Jesus Christ. In the picture, Johannites ornamented with a red cross are praying, kneeling on the yard of their castle. The Johannites functioned in the Rhodes fortress between 1310 and 1522. It is easy to identify the town topography, which was presented authentically and quite correctly. The location where the original artwork is deposited is not known.

The tectonic situation on the contact of the African and Eurasian plates is of complex character; in the Eastern Mediterranean, the contact zone first turns to the south along the western coast of Turkey and then toward the east. The Island of Rhodes is located in this area. The whole region is known for frequent earthquakes. One of them, illustrated in Fig. 85, most probably belonged to a group of earthquakes having the epicenters under the Sea of Crete or in SW Anatolia (intensity of up to I_o = VIII–IX, MSK-64). These earthquakes were usually strong enough to generate series of seawater waves, tsunamis, further devastating the littoral settlements.

Contemporary reports, describing the Rhodes event, claimed that the trembling of the Earth, which occurred at 3 a.m. in the night of May 3, 1481, was accompanied by a strong wind coming from the stormy sea. *"[S]ea water level rose more than ten feet high and flooded the coastal land threatening to the city of Rhodes with total destruction...the ground was shaken seven times that day..."* (Antonopoulos 1980).

The list of historical earthquakes, which occurred in the region of the Aegean and Crete Seas, is long. The oldest known earthquake visited Rhodes in the year 303 BC, being followed by series of strong quakes between 227 and 216 BC. One of them was probably the one which destroyed the city of Rhodes. By this event, the giant statue of Colossus, erected near the harbor entrance, one of the Seven Wonders of the ancient world collapsed. The seismic unrest, expressed by both earthquakes and seaquakes, continued sporadically during all later centuries, when many Greek and later Roman settlements in the area were severely damaged. The most horrible earthquake in the Eastern Mediterranean occurred on July 21, 365, AD, the epicenter of which was located under the sea southwest of Cyprus. It is difficult to assess the pertinent losses because the nearest Greek town Kurion had already been heavily damaged by the preceding earthquake(s) in the year 332 (or 342?). Direct evidence and written reports from Cyprus or from southern Turkey are missing, but according to huge tsunami waves, which smashed Egyptian port Alexandria, 400 km distant, and killed thousands of people there, the AD 365 earthquake magnitude must have been at least M = 7.5.

Urbs Rhodia labefacta: Terremotu.

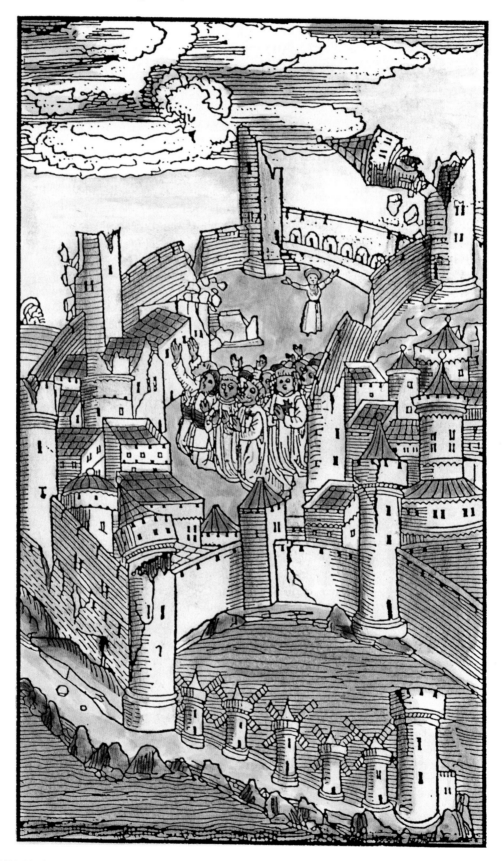

Fig. 85 The 1481 Rhodes earthquake. Anonymous, hand colored woodcut. Private collection, Prague

Istanbul Earthquake, 1566

Figure 86 is an illustration of a contemporary German broadsheet report on the earthquake in Istanbul, which occurred on May 10, 1556. The hand-colored woodcut, the work of Hermann Gall at Nürnberg, was printed and distributed in the same year (Deresiewicz 1982). The picture shows a heavily damaged Hagia Sophia Temple, a famous mosque in the town. Its three slim corner columns collapsed, and other buildings, palaces, churches, and great part of the city walls and gates were turned into ruins. The inhabitants panicked, aimlessly fluttered away, and tried to flee and get out of the city port. As mentioned in the broadsheet text, the disaster had been preceded by an appearance of a comet on March 5, which continued to be visible for 12 consecutive days. In the view of Middle Age Europeans, any advent of a comet was an omen of the potential incoming cataclysm such as a war, havoc, or natural disaster.

However, the 1556 earthquake (I_o = VIII) was not the strongest seismic event, which has stricken Constantinople in its history. Some 50 years earlier, the city had been affected by another, even worse disaster. On October 10, 1509, an earthquake of the intensity of I_o = X, followed by many aftershocks, completely devastated 109 mosques, over 1,000 houses, and a substantial part of the city fortifications; some 13,000 people died. Large losses were experienced also in the surrounding settlements, partly caused by tsunami waves initiated by the quake. The earthquake effects were felt as far as in Greece, Romania, and at the Nile Delta (Ambraseys 2001)

Strong earthquakes in Turkey are not rare. The major fault system of the transform Anatolian Fault runs through northern Turkey and crosses the Marmara Sea, where seismic activities culminate. The tectonic structure of the area, which creates a link connecting the Alpine and Himalayan mountain belts, is complex; the border zone of the European plate is broken there into several microplates, which move individually.

Geoscientists can assess possible location and approximate magnitude of the future earthquakes, but they cannot predict the exact time when this might happen; the predictions have only a statistical character. It was assessed that Istanbul would be threatened by a similar strong earthquake within the next 30 years with a 60% probability.

J. Kozák and V. Čermák, *The Illustrated History of Natural Disasters*,
© Springer Science+Business Media B.V. 2010

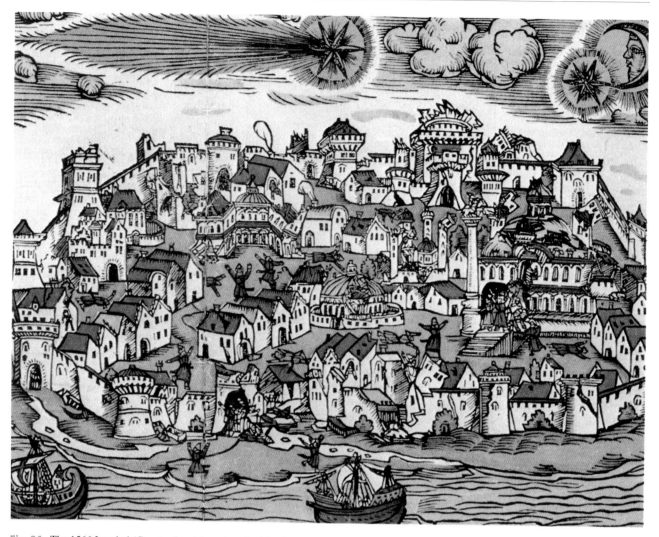

Fig. 86 The 1566 Istanbul (Constantinople) earthquake. Hand colored woodcut. Private collection, Prague

Two Earthquakes at Yedo (Tokyo), Around 1650 (?) and in 1855

Japan is a country of more than 3,000 islands extending along the Pacific coast of Asia. Its location on the Pacific Ring of Fire, gives Japan frequent low-intensity tremors and occasional volcanic activity. Destructive earthquakes, often accompanied by tsunamis, occur several times each century. Most of us can still remember two recent major quakes, which struck Japan, namely the 1995 Great Hanshin Earthquake and the 2004 Chūetsu earthquake.

Tectonically, Japan is located at the western rim of the giant Pacific plate, where three other large plates meet, namely Eurasian, North American, and Philippine; thus, Japan is exposed to the consequences of the subduction processes constantly running there, where the Pacific tectonic plate submerges under the continental Eurasian plate and partly also under the North American plate. These circumstances allow classifying Japanese archipelago as the region where its inhabitants may have an everyday experience with earthquakes, tsunamis, and volcanic eruptions.

Yedo and Yedso are the old Japanese names of Tokyo. The mid-seventeenth-century picture (Fig. 87) of an alleged earthquake in Tokyo combines seismic event with a volcanic eruption. The scene was painted by an anonymous European drawer accompanying A. Montanus, the officer of the East Indian Company. The copper engraving illustrated the general report on the Japanese Empire composed by Montanus and published under the title *Denkwürdige Gesandtschaften der Ost-Indischen Gesellschaft...Kaiser von Japan* (Montanus 1669).

The earthquake manifestations were presented quite dramatically; crevasses and subsequent depressions appeared in the ground, light wooden constructions collapsed down, and the town population panicked around. Such a scene may well illustrate an earthquake of the intensity at least $I_o = X$, EMS-98. It is of interest that this picture, which presented one of the oldest known illustrations of a Japanese earthquake, was created by a European, regardless of the fact that the liking for observing nature events had always been very popular in Japan. The corresponding text to the picture, however, did not hold any concrete information that would enable to identify the event. Similar earthquakes were frequent in Japan; however, the differences between the European and Japanese old calendars did not allow setting the correct date of the

event. Furthermore, it is not clear whether the painting was inspired by own experience of the artist or whether it was drawn according to a narrative story of someone. In any case, Montanus' illustration deserves our appreciation, both for the high professional composition level and for its volume of macroseimic information.

The Japanese art of depicting dynamic natural events has always been very specific, since the Japanese way of pictorial documentation grew up and developed from a quite different cultural background than that in Europe. Until the 1860s, when the Meiji era came into existence, Japan and its population had lived in an isolated world, which by far preferred the artistic value of a painted composition rather than its topographic correctness.

For a European artist of the first half of the nineteenth century, common Japanese paintings, especially those portraying large segments of the countryside, sometimes seemed simple and primitive. Many Japanese illustrations of that time had no perspective; they did not respect any distance-size requirements. Also, the proper explanation of the nature of earthquake and volcanic phenomena in the pre-Meiji period had not troubled Japanese savants much. According to a widespread mythological concept, the evil causing earthquakes had a shape of a giant catfish living deep under the Earth's surface. When it moved, it caused a trembling of the Earth surface.

As an example of Japanese early earthquake interpretation, we present a woodblock print (Fig. 88), illustrating a traditional Japanese catfish myth. The inscription states that the misfortune sent from the heaven deprived the rich people and reworded the poor (Bolt 2006). After Japan opened to the outer world in the 1860s, both modern scientific level of understanding the natural disasters and technically correct pictorial representation were quickly installed. And, in some aspects, Japanese artists and scientists even appeared to excel their overseas teachers.

A strong earthquake struck Tokyo in 1855, which was actually one of the most destructive shocks that had ever afflicted the town. This earthquake considerably contrasted other shocks felt there. Actually, most Tokyo earthquakes have their epicenters to the east from the mainland in the Pacific Ocean, where three tectonic plates meet. Here, the

J. Kozák and V. Čermák, *The Illustrated History of Natural Disasters*,
© Springer Science+Business Media B.V. 2010

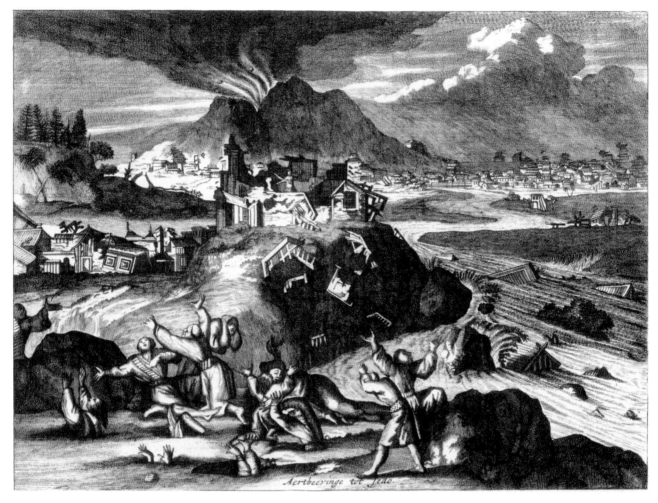

Fig. 87 The 1650 Tokyo/Yedo earthquake accompanied by a volcanic eruption. 17th century copper engraving. Private collection, Prague

Philippine plate submerges toward the north along the Sagami trench, and the Pacific plate submerges under the North American plate. Several other disastrous earthquakes occurred there, for example, the 1703 Genroku earthquake and the 1923 Kanto earthquake, which strongly affected Tokyo. However, the epicenter of the 1855 earthquake, of magnitude ~7, was located on land, directly below the city. Its aftermath was gruesome, not only by the number of victims, but also because of numerous subsequent fires.

Let us examine, by means of the example of this strong 1855 earthquake, how the illustration techniques changed in the transition period when the age of traditional Japanese political, cultural, and scientific isolation was terminated and a new age of rational thinking of the Meiji period was emerged.

The Japanese depictions, which portrayed the 1855 Tokyo earthquake, were usually marked by pictorial elements still related to both above-mentioned cultural eras. Figure 89 may serve as a good example: in the bottom part of the picture, we can see a realistic scene of that time Tokyo, one-floor village-type houses heavily damaged by an earthquake,

and some in fire. The upper part is dominated by the divine sky riders controlling the situation from above; the principal god at the left keeps a heavy stone prepared to throw it down to neutralize the catfish responsible for the earthquake according to traditional mythic interpretation.

In the depictions of the same event, which were created later, when the new spirit based in great deal on the European standards dominated, traditional mythological standpoints were abandoned and the earthquake effects became similar to those familiar in Europe and elsewhere. Modern Japanese illustrations of earthquake effects were often focused on human disaster seen "in a short distance." For example, we reproduce two segments (Fig. 90) of modern images by Arai Shurio who portrayed the 1855 event sometimes later, in the 1880s. His realistic illustrations were reproduced in the book on Japanese poetry (Florenz 1890).

In general, among countless woodblock prints created in Japan in the course of eighteenth and nineteenth centuries many portraits of earthquake and tsunami effects can be found. Recently, a splendid book on this subject was launched in Japan, in which the most famous woodblock

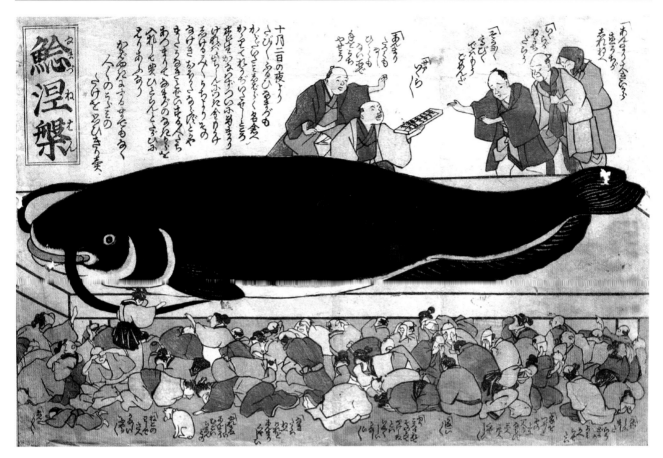

Fig. 88 Japanese wood-block print showing a mythic catfish that causes earthquakes. Private collection, Berkeley, California. Courtesy of Ms. B. Bolt

compositions of the Earth's dynamical manifestations are reproduced and commented (Kitahara et al. 2003). This marvelous pictorial collection documents well that earthquakes, tsunamis, and volcanic effects always presented an important part of life in Japan. In contrast, in China, where disastrous earthquakes also occurred frequently in history, no depictions of earthquakes can be found. A chief present Chinese seismologist at the State Seismological Bureau in Beijing, when asked why no historical images of earthquake disasters exist in China, simply answered: "*because they are not nice. We, in China, paint only beautiful and pleasant motives.*"

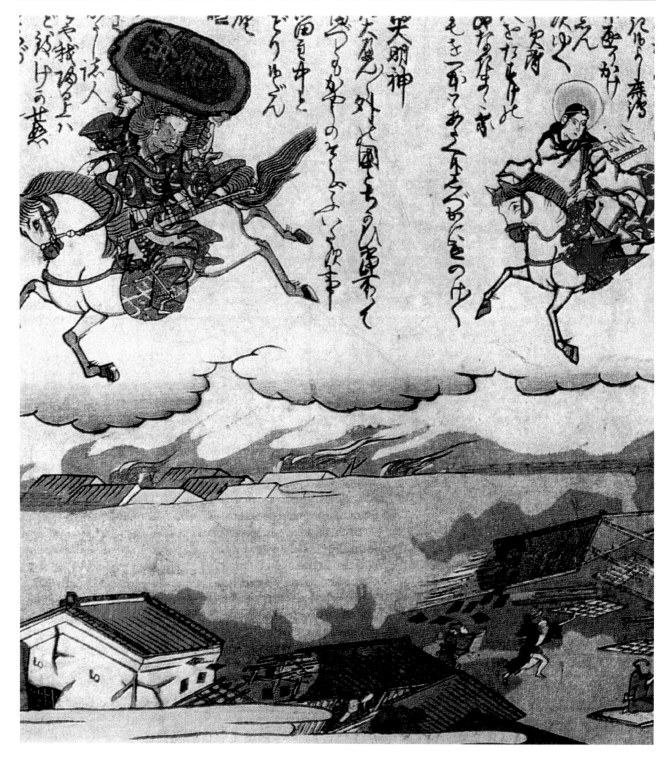

Fig. 89 An allegorical scene related to the 1855 Tokyo earthquake. Color Japanese woodblock print of the mid 1850s. Copy in the private collection, Prague

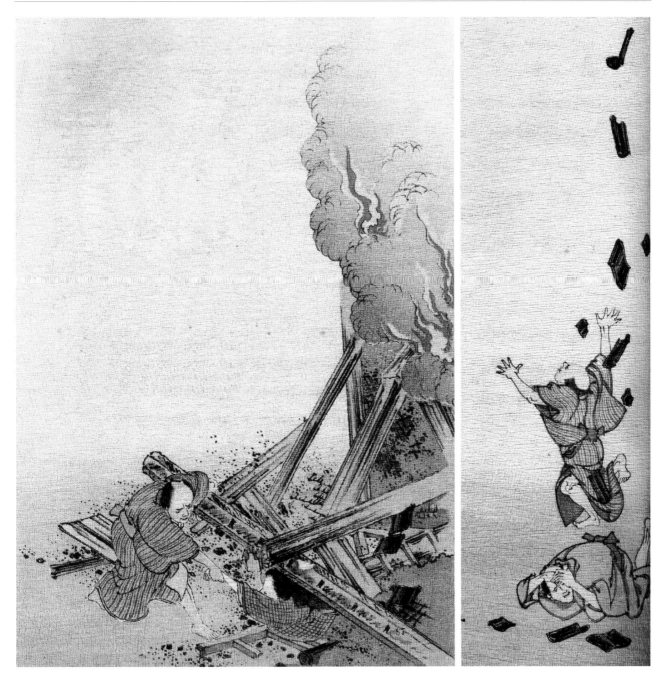

Fig. 90 Two segments of woodblock illustrations by Arai Shurio (Florenz, 1890s). Private collection, Prague

Earthquake at Port Royal (Jamaica), 1692

Jamaica is situated on the northern rim of the Caribbean tectonic plate, near the Cayman trench. Many earthquakes originated in this region, which were felt in Jamaica as well as in Cuba. However, epicenters of some quakes might have been located directly in Jamaica, and their impacts were more destructive, for example, the events in 1687, 1692, 1781, 1812, or 1907.

Figure 91 presents a contemporary broadsheet (black & white copper etching) informing about the misfortune, which happened in Jamaica. The picture is introduced by a title saying, *A True and Perfect Relation of that ... Earthquake, at Port-Royal in Jamaica, which happened on ... 7th of June 1692*. The broadsheet was originally composed, printed, and published in London by G. Smith at the end of the seventeenth century, and only after more than two centuries, it appeared in the book entitled "The Governors of Jamaica in the Seventeenth Century" (Cundall 1936).

The picture shows the town of Port Royal in Jamaica heavily damaged by the earthquake on June 7, 1692. The scene was portrayed in an oblique view oriented from sea toward the coast. At the first sight, it is noticeable that – as concerns the seismic damage – the town can be subdivided into two different parts. While the offshore part of the town located in the background was practically untouched by the shock, the front part adjacent to the sea, above all the harbor and its closest vicinity, was presented as completely ruined.

The illustration, seen from an elevated position above the sea level, holds valuable macroseismic information enabling to reexamine the earthquake effects. Simultaneously, the picture gives a good example to demonstrate how a historical image of an earthquake may be today understood and analyzed. Kozák and Ebel (1996) used this illustration to explain an unusual phenomenon expressed clearly in the depiction, namely a sharp detectable division line in the image separating the undamaged and the ruined parts of the city. Making use of the complementary verbal information of the event, attached to the depiction, it was possible to ascribe the total destruction of the town not only to the earthquake, but also mainly to the ground liquefaction effects. Triggered by a seismic tremor, these effects caused a sandy segment of the shore, on which a part of Port Royal was built, to brake away and slip down into the sea including houses and people in it. The number of casualties of this earthquake was assessed between 2,000 and 3,000. It appeared that the primary earthquake effects were considerably lower than the resulting surface-slip effects initiated by the quake; however, the quake was strong enough to trigger the process of liquefaction and subsequent ground slip.

These considerations resulted in the substantial lowering of the maximum earthquake intensity. The event was classified by a magnitude $M = 7.7$ in the DNAG catalogue (Engdahl and Reinhart 1991), which corresponds toa maximum intensity $I_0 = X$ (MM scale). However, taking into account the historical pictorial materials, such as presented above, this classification may be lowered to about $I_0 = VII$ (MM scale).

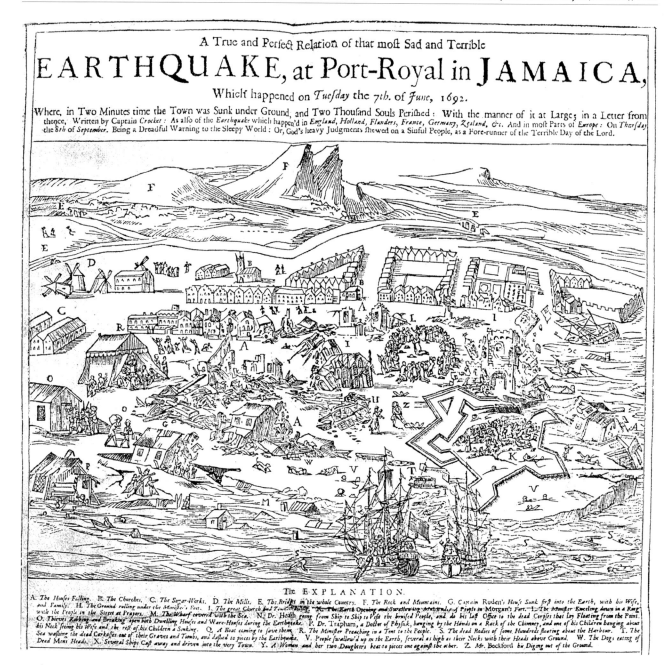

Fig. 91 The 1692 Port Royal earthquake, Jamaica. Copy in private collection, Prague

Great Lisbon Earthquake of 1755

At the middle of the eighteenth century, Lisbon, capital of Portugal, was one of the finest, wealthiest, and most beautiful and luxurious towns in Europe. It was Europe's fourth largest city, after London, Paris, and Naples. Situated on the edge of the Atlantic Ocean, at the latitude that – by courtesy of sea breezes – provided an agreeable climate, it was Europe's major maritime gateway to the world, through which a substantial part of the European expansion and colonization had passed.

The 1755 Lisbon earthquake, known also as the Great Lisbon Earthquake, struck at 09:40 a.m. on Sunday, November 1, 1755, the Catholic holiday of All Saints Day. That was the time, when most of the godly citizens of Lisbon were at prayer. The earthquake lasted between 3 and 6 min. Contemporary reports stated that the earthquake ruined a great deal of the city edifices and caused gigantic fissures 5 m wide to appear in the city center. Approximately, 40 min later, a huge tsunami wave entered the mouth of the Tagus River and hit the coastal quarters of Lisbon and other settlements located along the river estuary banks; the first wave was followed by two more waves. Overthrown hot stoves in many kitchens initiated numerous local fires that resulted in vast and all fusing flaming inferno which completed a near-total destruction of Lisbon. The time of the earthquake and its position in an area of fairly shallow water were the main factors that contributed to such devastating effects. Eighty-five percent of the Lisbon houses were ruined or heavily damaged. The event was one of the most destructive and deadly earthquakes in European history. Of Lisbon's population of ~275,000, 40,000–60,000 people were killed.

The 1755 Lisbon earthquake is commonly classified as the strongest seismic event, which has ever occurred in Europe; its magnitude was assessed as approaching to $M = 9.0$ (corresponding to epicenter intensity of $I_o =$ XII, on the 12-degree EMS-98 macroseismic intensity scale). It is believed that the hypocenter of the event was located under the bottom of the Atlantic coastal waters, some 200–220 km south-southwest of Cape St. Vincent, in the collision zone between the African and Eurasian tectonic plates. Modern Portuguese seismological researches, however, moved the epicenter location eastward and placed it on the Pombal Scarp running in north–south direction along the Portuguese coast (Baptista et al. 1998).

Material losses to buildings and constructions by tsunami and earthquake were recorded not only in Lisbon, but also in a great deal of Portuguese territory (including Azores) and partly also in southwest Spain and in the attached coast of Morocco in Africa. The zone of seismic perception extended as far as Scandinavia, Central and Western Europe, North American coast, West Indies, parts of Brazilian coast, and to most of the north-western coastal zones of Africa. The assessed number of casualties varied from 40,000 to 100,000. For a more detailed description of the event, see e.g., Kendrick (1956), Fonseca (2004), or Kozák et al. (2005).

Figure 92 shows the city heavily damaged by the earthquake. From the left, a giant tsunami wave overwhelms the city. People are seen in tossing boats. The situation was viewed from the southeast, over the River Tagus. Although this depiction appears to be based on more-or-less a true portrayal of the city, excess of invention of the painter distorted the image authenticity; we may only anticipate that the composition was created according to verbal description of the disaster.

The bilingual text-legend in Latin and German in the central part of Fig. 93 gives a brief description of the 1755 earthquake and its effects in the town. A bulky decorative copper engraving was created in the cartographic workshop of Tobyas Konrad Lotter in Augsburg, shortly after the Lisbon catastrophe in November 1755. The upper part of the picture presents a view – rather a town map – before the earthquake. This part of the composition is a copy of an anonymous view published in Braun-Hogenberg's "*Civitates Orbis Terrarum*" of 1572. Lotter actualized the sixteenth century vedute by sketching it in a baroque fortification in front of the "New royal residence" onshore the Tagus River. In the lower part of the print, we can see the natural side view of the town devastated by the earthquake and consequent fires; in the foreground, many boats with people aboard are tossed on the agitated stormy Tagus river waters.

This composition is a variant of a similar sheet, which had been published by Matthias Seutter, editor and engraver in Augsburg, some years before the earthquake; of course, that time, in the lower part of the print, flourishing "pre-earthquake" Lisbon was shown in its full beauty. Konrad Lotter, the author of the prospect, pasted the earthquake consequences into Seutter's agreeable composition, and did not worry much about the authenticity of his depiction. Seismic damage to individual objects was illustrated according to word of mouth, and when not sure, the drawer mercifully clouded the respective localities by smoke of fires. Also, two small volcanoes shown on the vedute borders were added through drawer's own effort to increase the dramatic impact of the scene of disaster.

The print is anyhow also interesting for another reason; it never appeared as a part of any Lotter's atlas but was fabricated in a few solitary copies only. One can judge that these solitaire prints were intended as model images and thus issued in a limited number of copies to be shown to the Atlas dealers of the Lotter's printing office. Perhaps, this solitaire prints might have served as a preview for the potential buyers and prescribers to decide whether this print should be included into the new Atlas edition. We may only anticipate that the common opinion was not inclined to file this "ugly" print into the new Atlas editions so that it became forgotten in just a few copies. As far as the authors know, except the copy presented here there exist at least three other partly colored prints – exemplars of Lotter's Lisbon earthquake, one of them being deposited in the Municipal Museum of Lisbon.

In the areas less affected by the earthquake and tsunami, numerous fires finished the picture of complete devastation; flames raged for five subsequent days (Fig. 94). Many Lisbon buildings including famous palaces and libraries were destroyed, as well as many examples of Portuguese distinctive sixteenth-century Manueline architecture. And again, buildings that had suffered relatively little by the earthquake itself were burnt off by fire. For example, the new Opera House, opened just 6 months before (under the ill-fated name Phoenix Opera), burnt completely except of its vertical stony outer walls. The Royal Ribeira Palace, which stood just beside the Tagus River in the modern square of Terreiro do Paco, was destroyed by the earthquake and the tsunami. Inside the Palace, the 70,000-volume royal library as well as hundreds of works of art, including paintings by Titian, Rubens, and Correggio, was lost, too. The royal archives disappeared together with detailed historical records of oversea discoveries by Vasco da Gama and other early navigators. The earthquake also damaged major churches in Lisbon, namely the Lisbon Cathedral, the Basilicas of São Paulo, Santa Catarina, São Vincente de Fora, and the Misericordia Church. The Royal Hospital of All Saints (the largest public hospital at the time) in the Rossio Square was consumed by fire and hundreds of patients burned to death. The tomb of the national hero Nuno Alvares Pereira was lost, as well.

Today visitors to Lisbon may still walk the ruins of the Carmo Convent, which were preserved to remind Lisboners of the destruction. Figure 95 remembers the Lisbon tragedy as a simple primitive imaginary illustration which appeared in the contemporary Czech leaflet. The image was topographically and factually mistaken (note the volcanic manifestations and falling pieces of hot lava).

Lisbon was not the only Portuguese city affected by the catastrophe. Throughout the south of the country, in particular the Algarve, destruction was equally rampant. Here the effects of the disastrous tsunami reinforced the destruction caused by the earthquake. The earthquake was felt throughout the Iberian peninsula, in southwest France, in much of Morocco, where another 10,000 people lost their lives, and in the Madeira archipelago. Everywhere the earthquake caused damages, deaths, and injuries. In mainland Portugal, the seismic intensity reached the maximum in the areas between Tavira and Cape St. Vincent, in Evora region, and in Algarve. Shock waves of the earthquake were felt throughout most of Spain; two death tolls were reported from Madrid.

To avoid falling ruins of the houses in the narrow streets, many people naturally sought safety in the open places. Many tried to board the ships anchored on the river bank, many assembled in the lower land toward the open sea. The water along the sea shoreline first dramatically receded, widely exposing the sea bottom; however, some minutes later, an enormous sea wave came from the ocean, continued up the Tagus River further upstream, sweeping away everything and causing further devastation. Some boats, overcrowded with refugees, were overturned and sank, several boats were thrown on the shore, and hundreds of people were swept away and perished. In coastal regions the destructive effect of tsunami was greater than the effects caused by the earthquake itself.

The tsunami waves were strong in southwest Spain, along the coast of the Gulf of Cadiz, where the sea waves penetrated into the Guadalquivir River, reaching Seville. At Gibraltar, the sea level suddenly rose by about 2 m. On the northwestern coast of Africa, the tsunami was strong but it attenuated rapidly in the Mediterranean Sea. The tsunami reached most of the western European coast, as far as southern England where 3 m waves were reported. Huge sea waves crossed the Atlantic Ocean, struck Martinique and Barbados, where the sea visibly rose at the first amplitude before the succeeding wave came with a greater amplitude.

Figure 96 presents a typical illustration of a natural disaster, which appeared in the popular encyclopedic volumes in the second half of the nineteenth century. The illustration is simplified and highly stylized and does not enable the reader to make a concrete idea to evaluate the earthquake consequences. The author's interest was primarily focused on the agitated Tagus River and sinking ships.

As if the earthquake and tsunami were not enough, the Lisboners had to endure yet another trial – the devastating

fire. The earthquake occurred at a time when most people were preparing for their All Saints' Day Sunday lunch and had their cooking fires on. Immediately after the earthquake the first fire foci appeared. Some fires were extinguished, however, in some parts of the city, especially in the densely populated urban districts, now abandoned by their inhabitants, flames spread quickly around. After a short time most of the unhappy town appeared to be in flames. Narrow streets, full of debris, blocked an access and slowed down any efficient fight with the fire. No wonder that the fire grew to catastrophic dimensions. It is sad to say that in some cases the fires were set to camouflage looting. The fire raged for 5 days, and the work of destruction was completed. The total burned area of more than 300 ha together with a number of destroyed houses, palaces, human victims, and all losses were comparable to other historical great fires of London (1666), Chicago (1871), or to a huge fire that accompanied the San Francisco earthquake in 1906.

We may quite rightly anticipate that a seismic event of the size of the Lisbon earthquake was preceded by a long-term process resulting in extremely large concentration of tectonic stresses in the focal zone and in its vicinity. Such underground course of strong earthquake "preparation" is usually manifested by the occurrence of various unusual surface phenomena, which could not escape the attention of local inhabitants.

Today we know that these precursory phenomena really appeared in many localities of Portugal. Strong foreshocks, which had been felt in Lisbon, Alenquer, Aveiro, Portalegre, Madrid, Alcalá, Carmona Lebrija, Cadiz, and in several other places occurred only few days before November 1, some appeared shortly before the main shock. Other unusual manifestations were observed, such as strange gaseous exhalations, repugnant smell of water in wells and fountains, water-level changes, agitation of domestic animals, etc. The quaintest report came from Cadiz (Spain), where "worms crawled out of holes eight days prior to the earthquake".

Unfortunately, no particular attention was paid to these unusual evidences, nobody was able to interpret them correctly, i.e., to understand that they might have signalized an approach of a strong earthquake; only later after the event, inquisitive naturalists recollected and recorded these phenomena. … Therefore the sudden and unexpected seismic shock surprised the Lisbon inhabitants completely unprepared (Fig. 97).

After the earthquake, Portugal plunged into a chaotic situation. Immediately after the elemental forces lost their initial fury, other, more practical problems confronted those who survived; it was necessary to extinguish the numerous fires, ensure the provisional accommodation for thousands of refugees outside the towns, and supply them with necessary food and water. Equally important was the detection, excavation, and inhumation of the additional thousands of victims still imprisoned under debris. Finally, it was extremely urgent to prevent thieves and robbers from plundering the ruined town: a fair number of bandits, thieves, and robbers got together and burst into Lisbon – one of the wealthiest towns of that time – and without any pity started systematically to loot the ruins, prey the corpses, and often, to mask their crimes, they set up new fires. As a warning against looting, King Joseph I of Portugal ordered gallows to be constructed in several parts of the city.

Owing to a stroke of luck, the royal family escaped unharmed from the disaster. King Joseph I of Portugal and the court had left the city, after attending mass at sunrise, fulfilling the wish of one of the king's daughters to spend the holiday away from Lisbon. After the earthquake, Joseph I developed a fear of living within walls, and the court was accommodated in a huge complex of tents and pavilions in the hills of Ajuda, then on the outskirts of Lisbon. The king's claustrophobia never waned, and it was only after Joseph's death that his daughter Maria I of Portugal began building the royal Ajuda Palace, which still stands on the site of the old tented camp.

Fortunately enough, there was a man who immediately took the necessary measures to minimize the material damage, reconstruct the town, and organize the return of its inhabitants to normal life, namely Sebastião José de Carvalho De Melo, Minister of the Kingdom, later Marquis de Pombal. Pombal became notable for his swift and competent leadership in the aftermath of the earthquake. In addition he implemented sweeping economic policies in Portugal to regulate commercial activity and standardize quality throughout the country. The term Pombaline is used to describe not only his tenure, but also the architectural style which formed after the great earthquake. Pombal – right after the earthquake – being asked, what to do first replied by his famous command: *"Bury the dead and take care of the living"*. In the critical days and weeks after the disaster De Melo displayed and defended the admirable, clear, and correct concept of reducing the damage due to the earthquake. We have to appreciate his personal courage and efficiency to manage the situation: King Joano I left Lisbon; afterwards a larger part of the Portuguese nobility joined with the representatives of the Catholic Church against De Melo. The Church could not forgive De Melo because he had ordered to burry hundreds of Lisbon corpses en bloc in order to prevent a potential blow up of epidemics, and intrigued against De Mello and his measures. Despite the calamity, Lisbon thus suffered no epidemics. Shortly after the disaster De Melo ordered to clean the ruined parts of Lisbon from debris and outlined his project to erect a new, modern regularly grid-shaped quarter of the town centre and within less than a year his projects were realized. The new central area of Lisbon was designed to resist subsequent earthquakes. Architectural models were built for tests, and the effects of an earthquake were simulated by marching troops around the models. The buildings and major squares of the Pombaline Downtown of Lisbon

are nowadays one of Lisbon's main tourist attractions: they are the world's first seismically resistant buildings.

Marquis de Pombal's response was not just limited to the practicalities of reconstruction. He also ordered a questionnaire regarding the earthquake and its effects and sent to all parishes of the country. Among others, the questions included: *How many aftershocks were felt? What kind of damage was caused?, How long did the earthquake last?, or What happened in wells and water?* The answers to these and other questions are still archived in the Torre do Tombo, the national historical archive. By studying and cross-referencing these accounts, modern scientists were able to reconstruct the event from a scientific perspective. Since Pombal was the first to attempt an objective scientific description of the causes and consequences of an earthquake, he may be regarded as a forerunner of modern seismological scientists. These "seismological" achievements sometimes resulted in considering Marquis de Pombal as one of the father-seismologists and the 1755 Lisbon earthquake as the beginning of modern seismological research. Such opinion may be exaggerated. Seismology, as entirely scientific discipline, had still waited for its actual birth for another 90–100 years until R. Mallet, J.F.J. Schmidt, O. Volger, and others published their fundamental works on earthquakes, which occurred later, namely in the 40s and 50s of the nineteenth century.

Over hundred depictings of the Great Lisbon Earthquake effects appeared successively. Among them, both more-or-less realistic pictures correctly depicting the damaged town and a variety of imagined pictures and pure fantasies can be found. Sometimes, the accurate depiction and the artistic license are mingled. In general, the inaccuracy of the illustrations increased with the distance of the localities (from Lisbon), in which the images were created, and with time that had elapsed since November 1755. Among all the pictures related to the 1755 Lisbon earthquake, the engravings of Jacques-Philippe Le Bas belong among the most correct pictorial documents.

Le Bas (1707–1783) was the principal engraver of the king of France, Louis the XV; his engravings were characterized by a quasi-photographic accuracy, and they are of great admiration for their artistic impression. Le Bas compositions were copied many times in the course of the eighteenth and nineteenth centuries, unfortunately sometimes with a decreasing quality and degree of correctness.

Figure 98 presents two of the six Le Bas engravings of the Great Lisbon earthquake. No doubt that Le Bas demonstrated convincingly earthquake damage to principal buildings and localities in Lisbon. His engravings were based on sketch drawings made on the spot by two French painters, named Paris and Pedegache. This "pictorial inventory" of the Lisbon disaster was made according to special directives given to Le Bas by Louis the XV. Both painters were delegated to the damaged town in order to make a series of detailed drawings of the earthquake disaster according to which Le Bas later engraved the six above-mentioned compositions. The first version of the Album (Le Bas 1757) with French-Portuguese captions became quickly popular in Europe and was soon repeatedly re-printed, e.g., in original size in London (with the captions in English) or in reduced and simplified form elsewhere. Sometimes copies of Le Bas compositions have appeared in the Antiquarian market, in hand-colored version. The complete set of original Le Bas compositions represents the oldest album of detailed strong-earthquake portrayals. Due to their high artistic performance they represent an admirable and valuable series of seismic documentation for both seismologists and for old graphic lovers and collectors.

Figure 98 (top) shows the construction of the Opera House or Riberia Theatre that had been completed in March 1755, only 7 months before the quake. It was a magnificent edifice, much longer than wide, one of the richest theatres in Europe at that time. The outer stony walls of the construction survived the earthquake quite well. However, its interiors and roof were totally destroyed by the fire, as it is truly recorded in the picture.

Figure 98 (bottom) shows the damage to the town by the earthquake and fire, as seen from the Patriarchal Square. The Royal Palace, part of which can be seen on the left, was built in the early sixteenth century on the storehouses of the former House of India and afterwards gradually extended in the second half of the eighteenth century. The 1755 earthquake itself did not make much harm to the Palace edifice, but again, the fire was fatal. The Palace Library, one of the largest European libraries of that time, was lost together with its numerous volumes. After the earthquake, the Palace ruins were demolished. Part of the Patriarchal's ruins are depicted on the right. Construction of the Chapel Royal near the Royal Palace was initiated during the reign of Manuel I, his successors enlarged and improved the Chapel and promoted it to the status of another cathedral; after its reconstruction it was substantially improved. Since that time it was called the Patriarchal. As for many other buildings of the town, here also the earthquake damage was minor, but the subsequent fire was fatal. In the back plane of the picture, the ruins of a part of the town are portrayed, nowadays occupied by the Chiado Quarter, the elegant part of Lisbon. The effects of fire are clearly evident in the ruined buildings, although some exaggeration cannot be ruled out.

In November 2005, three international symposia were held in Lisbon to commemorate the quarter millennium anniversary of the 1755 disaster. In these symposia over a hundred original contributions were presented; some of them addressed new reinterpretations of historical data as concerns the assessment of the new epicenter location and seismic energy released.

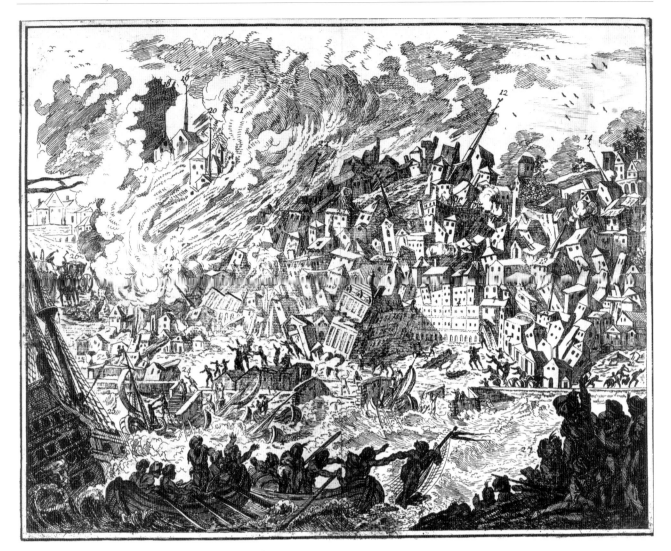

Fig. 92 "*Lissbone Abysmée*". Copper engraving, a solitaire print of the 18th century, probably a French broadsheet illustration. Reproduced from the monograph by Kozák and Thompson (1991). Private collection, Prague

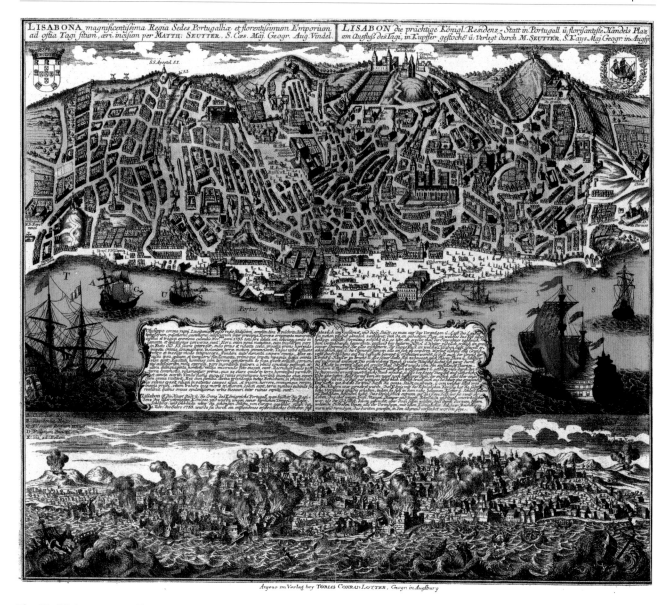

Fig. 93 *"Ruinae eversae Olysipponis — Ruinen der Stadt Lissabon"*. Konrad Lotter's composition, double prospect of the pre- and after-earthquake Lisbon. Hand colored large folio copper engraving with bilingual text. Private collection, Prague

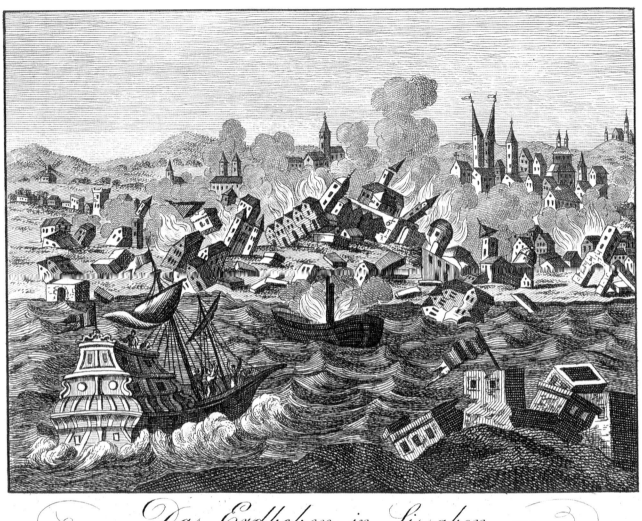

Das Erdbeben in Lissabon

Fig. 94 Ruined Lisbon on fire with burning ships; viewed from south to north. Copper engraving published by Reinhold (1819-21), from the Czech illustrated weekly journal *Hyllos* issued in Prague between 1819-22. Private collection, Prague

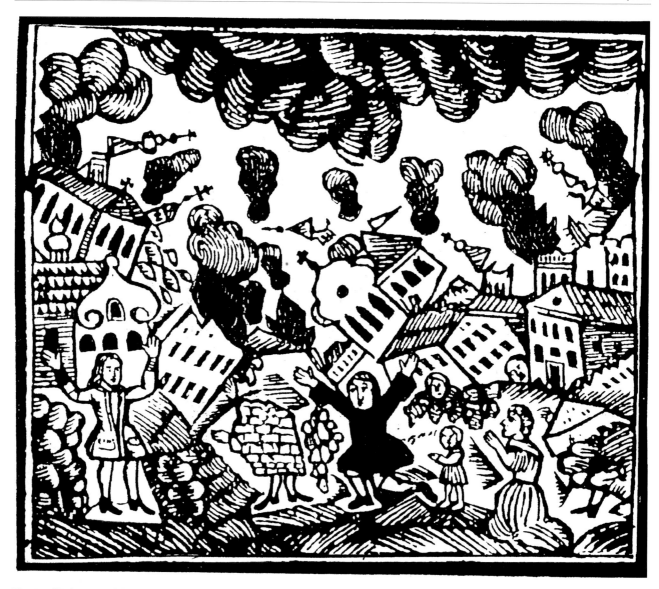

Fig. 95 "*Lisbon tragedy*". Rough wood-cut broadsheet illustration. Published by J. Kamenicky, Litomyšl (Bohemia). Private collection, Prague

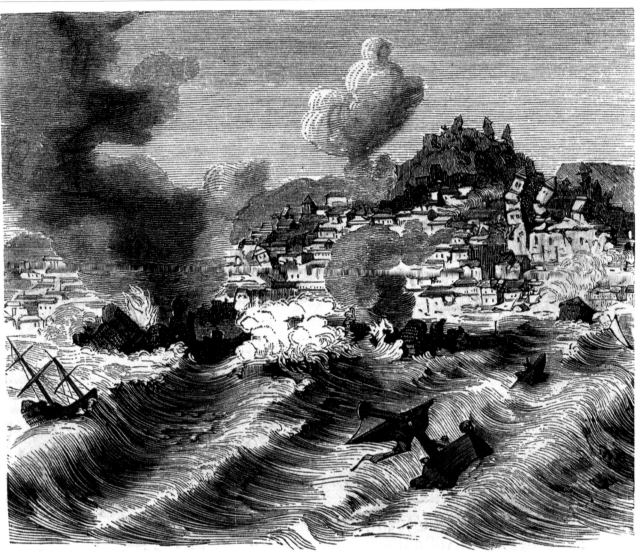

Erdbeben von Lissabon, 1. Novbr. 1755.

Fig. 96 "*Erdbeben von Lissabon, November 1, 1755*". Hand colored xylographic illustration of Lisbon earthquake reproduced from the book by Zimmermann (1882). Private collection, Prague

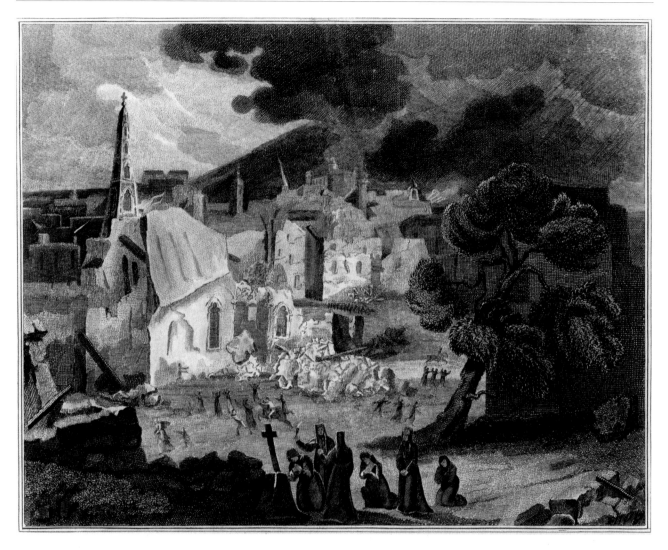

THE DESTRUCTION OF LISBON BY AN EARTHQUAKE IN 1755.

Published by J. Mc Cowan Cᵒ Windmill Sᵗ

Fig. 97 Heavily damaged church; praying people in the foreground, collapsed houses in the background. Hand colored copper engraving, a single print of 1817. Private collection, Prague

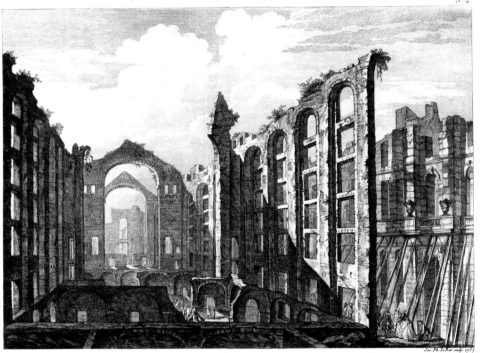

Casa da Opera Sale de l'Opera

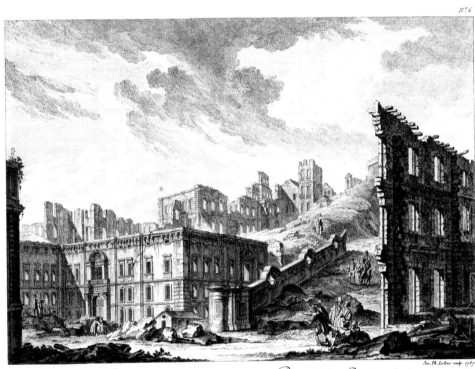

Praça da Patriarchal Place de la Patriarchale

Fig. 98 Le Bas engravings (see text). Private collection, Prague

Calabrian Earthquakes of 1783 and Later On

A devastating earthquake occurred in Calabria and in northeast Sicily on February 5, 1783, followed by a long series of aftershocks in the region, which continued in the following years. During this aftershock, a series of earthquake epicenters migrated from the Messina Strait toward NNE, along the axis of the prolonged Calabrian Peninsula. The major seismic attack of the 1783 event was represented by four strongest shocks that occurred between February 5 and 7, 1783. Compared with the strongest European earthquake, the preceding 1755 Lisbon earthquake, the intensity I_o of which was assessed XI–XII on the MSK-64 scale, the 1783 Calabrian earthquake was weaker, reaching "only" I_o = XI on the MSK-64 scale; however, it was accompanied by numerous aftershocks of intensities IX–X in the period that followed.

Calabria, a region in southern Italy, is located at the "toe" of the Italian "boot". Bounded to the west by the Tyrrhenian Sea and to the east by the Ionian Sea, this region, in which the collision zone between the African and Eurasian tectonic plates sharply turns from its general west-east course towards northwest, has been always known as a seat of strong earthquakes. Additionally, the largest European volcano Etna, located near the eastern shore of Sicily and a group of active volcanoes in the southern Tyrrhenian Sea, the Lipari Islands, predestined this region as a zone of frequent volcanic and seismic disasters. Fig. 99 offers the map of the region; the hand-colored copper engraving was taken from the *Physical Atlas* of Heinrich Berghaus (1838–1948), the olive-green ovals denote the zones of the strongest seismic effects in the map.

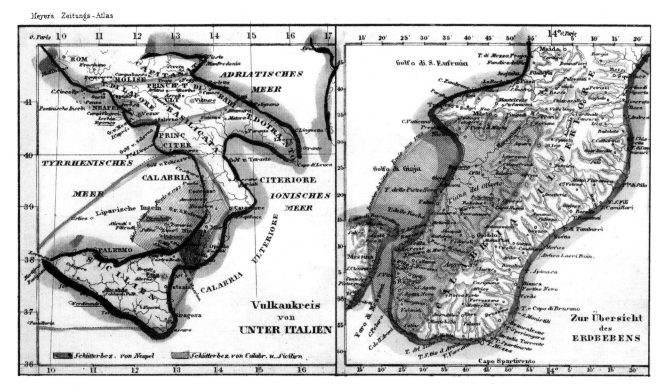

Fig. 99 An early map of the 1783 Calabrian earthquake plotted in the mid-19th century. Private collection, Prague

J. Kozák and V. Čermák, *The Illustrated History of Natural Disasters*,
© Springer Science+Business Media B.V. 2010

By the number of about 50,000 casualties, the violent 1783 Calabrian earthquake is comparable with the deadly record of the previous East-Sicilian Val de Noto earthquake of 1693. Together with the Great Lisbon earthquake of 1755, the 1783 Calabrian event belongs to the most outstanding European seismic disasters of the eighteenth century, not only due to high seismic intensity and fatal consequences, but also because the focal zone of the earthquake was relatively shallow and therefore most physical manifestations of the event, such as large block collapses, massive landslides, and wide crack openings appeared clearly visible on the Earth's surface. All these facts have attracted many Italian and European scholars to study this earthquake in detail; see, e.g., Placanica (1985). The copious and detailed documentation thus signaled a rapidly increasing interest to understand the nature of the disaster. Actually, the 1783 Calabrian event has the largest pictorial documentation of all world earthquakes of the pre-photographic era.

The series of strong earthquakes of magnitude $M \geq 6.0$ vexed the region for most of the next decade. The hitherto "surviving" and only partly damaged buildings did not hold out the subsequent tremors and the destruction carried on. The Italian records of historical earthquakes confirm that the series of moderate earthquakes in the Calabrian region had been continuing up to the end of the eighteenth century (Postpischl 1985). The increased seismic activities concentrated along the axis running through southern Calabria, from a small settlement of Catanzaro in the northeast to towns of Reggio di Calabria and Messina (the latter actually located in Sicily) in the southwest. Total length of this gigantic epicenter zone exceeded 130 km. The Calabrian earthquake series resulted to be the strongest seismic event in Europe as concerns its time succession as well as the total amount of released seismic energy.

Pictorial compositions by D. Schiantarelli and I. Stilo are among the most authentic earthquake illustrations valuable from the viewpoint of preserving macroseismic information. Both the artists accompanied a special investigation commission delegated to the damaged region by the King of Naples and Sicily. The commission's duty was to assess the disaster size and prepare a detailed report on the event (Sarconi 1784). Copper engravings, which were later created, mostly utilized original Schiantarelli's and Stilo's drawings and sketches as model depictions; this collection comprises a series of 69 pictorial compositions, which convey a convincing detailed image of the 1783 disaster (as an example see Fig. 100). This series is of particular value for today's seismologists, because besides documenting the damage to villages and towns, the authors also paid attention to the surface ground deformation phenomena, which occurred in and around the epicenter zone. It was characteristic for the painter-couple Schiantarelli-Stilo that they – both being architects – had a refined taste for an accurate and realistic

expression of the degree of damage to building exteriors as well as the whole constructions. It was their precise portraying of the damage level which – as proved 200 years later – could be easily quantified in terms of later defined macroseismic intensity scales.

Detailed rough-casts, taken on the spot, systematically covered a vast territory, more than 100 km long, that was affected by the earthquake. As such, the above collection presented the very first pictorial documentation of a strong earthquake of this kind. Sarconi's book is nowadays highly valued. Only a limited number of copies survived, one copy is deposited in the graphic collection "Civica raccolta delle stampe Achille Bertarelli" at Milano (Milan), another copy is kept in the Getty's Collection in Los Angeles. It may be noted that the work of the Royal Investigation Commission mapping the earthquake damages was marked by mutual misunderstanding of the individual members, namely, as concerns publishing the results and pertinent iconographical documentation. This affair is described in detail and commented by Placanica (1985)

Figure 101 brings two attractive views related to the 1793 Calabria earthquake. Both pictures belong to a series of "Laterna Magica" depictions which became very popular in Europe after the 1740s. This new illustration, representation and projection technique, enabled both to screen the views on a wall in a *Camera obscura* (dark room) and to examine closely a picture with help of "peephole". The necessary equipment was a box with a light source (a candle or kerosene lamp) and simple mirror-projection optics. Sometimes optical lens was used to improve the projection. In the second half of the eighteenth century, it became popular to organize "project parties" as a kind of social entertainment. The participants gathered together to jointly enjoy new views approaching distant countries as well as "the latest records" of important events (battles, fires, catastrophes, executions, etc.). This new way of amusement had come from England and quickly spread over via France to Germany, where it flourished in Bavarian Augsburg between the 1750s–1780s.

In the depiction we can see wide cracks in the earth, high degree of damage to churches, palaces, and houses, including free-standing columns and sculptures; all these effects indicate macroseismic intensity at least $I_0 = X$ degree of the MSK-64. In some details, however, the depiction seems to be exaggerated and/or unrealistic, note, e.g., the oblique positions of the falling monuments and parts of the buildings, which can be clearly classified as an artist's attempt to imaginatively convey the conditions at the moment of the main shock. At the end of the 18th century, these pictures were repeatedly copied, sometimes converted left to right, which reduced their topographical value.

The above half-folio size picture (Fig. 101, top) presents a view on destroyed Messina. This illustration is a work which originated in the Augsburg Academic Publishing

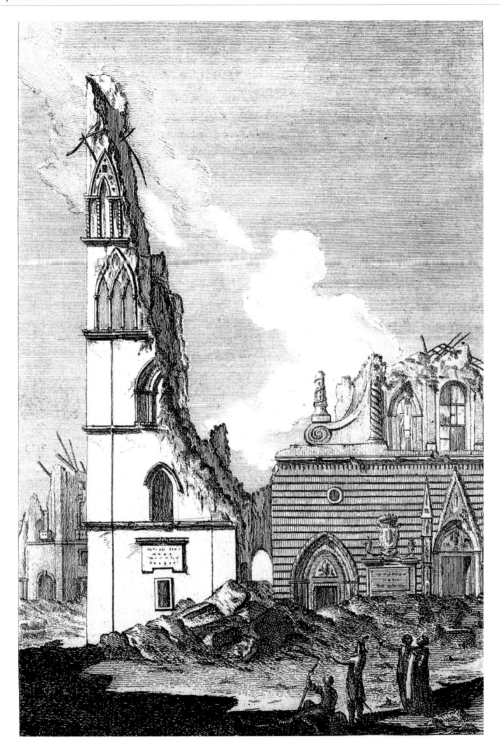

Fig. 100 Cathedral of Messina, the front nave of which was completely destroyed and the nearby campanile torn down. Illustration from the atlas-book Sarconi (1784). Print copy courtesy of C. Margottini, Rome. Copy in a private collection, Prague

House. On purpose, the heading of the vedute was printed in a reverse way; when screening, the title, together with the whole illustration, reverses left to right to the proper position. The bilingual text (German and French), explaining the details of the event, and located below the picture, was to

be read when handed, therefore there was no reason to be reversely printed.

The above picture convincingly illustrates the seismic damage to edifices (destroyed St. Mary's Cathedral and the surrounding palaces); besides, however, it is also focused on

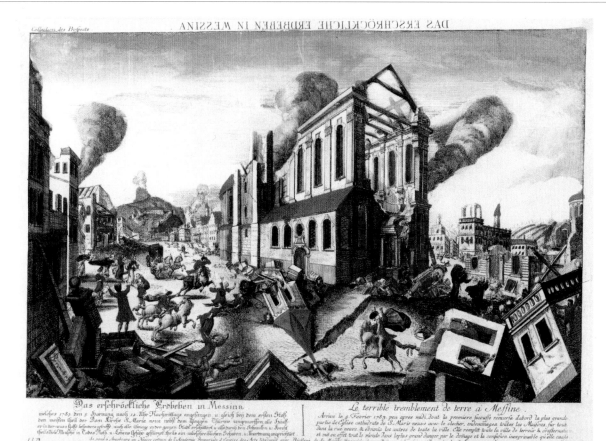

Fig. 101 *"Vue de l'optique"* composition prepared for a wall projection. The upper picture shows the Messina town destroyed by the 1783 earthquake. The lower picture illustrates the town of Reggio di Calabria in the Messina Strait. Hand colored copper engravings, German print of the mid 1780s. Private collection, Prague

CALABRIAN PEASANTS SWALLOWED UP IN CREVASSES, 1785.

Fig. 102 *"Calabrian peasants swallowed in crevasses during the 1783 earthquake"*. Xylographic illustration of 1869. Private collection, Prague

the panic among population, which followed after the main shock occurrence. Local inhabitants are shown as trying to escape in havoc, rich people in carriages or on horses, and others on foot. All of them desperately try to find some safety in an open-air space. The unrealistic depiction of the collapsed houses, presented, namely, in the lower-right corner, reveals that the painter in transalpine Augsburg had little experience with real seismic effects. The deep cracks in the ground are worth mentioning because they indicate macroseismic intensity degree $I_o \geq X$. Smoking Etna on the horizon seems to be pasted-in according to the drawer's fantasy.

The bottom picture (Fig. 101, bottom) is the work of a Parisian workshop specialized in the *"Vue de l'optique"* production. This view has only French text and does not indicate the name of an artist or publisher. The scene is similar to the previous one with the only difference that the picture presenting the destruction of Reggio di Calabria is not left-right reversed. This was typical for illustrations of French provenance, which sometimes were reversed and sometimes were not. German products were always consistently prepared

for the mirror projection. We may also speculate that the French image was created later, when its maker had actually seen the Augsburg work and somehow "forgot" to reverse his work properly. The drawer of this sideview focused himself on the ruined city of Reggio; looking toward the north, we can see a bid of the sea in the Messina Strait on the horizon.

The occurrence of large earthquake-initiated crevasses in the ground, sometimes arranged in a star-shaped pattern, was remembered in an artwork which appeared more than 80 years after the event. Figure 102 is a xylographic illustration taken from the book by Zürcher and Margolé (1869). The image is signed by Riou, a famous French graphic designer of the end of the nineteenth century. The time denotation of the event, 1785, corresponds either to an aftershock which occurred 2 years after the main shock, or the author made a mistake in the main 1783 Calabrian shock occurrence. One way or the other, the illustration documented the fact that even a long time after the Calabrian earthquake, the tragedy is not forgotten and is worthy of being remembered.

Valona (Albania) Earthquake, 1851

Figure 103 is a hand-colored xylography reproduced from an unidentified issue of the German Journal *Illustrierte Zeitung* (1851). The image realistically depicts the consequences of an earthquake, which struck the Albanian coast on October 12, 1851. Obviously, this was a very shallow earthquake, with the deformation range reaching up to the ground surface. A whirl of dust appeared above the propagating rupture opened in the ground. The detection of the dust cloud movement – if its velocity is reliably assessed, i.e., seen from the direction perpendicular to the seismogenic fault – helps to evaluate the corresponding rupture velocity. Correct assessment of a rupture velocity is a key parameter to calculate the kinematical and dynamic parameters of seismic source properties of a given earthquake.

The loop of the collision zone of the European and African tectonic plates is running from Calabria along the central part of Italy northward, at Friuli it turns back to south and along the eastern Adriatic Sea coast, it crosses Croatia, Montenegro, Albania, and western Greece, where it finally turns eastward toward the Cyprus. Right here, at this

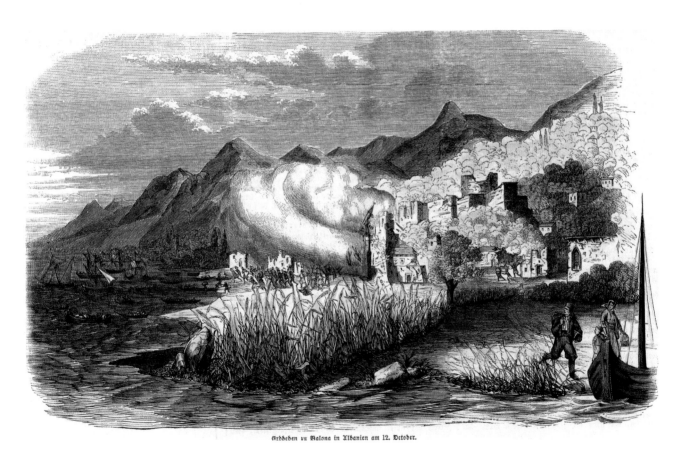

Erdbeben zu Valona in Albanien am 12. October.

Fig. 103 The 1851 Valona earthquake, Albania. Hand colored xylographic illustration. Private collection, Prague

J. Kozák and V. Čermák, *The Illustrated History of Natural Disasters*,
© Springer Science+Business Media B.V. 2010

collision zone, which represents the maximum concentration of seismic and volcanic energy in Europe, is the zone, in which strong earthquakes occurred in the past. We may remember, for example, the 1667 Dubrovnik event or later the 1893 Zakynthos Island earthquakes. Also, the 1851 Valona event belongs to the series of seismogenic movements releasing the tectonic stress in this exposed zone and may illustrate the renowned "pebble in a rotating gear".

Zagreb (Agram) Earthquake, Croatia, 1880

In most of Slovenia, as well as in northern Croatia, earthquakes are not rare. This is the region where the collision zone between the African and Eurasian tectonic plates bends sharply. Also the proximity of the Peripienine lineament, crossing Central Europe from Cracow in Poland over Vienna up to the Udine town in Friuli (NW Italy), contributes to the increased seismic activity in the region. A strong earthquake occurred there in 1976 with the epicenter near Udine.

The city of Zagreb was destroyed by earthquake several times in history, for example, in 1830, and then twice in September and October 1838. Other strong earthquakes were felt between Zagreb and Ljubljana in 1871 and 1878. However, the event of November 9, 1880, of the magnitude $M \approx 6.3$ and estimated intensity of $I_o \approx$ VIII–IX on the EMS scale, was the most famous. More than 500 houses, large buildings, churches, and castles were seriously damaged. The earthquake struck in the region of more than 25 km in diameter; the main shock was followed by a number of destructive aftershocks on February 26, March 24, and finally on October 23, 1881. Figure 104 presents a street scene in Zagreb during the 1880 earthquake; seismic damage to the walls of the tower *Bei Steinthor* (At Stony Gate) was expressed very realistically.

The aftermath of the earthquake was felt mostly in Zagreb and in its vicinity. However, the event stirred up certain panic in the whole Austro-Hungarian monarchy, the population of which was harshly confronted with the fact that not only foreign countries, such as Italy, Greece, or Turkey, were endangered by earthquakes, but also their own country, regarded as a territory seismically relatively quiet, might be vulnerable to a seismic disaster. To account a potential earthquake threat in the Austro-Hungarian monarchy, a detailed survey was ordered, which resulted in a rich photographic documentation. Long series of disaster inventory were kept in the Zagreb Municipal Museum; also newspapers and illustrated weeklies of that time widely reported about the 1880 event and offered numerous pictures of damaged houses and other constructions. In spite of many keen disputations about seismic danger, the discussions did not bring any practical measures; the authorities hoped that the previous earthquakes had been only accidental and that in the future such danger would be unlikely.

However, 15 years later (in 1895), another strong earthquake struck Ljubljana, located north of Zagreb, and the unexpected seismic danger proceeded closer to Vienna, the Empire capital. The latter event – in contrast to the 1880 Zagreb earthquake – mobilized the Austrian government, geologists, and other naturalists to act briskly and be prepared to effectively adopt the necessary measures.

Figure 105 presents the building of the St. Mark's Church heavily damaged by the 1880 earthquake. The illustration appeared originally in Viennese newspapers but was reprinted and published later also in the Czech Journal *Světozor* (1880). St. Mark's church was one of the most damaged structures in the town; note large vertical ruptures in both, major and side naves; the roof partly collapsed down, and the church tower was open cracked along all its height. People kept themselves in a safe distance from the statically disturbed structure.

J. Kozák and V. Čermák, *The Illustrated History of Natural Disasters*,
© Springer Science+Business Media B.V. 2010

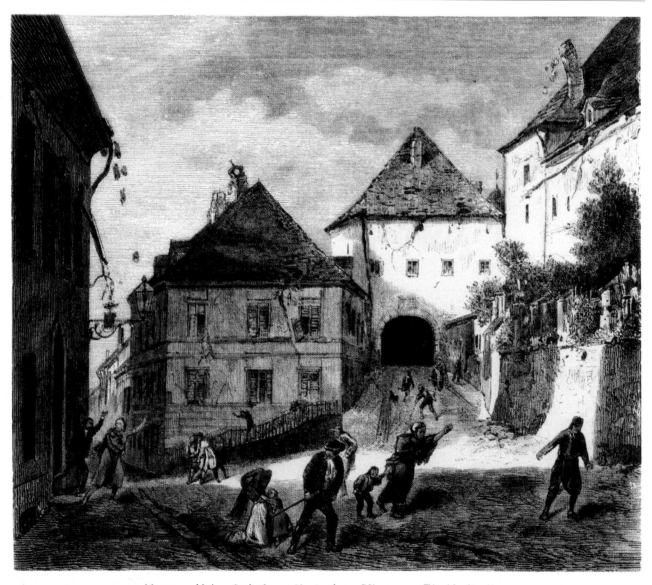

Agram. Beim Steinthor. Nach einer Skizze von Th. Breidwiser.

Fig. 104 The 1880 Zagreb earthquake, Croatia. Contemporary hand colored xylographic journal illustration. Private collection, Prague

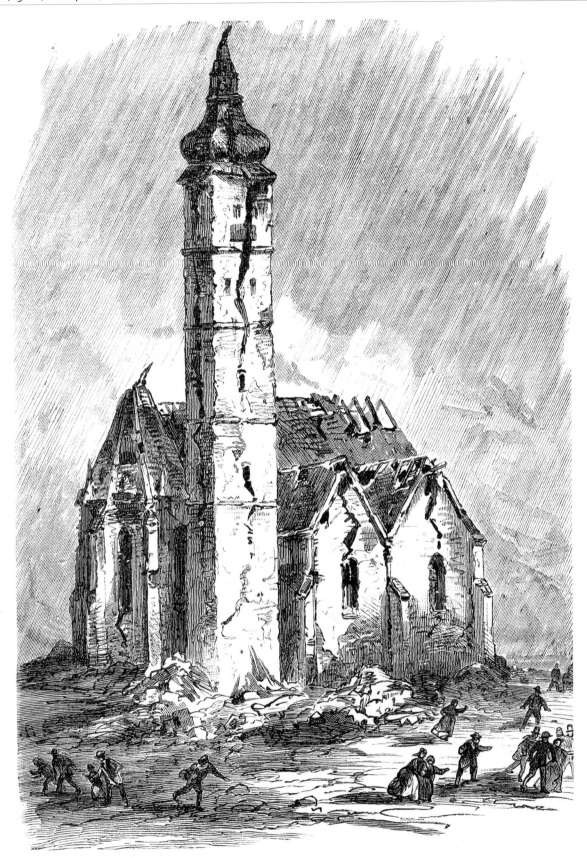

Die Markuskirche in Agram nach dem Erdbeben.

Fig. 105 *"The Markuskirche in Agram (=Zagreb) nach dem Erdbeben"* (St. Mark's Church after the earthquake). Lithographic journal illustration of a contemporary Czech newspaper. Private collection, Prague

Two Earthquakes in Italy: Ischia 1881 and Casamicciola 1883

The island of Ischia forms the western end of a large seismically and volcanologically active arc of Central Italy, which involves also the Phlegraean Fields, Pozzuoli, Naples, and Vesuvius volcano. Frequent volcanic eruptions magma outbursts, tectonic earthquakes, high heat flow, and other anomalous geophysical phenomena together with appreciable ground vertical movements are typical for this region.

A newspaper illustration (Fig. 106) shows a church ruined by the 1881 Ischia earthquake on March 4 (I_o = VIII, MCS). As the picture demonstrates, the interior of the church was completely ruined when the vault collapsed down. The gloominess of the scene was accentuated by two persons searching through the ruins, looking for potential victims who might have survived. According to the depiction, large untreated rounded stony blocks were used for the church

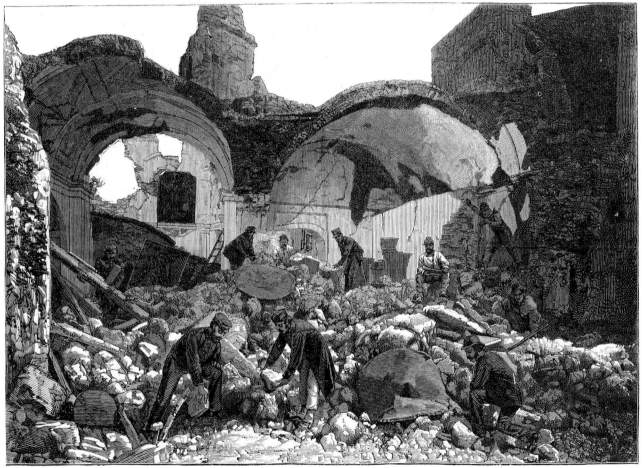

INTERIOR OF A CHURCH AFTER THE EARTHQUAKE.

THE EARTHQUAKE IN THE ISLAND OF ISCHIA.--FROM PHOTOGRAPHS.--[SEE PAGE 282.]

Fig. 106 The 1881 earthquake in the Island of Ischia. Xylographic print from the Harper's Weekly (1881). Private collection, Prague

J. Kozák and V. Cermák, *The Illustrated History of Natural Disasters*,
© Springer Science+Business Media B.V. 2010

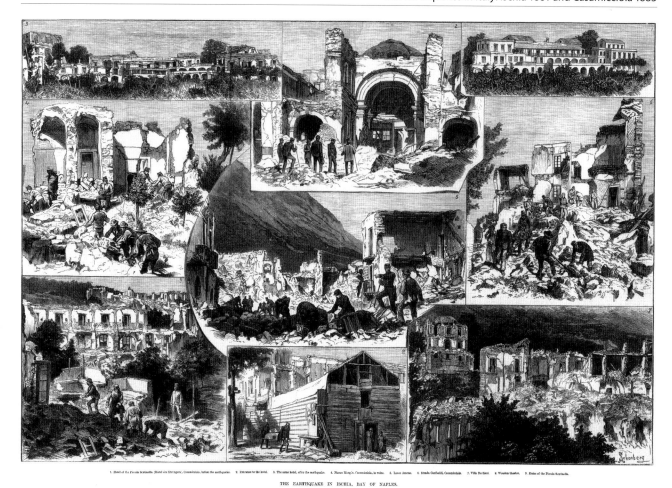

THE EARTHQUAKE IN ISCHIA, BAY OF NAPLES.

Fig. 107 The 1883 Casamicciola earthquake, Ischia, Bay of Pozzuoli. Xylography print from The Illustrated London News (1883). Courtesy of R. Musson, Edinburgh. Private collection, Prague

construction, tied together with limy mortar. Such construction, however, granted rather poor strength in tension regardless how thick the walls were. Even though the intensity of the 1881 earthquake was only VIII, the local manner of using untreated rocks as building material could explain extensive seismic damage: heavy and unstable walls of low endurance did not stand up the earthquake, collapsed down, and buried a number of local inhabitants. Worst of all, small town Casamicciola was damaged, 249 houses crashed down, 121 persons died in the ruins, and 140 others were injured. Large damage to houses and high number of casualties of this medium-size earthquake occurred due to its very shallow focal depth (~2 km).

A large double-page folder (Fig. 107) "summarized" and illustrated the all-round losses caused by the Casamicciola earthquake on July 28, 1883 (I_o = XI, MCS). This earthquake struck 2 years after the 1881 event and completed the previous damage of the Ischia island settlements. The folder, author-signed "C. Schönberg," encompasses eight smaller figures presenting details of several ruined houses in Casamicciola; the series is supplemented by the picture of hotel *Picolla Sentinella* (top, right), as it looked before the earthquake. Army units were called for searching the ruins and finding out the casualties.

As mentioned above, the region was affected by a relatively weaker earthquake 2 years earlier and, of course, many buildings – still not repaired – were statically disturbed. When a stronger earthquake struck again in 1883, quite naturally Casamicciola town, similarly as a number of other settlements in the vicinity (Fontana, Barano, Piejo, Moropane, Fiorio Marina and Lacco Marina), was razed. Altogether, 2,313 dead and 762 seriously wounded were reckoned; the double catastrophe stigmatized the life on the island for many years.

Figure 108 illustrates the situation in the town streets of Diana Marina, a small town on the French-Italian border, during the earthquake of February 23, 1887. The epicenter intensity of the shock was assessed as I_o = IX (MCS); more than 600 people died. This earthquake, which was felt also in French Riviera, especially in Menton and Nice, where it caused the collapse of a maiden school (see Fig. 8), was interpreted by Frenchmen as a "French one", regardless of the fact that the epicenter was located in the Italian part of the Ligurian Sea coastal zone; seismic damage was also the largest in Imperia – Diano-Marina. The earthquake waves spread inland to the north and afflicted the vast region of Lombardy and Piedmont up to the Aosta River valley; the aftershocks were felt for the whole year, till February 1888.

The French journals and magazines of that time brought a lot of information and illustrations from the devastated Riviera, showing people fleeing in panic, fugitives camping on the sea coast, and of course, numerous portrayals and

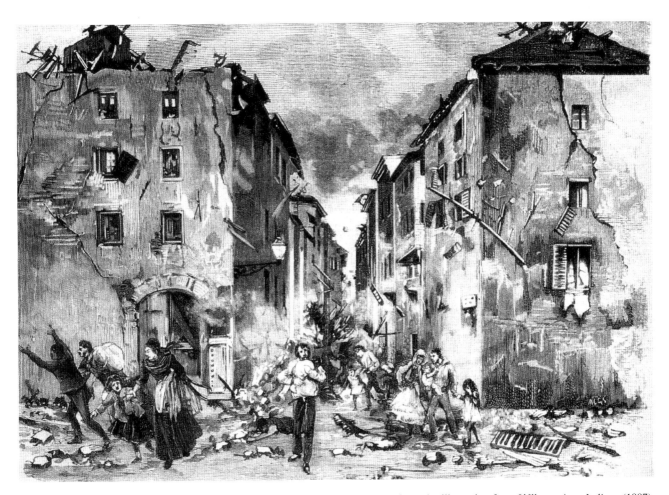

Fig. 108 The 1887 Imperia earthquake in the Italian/French Riviera. Newspaper xylography illustration from *L'Illustrazione Italiana* (1887). Private collection, Prague

snapshot of the ruins of the maiden school in Nice, from all possible angles. The Italian media also informed in detail about the catastrophe and presented pictures of many collapsed houses, ruined buildings, casualties under debris, and burials of victims. In the above picture, we can well recognize a stampede of the inhabitants from the shaking houses in Diano-Marina, where the walls of houses were split, towers and roofs fell down, and debris were piled up on the ground; generally, the image presents a realistic view of the situation in the first moments after the earthquake struck.

Another illustration (Fig. 109), based on a photograph model by Clair-Guyot, correspondent of the Parisian journal *L'Illustration*, illustrated the situation, which occurred several hours after the main shock. We can see many houses completely damaged and the ruins in which people were buried under the debris; those who survived were desperately searching for their relatives. The victims were excavated and their bodies were carried out in provisional coffins.

Both coastal zones of the northwestern Mediterranean, French Riviera, and Italian Liguria coast have been often visited by strong earthquakes in the past. In addition to the 1887 Imperia earthquake, we may commemorate, e.g., the 1564 Nice or the 1708 Aix en Province events, both discussed earlier in this book. Seismologists relate the increased seismic activity of the region to the dynamic processes running along the collision zone separating the Eurasian and African tectonic plates.

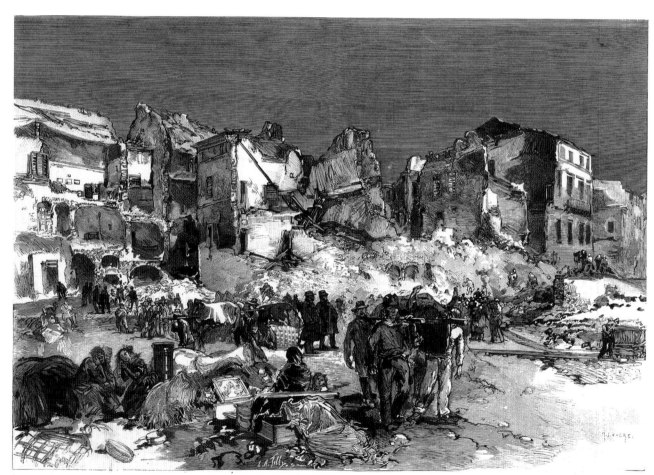

LES TREMBLEMENTS DE TERRE. — DIANO-MARINA : L'ENLÈVEMENT DES CADAVRES APRÈS LE CATACLYSME
D'après une photographie de M. Clair-Guyot, envoyé spécial de l'*Illustration*.

Fig. 109 Diano-Marina town in NW Italy after the 1887 earthquake. Newspaper xylography illustration from *L'Illustration, Journal Universal* (1887). Private collection, Prague

Earthquake at Shemakha, Azerbaijan, 1902

The illustration in Fig. 110 was entitled *On the Terrible Earthquake at Shemakha: a Town in Ruins*. The picture, which was published in the Czech journal *Nové Ilustrované Listy* illustrated the seismic event that occurred in the present Azerbaijan in 1902. This region, located on the southeastern foothills of the Caucasus mountain range, was always seismically active, similar to the whole tectonically alive belt stretching westward from Baku (on the Caspian Sea), along the Caucasus mountain ridge, across Crimea to the Romanian Vrancea zone. The town of Shemakha, the former capital of the country, located about 110 km west of Baku, repeatedly suffered from earthquakes in the past. A series of recorded strong earthquakes occurred there in 1667 and continued in 1830 and 1867, when the magnitude reached up to $M = 8$. On February 13, 1902, a seismic catastrophe struck again, which completely razed out the whole unhappy town of Shemakha. The damage was severe enough that the authorities decided to move the offices to Baku, which then became the new capital of Azerbaijan. The importance of Baku rose quickly, thanks to rich oil fields opened in the coastal waters of the Caspian Sea; Baku is now the largest city in the whole region with more than two million inhabitants.

The devastation of Shemakha was actually so crucial that some proposals even called for abandoning it, or to move it to another place. Nevertheless, the town was finally restored on its original grounds, in particular, due to its ancient character and tradition; the old mosque Djuma Mechet was built there as early as AD 809.

However, the intensity of the 1902 earthquake probably did not exceed I_o = IX on the Rossi–Forel scale, what would roughly correspond to magnitude $M \sim 6.9$; the tragic consequences occurred due to a relatively shallow earthquake hypocenter ($h = 18 \pm 10$ km) located in a close proximity under the town center. Almost all houses were collapsed, and 18,000 people lost their homes; death toll reached 2000. The records said that 1,714 people were buried in the local Moslem cemetery within the first week after the earthquake. The despairing situation was further complicated by frosty Caucasus winter when the whole area was covered by snow. The topical reports also informed that altogether 126 villages and settlements in the Shemakha County suffered larger or smaller damage.

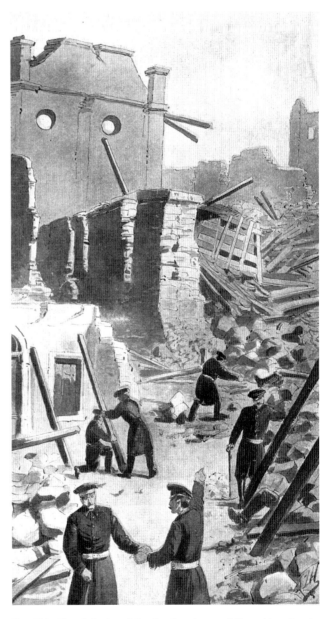

Fig. 110 Guarded ruins of the abandoned town of Shemakha, after the 1902 earthquake. Xylographic print. Private collection, Prague

J. Kozák and V. Čermák, *The Illustrated History of Natural Disasters*,
© Springer Science+Business Media B.V. 2010

Submarine Explosion Near Juan Fernadez Island, Chile, in 1835 (or 1837)

Figure 111 presents an illustration, which appeared in the report of T. Sutcliffe (1839), entitled *The earthquake of Juan Fernandez, as it occurred on the island of Juan Fernandez and Tolcahuana in the year 1837*. However, the correct date of the seismic event should be 1835. We see a dramatic scene, where a group of alarmed inhabitants of the island uneasily watch the submarine volcanic eruption (sometimes called "explosion") and search for certain protection against tsunami waves on coastal reefs.

Juan Fernandez is an island located in the eastern Pacific Ocean about 800 km westward off the Chilean coast. In the region of the East Pacific ridge, the Nazca Plate is splitted by a system of transform faults into several microplates, which move separately from each other. Seismic energy accumulated on the collision margins can then be suddenly released as an earthquake. This is the case of the Eastern Island or the Juan Fernandez microplates. The latter, on its northern rim, just at the Juan Fernandez ridge, plunges under the Nazca

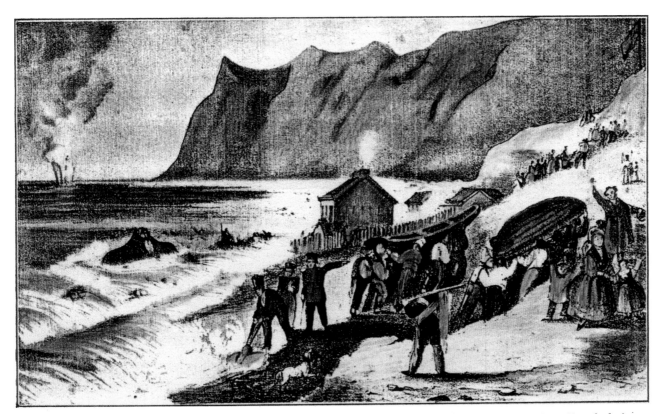

Maremoto del 20 de Febrero de 1837 en Bahía Cumberland (San Juan Bautista. Mas a Tierra.-Juan Fernández) y erupción cerca de la Punta Bacalao, según Sutcliffe.

Fig. 111 "*Maremoto del 20 de Febrero de 1837 en Bahía Cumberland*". Hand colored lithographic book illustration. Private collection, Prague

Plate, where the epicenter of the 1835 earthquake was located. Surprisingly enough, the Juan Fernando earthquake, which occurred far in the wastewaters of the Pacific Ocean, became very important as concerns the development of the early theories of the nature of earthquakes.

Four outstanding naturalists of that period embarked into the explanation of this unusual seismic event and tried to formulate a pertinent common theory on earthquake initiation and occurrence.

Alexander von Humboldt (1769–1859), since his journey to South America, where he witnessed several earthquakes and also collected reports on earthquakes, tried to formulate a theory on the causes of earthquakes' occurrence and on their propagation through the Earth. He gradually modified his initial Neptunistic position and emphasized the basic role of general volcanism.

Karl Gustav Christopher Bischof (1792–1870) introduced chemical methods in geology. He studied the state of heat in the interior of the Earth and – being inspired by the 1835 Juan Fernando event – recognized the importance of the effects of water inside the Earth's crust. As a follower of Neptunism, he supported the subsidence theory of earthquakes.

Charles Darwin (1809–82) participating in the circumnavigation of the Earth aboard the Beagle ship – on the occasion of the great Chilean earthquake (February 20, 1835) – formulated a plutonic earthquake theory, which created part of his texts on the relation between volcanic phenomena and the elevation of the coast of South America.

Jean Baptiste Boussingault (1802–87) promoted his "earthquake" theory based on the 1835 Juan Fernando event by pointing out the violent elevation of the hardened earth crust with subsequent subsidence and the emergence of caves.

Today, armed with present knowledge on earthquakes, we may comment all above outlined attempts as follows: Since the 1835 event was of a very specific character, it does not seem to be a good example for a proper illustration of any common theory on earthquake nature.

Figure 112 is a copy of a French leaflet informing about the eruption of the Soufrière volcano accompanied by a volcanic earthquake in the Guadeloupe Island, on February 8, 1843. The leaflet was printed in the French town Mets in 1843. Carefully engraved composition shows the landscape of the event; on the right, we see a volcano belching flame and smoke from its three craters. The stricken town of Point à Pitre, located below the volcano, is beleaguered by several fires. In the central part of the illustration, the locals are fleeing on their vessels to the safety of calm sea waters. It should be noted that the volcanic eruption, no matter how strong it was, did not generate any tsunami waves. On the left, the panic-stricken inhabitants are watching the destruction of their town from safe distance. The bottom part of the leaflet is reserved for the verbal description of the event.

Fig. 112 "*Tremblement de terre de la Guadeloupe*" (The earthquake in Guadeloupe). Xylography illustration. Private collection, Prague

San José Earthquake, Costa Rica, 1888

Figure 113 was taken from the German edition of *Frank Leslie's Illustrierte Zeitung*, 1889; the picture familiarizes us with Costa Rican town San José, a town consisting a great deal of simple ground-floor houses strongly damaged by the earthquake of December 29–30, 1888. Seismic losses were multiplied by a number of local fires ignited by overturned stoves and ovens. Both church steeples were shown as strongly damaged, inclined, and threatened to collapse.

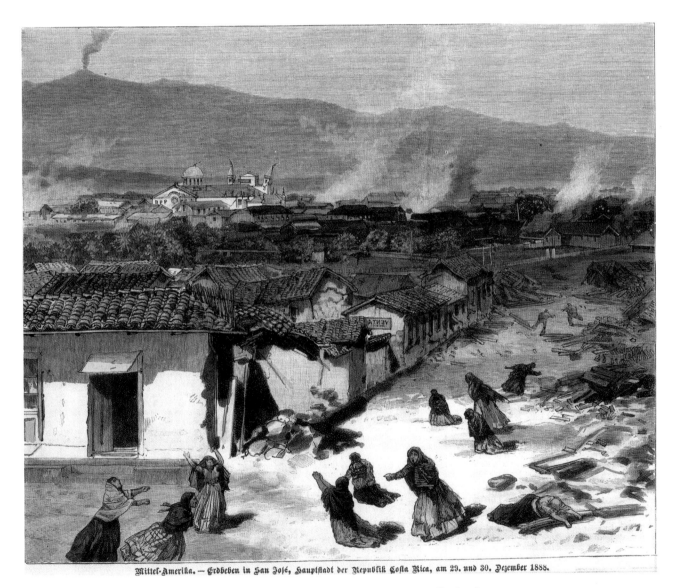

Mittel-Amerika. — Erdbeben in San José, Hauptstadt der Republik Costa Rica, am 29. und 30. Dezember 1888.

Fig. 113 The 1888 earthquake at San Jose, Costa Rica. Hand colored xylography. Private collection, Prague

J. Kozák and V. Čermák, *The Illustrated History of Natural Disasters*,
© Springer Science+Business Media B.V. 2010

The general impression of the scene was emphasized by the consternation of local people in front part of the picture and by a smoking volcano on the horizon.

Costa Rica belongs to the most complex regions of Central America where several tectonic plates meet, namely the continental plates of South and North America and three oceanic plates Nazca, Cocos, and Caribbean. It follows that earthquakes and volcanic eruptions are an everyday experience there. The December 1888 earthquake destroyed many buildings in San Jose and also in the nearby settlements of Cartago, Alajuela, and Poas. The major damage was reported especially to the church and bank buildings in the capital. Also, local river beds changed. It is difficult to estimate the number of victims at present; the old chronicles did not record them.

After the 1888 destruction of San Jose, three experimental seismically resistant metal buildings were erected in the town. Most famous of them, Edificio Metalico, was designed by French architect Victor Baltard. His Edificio, better say Palace, became a symbol of the public education system pushed forward by the liberal Costa Rican State at the end of the nineteenth century

The 1861 Earthquake at Mendoza, Argentina

Figure 114 offers a realistic picture of the destruction of the large Argentinean town Mendoza, located on the eastern slopes of the *Cordilliera de los Andes*. The earthquake of 1861, March 20, can be characterized by magnitude $M \sim 7.2$ in the Richter scale, (corresponding to $I_o = IX$ in the Mercalli macroseismic intensity scale). Its epicenter was located at an estimated depth of 30 km. The image nicely discloses the fact that the destructive effects of subsidence earthquakes on large buildings are stronger when the structure length is comparable with the length of the incident seismic waves.

Contrary to the above earthquake, which was shallow, most earthquakes occurring in the Argentina–Chile border zone, running north to south along the Andean mountain range, belong to the deepest earthquakes in the world. The tectonic plate which forms the bottom of the eastern Pacific Ocean submerges below the western shore of South America; strain accumulates by the discontinuous stick-slip-type displacement of the subducting plate, and the accumulated shear stress is released in the form of an earthquake. Shallow earthquakes are typical for the coastal zone; with the increasing

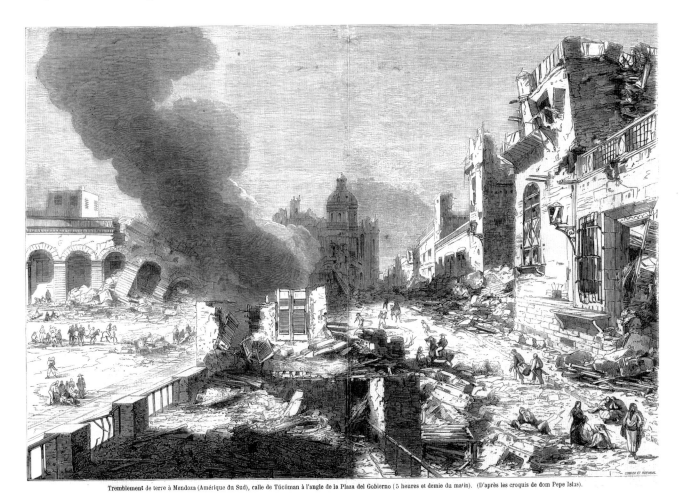

Tremblement de terre à Mendoza (Amérique du Sud), calle de Tucũman à l'angle de la Plaza del Gobierno (5 heures et demie du matin). (D'après les croquis de dom Pepe Islas).

Fig. 114 The 1861 Mendoza earthquake. Xylographic newspaper illustration reproduced from French journal *Le Mondé Illustrée* (1961). Private collection, Prague

distance from the shore line, the earthquakes are deeper. At a certain depth of several hundreds of kilometers, due to increasing temperature and pressure, the subducting rocks become plastic and are not able to accumulate shear stress any more (i.e., to generate earthquake). The deepest earthquakes recorded at the eastern foothill line of the South American mountain ridge, just at the Mendoza level, are linked with the subduction mechanism in the east Pacific.

The 1861 earthquake severely devastated the provincial capital Mendoza, killing 8,000–10,000 of its residents.

Most of the buildings were heavily damaged or ruined, including the *cabildo* (colonial government house). The town was reconstructed in a nearby location, and the authorities moved to their new seat in 1863. The new constructions, which incorporated modern architectural tendencies, were markedly different in comparison with the old colonial buildings. Today, Mendoza citizens are proud of the large squares and wider streets and sidewalks, which bestow Mendoza a prominent position among the other cities of Argentina.

Arequipa/Arica Earthquake (Peru–Chile Border Zone), 1868

Similar to the Lisbon earthquake which did not occur in Lisbon, but in the Atlantic Ocean near the Portuguese coast, the Peruvian–Chilean earthquake of August 13, 1868, also did not occur inland, but in the coastal waters of the Pacific Ocean. And, as the Lisbon event in 1755, the 1868 Arica earthquake also generated large, devastating tsunami waves.

Figure 115 presents a hand-colored xylograph, entitled "The Recent Earthquake in South America." This picture originally appeared as a double-page newspaper illustration in London in 1868. Its bottom part shows the border town of Arica (formerly in southern Peru, nowadays in northern Chile) viewed from the southwest, from a place opposite to a mighty rock cliff. The town, located on a gentle slope, was devastated by the earthquake. Some houses regardless of severe damages were still standing. However, the front part of the town, spreading along the sea coast (behind the sailboat), was swept away by a tsunami wave. The upper part of the picture, viewed from north to south, documents the final stage of the catastrophe.

THE LATE EARTHQUAKE IN SOUTH AMERICA.

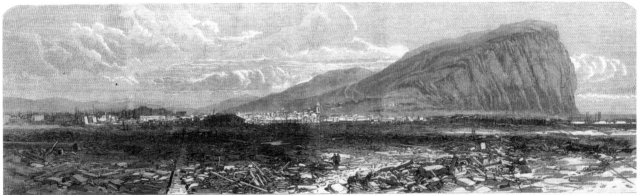

RUINS OF ARICA, IN PERU.

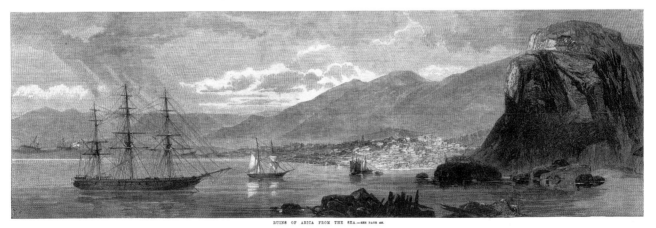

RUINS OF ARICA FROM THE SEA.—SEE PAGE 406.

Fig. 115 Two views of the coastal town Arica at the Peruvian/Chilean border after the 1868 earthquake. Hand colored large folio prospect from The *Illustrated London News* (1868). Private collection, Prague

Figure 116 entitled *The earthquake at Arequipa, Peru: The Plaza Mayor and encampment of the people*, brings us to inland town Arequipa, almost 100 km far from the Pacific Ocean coast. This hand-colored xylography appeared in the Illustrated London News of October 31, 1868. The town inhabitants who abandoned their heavily damaged houses are shown camping in temporary shelters built in the Plaza. Serious seismic damage to both destroyed towns, some 270 km apart, were convincingly documented; seismic epicenter zone had to be quite large, lengthwise oriented, and located along the ocean coast. This fact confirms the assumption of a large segment of the lithospheric plate, which simultaneously sunk down together with a vertical movement of the ocean bottom along the depressed zone. Such mechanics is common in case of subduction process.

The tsunami waves, generated by the Peruvian earthquake, spread toward the west, at a speed of 800–1,000 km /h. They crossed the Pacific Ocean and hit its western coasts within a few hours. High waves were recorded not only at many Pacific islands, but also on the coast of New South Wales in Australia and in New Zealand. The naturalists, who even in the 1860s erroneously considered high sea waves of this kind as a certain type of excited tidal waves, after the Arica–Arequipa event had to adopt the correct explanation of the origin of tsunami waves. The Austrian geologist F. Hochstetter, who observed tsunami while visiting Australia in August 1868, already called tsunami waves *Erdbebenwelle* (= earthquake waves) (Hochstetter 1868). Only later, in the twentieth century, a Japanese word tsunami, meaning a *long wave in a harbor*, got commonly established for this natural phenomenon.

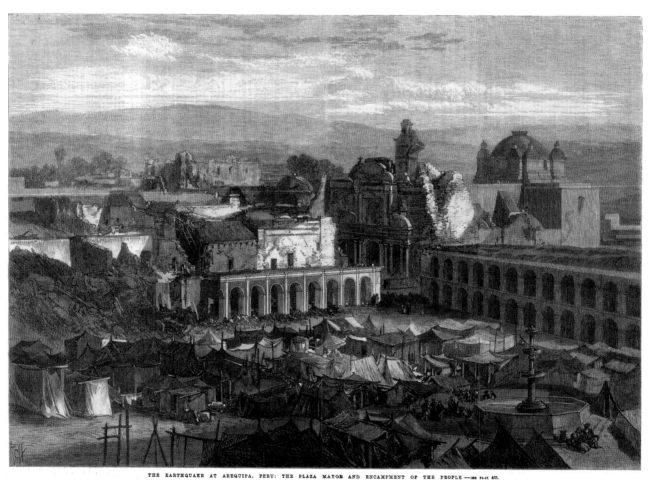

THE EARTHQUAKE AT AREQUIPA, PERU: THE PLAZA MAYOR AND ENCAMPMENT OF THE PEOPLE —SEE PAGE 433.

Fig. 116 The main plaza in the Arequipa town, Peru, after the 1868 earthquake. Private collection, Prague

San Salvador Earthquake, Salvador, 1873

The destructive ground trembling of March 4 and 19, 1873, visited a large region in Central America and almost completely destroyed San Vicente town, the capital of San Salvador. Figure 117 presents a xylographic newspaper illustration taken from the Harper's Weekly of 1873. The picture illustrates a crowd of city inhabitants in panic, who, after the first few shocks, flew desperately out of the buildings to an open space. In the background on the left, the portal columns of palaces collapsed and the scene was clouded by unsettled dust. A closer view on the illustration may reveal that the town buildings are exaggerated in size: contemporary records wrote about San Salvador as a smaller town of mostly one-storied houses and of a wooden facade of the Cathedral.

San Salvador, located in the proximity of the Pacific coast, belongs to the region that is frequently afflicted by earthquakes caused by the subduction of the Cocos tectonic plate. The series of recorded Salvador earthquakes began with the 1524 event; later, the town was seriously hit by the earthquake of April 16, 1854, which was felt also in adjacent Honduras. The following earthquake of 1879 used to be related with the volcanic activity of the Ilgopango volcano.

As a matter of interest, the 1873 earthquake was also described in detail in the narrative written by a correspondent of the New York Word Journal who experienced the event in nearby Corinto harbor in Nicaragua and who visited San Salvador town with the rescuers shortly after the disaster. The rescue squadron found about 50 dead bodies and 150 wounded persons upon its arrival in the ruined town. Let us quote some parts of the New York Word report: "Nothing unusual was observed during the night of the 18th but early in the morning of the 19th a telegram came from the capital

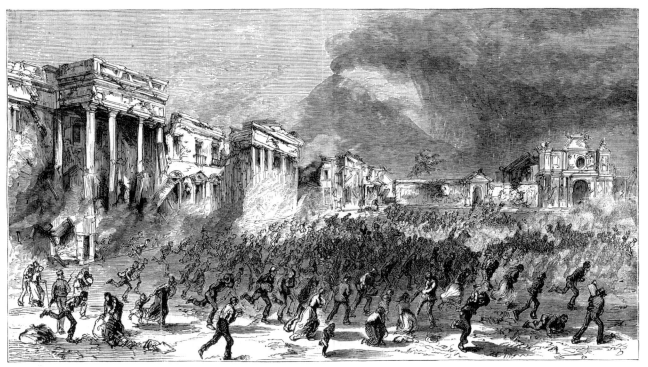

THE DESTRUCTION OF SAN SALVADOR BY AN EARTHQUAKE.—[SEE PAGE 373.]

Fig. 117 The destruction of San Salvador town by the 1873 earthquake. Xylographic journal illustration. Private collection, Prague

J. Kozák and V. Čermák, *The Illustrated History of Natural Disasters*,
© Springer Science+Business Media B.V. 2010

announcing that…San Salvador had ceased to exist… in the whole city, which numbered between 15.000 and 20.000 inhabitants … just a solitary building standing uninjured was found. This was a large wooden edifice belonging to an ecclesiastical body known as the College of Trent … beside this, the wooden façade of the Cathedral stood erect."

And the report goes on as follows: "the first order issued by the President General Gonzales, was a decree authorizing and requiring all citizens instantly to shoot down any man found with portable property of which he could not give a satisfactory account. Thanks to the energy and decision of the Executive, the horrors of this appalling scene were not aggravated by any such outbursts of human devilry and lawlessness as those which make the blackest feature in the terrible story of the destruction of Lisbon a century and more ago."

Figure 118 is a newspaper illustration reproduced from the *Harpers's Weekly* (1886). It presents a "snapshot" of a night scene illustrating the 1886 earthquake at Charleston. The reported damage, which on the unconsolidated sediments of the coastal plain indicated maximum intensity $I_o = X$ on the MM scale, corresponds to the magnitude of the earthquake $M = 6.7$. The felt area exceeded two million square kilometers. The main shock was followed by a series of weaker aftershocks during September and partly in October. Regardless that the territory of Carolina is rather aseismic, earthquakes cannot be excluded there; compare the earthquakes in 1972 and 1974 of $M = 4.5$ and 4.7, respectively. These intraplate earthquakes, contrary to the earthquakes occurring on the plate margins, however, occur randomly only.

The 1886 earthquake caused relatively serious damage to many buildings in Charleston, such as wide cracks in the walls of St. Michael church, and caused several fires

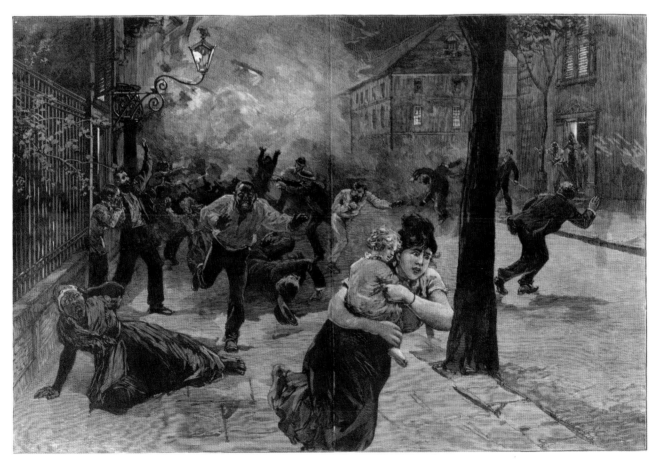

THE NIGHT OF THE EARTHQUAKE IN CHARLESTON, AUGUST 31, 1886.—Drawn by T. de Thulstrup.—[See Page 590.]

Fig. 118 The 1886 Charleston earthquake. A street scene in the night of August 31,1886, presenting the inhabitants flying in panic from their houses. The composition is signed by T. de Thulstrup. Reproduced from Harper's Weekly of September 1886. Private collection, Prague

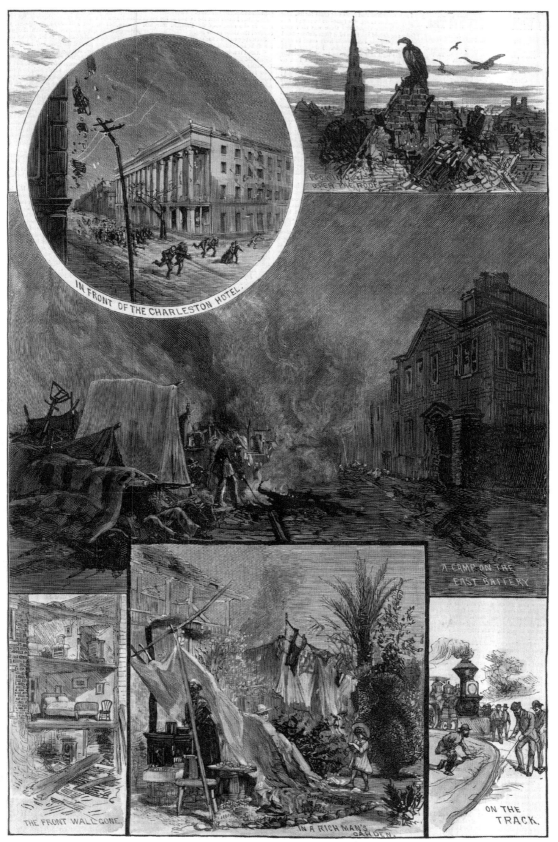

INCIDENTS OF THE EARTHQUAKE AT CHARLESTON.—Drawn by Schell and Hogan.—[See Page 590.]

Fig. 119 The pop-up picture composed of six situation-images illustrating the effects of the 1886 Charleston earthquake. Hand colored xylograph from the *Illustrated Harpers Weekly* (1886). Private collection, Prague

in the town. Unexpected shocks also provoked big agitation and panicked town inhabitants. The first ground tremor was felt around midnight and it forced sleeping people to a disoriented stampede (Fig. 119).

According to Stower and Coffman (1993), the 1886 earthquake on September 1 (or August 31) had its epicenter ~25 km NWN of Charleston and was the most damaging earthquake to occur in the southeastern United States and also one of the strongest historical shocks in the eastern North America. Many buildings in the old city of Charleston were scarred by the earthquake (cracks in walls, fallen chimneys, etc.,) and only a few houses escaped seismic damage. The number of victims ranged to about 60 people. Structural damage was reported far from Charleston up to central Alabama, central Ohio, Kentucky, Virginia, and West Virginia. There were significant surface effects observed in broad Charleston vicinity. Stower and Coffman (1993) indicate that the damage to railroad tracks northwest of the town included lateral and vertical displacements of tracks, formation of S-shaped curves, and longitudinal movements. Other surface earthquake effects, such as the occurrence of sand craters of diameter up to 6–7 m and ejection of muddy sand were recorded. As concerns the event's epicenter, the authors claim that the intraplate epicenter of this major shock is not unique for large earthquakes in the eastern and central United States … earthquakes occurring along boundaries of plates are well understood in terms of plate tectonics, but those occurring within plates are not similarly understood. This problem still is being studies more that 100 years after the earthquake.

Figure 120 is a newspaper print taken from the November 1868 issue of *Harper's Weekly*. The picture presents a composed illustration of the seismic damage caused by the 1868 Hayward earthquake of October 21. In the city of San Francisco, several houses were ruined or heavily damaged at their street facades up to the first floor. However, without complementary information, one cannot decide, what was the share of the destructive seismic waves and how much the hasty construction of San Francisco buildings could be blamed for the damage. Most of San Francisco buildings

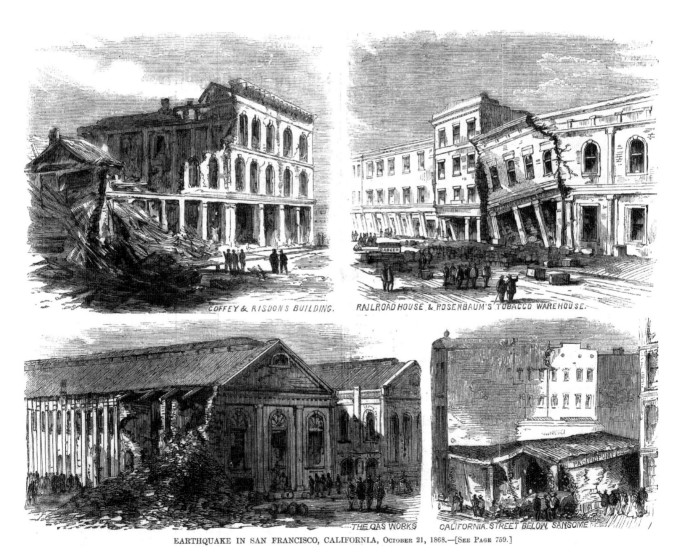

COFFEY & RISDON'S BUILDING.

RAILROAD HOUSE & ROSENBAUM'S TOBACCO WAREHOUSE.

THE GAS WORKS

CALIFORNIA STREET BELOW SANSOME

EARTHQUAKE IN SAN FRANCISCO, CALIFORNIA, October 21, 1868.—[See Page 759.]

Fig. 120 The Railroad House & Rosenbaum's tobacco warehouse ruined by the 1868 Hayward earthquake. Xylographic illustration of contemporary newspaper. Private collection, Prague

were risen up within few years during the Golden Rush in 1848, and it is notoriously known that the construction quality of many first town buildings had been rather poor.

The Hayward fault, the seat of the 1868 earthquake, runs parallel with the San Andreas Fault along the eastern coast of the San Francisco Bay. It belongs to the coastal belt of tectonically unstable fault system, along which the North American and Pacific plates mutually move and interact. A mutual movement of ~5–7 mm per year can be demonstrated in a slow (aseismic) displacement, which can be geodetically measured and is usually accompanied by a number of microquakes with shallow epicenters at 4–10 km depth. When these slow movements are constricted, seismic energy accumulates and is finally released in a strong earthquake, as in the 1868 event.

The 1868 Hayward earthquake was the strongest ever known event occurring on the Hayward fault, its intensity was determined as I_o ~ IX (which corresponds to the magnitude M = 6.9) strong effects were felt along the 32 km-long fault section. The region of destructive intensity extended over a distance of 600 km (Stover and Coffmann 1993). Similarly, as in the case of other earthquakes on the San Andreas fault, it was preceded by a series of several foreshocks within the years 1855–1866 of magnitude up to $M = 5$, which appeared to be one of the most devastating events in the region. Up to the year 1906, the Hayward earthquake was known as "the Great San Francisco earthquake", it left behind 30 dead and colossal material damage in Hayward, Oakland, and Berkeley, i.e., in towns which are practically situated on this fault.

The 1906 Great San Francisco Earthquake

The 1906 San Francisco earthquake was a strong seismic event that struck the town and the northern coast of California on 18 April, 1906. The earthquake surprised the inhabitants of the town early morning at 5:12 a.m. Earthquake epicenter was located on the San Andreas Fault, at 37.67°N, 122.48°W, at the depth $h = 20$ km. The number of casualties was estimated as 3,000 (largest in the history of USA), of which ~500 perished due to the earthquake, the rest due to fire. The event was recorded by seismometers all over the world (Lawson et al. 1908–1910; Stower and Coffman 1993). The earthquake and resulting fires are still remembered as one of the worst natural disasters in the history of the USA. The economic impact was tremendous, assessed as US$524 million on the 1906 price level.

As a consequence of the earthquake, significant vertical and horizontal displacements were observed along the rupture on the San Andreas Fault, a discontinuity that runs the whole length of California from the Salton Sea in the south to Cape Mendocino in the north at a distance of about 1,300 km. In the 1906 event, the main seismogenic displacements occurred especially in the northern third of the fault. The maximum observed horizontal surface displacement reported by the eye witnesses amounted to about 6 m. More accurate geodetic measurements confirmed displacements of up to 8 m and more (Lawson et al. 1908). A strong foreshock preceded the mainshock by about 20–25 s. Shaking of the mainshock lasted approximately 42 s. The macroseismic intensity generally reached VIII degree on the MM scale and up to IX degree in the northern areas around Santa Rosa, where the destruction was almost complete. Commonly accepted assessment for the magnitude of the earthquake was $M = 7.8$; however, other values between 7.7 and as much as 8.3 have also been proposed (Stower and Coffman 1993). Ground shaking was felt from Oregon in the north to Los Angeles in the south, and inland as far as to Nevada in the east.

Equally damaging, as the earthquake and its aftershocks, were the fires that got out of control; sometimes, the fires were even more destructive. Even though a number of new modern buildings were erected during 58 years of San Francisco existence, a great deal of buildings was still of simple wooden construction in 1906. Consequently, fires broke out in many parts of the town; most of the flames were farther fueled by natural gas mains damaged or interrupted by the earthquake. It is sad to confess that some fires were the result of arson set by the property owners. The insurance policy usually covered only fire losses, but most houses were not insured for earthquake losses. The house keepers therefore were not waiting and set fire to their, sometimes only slightly earthquake damaged, own houses. In a general mess and existing havoc, the fires from a number of local centers quickly spread over and the devastating fire seized the whole blocks of streets. As the most of water mains were broken, the city fire department had no enough extinguishing resources at its disposal to fight the fires effectively. Several fires in the downtown area merged together and created a single giant inferno. The fire ultimately destroyed over 500 city blocks of the downtown area (Hansen and Emmet 1989).

Mayor Eugene Schmitz issued an edict allowing police and military troops to shoot looters on sight, and several hundred people were actually executed. General Frederick Funston tried to bring the fire under control by detonating blocks of buildings around the fire to create firebreaks with all sorts of means. The explosions sometimes unfortunately set the ruins on fire or helped to spread it, however, this way eventually proved effective in stopping the fire from spreading westward to the remaining half of the city. The fires lasted for 4 days and nights. It has been estimated that as much as 90% of the total destruction resulted of the subsequent fires, although that figure may be exaggerated. The total death bill amounted up to 3,000 victims.

Figure 121 presents a color print, a newspaper illustration of the French magazine *Le Petit Parisien* of May 6, 1906 (nr. 900, p.144) – entitled *Une ville detruite – un tremblement de terre et des incendies aneantissent San-Francisco* (A ruined town – earthquake and fires devastating San Francisco). The artist's view is aimed from the top of damaged building at the southwest end of the main town's avenue Market Street to northeast over the Goat Island and the eastern part of the San Francisco Bay, somewhere to the hills above Berkeley. The northern sector of the town is set in fire and covered by

J. Kozák and V. Čermák, *The Illustrated History of Natural Disasters*,
© Springer Science+Business Media B.V. 2010

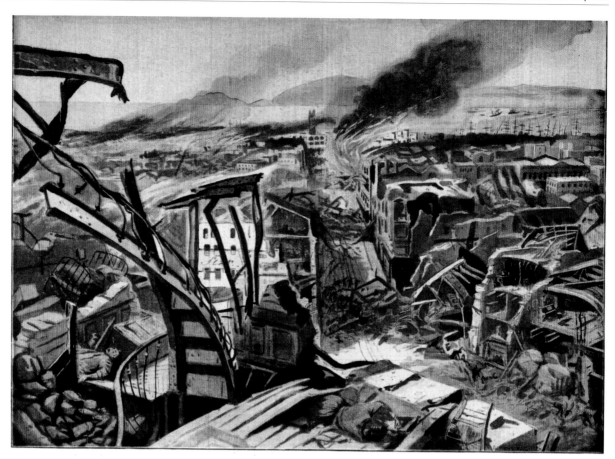

Supplément Littéraire Illustré du " Petit Parisien "

144

UNE VILLE DÉTRUITE. — UN TREMBLEMENT DE TERRE ET DES INCENDIES ANÉANTISSENT SAN-FRANCISCO

Fig. 121 San Francisco in fire. French newspaper illustration. Private collection, Prague

dense smoke, as well the right-hand side of the Market Street. The town itself is introduced as heavily affected by the earthquake, and most buildings are in ruins. Regardless that, today, it is difficult to judge the degree of objectivity and correctness of the illustration, the picture itself appears very realistic, also for its correct topographic orientation (a question may be asked whether the sketch was drawn from a photograph).

Figure 122, signed by Paul Dufresnes, was drawn up by the same technique as the previous illustration and was also adopted from Le Petit Parisien (May 6, 1906). It shows a drastic street scene of an ad hoc trial and execution of the robbers looting the damaged houses and robbing dead bodies. Quickly organized civic guards worked without undue delay and mercy.

Since the 1906 San Francisco earthquake a large effort of seismologists and other earth scientists has been paid to better understanding of high-level seismicity along the western coast of the USA, namely as concerns high seismic

activity of the San Andreas Fault, a coastal strip of California, which is densely populated today. Therefore, a dense network of seismic observatories and seismic arrays (= series of seismographs interconnected and operated through a central computer) have been installed in this region, which continuously monitor local seismicity. Today, the causes of earthquakes and mechanism of earthquakes in California are well known to local seismologists. Therefore, for the earthquakes' effects mitigation, their effort has been preferentially focused on the solution of two questions: first, how to develop and verify reliable predictions of future seismic danger (seismic risk) for individual parts of the state of California and for other seismically endangered regions of the western parts of the USA, and secondly, how to construct seismically resistant edifices and other technical constructions. In both these fields important achievements have been reached; in the last decades they are presented in regular meetings of the American Geophysical Union (AGU) annually held in December at the Mosconi Center, San Francisco, CA.

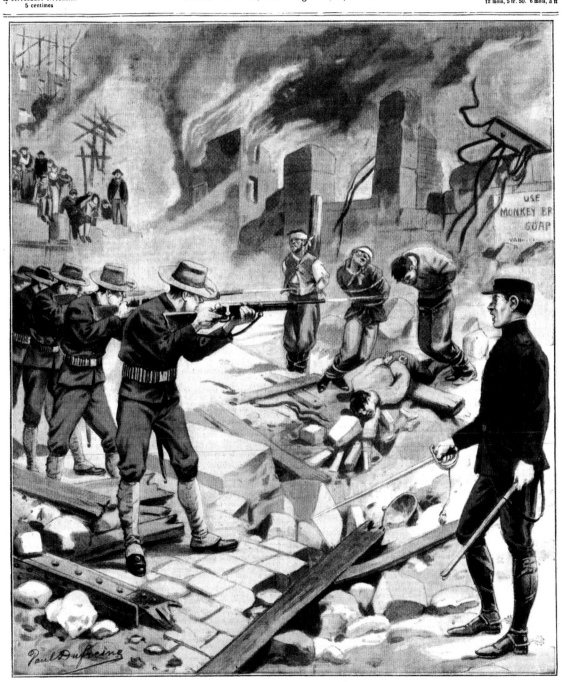

Fig. 122 On-spot execution of several persons caught red-handed, San Francisco 1906. Private collection, Prague

Two Calabrian Earthquakes, 1905 and 1908

Southernmost Italy, Calabria and Sicily, has experienced a great number of devastating nature catastrophes in its history, both earthquakes and volcanic eruptions. Etna's huge eruption in 1669 together with the following volcanic events of the eighteenth and nineteenth centuries, Sicilian earthquake as Monti Iblei of 1693, which devastated Catania and Noto towns, and especially the Great Calabrian (Messinian) earthquake of 1783, classify this territory as the most dangerous in Europe. Other equally hazardous earthquakes occurred there in the early twentieth century.

Figure 123 presents a title page of the Czech weekly "Illustrované Listy" (= *Illustrated Letters*), devoted to the Calabrian earthquake of September 8, 1905. The xylographic print is entitled *Terrible earthquake in Calabria, a view on the havoc at Monteleone*. The picture illustrates the rescue activities in the ruins of the collapsed houses, guarded by military patrol. In the background image, two soldiers are carrying away one of the victims. The Calabrian earthquake of 1905 (I_o = XI on the MCS scale, $h \sim 24$ km) with the epicenter in the Golfo di Santa Eufemia caused serious damage to the whole region, especially due to its shallow depth.

The 1905 earthquake came at a time, when people still remembered another strong preceding seismic catastrophe on the Ligurian coast of February 23, 1887. The maximum intensity was assessed as I_o = VIII on the MCS scale. Many people died at that time in churches, where they gathered for the Christian fest of Ash Wednesday, when church vaults collapsed. In total, the disaster took toll of about 630 dead and many others wounded (Postpischl 1985).

As it would not be enough, another horror visited the unhappy region 3 years later. A fatal earthquake occurred on December 28, 1908. According to Postpischl, the maximum intensity I_o of that earthquake reached up to XI–XII on the MCS scale. Among 20 aftershocks that followed the main shock on the same day, two reached values up to I_o = VIII, which completed the total damage. Since the earthquake was again quite shallow and the epicenter zone embraced the towns of Messina and Reggio Calabria, the death toll was high; the assessment of the total number of casualties varied between 60,000 and 120,000. Vertical movements in the earthquake epicenter under the Messina Strait generated large tsunami waves, which culminated near St. Alessio on the Calabrian coast, where they reached 12 m height (Hobbs 1909; Carcione and Kozák 2008).

Quite surprisingly, the turbulent and restless region of the narrowest part of the Messina Strait continues to attract engineers and constructors even today: a new bold project is seriously considered to connect Sicily and Calabria by a large, one-bow bridge. At present, preliminary technical solution and design proposal together with budget considerations are under way, especially as concerns the proper determination of the natural vibration frequency of portly bridge piers and active bridge arch suspension. The project may be deemed to be a courageous engineering proposal or can be quarried as a proud human challenge.

Figure 124 brings a full-page hand-colored illustration, a composition of three small pictures: two views on Via Cavour and the *Zestörte Häuser in Messina* (=destroyed houses in Messina). This sketch was drawn by the famous German seismologist August Sieberg, who visited the ruined town shortly after the earthquake. We can see a number of completely ruined houses with the surviving inhabitants who gathered in front of the ruins. The extremely high death toll rated this disaster among the deadliest events of the last century (only in town of Messina, the number of victims amounted to 65,000, i.e., over 42% of the total population). The earthquake struck early in the morning when most of the people were still sleeping. The intensity in most NE Sicily and SW Calabria reached I_o = X degree, and in some localities, even XI degree of the MCS. The isoseismal line limiting extended epicentral zone of $I_o \geq X$ of the MCS presented an oval region of 20×30 km (Margottini and Kozak 1992). The earthquake initiated a tsunami wave and strong ground swell in the Messina Strait together with a vertical ground movement on the Costa Viola coast, which increased the number of casualties among those who looked for safety on the sea coast.

Another illustration of the 1908 catastrophe is presented in Fig. 125; a dramatic situation shows people fighting to save their lives, fighting with merciless attacks of rough sea waves. The image is accompanied by text, the translation of which does not need any further comments: "*The awesome night of 28 December 1908 in Messina. The stormy sea waters are attacking the unhappy town already devastated by an earthquake. All what had survived has been ravaged now.*"

J. Kozák and V. Čermák, *The Illustrated History of Natural Disasters*,
© Springer Science+Business Media B.V. 2010

Vychází každou sobotu.　　　**Brno-Praha.**　　　Ročník XII.

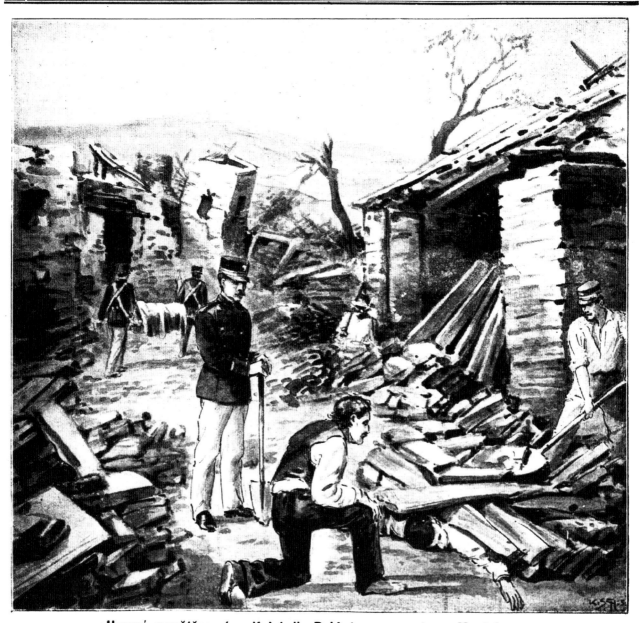

Hrozné zemětřesení v Kalabrii: Pohled na spousty v Monteleone.

Fig. 123　Calabrian earthquake in 1905 – rescuing the victims. Private collection, Prague

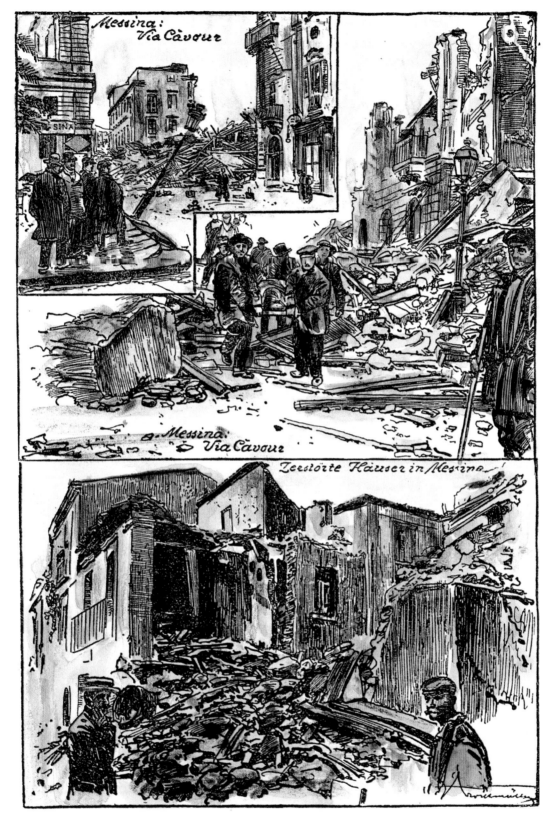

Fig. 124 The 1908 Calabrian earthquake, the situation in the streets of Messina. Hand colored sketch by A. Sieberg. Copy in private collection, Prague

Hrozné zemětřesení v jižní Italii.

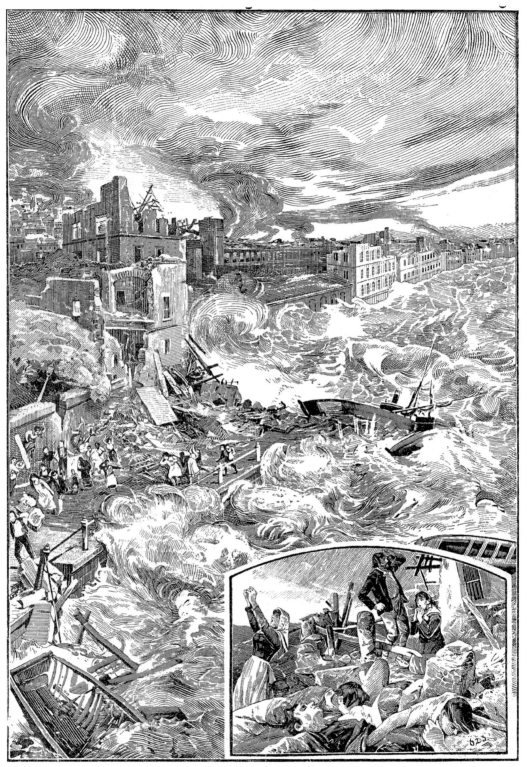

Hrůzyplná noc 28. prosince 1908 v Mesině. Rozbouřené moře zalévá vlnami svými zemětřesením spustošené město ničíc a pustošíc vše, co dosud bylo zachováno.

Fig. 125 The 1908 Calabrian earthquake. Xylography print from an unidentified Czech newspaper of 1908. Private collection, Prague

Milestones of Seismology

The development of seismology, a scientific discipline, which appeared under that name only at the end of the nineteenth century, proceeded discontinuously in the past. Certain long periods often occurred when no relationship existed with the knowledge actually obtained before. It is thus difficult to arrange a historical sequence of the progression into a number of clearly definable stages, which would logically concur. Therefore, we propose a list of major milestones – important facts, events, or findings – which have formed the advancement of seismology. As some of the famous earthquakes significantly influenced and accelerated this development, the dates of the selected major seismic disasters were inset, too.

1831 BC – First records of an earthquake in China. In the Shandong province, the mountain Taishan trembled by an earthquake.

780 BC – Reports on earthquakes in North China (period of Zhou dynasty). Since then, earthquakes in this region have been cataloged, the catalog seems to be quasi-complete (Bolt 1993)

Ancient Europe – Among the Greek philosophers who discussed earthquakes were, e.g., Thales of Miletus (624–546 BC), Anaximenes (585–525 BC), Anaxagoras (500–428 BC), and Aristotle (384–322 BC). In Rome, Seneca (4 BC – AD 65) speculated about earthquakes.

Approximately, in AD 132, Chinese scholar Zhang (or Chang) Heng constructed a dish-shaped seismoscope, which alerted on earthquake. This equipment enabled to determine arrival and approximate direction of arriving seismic waves.

Thirteenth century – First pictures of earthquakes, such as illuminations painted on vellum, illustrations of Italian manuscripts, and chronicles of thirteenth and fourteenth centuries; these depictions and accompanying texts were composed in agreement with the religious standpoints.

1544–1582 – First attempts to list the world's earthquakes. Münster (1544) in his encyclopedic volume *Cosmographia* listed the famous earthquakes of that time and illustrated them with simple woodcut prints. The catalog of earthquakes by J. Rasch (1582) *Von Erdbidem* (On Earthquakes) was published 4 decades later (Fig. 126).

1564 – First earthquake map. F. Moggiol introduced his map in which the localities affected by the Nice earthquake on July 20, 1564 were plotted. The sole copy of the map is kept in the University Library, Erlangen, Germany.

1627 – First seismic map presenting the damage distribution. M. Greuter (Poardi 1627) prepared two maps of the 1627 earthquake effects in the Capitanata province. The original maps are treasured in the Apostolic Library at Vatican.

1664–1665 – First hypothesis on the earth's structure. German Jesuit scholar Atanasius Kircher presented his comprehensive view on the earth's interior in his *Mundus Subterraneus* (Kircher 1678). The view is based on an assumption of a broad system of terrestrial channels of three types (water, air, and fire). Although Kircher's concept, fully speculative, was erroneous, it was commonly accepted by European savants for more than hundred following years.

1755 – Great Lisbon earthquake. Lisbon disaster, which presented the strongest and most destructive European seismic event in historical times, initiated a broad intellectual discussion on the causes of natural disasters, namely earthquakes (Fig. 127).

1755–1790 – First serious earthquake studies and the birth of seismology.

Georges-Louis Leclerc, Comte de Buffon (1707–1788), French naturalist and author of the extensive *Histoire Naturelle* (Buffon 1749–1804), influenced the following two generations of naturalists.

Among those inspired by the Lisbon earthquake belonged, e.g., two English naturalists John Michell (1724–1793), with his *The History and Philosophy of Earthquakes* (Michell 1761), and John Bevis (1693–1771), with his book of the same title (Bevis 1757), and their Swiss colleague Élie Bertrand (1712–1790), with his *Memoires Historiques et Physiques sur les Tremblements de Terre* (Bertrand 1757).

Charles Davison (1927) in his book *The Founders of Seismology* marked the middle of the eighteenth century as the birth of actual seismology.

1783–1792 – A long series of strong Calabrian earthquakes (Fig. 128). The 10-year long earthquake succession of tremors devastating Italian Calabria and eastern Sicily attracted the attention of many geosavants, among them were, e.g., G. Vivenzio, D.G. de Dolomieu, and others. The first attempt to propose a macroseismic intensity scale was made by Physicist D. Pignataro (1735–1802) who classified

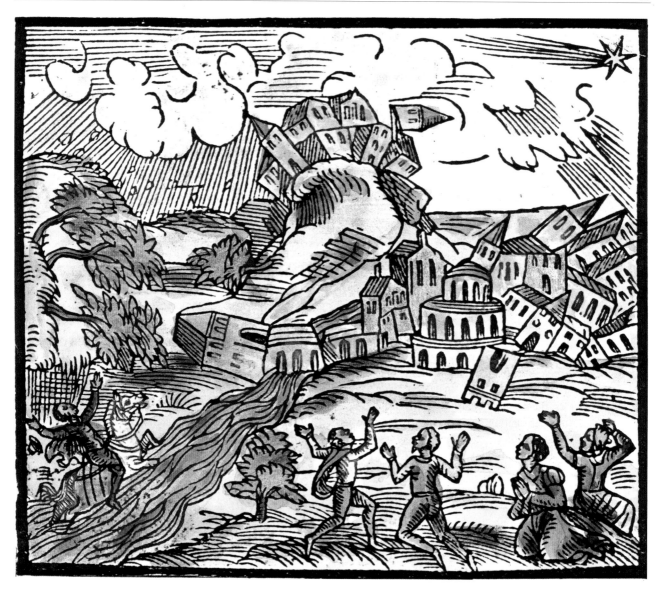

Fig. 126 An allegorical composition showing earthquake effects. The image decorated the front page of a tract on earthquakes by J. Rasch (1582). Hand colored woodcut. Private collection, Prague

the seismic series from February 1783 to October 1786 by five intensity levels as mild, medium, strong, destructive, catastrophic. However, Pignataro's scale was not used, as it was too rough and poorly defined (Vivenzio 1788).

1783 – First complex pictorial documentation of an earthquake event (based on Great Calabrian earthquake of February 1783). A series of 69 large-size copper engravings was prepared by two Italian architects P. Schiantarelli and I. Stilo (Vivenzio 1783). The series of pictures was completed by a detailed map of the stricken region. The original set is deposited in the collection of A. Bertarelli in Milan.

1828 – First seismic damage scale; German mathematician P.N.C. Egen (1793–1849) proposed a 6-degree scale to evaluate the damages caused by the Netherlands earthquake on February 23, 1828. However, a relatively weak earthquake

did not provide enough data to construct a reliable isoseismal map (Egen 1828).

1840 – First catalogs of world earthquakes; the catalog prepared by K.E.A. von Hoff (1840) may serve as a good example.

1856 – First European seismometers; a "*sismografo elettro-magnetico*" instrument was constructed by the Italian volcanologist Luigi Palmieri, director of the Volcanological Observatory on Vesuvius. His device enabled to determine the direction and intensity of seismic impacts, arrival time, and duration of seismic signal, in both vertical and horizontal components (Davidson 1927).

1856–58 – Volger's macroseismic map

When evaluating Visp earthquake data (event of July 25, 1855), Otto Volger formulated his intensity scale of 6 degrees

Fig. 127 Two of the Le Bas (1757) compositions presenting the Great Lisbon earthquake of 1755. Top: Damage to the Cathedral (Basilica de Santa Maria). Bottom: Damage to the St. Nicholas Church. Private collection, Prague

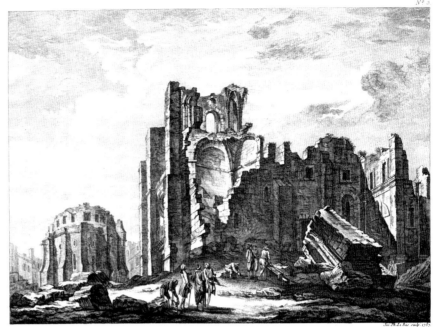

Basilica de Santa Maria. *La Cathedrale*

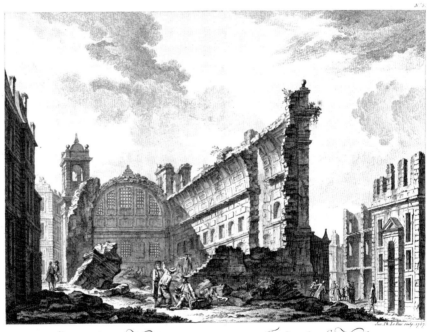

Igreja de S. Nicolau *Eglise de S. Nicolas.*

0, 1, ..., 5, beginning from 0 (strongest) up to 5 (weakest), based on damage to buildings and constructions. Also he constructed the first macroseismic map pointing out the localities affected by seismic tremors. Because the degree "0" was reserved for the strongest intensity Volger's scale was not applicable for earthquakes stronger than the Visp event (Volger 1856–1858).

1857 – Geological Survey of India was established; this institution later preformed an exemplary mapping of the whole Indian subcontinent.

1862 – First observational and theoretical principles of earthquake engineering were formulated.

Robert Mallet (1810–1881) formulated the theoretical principles of earthquake engineering when analyzing the

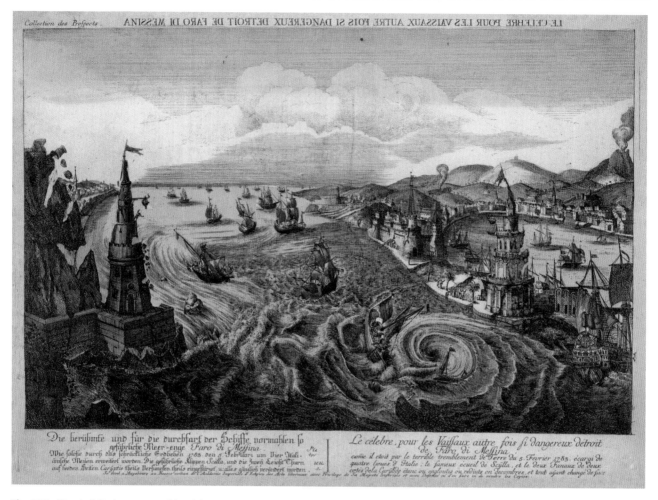

Fig. 128 *Vue de l'Optique* composition (=laterna magica technique) showing sea ships and boats endangered in the rough waters of the Messina Strait disturbed by the 1783 earthquake. Hand colored copper engraving. Private collection, Prague

earthquake in the Italian province Basilicata on December 16, 1857. Mallet's work was richly illustrated by stereoscopic photographs, lithographic views, sketches, and geological profiles (Mallet 1862). The interactions of seismic waves with man-built constructions were demonstrated on practical examples.

1868 – Tsunami described as a phenomenon generated by earthquake.

Before the 1860s, huge sea waves accompanying some earthquakes had been interpreted as a special case of standard tidal waves. Only, after the Arica earthquake of August 1858, these waves were correctly described as having seismic origin. Viennese geologist F. von Hochstetter (1868) promoted this idea in Central Europe.

1879 – United States Geological Survey was established.

This institution has been responsible for the earthquake-oriented research in the territory of the USA and in geographically attached regions.

1881 – Scottish Scottish engineer Sir James Alfred Ewing together with John Milne and Thomas Gray, during their stay in Japan, used damped horizontal pendulum to develop and construct the first seismograph for practical use (Ewing 1881, 1883). Milne, after his return back to Great Britain in 1885, built up a 40-station seismic network (ten stations in the UK plus 30 in the present Commonwealth countries) and is sometimes considered to be one of the father-founders of modern seismology (Bolt 1993).

1881 – The first generally accepted macroseismic intensity scale was accepted.

During the last 3 decades of the nineteenth century several proposals were put forward to introduce a macroseismic scale to measure earthquake intensity (macroseismic means "based on human perception"). Among the proposers, e.g., Forel of Switzerland, de Rossi, Mercalli, and later Cancani of Italy, and Rethly of Hungary should be named for many others. The final scale version was proposed independently by de Rossi and Forel at the turn of the 1870s/1880s and since then their 10-degree scale was used by most countries; in 1888, the scale was innovated by Giuseppe Mercalli as a 12-degree variant.

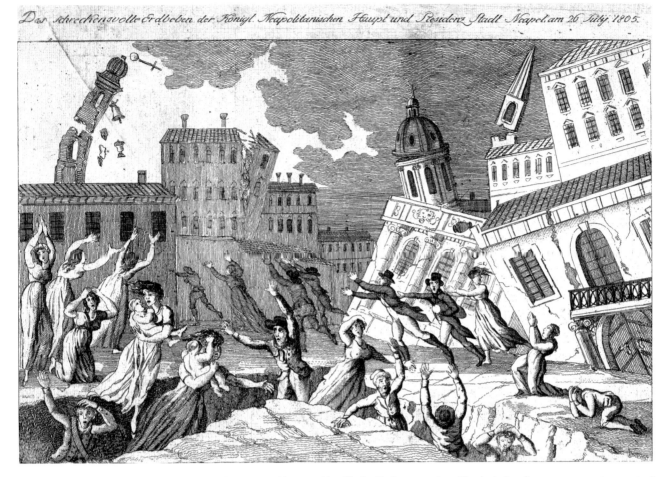

Das schreckensvolle Erdbeben der Königl. Neapolitanischen Haupt und Residenz Stadt Neapel am 26 July 1805.

Fig. 129 The July 26, 1805 Naples earthquake portrayed in an unidentified solitaire engraving. The depiction does not represent any actual earthquake documentation, namely with regard to the damage to the buildings. Large cracks in the ground, "swallowing" panicked inhabitants, allow us to estimate the earthquake intensity degree at I_o=X. Private collection, Prague

The 1890s – Introduction and common acceptance of the terms "Geophysics" and "Seismology"

The term "geophysics", as a branch discipline of geology, was sporadically used since the 1870s, but naturalized in the next 2 decades. Simultaneously, also the term "seismology" was accepted, as a subdiscipline of geophysics. On the first international conference on seismology in 1901, both terms were routinely used.

1897 – First national macroseismic service and installation of seismographs.

The first such service was established in the Austro-Hungarian Empire in 1897 in reaction to the seismic threat caused by earthquakes in Zagreb/Agram (1880) and in Ljubljana (1895). A seismic service project was realized by E. von Mojsisovicz (1897), a part of which was the installation of the seismographs. Around 1900 Austro-Hungarian monarchy became one of the countries best covered by seismographs.

End of the nineteenth century – Basic seismological terminology was commonly installed, such as e.g., (i) types of seismic events, distinction between tectonic and volcanic earthquakes having their origin in the internal dynamics of the Earth, earthquakes caused by gravity (rushing earthquakes, landslides, avalanches), earthquakes caused by human activities (mining tremors), and eventually microseisms; (ii) forerunners and aftershocks accompanying the major shock(s), twins, seismic swarms, etc.; (iii) types of seismic waves: body waves, i.e. P-waves (primary or longitudinal or also compression waves), S-waves (secondary or transversal or also shear waves), and surface waves (i.e., Rayleigh and Love waves); and (iv) travel-time curves indicating the arrival time of seismic signal as a function of the epicentral distance.

1900 – Emil Wiechert was appointed the first professor of seismology at the Goettingen University, Germany. Wiechert constructed the first damped seismograph, which was in operation in many variants in a number of countries during the first decades of the twentieth century.

After 1900 – Worldwide network of seismic stations installed.

There was intensive development of seismic observatories in various countries, design and construction of new and more sophisticated instrumentation techniques, advancement of basic knowledge about the earth's structure and its internal composition, and development of engineering seismology.

1901 – First international seismological conference, Strasbourg, Germany, April 1–3, 1991, with 32 participants from seven European countries and Japan.

1901 – Calculation of the epicenter distance based on the various velocity propagations of the individual seismic waves.

1906 – Confirmed the existence of the liquid core of the Earth at 3,000 km depth by R. D. Oldham in 1906, this depth was later corrected to 2,900 km by E. Wiechert in 1910 and 1922. In 1936, Inge Lehman completed the internal structure by confirming the existence of the solid inner core at 5,155 km depth.

1906 – Great San Francisco earthquake on 18 April, 1906, and its thorough analysis (Lawson et al. 1906–1908).

1910 – Croatian seismologist Andre Mohorovičić gave proof on sharp discontinuity separating the earth's crust from the earth's mantle at a depth range of 20–70 km.

1910 – Electromagnetic seismometers, the older mechanical recording of seismic signal was replaced by electromagnetic registration, proposed by the Russian seismologist Count Boris Golicyn.

Around 1910 – Japanese seismologist K. Wadati classified earthquakes according to the depth of the epicenter as shallow (crustal) earthquakes (less than 20 km), intermediate ($20 \leq h \leq 70$ km), and deep-focus earthquakes ($70 \leq h \leq 700$ km).

1911 – H.F. Reid (1911) described the principle of earthquake as a quick release of energy by shear relative movement of two blocks at depth in the lithosphere.

1912 – German meteorologist Alfred Wegener (1915) formulated his hypothesis of mutual movements of continents, the so-called continental drift theory.

1919 – International Union of Geodesy and Geophysics (IUGG) was established; one of its sections was the Section for Seismology, renamed in 1933 as the Association for Seismology, and in 1951 changed into the present International Association for Seismology and Physics of the Earth's Interior (IASPEI).

1923 – Great Kantō earthquake, Japan, September 1, 1923, with 105,000 victims, stimulated Japanese scientists to search for seismically resistant buildings.

1936 – Charles Richter in partnership with Beno Gutenberg, both from the California Institute of Technology, introduced the so-called magnitude, a single number to quantify the amount of seismic energy released by an earthquake.

1952 – European Seismological Commission was established.

1960–1970 – Plate tectonics was formulated, i.e., a theory that has been developed to explain the observed evidence for large-scale motions of the earth's lithospheric plates. The theory encompassed and superseded the older theory of continental drift from the first half of the twentieth century and the concept of seafloor spreading which developed during the 1960s.

After 1960 – The macroseismic scale, modernized by seismologists from the USSR, Eastern Germany, and Czechoslovakia, and in 1964 set up as the MSK-64 scale (Medvedev-Sponheuer-Karnik 1964). This scale was favored in Europe in the last third of the twentieth century.

1962–68 – Broadband seismometers were introduced, which were originally developed for the detection of subsurface nuclear explosions. Today they present a possibility of advanced seismic registration in very broad frequency spectra.

Since 1978 – Seismic arrays were built up, and there was substantial improvement in the determination of exact seismic source location.

1998 – European macroseismic scale (EMS-98).

Present obligatory macroseimic scale was established in the 1990s, under the guidance of G. Grünthal (Grünthal (ed.), 1998).

2002 – European Geophysical Union (EGU) was created by merging the former European Geophysical Society (EGS) and the European Union for Geosciences (EUG).

Bibliography

Ambraseys, N., 2001. The earthquake of 1509 in the Sea of Marmara, Turkey, Revisited. Bull. Seism. Soc. Am., 91, 6, 1397-1416.

Anonym, 1841. Iceland, Greenland and Faroe Islands, Oliver and Boyd, Edinburgh

Antonopoulos, J., 1980. Data from investigation on seismic sea waves events in the Eastern Mediterranean from 1000 to 1500 A.D. Annali di Geofisica, 33, 179-198.

Aprodov, V.A. 1982. Vulkany (Volcanoes), in Russian, MYSL ed., Moscow, 361 pp.

Baptista, M. A., Heitor, S., Miranda, J.M., Miranda, P.M.A. and Mendes-Victor, L., 1998. The 1755 Lisbon Tsunami: Evaluation of the Tsunami Parameters. J. Geodynamics, 25, 142-157.

Baratta, M., 1901. I Terremoti d´ Italia, Torino.

Berghaus, Heinrich, 1838-48. Physikalischer Atlas, Sammlung von Karten auf denen die hauptsächlisten Erscheinungen der anorganischen und organischen Natur, 1st Edition, J. Perths, Gotha. See also 2nd Edition 1848-1850, 3rd Edition 1849-1852.

Berghaus, Hermann, 1888 and later re-editions. Physikalischer Atlas, J. Perthes, Gotha.

Bertrand, E., 1794. Memoires Historiques et Physiques sur les Tremblemens de Terre, La Haye, 328 pp.

Bertuch, F. J., 1794&. Bilderbuch zum nutzen und Vergnügen der Jugend. B. Ph. Bauer, Wien and A. Pichler, Wien (&=innovated book versions were repeatedly edited up to the 1830s).

Bevis, J., 1757. The History and Philosophy of Earthquakes, Phil. Trans. Royal Soc. of London, 51, London.

Boccardo, G., 1869. Sismopirologia, Genoa, Italia.

Bolt, B.A., 1993. Earthquakes and Geological Discovery, Scientific American Library, New York, 230 pp.

Bolt B. A., 2006. The Earthquakes. W.H.Freeman and comp., New York, 390 pp.

Bory de Saint Vincent, J. B. G. 1804. Voyage dans les Quatre Principales Iles des Mers d´Afrique, Buisson, Paris, 217 pp.

Braun, G. and Hogenberg, A., 1572-1618. Civitates orbis terrarum, 6 vols, 365 copper engravings, Köln am Rhine.

Braun, G. and Hogenberg, F., 1581. Urbium praecipuarum totius mundi liber tertius, Köln am Rhine.

Brockhaus, F. A. (Ed.), 1894. Brockhaus´ Konversations Lexikon, 14th edition, Leipzig, Wien und Berlin.

Buffon, G-L. L., 1749-1804. Histoire Naturelle, Generale et Particuliere, avec la description du Cabinet de Roi, Paris.

Bylandt Palstercamp, A., 1836. Theorie des Volcanes, Atlas.

Carcione, J. M. and Kozák, J.T., 2008. The Mesina-Reggio Earthquake of December 28, 1908. Studia Geoph.Geod., 52, 661-672.

Christy, B. M. and Lowmann P.D. Jr., 1998. Global maps of volcanism. In: N.Morello (ed.), Proceedings of the 20th Symp. INHIGEO, Naples 1995, Brigati, Genoa.

Ciancio, L., 2005. Teatro del mutamento, Nicolodi editore, Rovereto.

Cocursin (or Caoursin), Guillaume, 1496. Obsidionio Rhodiae urbis descriptio. J. Reger, Ulm.

Condamine de, Ch-M. and Bouguer, P., 1748. Relación Histórica del Viaje a la América Meridional, Madrid.

Cundall, F., 1936. The Governors of Jamaica in the Seventeenth Century. The West India Committee, London.

Davis, Richard A. 1977. Principles of Oceanography, 2nd edition, Addison-Wesley.

Davison, Charles, 1927. Founders of Seismology. Arno Press, New York Times Comp., New York.

Deresiewicz, H., 1982. Some sixteenth century European earthquakes as depicted in contemporary sources, Bull. Seis. Soc. Am., 72, 2, 507-623.

Desmarest, N., 1771-1774. Mémoire sur l´origin and nature du basalte a grandes colonnes polygones, determinées par l´histoire naturelle de cette pierre , observée en Auvergnes, HARS, pp. 705-775.

Diderot, D. and D´Alembert J. R. Le, 1751-72. Encyclopaedie, ou Dictionnaire raisonné des Sciences, Histoire Naturelle, Regne Minéral, 6eme collection:Volcans, Plate II, Paris.

ECOS, 2002. Earthquake Catalogue of Switzerland, Swiss Seismological Service, Zürich.

Egen, P. N. C., 1828. Über das Erdbeben in der Rhein- und Niederlanden vom 23 Februar 1828. Ann. Phys. Chem. 13/89.

Engdahl, E. R., and Reinhart, W.A.,1991. Seismicity of North America Project, Neotectonics of North America, Geol. Soc.Am., Decade Map Volume 1, 21-27.

Ewing, J.A., 1881. On a new seismograph, Proc.of Royal Society, London, 31, 440-446.

Ewing, J.A., 1883. Earthquake Measurement, Univ. Sci. Dept. Mem., Tokyo, 23 plates, 92 pp.

Falconi, M., 1539. Dell´incendio di Pozzuolo Marco Antonio delli Falconi. all´illustrissima signora marchesa della Padula net 1538, G. Sulzbach, Napoli.

Feldman, L. H., 1993. Mountains of fire: earthquakes and volcanic eruptions in the historic part of Central America (1505-1899). Labyrinthos, Culver City, Calif. 1993.

Florenz, K., 1890?. Japanische Dichtungen. T. Hasegawa, Tokyo & T. Harrassowitz, Leipzig.

Fonseca J. D., 2004. The Lisabon Earthquake, Argentin, Lisboa.

Fouqué A., 1879. Santorini et ses eruptions, Paris.

Furchheim, F., 1897. Bibliografia del Vesuvio, Napoli.

Garcia, J. Q., 1881. Sobre los temblores e rierra ocurridos en Julio de 1880 en la Isla Luzon. Manila.

Geistbeck, A., 1897. Bilderatlas zur Geographien von Europe mit beschreibendem Text, Bibliographisches Institut, Leipzig und Wien.

Gruenthal, G. (Ed.), 1998. European Macroseismic Scale 1998, EMS-98, Cahiers du Centre Européen de Géodynamique et de Seismologie, 15, 1-99.

Grünpeckh, J., 1509. Speculum Naturalis Coelestis et Propheticae Visionis, Stuchs, Nürnberg.

Haas, H., 1911. Neapel, seine Umgebung und Sizilien, Velhagen & Hlassing, Bielefeld und Leipzig.

Hamilton, W., 1772. Account of the discoveries in Pompeii, Naples.

Hamilton, W., 1776. Campi Phlegrei, Naples.

Hamilton, W., 1779. Suplement to the Campi Phlegrei, Naples.

Hansen, G. and Emmet,C., 1989. Denial of Disaster: The Untold Story and Photographs of the San Francisco Earthquake of 1906 Cameron and Comp., 160 pp.

Hobbs, W. A., 1909. The Mesina earthquake. Bull. Amer. Geogr. Soc., 56, 409-422.

Hoff, K.E.A., 1840. Chronik der Erdbeben und Vulkan Ausbrüche, Rotha, 876 pp.

Hoffmann, F., 1839. Geognostische Beobachtungen, Berlin.

Hochstetter, F. v., 1868. Über das Erdbeben in Peru am 13. August 1868 und die dadurch veranlassten Flutwellen in Pazifischen Ocean, namentlich an der Küste von Chili und von Neu-Seeland. Abt. Kais. Akad. Wissensch. Wien, Mathem.-naturwiss. Klasse, LVIII, Band II, 837-860.

Hochstetter, F. v., 1873. Geologische Bilder, (24 large color lithographic tables). J.F. Schreiber, Esslingen.

Holmes A., 1978. Principles of Physical Geology (3rd ed.). Wiley. pp. 640-641.

Hon, Le, 1865. Histoire complete de la grande éruption du Vésuve, Brussels.

Hondt, P., 1757. Historie Générale des Voyages, oz Nouvelle Collection de Toutes les Relations de Voyages par Mer et par Terre, Den Haag.

Humboldt, A. v., 1810. Vues des Cordilleres et Monuments des Peuples Indigenes de l´Amerique, Paris.

Humboldt, A. v., 1845-62. Kosmos. Entwurf einer physikalischen Weltbeschreibung, 5 Vols, J. G. Gotta, Stuttgart und Tübingen.

Humboldt, A. v., 1906. Obrazy z p írody (=Picture of the Nature, in Czech). J. Otto, Praha.

Hutton, J., 1795-1899. Theory of the Earth, with Proofs and Illustrations, 3 Vols, London.

Jansson (Jansonius), J., 1657. Forum Vulcani. In: Theatrum....Italiae aliarumque in insulae Maris Mediterraneas, Plate No. 36th, Amsterdam.

Jeitteles, H., 1859. Bericht über das Erdbeben am 15. Banner 1858 in Karpaten und Sudeten, Sitzungsberichten d. K. Akad d. Wiss. in Wien,, Wien.

Johnson, A. J. and Ward, 1864. Johnson´s New Illustrated Family Atlas, New York.

Junghuhn, F., 1845. Topographische und naturwissenschaftliche Reissen durch Java, 518 pp.

Kendrick, T.D., 1956. The Lisbon Earthquake. Methuen, London.

Keys, D., 1999. Catastrophe, an investigation into the origins of the modern world, Arrow Books, London, 509 pp.

Kircher, A., 1678. Mundus Subterraneus, in XII libros degustus, 3rd edition (2 Vols), (1st edition in Amsterdam in 1664-1665).

Kitahara, I. et al., 2003. Documenting Disaster, Natural Disasters in Japanese History, 1703-2003, Nat. Museum of Japanese History, Chiba.

Kozak, J. and Thompson M-C., 1991. Historical Earthquakes in Europe. Swiss Reinsurance, Zutích.

Kozák, J., and Ebel, J.E., 1996. Macroseismic information from historic pictorial sources, Pure Appl.Geoph., 146, 1, 103-111.

Kozák, J., Moreira, V.S. and Olroyd, D.R., 2005. Iconography of the 1755 Lisbon Earthquake. Academia, Praha.

Krafft, M., 1993. Volcanoes: Fire from the Earth. H.N. Abrams, New York.

Krammer, H., (Ed.), 1902-1904. Weltall und Menschheit, 5 Vols, Bong & Co., Berlin, Leipzig, Wien und Stuttgart.

Krug von Nidda, (ca 1840). Karsten´s Archives, Vols VII-IX.

Lawson, A.C. et al., 1908. Atlas of maps and seismographs. Report upon the California Earthquake of Apríl 18th, 1906. Washington D.C.

Le Bas, Jacques-Phillippe, 1757. Colleçao de algunas ruinas de Lisboa causas pelo terremoto e pelo fogo do primeiro de Novembro do anno 1755. Recoueil des plus belle ruines de Lisbonne caussées par le tremblement et par le feu du premier Novembre 1755, Paris.

Leonhard, K. C.v., 1844. Vulkanen Atlas, F. Schweizerbart, Stuttgart.

Lycosthenes, C. (Wolffart, K.), 1557. Predigiorum acostentorum chronicon, H. Petri, Basel.

Lyell, C., 1830-1833. Principles of Geology, 3 Vols, London.

Magnus, O., 1550. Historia de Gentibus Septentrionalibus, Roma.

Mallet , R., 1862. Great Neapolitan Earthquake of 1857. Report Royal Society of London, 3 Vols., Chapman and Hall, London.

Margottini, C. and Kozak, J., 1992. Terremoti in Italia dal 62 A.D. al 1908. ENEA, Rome.

Mayer-Rosa, D. and Wechsler, E., 1991. The Basel 1356 earthquake, effects on contemporary buildings in the town of Basel, in .J.Kozak (Ed.), Proc. Symp. Historical Earthquakes in Europe, 190-196, Geophysical Institute, Prague.

Medvedev, S.V., Sponheuer, W. and Kárník, V.,1964. Seismic intensity scale, version 1964, Soviet Geophysical Committee, Moscow.

Meghraoui M., Delouis, B., Ferry, N., Giardini, D., Huggenberger, P., Spottke, I. and Granet, M., 2001. Active normal faulting in the Upper Rhine Graben and paleoseismic identification of the 1356 Basel Earthquake. Science, 293, 2070-2073.

Michell, J., 1761. Conjectures concerning the cause and observations upon the phenomena of earthquakes: particularly that of the great earthquake of the first of November, 1755. Phil. Trans. 51, 566-634.

Mojsisovics v., E., 1897. Berichte über die Organisation der Erdbebenbeobachtung nebst Mittheilungen über während des Jahres 1896 erfolgte Erdbeben, Mitth. der Erdbeben- Commission d. k. Akad. d. Wiss. in Wien. Mathem.-naturwiss. Cl., Bd. CVI, Abt. I. 20-37.

Montanus, A., 1669. Denckwurdige Gesandschafften der Ost-Indischen Gesellschaft an unterschiedliche Kaiser von Japan, Amsterdam.

Münster, S, 1541&. Cosmographia, H. Petri, Basel (&=44 re-edited versions existed between 1541 and 1628).

Newhall, C. and Steve, S.,1982. The volcanic explosivity index (VEI): An estimate of explosive magnitude for historical volcanism. J. Geophys. Res., 87 (C2), pp. 1231-1238.

Ortelius, A., 1596. Thesaurus Geographicus, Amsterdam.

Panorama des Universum, (1835). Der Pick von Teneriffa, G. Haaese Sohne, Prague.

Parotto, M. and Pratullon, A., 1981. Schema Strutturale dell´Area Mediterranea Centrale e Orientale, C.N.R., Publ. No. 262, Roma.

Petermann, A., 1857. Skizze der Pic von Orizaba, Petermann´s Geographische Mittheilungen, Jahrgang 1857, J. Perthes, Gotha.

Petermann, A., 1858. Skizzen aus dem Indischen Archipel, Petermann´s Geographische Mittheilungen, Jahrgang 1858, J. Perthes, Gotha.

Placanica, A., 1985. Il filosofo la catastrofe. Storica Einaudi, Torino.

Plešinger, A., and Kozák, J., 2003. Beginnings of regular seismic service and research In the Austro-Hungarian Monarchy: part II. Stud. Geophys. Geod., 47, 757-791.

Poardi de, Giovanni V., 1627. Nuova relatione del grande e spaventoso terremoto successo nel Regno di Napoli, nella provincia di Puglia, in venerdi alli 30 Luglio 1627. Rome.

Postpischl, D., (Ed.), 1985. Atlas of isoseismal maps of Italian earthquakes. Quaderni de la Ricerca scientifica, 114:2a, Consiglio nazionale delle ricerche, Bologna.

Prévost, C., 1835. Notes sur l'ile Julia pour servir a l'histoire de la formation des montagnes volcaniques, Mémoires Soc. Géol. France, Paris.

Rasch, J., 1582. Von Erdbiden, Etliche Tractat, A. Berg, München.

Reid, H. F., 1911. The elastic rebound theory of earthquakes. Univ. California publications, Bull. Dept Geol., 6, 19.

Reinhold, A.C. (Ed.),1819-21. Lisabon (earthquake). Hyllos, Czech national journal for youth, Prague.

Reinhold, A. C. (Ed.), 1844. Zerstörung von Point-a-Pitre, Erinnerungen an merkwürdige Gestände (Journal), Prag.

Reinzer, F., 1712. Philosophische und politische Beschreibung und Erklärung der Meteoriten. J. Wolffen, Augsburg.

Riedl, J., 1816. Schauplatz der Schöpfung in naturhistorischen Alphabeten, Sien.

Rossi de, M.S. and Forel, F.A., 1881. Macroseismic intensity scale description, Jahrbuch d. Tellurischen Observatoriums zu Bern, No 7, Bull. Vulc. Ital. 10, 67-68.

Saint-Non, J. C. R. de, 1781-86. Voyage pittoresque a Naples et en Sicile, 4 vols, Paris.

Sarconi, M., 1784. Istoria di fenomeno del terremoto avvenuto nelle Calabrie e nel Valdemone nell´ anno 1783, 3 vols, G. Campo, Naples.

Schedel, H., 1493. Weltchronik (i.e., the Nürnberg Chronicle), Nürnberg.

Schmidt, J. F. J. 1881. Vulkanen und Erdbeben, A. Georgi, Leipzig.

Simkin, T., Siebert, L., McCleland, L., Bridže, D., Newhall, Ch. and Latter, J.H., 1981. Volcanoes of the World: a Regional Directory, Gazetteer, and Chronology of Volcanism During the Last 10,000 Years. Hutchinson Ross Publ. Co., Stroudsburg, PA.

Stower, C.W. and J.L. Coffman, 1993. Seismicity of the United States,1568-1989, U.S. Geol. Survey, prof. paper No. 1527, Washington.

Sutcliffe, T., 1839. The earthquake of Juan Fernandez, as it occured on the island of Juan Fernandez and Tolcahuana in the year 1835. J.O. Longman and J. Thompson, London and Manchester.

Tazieff, H., 1951. Crateres en feu, Arthaud, Paris.

Tiedemann, H., 1991. Earthquakes and Volcanic Eruptions, A Handbook for Risk Assessments, Swiss RE, Zürich.

Titsingh, I., 1822. Illustrations of Japan, consisting of private memoirs and anecdotes of the reigning dynasty of the djogouns or sovereigns of Japan, A. Ackerman, London.

Toledo P.G. da, 1539. Ragionamento del terremoto del Monte Novo, dell´apprimento di terra in Pozzuolo nell´ anno 1538.

Turcotte, D. L. and Schubert, G. 2002. Plate Tectonics, Geodynamics (2nd edition). Cambridge University Press.

Vega P. F. la, 1780. Carte du golfe de Pouzzuoles avec une partie des Camps Phlegréens dans la Terre de Labour.

Verbeek, R.D.M., 1884. Krakatau Album, Nationaal Aardrijkskundig Institut, Batavia.

Vivenzio, G., 1788. Istoria de tremuoti avvennuti nella Provincia della Calabria ulteriore…preceduta da una Teoria ed Istoria generale de´ Tremuoti, 2 vols, Stamperia Reale, Napoli.

Volger, G.H.O, 1856. Untersuchungen über das letzjahrige Erdbeben in Central-Europa, Petermann´s Geographische Mitteilungen, pp. 85-102, J. Perthes, Gotha.

Wegener, A.L., 1915. Die Entstehung der Kontinente und Ozeane, F. Vieweg & Sohn Akt. Ges., Braunschweig.

Wechsler, E., 1987. Das Erdbeben von Basel 1356, Schweiz, Erdbebendienst, ETH, Zürich, 128 pp.

Zahn, J., 1696. Specula physico-mathematico-historica notabilium ac mirabilium sciendorum, 3 Vols, Nürnberg.

Zimmermann, W.F., 1882. Der Erdball und seins Naturwunder, G. Nemlel, Berlin.

Zollinger, H., 1858. Die Indische Archipel, vol.1958, part II. In: Petermann`s Geographische Mittheilungen, Jahrgang1858, J. Perthes, Gotha.

Zürcher, F., and Margollé, É., 1869. Volcanoes and Earthquakes. J.B. Lippincott, Philadelphia.

Index